CHIMIE
DES COULEURS

POUR

LA PEINTURE A L'EAU ET A L'HUILE

IMPRIMERIE DE PILLET FILS AÎNÉ, RUE DES GRANDS-AUGUSTINS, 5.

CHIMIE
DES COULEURS

POUR LA

PEINTURE A L'EAU ET A L'HUILE

COMPRENANT

L'HISTORIQUE, LA SYNONYMIE,
LES PROPRIÉTÉS PHYSIQUES ET CHIMIQUES, LA PRÉPARATION,
LES VARIÉTÉS, LES FALSIFICATIONS,
L'ACTION TOXIQUE ET L'EMPLOI DES COULEURS
ANCIENNES ET NOUVELLES

PAR M. J. LEFORT

PARIS
VICTOR MASSON, LIBRAIRE-EDITEUR
PLACE DE L'ÉCOLE-DE-MÉDECINE, 17
—
1855

L'Éditeur se réserve le droit de traduction.

INTRODUCTION.

M. Bouvier, dans son *Manuel des jeunes artistes et amateurs en peinture*, s'exprime ainsi : « Il serait à souhaiter que les peintres eussent plus de connaissances qu'ils n'en ont généralement sur la chimie des couleurs. »

Il est bien certain que la connaissance des réactions chimiques rend à l'artiste des services dont l'importance se fait sentir dans une foule de circonstances. Il acquiert par cela même des indications précieuses toutes les fois qu'il s'agit de composer des mélanges avec des substances capables de réagir les unes sur les autres, ou bien encore lorsqu'il veut appliquer certaines couleurs sur des objets journellement exposés à l'action destructive des agents phy-

siques et chimiques, comme les rayons lumineux et scolaires, et les gaz méphitiques.

C'est par les progrès incessants de la chimie, et surtout par les découvertes de nos expérimentateurs modernes, que les artistes ont pu apprécier théoriquement d'abord, pratiquement ensuite, ces brillantes couleurs qu'ils emploient, et que l'on est parvenu à remplacer des substances, aussi dangereuses à préparer qu'à employer, par d'autres, sinon inoffensives, du moins peu délétères.

Le premier soin du chimiste qui vient de découvrir une combinaison nouvelle est de rechercher le parti que les arts peuvent en tirer. De là, pour le sujet que nous voulons traiter, cette grande quantité de substances colorées que l'industrie livre journellement à l'usage de la peinture.

Notre but, ainsi que l'indique le titre de cet ouvrage, est de faire connaître aux personnes qui préparent et emploient les couleurs, la nature des substances employées par les peintres de l'antiquité, d'indiquer la composition chimique, la préparation, le degré de solidité et l'action sur l'économie animale de toutes celles que l'on trouve dans le commerce, et enfin de signaler les falsifications qu'on leur fait subir.

Notre intention n'est pas seulement de décrire les propriétés physiques et chimiques des couleurs les plus employées de nos jours, mais encore de rappeler

toutes celles qui ont été proposées, puis rejetées comme désavantageuses. Tel produit chimique qui, dans un temps donné, ne peut servir avantageusement à la peinture, peut, par suite des modifications apportées dans sa préparation, trouver un emploi très-favorable. Ne voyons-nous pas l'oxyde de zinc tour à tour proposé et tour à tour rejeté, acquérir maintenant une importance qui s'accroît de jour en jour?

Cet ouvrage, qui s'adresse aussi bien aux peintres qu'aux fabricants de couleurs, est le résultat de plusieurs années d'études; mais, quelque soin que nous ayons apporté dans nos expériences et dans nos renseignements, puisés aux meilleures sources, il a dû nous échapper beaucoup de faits importants.

Si on réfléchit que chaque chimiste manufacturier opère avec un outillage particulier et dans de certaines conditions qui constituent ce qu'on appelle communément le *tour de main* ou secrets de fabrique, on en concluera qu'il est assez difficile, pour ne pas dire impossible, d'indiquer tous les modes opératoires suivis jusqu'à ce jour.

Chaque fabricant applique aux couleurs déjà connues, ou bien à des mélanges de plusieurs d'entre elles, un nom, une marque, un numéro, et enfin une forme, qui en font des variétés particulières. De là cette profusion de substances colorées, dont la teinte riche l'emporte trop souvent sur la solidité; de là

aussi cette confusion qui fait que ces produits varient avec les détaillants ; et de là enfin pour nous l'obligation d'entreprendre un certain nombre de recherches, dont les résultats ont été souvent en contradiction avec les données qu'on trouve décrites dans les auteurs.

Nous avons dû nous attacher à concentrer dans le plus petit nombre de pages possibles tout ce que nous avions à dire sur l'emploi des couleurs, réservant la plus grande place pour tout ce qui se rattache à leur préparation.

L'industrie, dit-on de toutes parts, ne s'apprend pas dans les livres, cela est très-vrai ; mais on conviendra aussi que sans la théorie on s'expose journellement à des déceptions, à des pertes d'argent et de temps, que la parfaite connaissance des réactions aurait pu prévenir.

Pour mettre ce livre à la hauteur de la science, nous avons dû, d'une part compulser tous les recueils périodiques qui traitent de la matière, et d'une autre part, puiser nos renseignements dans les écrits de nos devanciers ; pour cela nous citerons particulièrement le *Manuel de peinture*, de Bouvier ; l'*Art du peintre, doreur et vernisseur*, de Watin et Bourgeois ; le *Manuel de peinture*, de M. Mérimée ; les *Manuels du fabricant de couleurs et du coloriste* de l'*Encyclopédie Roret* ; et enfin, pour les falsifications, l'excellent *Dictionnaire* de M. Chevallier.

Nous avions d'abord l'intention de décrire les couleurs d'après leur composition chimique, et d'en faire des séries spéciales. Mais nous n'avons pas tardé à nous apercevoir que ce nouveau plan jetterait beaucoup de perturbation dans leur étude.

Chaque teinte forme donc un chapitre séparé; et, pour y mettre la plus grande régularité, nous procédons du simple au composé; c'est ainsi que nous commençons par les corps simples, les oxydes, les acides et les sels, pour finir par les substances végétales et animales. Ce n'est que dans de rares circonstances que nous nous éloignons de cet ordre.

Tous les produits dont la composition chimique a été parfaitement définie sont représentés par une formule qui permet de connaître immédiatement la nature de leurs principes constituants.

Nous n'ignorons pas que cet ouvrage présente un grand nombre de lacunes à combler. En le publiant aujourd'hui, notre but est d'imprimer à la chimie appliquée, à la peinture, une impulsion nouvelle. Le lecteur pourra juger jusqu'à quel point nous avons réussi.

<div style="text-align:right">J. LEFORT.</div>

15 mars 1855.

CHIMIE
DES COULEURS

POUR

LA PEINTURE A L'EAU ET A L'HUILE.

CONSIDÉRATIONS GÉNÉRALES

SUR LES COULEURS.

Toutes les substances colorées dont il est question dans cet ouvrage se rapportent, quant à la nuance, aux sept couleurs du spectre solaire, qui sont, comme chacun sait, le *violet*, l'*indigo*, le *bleu*, le *vert*, le *jaune*, l'*orangé* et le *rouge*. Lorsqu'elles ne réfléchissent pas d'autres nuances, on les nomme *primitives* ou *fondamentales*.

Toutes celles, au contraire, qui résultent du mélange des couleurs primitives, sont désignées sous le nom de *secondaires*.

Il résulte de là que les nuances de ces dernières sont aussi variées que l'art se plaît à les reproduire.

Les qualités qu'on recherche dans une couleur, sont : 1° une teinte riche ; 2° une grande fixité ; 3° la propriété de couvrir les objets sur lesquels on l'applique ; 4° de se mélanger parfaitement aux liquides qui servent à la délayer ; 5° de sécher très-vite lorsqu'elle est étendue ; 6° d'être insoluble dans l'eau ; 7° de n'être pas décomposée par son mélange avec d'autres couleurs.

Les nombreux produits destinés à la peinture à l'eau et à l'huile sont empruntés, mais en proportions différentes, aux trois règnes de la nature.

1° Le règne minéral fournit environ les trois quarts des couleurs dont nous traçons ici l'histoire, et a des propriétés couvrantes qu'on ne retrouve pas dans les autres ; elles joignent généralement une solidité beaucoup plus grande. Ce sont elles que la peinture à l'huile emploie le plus souvent. De ce nombre sont les métaux, leurs oxydes et leurs combinaisons salines.

2° On tire du règne végétal un certain nombre de couleurs assez belles, mais manquant de corps et souvent de fixité ; aussi les réserve-t-on plus particulièrement pour la peinture à l'eau. Elles consistent en principes colorants, des feuilles, des fleurs et des racines, précipités au moyen des alcalis.

3° Le règne animal ne fournit guère que trois substances : la cochenille, la sépia et le jaune indien ; couleurs assez belles et assez solides, mais d'un usage assez restreint, surtout la dernière.

Elles se divisent en couleurs naturelles et en couleurs

artificielles; les premières passent généralement pour être les plus solides, mais leur teinte n'est pas toujours aussi belle, et comme elles ont une densité plus grande, il en résulte qu'elles couvrent très-bien. Les secondes affectent les nuances les plus variées, ne s'étendent pas aussi bien sous le pinceau, et résistent moins longtemps à l'action des agents extérieurs.

De l'avis des historiens et des chimistes(1), les peintres de l'antiquité n'employaient qu'un petit nombre de couleurs appartenant, pour la plupart, au règne minéral, et d'une fixité parfaitement reconnue, parce qu'ils les préparaient eux-mêmes. Mais les travaux incessants de nos chimistes modernes ont fait découvrir, depuis, une foule de combinaisons diversement colorées que l'industrie fait servir d'une manière plus ou moins heureuse à la peinture en général. De là cette profusion de substances existant actuellement dans le commerce sous des noms qui n'indiquent pas ordinairement la véritable composition chimique.

Toutes les recherches qui ont pour but de remplacer une couleur peu solide et d'une nuance désavantageuse par une autre plus fine et plus belle, ne peuvent qu'être bien accueillies par les artistes. Malheureusement il n'en est pas toujours ainsi.

Ce que le fabricant actuel recherche avant tout, c'est de livrer au commerce des produits d'une teinte aussi belle

(1) Chaptal et Humphry Davy ont donné sur des couleurs trouvées dans les ruines de Pompéia, dans des monuments romains, et enfin sur des fragments de peinture de la *noce Aldobrandine*, des indications précieuses sur lesquelles nous aurons souvent l'occasion de revenir.

que possible et au prix le moins élevé, sans s'inquiéter s'ils présentent une solidité assez grande. Un pareil résultat ne peut avoir que des conséquences désastreuses pour l'avenir. Il est fort à croire, en effet, qu'en composant de semblables couleurs, ces belles toiles, qui font maintenant notre admiration, perdront dans un temps plus ou moins éloigné ces tons riches que l'artiste a reproduits avec tant de fidélité et que l'on retrouve encore dans les tableaux des anciens maîtres.

Pour qu'une couleur réunisse toutes les qualités qu'on exige dans son emploi, il faut qu'étendue avec le pinceau en couche excessivement mince, toutes les parties soient liées entre elles, de manière à ce que l'on ne puisse apercevoir les objets sur lesquels on l'applique.

On obtient en partie ce résultat par l'extrême division de la substance que l'on délaye dans le liquide.

L'usage a appris depuis longtemps qu'une couleur couvrait d'autant mieux qu'elle était plus dense ou lourde. C'est ce qui explique pourquoi les composés de plomb sont considérés comme les meilleures couleurs, et pourquoi le blanc de zinc léger est moins estimé que celui qui a subi une forte compression.

Les travaux récents de nos chimistes nous ont appris que, dans la préparation des substances que l'on obtient par double décomposition, il n'était pas indifférent d'opérer à froid ou à chaud. On a remarqué que, précipités à chaud, c'est-à-dire avec des liqueurs bouillantes, les produits sont plus denses et ont, pour ceux qui sont colorés, une teinte plus foncée.

La précipitation a encore pour avantage de fournir des

couleurs en poudre très-fine ; mais alors il est indispensable, toutes les fois que faire se peut, de les chauffer à une certaine température, afin de les priver de l'eau d'interposition qu'elles contiennent. On n'ignore pas, en effet, que sans cette précaution elles se délayent mal dans les corps gras et perdent une partie de leur propriété couvrante. Ceci explique pourquoi la céruse de Clichy, obtenue par précipitation, couvre moins bien que la céruse fabriquée par le procédé hollandais.

Sous le nom de solidité ou de fixité, on désigne en peinture la propriété que possède une couleur de conserver pendant un temps plus ou moins long la teinte qui la caractérise.

On peut former sur le degré de solidité des couleurs plusieurs divisions que nous allons faire connaître.

1^{re} SECTION. — COULEURS TRÈS-SOLIDES.

BLANCHES.
- Oxyde de zinc.
- Blanc d'Espagne.
- Craie.
- Argent en coquille.
- Chaux vive.
- Sulfate de baryte.
- Sulfate de chaux.

JAUNES. . .
- Or en coquille.
- Jaune-Mérimée.
- Ocre jaune.
- Jaune de Naples.
- Terre d'Italie, Ocre de rue.
- Jaune minéral.

JAUNES...	Jaune de chrome. Chromate de baryte. Laque minérale.
BLEUES...	Outremer-Guimet. Bleu d'azur naturel. Bleu de cobalt. Smalt. Outremer de cobalt.
NOIRES...	Noir de fumée, de vigne. Noir d'ivoire. Noirs de lampe, de charbon, pêche, liége, hêtre, châtaigne. Noir de Francfort. Noir d'Allemagne.
ROUGES...	Arséniate de cobalt. Ocre rouge. Laque de garance. Carmin de cochenille. Laque carminée. Rouge de Prusse. Rouge d'Angleterre, Colcothar, Brun-rouge. Rose de cobalt. Bol d'Arménie.
VERTES...	Vert de chrome. Vert de Rinmann. Vert de montagne naturel. Vert Milory. Terre de Vérone.
BRUNES...	Terre de Sienne calcinée. Brun de manganèse. Brun Vandick. Bitume de Judée, Terre d'Ombre, Terre de Cassel.

2ᵉ SECTION. — COULEURS MOINS SOLIDES.

BLANCHES.
- Carbonate de plomb, Céruse.
- Sulfate et Sulfite de plomb.

JAUNES...
- Or mussif.
- Gomme-gutte.
- Massicot.
- Sous-sulfate de plomb.
- Sulfure de cadmium.
- Jaune indien.
- Jaune bouton-d'or.
- Jaune d'antimoine, de Mars, Ocres artificielles.

BRUNES..
- Brun doré de plomb.
- Ulmine.

BLEUES..
- Carmin bleu.
- Tournesol.

NOIRES..
- Encre de Chine.
- Noir de houille.
- Noir de composition.

ROUGES..
- Mine orange.
- Minium.

VERTES..
- Vert de Mittis.
- Vert Paul Véronèse.
- Vert de Schweinfurt.

BRUNES..
- Brun de chicorée.
- Brun de Prusse, Sépia.
- Bistre.

3° SECTION. — COULEURS PEU SOLIDES.

JAUNES . .
- Terra-merita.
- Jaune de safran.
- Stil de grain.
- Arsénite de plomb.
- Laque de gaude.

BLEUES . .
- Cendres bleues artificielles.
- Bleu minéral ou bleu d'Anvers.
- Indigo.

ROUGES . .
- Cinabre.
- Rouge de carthame.
- Laque de Fernambouc.

VERTES . .
- Ocre verte.
- Vert de vessie.
- Vert anglais.
- Cendre verte.
- Vert de Scheele.
- Vert de montagne.
- Vert de Brême.

POURPRE . . | Pourpre de Cassius.

VIOLETTES . | Violet végétal.

4° SECTION. — COULEURS TRÈS-PEU SOLIDES ET QUE LE PEINTRE NE PEUT MÉLANGER.

JAUNES . .
- Jaune d'iode.
- Sulfure d'arsenic.
- Turbith minéral.

BLEUES . .
- Carmin bleu.
- Tournesol.
- Platt indigo.

ROUGES . . . { Réalgar.
Chromate de mercure.
Bi-iodure de mercure.

VERTES . . { Vert-de-gris.
Verdet.
Vert d'iris.
Cinabre vert.
Vert minéral.
Vert de Prusse.

On comprend de suite que ce genre de classification ne peut rien avoir d'absolu ; car telle couleur peu durable dans la peinture à l'eau, le deviendra davantage lorsqu'on l'aura fait servir dans la peinture à l'huile, et *vice versa*.

La composition chimique d'une couleur suffit déjà en partie pour faire connaître son degré de fixité. En effet, c'est autant par elle que par l'usage qu'il est permis d'affirmer que l'iodure de mercure, par exemple, substance décomposable à l'air à une basse température, sera plus facilement détruit par les rayons solaires que le chromate de plomb, qui résiste à une très-haute température sans être décomposé, même partiellement.

Du mode de préparation qu'on aura employé pour obtenir une couleur, on pourra encore juger de son degré de fixité. Toutes choses égales d'ailleurs, la couleur sera d'autant plus durable qu'elle aura été obtenue à une haute température et qu'elle résistera plus longtemps à l'action de la chaleur. C'est ce qui explique pourquoi certains oxydes métalliques (rouge d'Angleterre, minium) sont beaucoup plus solides que la plupart des combinai-

sons préparées par double décomposition (iodure de plomb, iodure de mercure).

Aux causes que nous venons de faire connaître, il faut encore ajouter l'altération profonde que subissent certains produits chimiques, lorsqu'on les mélange, soit pour rehausser le ton de la couleur, soit pour obtenir des nuances particulières.

L'association des couleurs produit quelquefois une action chimique que le peintre doit avant tout connaître, soit par la théorie, soit par la pratique.

L'artiste a très-souvent l'occasion d'éclaircir ou de foncer la teinte de la couleur principale; mais il ne doit pas perdre de vue que ces mélanges doivent être faits, autant que possible, avec des produits de même nature : sans cela, il obtient sur le moment des teintes très-riches, mais en général peu durables. Nous citerons comme exemple l'indigo, que l'on ajoute quelquefois aux cendres bleues et à l'outremer, pour obtenir une nuance plus foncée.

L'un des plus graves inconvénients que présentent les couleurs mélangées, réside dans le changement complet de la teinte que l'on veut obtenir; et on a remarqué, à cet égard, que ces mélanges ne possèdent pas une très-grande solidité; il se produit alors des réactions chimiques qui tendent à détruire des couleurs souvent assez solides pour donner naissance à d'autres produits d'une existence presque éphémère. Ce résultat assez commun avec les couleurs broyées à l'huile, devient plus sensible avec celles qui sont employées dans la peinture à l'eau. C'est qu'avec ce dernier liquide, la réaction

tarde moins à s'effectuer, et se fait d'une manière plus profonde.

Les couleurs doivent être, autant que possible, conservées dans des endroits secs. Comme la plupart des substances pulvérulentes, elles absorbent assez facilement l'humidité atmosphérique. Pour les sécher, on les expose à une température graduée, celle de l'étuve, par exemple. Nous avons déjà dit que celles qui sont humides se délayent difficilement dans les corps gras, et partant couvrent mal.

Elles ne peuvent toutes servir indistinctement pour la peinture à l'eau et à l'huile ; il en existe cependant quelques-unes qui se délayent très-bien dans ces deux liquides.

Parmi les agents qui concourent le plus à la destruction des couleurs en général, il faut mettre en première ligne les rayons lumineux et solaires, puis les émanations gazeuses existant dans l'atmosphère.

Tout le monde sait que la lumière et le soleil ont pour effet de détruire les teintes vives de certaines couleurs, au point de les décolorer complétement après un temps plus ou moins long ; mais tout le monde sait aussi que ce résultat dépend beaucoup de la qualité du vernis qu'on a employé. Tant qu'une couleur se trouve suffisamment garantie par la couche de vernis qu'on y applique, sa teinte ne change pas d'une manière sensible, mais toutes les fois que les rayons solaires ont une action directe sur elle, la décoloration ne se fait pas attendre, surtout lorsqu'on s'est servi d'un produit de mauvaise qualité et compris dans les dernières sections.

Toutes les fois que les gaz méphitiques qui se dégagent de certains lieux, et dans des conditions particulières, peuvent former avec la matière colorante des combinaisons particulières, la teinte change de nuance. C'est ainsi que les composés de plomb noircissent au contact des émanations méphitiques et produisent du sulfure noir de plomb, et que certaines peintures blanches pour lesquelles on a employé des siccatifs à base de sels solubles de zinc et de manganèse, prennent avec le temps une légère teinte jaunâtre ; il se forme des sulfures de zinc et de manganèse, qui sont toujours moins blancs que la peinture elle-même.

Les couleurs peuvent être divisées, d'après leur degré de toxication, en quatre classes.

1^{re} CLASSE. — COULEURS DANGEREUSES.

Orpiment.
Réalgar.
Arsénite de plomb.
Arséniate de cobalt.
Vert-de-gris.

Verdet cristallisé.
Vert de Scheele.
Vert de Schweinfurt.
Vert de Mittis.
Vert Paul Véronèse.

2^e CLASSE. — COULEURS MOINS DANGEREUSES.

Céruse.
Massicot, litharge, minium.
Jaune de Naples.
Jaune de chrome.
Iodure de plomb.
Oxydo-chlorures de plomb.
Sulfure d'étain.

Antimoniate de plomb.
Laque minérale.
Jaune minéral.
Rose de cobalt.
Chromate de cuivre.
Rouge pourpre.
Pourpre de Cassius.

Iodure de mercure.
Turbith minéral.
Chromate de mercure.
Sulfate de plomb.
Sulfite de plomb.
Tungstate de plomb.
Antimonite de plomb.

Bi-oxyde de plomb.
Outremer de cobalt.
Bleu Thénard.
Bleu de Montagne.
Vert de chrome.
Vert de montagne.
Poudre de bronze.

3ᵉ CLASSE. — COULEURS PEU VÉNÉNEUSES.

Oxyde de zinc.
Chaux vive.
Oxyde d'antimoine.
Oxydo-chlorure d'antimoine.
Blende.
Sulfure de cadmium.
Chromate de zinc.
Chromate de chaux.
Chromate de baryte.

Gomme-gutte.
Rouge-brun.
Smalt.
Vert de Rinmann.
Vert de Prusse.
Cinabre vert.
Vert Milory.
Bleu minéral.
Outremer.

4ᵉ CLASSE. — COULEURS INOFFENSIVES.

Argent en coquille.
Carbonate de chaux.
Sulfate de chaux.
Sulfate de baryte.
Or.
Ocres jaune et rouge.
Rouge de Venise.
Rouge d'Anvers.
Terra-rosa.
Terre d'Italie.
Ocre de rue.
Jaune, violet, rouge de mars.
Brun et orange de mars.

Carthame.
Carmin de cochenille.
Laque carminée.
Violet végétal.
Brun de manganèse.
Brun Vandick.
Terre d'ombre.
Terre de Sienne.
Terre de Cologne.
Brun de Prusse.
Sépia.
Tous les noirs.
Encre de la Chine.

Curcuma.
Jaune indien.
Stil-de-grain.
Laque de gaude.
Colcothar.
Bol d'Arménie.
Laque de garance.
Carmin de garance.
Laque de Fernambouc.

Bleu de Prusse.
Indigo.
Carmin bleu.
Platt indigo.
Terre verte de Vérone.
Laque verte.
Vert de vessie.
Vert d'Iris.

CHAPITRE I^{er}

COULEURS BLANCHES

ARGENT EN COQUILLE.

L'argent que l'artiste emploie pour obtenir le ton blanc, dit d'argent, est fourni par les batteurs de métaux précieux.

Pour l'approprier à l'usage auquel on le destine, les fabricants de couleurs lui font subir une préparation qui a pour but de le réduire en poudre fine, au moyen de certains intermèdes, comme le miel ou le sucre de fécule.

Pour cela, on choisit les rognures d'argent très-pur, ou bien les feuilles défectueuses que l'on ne pourrait mettre en livret; on les mélange avec une petite quantité de miel ou de glucose, parfaitement blanche et privée de ma-

tière étrangère, puis on broie le tout avec une mollette sur un porphyre ou dans un mortier de marbre. Lorsque la matière est bien homogène, on la délaye dans une grande quantité d'eau chaude, qui dissout l'intermède, et laisse l'argent en poudre impalpable. On lave le précipité à plusieurs reprises par décantation, puis on le jette sur un filtre sans plis de papier joseph; enfin, on fait sécher à l'étuve.

La poudre d'argent est délayée dans une solution concentrée de gomme arabique très-blanche, et ne contenant aucune impureté; on en revêt les trois quarts environ de l'intérieur de petites coquilles longues, en ayant soin d'en fixer dans un point la grosseur d'une forte lentille, et on fait sécher à l'étuve.

Pendant cette préparation, l'argent conserve très-bien l'éclat métallique qu'on lui connaît.

Pour préparer la poudre d'argent, un auteur indique de précipiter ce métal de la dissolution nitrique, au moyen d'une lame de cuivre; ce dernier produit du nitrate de cuivre, tandis que l'argent se dépose sous la forme d'une poudre noire qu'on lave avec de l'eau acidulée par de l'acide nitrique, puis avec de l'eau chaude. Mais des essais comparatifs ont montré que par ce procédé l'argent perdait la plus grande partie de son éclat, et avait beaucoup plus de tendance, vu son extrême division, à s'oxyder et à noircir.

La valeur d'une coquille d'argent est en raison de l'épaisseur de la couche et de la grosseur du bouton.

D'après nos recherches, une coquille de grandeur ordinaire contient de 6 à 7 centigrammes d'argent pulvé-

risé ; il en résulte qu'avec un poids de 5 grammes de mé-
tal ou un franc, un fabricant peut obtenir de soixante-
quinze à quatre-vingts coquilles.

L'artiste exercé apprécie très-bien *de visu* la valeur des coquilles qu'il achète, mais il doit s'assurer que l'argent ne possède pas d'alliage, c'est-à-dire de cuivre. Pour cela, il pourra dissoudre le contenu d'une ou deux de ces coquilles dans une petite quantité d'acide nitrique. Si la solution prend une teinte verdâtre ou bleuâtre, il sera certain que l'argent n'était pas pur.

L'argent en coquille forme une couleur d'une très-grande solidité, et nullement vénéneuse : c'est surtout dans l'enluminure qu'on en fait usage.

CHAUX VIVE.

La chaux ou oxyde de calcium est l'une des substances que l'on retrouve en plus grande quantité dans la nature, mais jamais à l'état de pureté. Elle est toujours combinée aux acides carbonique, sulfurique, phosphorique et silicique, etc., avec lesquels elle forme le marbre, la craie, le plâtre, les os des animaux, et enfin une multitude de minéraux.

La préparation de la chaux vive ou caustique, et telle que la peinture l'emploie, est basée sur la décomposition à une température élevée du carbonate de chaux (marbre, pierre à chaux). Tout le monde sait que l'élimination de l'acide carbonique s'obtient en brûlant de la houille mélangée avec de la pierre calcaire, réduite en morceaux peu volumineux. La décomposition s'exécute dans des fours de

forme variable. La construction la plus simple consiste en trous de forme ovoïde, creusés dans les flancs d'une colline et ouverts par le bas. On commence par remplir toute la partie inférieure de combustible (bois et charbon), puis on forme des couches de calcaire et de houille, jusqu'à ce que la fosse soit entièrement remplie. On allume le feu sous la voûte, la flamme en passant par les fissures des couches met toute la masse en ignition. Lorsque tout le combustible est brûlé, on laisse refroidir, et on retire la chaux par l'ouverture inférieure.

Mais le plus ordinairement on se sert de fours coulants ou continus, qui permettent de poursuivre l'opération pendant des semaines entières et sans interruption.

Un four continu ressemble dans son intérieur à un cône renversé ; on le charge de pierre calcaire et de houille par sa partie supérieure, et à mesure que la chaux descend on la retire par l'ouverture inférieure, en même temps que d'autres ouvriers le rechargent. Ce moyen évite beaucoup de combustible, et peut fournir 50 hectolitres de chaux très-bien calcinée dans les vingt-quatre heures.

On reproche cependant à ce procédé de fournir une chaux souillée de matières étrangères, de cendres, par exemple, qui lui communiquent une teinte grise rougeâtre.

Pour obvier à ces inconvénients, on a imaginé de construire des fours dans lesquels le combustible brûle dans des foyers séparés. Le produit que l'on obtient est toujours à un prix plus élevé, mais il possède une blancheur qui ne se compare pas, surtout si l'on a eu le soin de prendre de la pierre calcaire très-peu colorée.

Les fabricants de chaux ont reconnu depuis longtemps que pour décomposer complétement et rapidement le calcaire, il fallait : 1° mouiller la pierre avant de la mélanger avec la houille ; 2° la choisir toujours compacte, et la réduire en morceaux peu volumineux ; 3° prendre de préférence la houille sèche ; 4° régler le feu de manière à éviter une trop forte calcination : sans cette dernière précaution on obtient de la chaux *brûlée* qui ne s'éteint pas.

Telle qu'elle sort des fours, la chaux vive ou caustique n'est pas de l'oxyde de calcium parfaitement pur, presque toujours elle contient de l'alumine, de l'acide silicique, de l'oxyde ferrique, de la potasse, de la magnésie et de l'oxyde de manganèse. Elle est d'autant plus blanche que le carbonate calcaire était plus pur, et surtout qu'il contenait moins d'oxyde de fer. Aussi le marbre blanc fournit-il de la chaux d'une blancheur parfaite.

Dans son plus grand état de pureté, on la représente ainsi :

$$\underbrace{Ca.}_{\text{Calcium.}} + \underbrace{O.}_{\text{Oxygène.}}$$

Exposée à l'air, elle en attire rapidement l'acide carbonique et l'humidité ; elle se réduit peu à peu en poudre : on dit alors qu'elle se *délite* ; il s'est formé un mélange de carbonate de chaux et de chaux hydratée.

Elle a la plus grande affinité pour l'eau, avec laquelle elle se combine en donnant naissance à un dégagement de chaleur qui peut aller jusqu'à 300°. Elle se fendille dans tous les sens en produisant un sifflement accompa-

gné d'épaisses vapeurs aqueuses : on dit qu'elle *foisonne;* et lorsqu'elle a absorbé environ le quart de son poids d'eau, elle se réduit en une poudre blanche et volumineuse qui constitue la chaux éteinte ou l'hydrate de chaux.

Cette dernière combinaison, délayée dans de l'eau, donne le lait de chaux que les peintres employent pour le badigeonnage, mais on y ajoute toujours une certaine quantité d'argile ocreuse ou de noir de fumée, afin de détruire la teinte jaunâtre qu'elle possède.

Le lait de chaux ne peut encore être employé qu'après avoir été mélangé avec une petite quantité de colle, qui lui donne du corps. Pour la détrempe, on y ajoute presque toujours de l'alun, qui a pour but de donner à la peinture une plus grande solidité. Dans ce cas il s'est opéré une décomposition du sel d'alumine, qui a donné naissance à une combinaison insoluble d'alumine hydraté et de chaux, de sulfate de chaux également insoluble, et enfin à du sulfate de potasse, qui reste dissous.

M. Lassaigne a conseillé de remplacer l'alun par de l'argile blanche.

En Allemagne, on connaît sous le nom d'*enduit blanc* un mélange de chaux éteinte, d'argile et de plâtre, qui est d'un emploi journalier pour la peinture des murailles.

La chaux que le commerce livre aux artistes durcit rapidement à l'air, par suite de l'acide carbonique qu'elle absorbe; mais elle ne peut entrer dans la composition des couleurs proprement dites, car par son alcalinité elle les décompose presque toutes. Elle se solidifie assez vite lorsqu'on la broie avec de l'huile, et présente le défaut de

jaunir avec le temps. Il se produit dans cette circonstance un savon calcaire qui ne présente aucune solidité ; elle est d'un emploi journalier pour la grosse peinture, le badigeonnage, par exemple.

C'est une couleur peu vénéneuse.

BLANC DE ZINC.

De toutes les couleurs dont nous traçons ici l'histoire, il n'en est pas qui aient autant apporté de changement dans l'art du peintre que le blanc ou oxyde de zinc substitué à la céruse.

De tout temps les savants se sont occupés du soin de soustraire les ouvriers aux graves maladies qu'occasionnent la fabrication et l'usage des préparations de plomb.

Dès l'année 1782, un chimiste manufacturier de Dijon, nommé Courtois, proposa de remplacer, dans la peinture à l'huile, le carbonate de plomb par le carbonate de zinc. Sur les indications fournies par cet industriel, qui préparait alors le carbonate de zinc en grand, Guyton de Morveau présenta, quelques années après, un mémoire à l'Académie de Dijon, dans lequel il fait connaître les avantages de cette substitution, et les moyens d'obtenir ce produit à un prix peu élevé. Les essais entrepris à cette époque, tout en établissant que la peinture au carbonate de zinc séchait plus lentement et possédait une teinte moins avantageuse que celle de la céruse, montrèrent cependant qu'à l'état de fraîcheur elle ne répandait pas d'odeur désagréable, et ne noircissait pas au contact des émanations sulfureuses. Le prix élevé du zinc à l'époque où ces faits se

passaient, et surtout la routine, cette pire entrave du progrès, firent peu à peu tomber cette substance dans l'oubli.

En 1796, l'Anglais Atkinson, de Harrington, prend une patente pour l'application et la préparation de l'oxyde de zinc, au moyen de la galène, qu'il décompose à une température élevée, après l'avoir mélangée avec du charbon.

M. Mollerat, en 1808, tente de nouveau la préparation en grand de l'oxyde et du carbonate de zinc ; mais il donne la préférence à ce dernier, qui est plus blanc. Comme Guyton de Morveau, il convient que si ces substances ne possèdent pas toutes les qualités de la céruse, elles n'ont pas l'inconvénient de nuire à la santé des ouvriers qui les fabriquent et des artistes qui les emploient.

Ces observations étaient à peu près tombées dans l'oubli, lorsqu'en 1842 M. Rouquette prit un brevet d'invention pour la préparation industrielle de l'oxyde de zinc. Nous ferons connaître plus loin les principes généraux de ce mode d'opération.

Dans deux mémoires présentés à l'Académie des sciences en 1844 et 1845, M. Mathieu, tout en tenant secret le genre de fabrication qu'il emploie, fait de nouveau sentir les avantages de la substitution du blanc de zinc au blanc de plomb. Les expériences de ce chimiste passèrent à peu près inaperçues, lorsque M. Leclaire, reprenant la question où ses devanciers l'avaient placée, arriva le premier à préparer de l'oxyde de zinc à un prix très-peu élevé, et de plus dans un état de blancheur comparable à la plus belle céruse.

A partir de cette époque, la cause du blanc de zinc fut gagnée. Pour compléter sa découverte, M. Leclaire a fait

connaître depuis diverses couleurs à base de zinc qui, si elles n'ont pas encore eu tout le succès désirable, permettent du moins d'espérer que, dans un avenir prochain, l'oxyde de zinc remplacera l'oxyde de plomb dans la plupart de ses composés.

L'emploi du blanc de zinc et des composés à base de ce métal, peut être regardé comme une découverte de la première importance, tant sous le rapport des avantages que ces couleurs fournissent à la peinture que sous le rapport hygiénique.

Son plus grand avantage est, comme on sait, de résister beaucoup plus longtemps que les composés de plomb à l'air et aux émanations sulfureuses. Son prix est plus élevé que la céruse, mais à poids égal, il couvre une plus grande surface; ainsi des essais comparatifs ont montré que 1 kil. de blanc de zinc couvrait la même étendue que 1 kil. 30 grammes de céruse. Les boiseries des appartements, les papiers peints au blanc ou aux composés de zinc ne répandent pas l'odeur désagréable et délétère que l'on observe lorsqu'on s'est servi de couleurs à base de plomb, de cuivre et d'arsenic. On reproche cependant au premier de sécher plus lentement que les secondes. L'oxyde de zinc ne possède pas, il est vrai, la propriété de se dessécher rapidement à l'air, mais on fait disparaître cet inconvénient par l'addition de siccatifs d'une nature particulière.

Voilà pour le point industriel.

Maintenant, considéré au point de vue de l'hygiène et de la salubrité, il est hors de doute qu'il soustrait les ouvriers et les peintres à cette grave maladie à laquelle on

a donné le nom de colique des peintres. Voulons-nous dire par là que le blanc de zinc est tout à fait inoffensif? pas le moins du monde. MM. Becquerel et Blandet ont eu l'occasion d'observer, chez quelques personnes soumises aux émanations de zinc métallique et oxydé, des accidents, peu graves il est vrai, mais qui doivent cependant nécessiter de la part de ceux qui le manipulent des précautions particulières.

Le blanc de zinc parfaitement pur est un protoxyde que la chimie représente de la manière suivante :

$$\underbrace{Zn.}_{\text{Zinc.}} + \underbrace{O.}_{\text{Oxygène.}}$$

Il possède pour caractères principaux, d'être tout à fait insoluble dans l'eau, l'alcool, l'éther et les huiles grasses et volatiles ; mais les acides concentrés ou moyennement étendus le dissolvent assez facilement, surtout à chaud. L'acide sulfhydrique et les sulfures alcalins forment avec lui un sulfure blanc qui ne noircit jamais. Il est complétement fixe et indécomposable par la chaleur. Exposé à l'air, il en attire l'acide carbonique et forme un carbonate qui fait effervescence avec les acides.

La fabrication du blanc de zinc est des plus simples; tous les modes connus jusqu'à ce jour, et ils sont nombreux, reposent sur l'oxydation par l'oxygène de l'air du zinc métallique réduit en vapeur. On remarque que le prix du blanc de zinc n° 1 est le même, ou à peu de chose près, du zinc métallique. L'augmentation de poids par l'absorption de l'oxygène suffit, et au delà, pour couvrir tous les frais de fabrication ; c'est que théoriquement par-

lant, 100 kilos de zinc métallique donnent 124 kilos de blanc de zinc, mais on n'en recueille jamais plus de 110 à 112 kilos, en raison de la perte occasionnée par l'impureté du métal ou par la volatilisation au dehors des appareils.

Comme exemple de fabrication du produit en question, nous prendrons l'usine de Clichy la Garenne, qui verse dans le commerce français et étranger du blanc et du gris de zinc en quantités considérables.

Les appareils servant à réduire le zinc en vapeur sont en terre réfractaires : ils représentent des moufles terminées en biseau vers leur ouverture. Leur longueur est de 70 à 75 centimètres, sur une hauteur de 16 à 17 : la largeur à l'orifice est de 9 à 10 centimètres sur 5 de hauteur.

Chaque appareil peut contenir deux saumons de métal ; on en place huit à dix sur deux rangs adossés dans un four à réverbère qui communique, à l'aide de tubes, avec plusieurs chambres, dites de condensation.

Le four est chauffé à une température suffisante pour porter les moufles au rouge blanc. A l'aide d'une guérite située devant l'orifice de chacune d'elles, on introduit les saumons. Sous l'influence de la haute température produite, le métal fond, puis se volatilise ; un courant d'air chaud, dirigé à l'aide de tubes en fonte vers l'embouchure des cornues, et fourni par un ventilateur ou une cheminée d'appel, brûle le zinc, et entraîne par son mouvement l'oxyde dans les chambres où il se condense. Lorsque tout le métal contenu dans les moufles est converti en oxyde, on ouvre les guérites, on y replace une nouvelle quantité de zinc, et on continue l'opération ; il est indis-

pensable de dégager de temps à autre l'embouchure des appareils avec des gratteurs mécaniques. Une petite quantité d'oxyde et de métal vient former à l'orifice une crasse que l'on détache et qui vient tomber dans une trémie disposée sous les moufles. Ces crasses sont quelquefois livrées au commerce pour les peintures communes ; on leur donne le nom de *gris de zinc,* ou bien encore on les chauffe avec de la poussière de charbon dans les mêmes moufles.

Toutes les chambres communiquent entre elles à l'aide de cloisons que l'on ferme à volonté ; la cloison de la dernière chambre est formée par un châssis en fer, garni d'une toile métallique qui retient l'oxyde, et permet aux gaz seuls de se volatiliser au dehors. On recueille le produit dans des barils au moyen de trémies ou plans inclinés placés à la partie inférieure des chambres ; une toile serrée qui relie les trémies avec les barils s'oppose à la déperdition de la matière dans l'atelier.

Le blanc de zinc n'a pas le même aspect dans toutes les chambres : celui que l'on recueille dans la première, c'est-à-dire la plus rapprochée du foyer, est un mélange d'oxyde et de zinc métallique, souillé par des quantités plus ou moins grandes de cadmium, de fer et de cuivre. Celui qui provient de la dernière chambre possède presque toujours une légèreté beaucoup plus grande, aussi mélange-t-on les produits des divers chambres pour obtenir un tout homogène. Nous ferons connaître plus loin les différences qui existent entre ces deux oxydes.

Au sortir des chambres, le blanc de zinc a besoin d'être comprimé : 1° pour qu'il tienne moins de place ; 2° pour

qu'il absorbe moins d'huile : on a remarqué, en effet, que plus il est léger, plus il a besoin d'huile pour être amené en consistance convenable.

Dans ce genre de fabrication, la conduite du courant d'air est très-importante à régler. L'oxygène doit être en quantité suffisante pour oxyder complétement les vapeurs métalliques; sans cela, il se produit du sous-oxyde (ou mieux un mélange d'oxyde et de zinc métallique) qui communique au produit une teinte grisâtre. Un courant d'air trop fort tend, au contraire, à expulser au dehors des appareils une partie de la poussière.

Le métal doit être aussi pur que possible. On a reconnu que le vieux zinc, qui contient plus particulièrement de l'étain, fournit un oxyde plus blanc que le zinc neuf, souillé presque toujours par du fer, du cadmium ou du cuivre. On a conseillé, pour fixer ces métaux, de les sulfurer. Pour cela, on ajoute dans les moufles une petite quantité de sulfure de zinc réduit en poudre fine.

Chaque fabricant possède, on peut le dire, un outillage particulier : au lieu de moufles ou de cornues, quelques-uns chauffent le zinc sur la sole même du fourneau. Ainsi, un industriel belge se sert d'une plaque de terre réfractaire munie de rebords qui s'opposent à la déperdition du métal en fusion. Un courant d'air chaud entraîne avec lui l'oxyde dans des chambres où on fait le vide.

Au lieu du courant d'air, on se sert de vapeur de charbon ou de coke dépouillé de cendres et de parties fuligineuses. Un fabricant anglais, dans le but d'obtenir du blanc de zinc parfaitement oxydé, soumet la vapeur

métallique d'abord à un courant d'air chaud, puis à un autre courant de vapeur de charbon de bois ou de coke, préalablement purifié par son passage à travers la chaux; le produit, entraîné dans des chambres éloignées du foyer, vient se rendre dans une trémie, où on le recueille.

Partout où il existe des minerais riches en zinc, il y a avantage à préparer directement le blanc de zinc par sa réduction avec le charbon. Nous avons dit en commençant que l'Anglais Atkinson avait conçu le premier l'idée de préparer l'oxyde de zinc par ce moyen. Un industriel américain, Samuel Jones, de New-York, a construit un appareil qui lui permet de retirer à volonté des minerais zincifères (calamine, blende), du zinc métallique et du blanc de zinc.

Son système consiste : 1° en un four pouvant contenir cinquante à soixante cornues, reposant à plat et séparées entre elles de manière à permettre à la chaleur de se répandre uniformément; 2° en une chambre dans laquelle vient se rendre le zinc réduit en vapeurs. Un clapet, situé à la partie supérieure, permet à l'air dilaté de sortir, mais s'oppose à son introduction. Sous l'influence de la chaleur, le zinc, réduit à l'état métallique par le charbon, se volatilise et se condense dans la chambre où on le recueille.

Lorsqu'on veut obtenir du blanc de zinc, on fait arriver dans la chambre, à l'aide d'un puissant ventilateur, un courant d'air chaud qui oxyde le métal au fur et à mesure de sa volatilisation. Le courant d'air, chargé de blanc de zinc, se rend, à l'aide de tubes disposés *ad hoc*,

dans un grand sac ou chausse, qui permet seulement aux gaz de se perdre.

Le sac que M. Jones emploie est en coton très-fort et à mailles très-serrées ; il est fermé à son extrémité et a une longueur de 1 mètre 1/2 à 2 mètres ; vers son milieu sont suspendus deux autres sacs plus petits, qui communiquent ensemble, et qui, placés perpendiculairement par rapport au sac principal, font l'office de récipients. Ces deux sacs sont fermés à leurs extrémités par des courroies mobiles qui servent à les vider lorsque l'opération est achevée.

Tous les fabricants savent que l'oxyde de zinc, obtenu par l'oxydation à l'air du métal en vapeur, n'est pas homogène dans toutes ses parties. La moitié environ forme un produit d'une légèreté très-grande que l'on nomme *blanc de neige*; l'autre, au contraire, qui porte le nom de *blanc de zinc*, possède une densité assez grande.

D'après quelques artistes, le second posséderait beaucoup mieux que le premier la propriété de couvrir. On a basé sur ce fait un procédé de fabrication qui consiste à séparer ces deux oxydes. Ainsi M. Rouquette était arrivé, en ménageant le courant d'air dirigé vers l'orifice des moufles, à entraîner le blanc léger dans une chambre située au-dessus même du four, tandis que le blanc lourd tombait dans une trémie placée au-dessous des vases distillatoires et à côté du cendrier.

M. Sorel a imaginé un appareil qui, tout en apportant une notable diminution dans les frais du combustible, lui permet de séparer ces deux produits d'une manière très-heureuse.

Dans des moufles de grande dimension, on place une certaine quantité de zinc qu'on chauffe jusqu'à la fusion seulement; puis on l'enflamme; mais la matière ne tarderait pas à s'éteindre si, au moyen d'un rateau en fer, on n'avait le soin d'enlever la couche d'oxyde qui se forme incessamment à la surface du bain. Le zinc, en contact continuel avec l'oxygène de l'air, produit un oxyde très-léger qu'un courant d'air entraîne dans des chambres situées au-dessus du four. Celui qui reste à la surface du bain, chassé du moufle par l'agitateur mécanique, tombe dans un réservoir placé près du foyer.

Ce dernier, nommé *blanc de trémie*, ne possède jamais une blancheur aussi grande que celui qui a été volatilisé; mais, en fractionnant les produits, M. Sorel arrive à séparer complétement la partie la plus blanche de celle qui est colorée.

Le blanc de zinc, au dire de certains artistes, serait loin de posséder la propriété couvrante de la céruse; il est reconnu que le blanc de neige, tout en se délayant très-bien dans les divers véhicules employés en peinture, ne couvre pas aussi bien que le blanc de trémie qui provient des crasses. Pour lui faire acquérir plus de densité, on a conseillé de le soumettre de nouveau à une forte calcination dans des creusets de terre, et mieux encore de le délayer dans une certaine quantité d'eau, puis de former avec la pâte des pains qu'on fait sécher à l'étuve; il devient, par ces deux opérations, assez difficile à broyer; mais il couvre beaucoup mieux; et, de plus, il acquiert, lorsqu'il a été mouillé, une teinte blanche plus belle.

Tous les liquides qui servent à délayer le blanc de

plomb, servent également pour le blanc de zinc; étant toujours, ou presque toujours en poudre impalpable, il n'a pas besoin d'être broyé pendant longtemps pour être amené en consistance convenable. Malgré cela, les fabricants de couleurs le livrent très-souvent broyé à l'huile, dans les proportions de 28 à 30 pour 100 de ce véhicule, pour 70 à 72 pour 100 de blanc de zinc.

On l'emploie à l'huile, à l'essence, à la colle; il n'altère nullement les autres couleurs avec lesquelles on le combine. Il rend à la grande comme à la petite peinture des services dont on apprécie tous les jours l'importance : peintes au blanc de zinc, les salles de bains, les fosses d'aisances ne prennent plus ces teintes grisâtres que ne pouvaient garantir les meilleurs vernis, lorsqu'on s'est servi de blanc de plomb.

Le blanc de zinc forme diverses variétés dans le commerce de la droguerie. Pour le rendre siccatif, quelques fabricants l'additionnent de substances pulvérulentes dont nous ferons connaître tout à l'heure la composition.

Les matières étrangères que l'on rencontre le plus ordinairement dans le blanc de zinc sont : le blanc de plomb et de sulfate de chaux ou sulfate atomique (1).

A proprement parler, l'addition du carbonate de plomb ne constitue pas une fraude; ces deux substances ne sont pas à des prix tellement différents, qu'il puisse y avoir un avantage pécuniaire à faire ce mélange, ensuite le

(1) Peu de temps après la découverte de M. Léclaire, on a livré aux artistes, sous le nom de *blanc de Vitry*, un mélange à proportions variables d'oxyde de zinc et de sulfate de baryte. Le peu de succès qu'a obtenu cette couleur, fait qu'elle est à peu près inconnue maintenant.

blanc de plomb communique au blanc de zinc les propriétés couvrante et siccative qui lui manquent.

Mais l'addition du sulfate de chaux est, au contraire, le résultat d'une falsification qui s'exerce malheureusement sur une grande échelle. Ayant une pesanteur spécifique peu différente de celle du blanc de zinc, il forme, après un mélange convenable, un tout parfaitement homogène. Ce sel, que l'on trouve dans le commerce sous le nom de *sulfate atomique*, se fabrique aux portes mêmes de Paris, en réduisant en poudre impalpable la pierre à chaux parfaitement blanche.

Voici le moyen de découvrir les deux genres de falsifications que nous venons d'indiquer.

Le blanc de zinc ne doit pas, lorsqu'il est traité par un acide, fournir de gaz carbonique; trituré dans un mortier avec une solution de sulphydrate d'ammoniaque, il ne doit pas prendre une teinte brune ou noire. Si ces caractères se présentaient, on pourrait en conclure qu'il contient de la céruse.

Pour reconnaître la présence du sulfate de chaux, il faut faire dissoudre une petite quantité d'oxyde de zinc suspect dans de l'acide nitrique concentré et chaud. Une partie de la liqueur étendue de cinq à six fois son poids d'eau distillée et saturée d'ammoniaque, puis additionnée de quelques gouttes d'oxalate d'ammoniaque, laisse déposer un précipité d'*oxalate de chaux* que l'on peut recueillir, puis calciner, pour le convertir en carbonate de chaux ou marbre. Enfin, l'autre partie de la solution nitrique fournit, avec le chlorure de baryum, du sulfate de baryte insoluble dans les acides mêmes concentrés.

Il est reconnu par la plupart des artistes que les couleurs broyées à l'huile, et vendues en pâte dans le commerce, sont plus souvent falsifiées que celles qui sont en poudre. On espère, sous cet état, ôter à l'expert tous les moyens de découvrir la fraude.

Pour déceler le sulfate de chaux dans le blanc de zinc broyé à l'huile, il suffit de calciner 30 grammes environ de pâte dans un creuset de terre. Lorsque tout le corps gras a été décomposé, on laisse refroidir, et on traite le résidu par l'eau distillée froide. On obtient une liqueur qui, jetée sur un filtre, répand déjà une odeur de sulfure alcalin ; cette odeur s'exalte encore plus, si on verse dans la solution quelques gouttes d'acide sulfurique ou d'acide nitrique ; il se dégage alors de l'acide sulphydrique en quantité d'autant plus grande que l'oxyde était plus impur. Disons aussi que l'on doit tenir compte de la petite quantité de sulfates de zinc et de manganèse qui entre dans la composition des siccatifs en poudre.

SICCATIFS POUR LE BLANC DE ZINC.

Dès l'année 1845, M. Leclaire, pour remédier au défaut de siccité du blanc de zinc, a imaginé de rendre l'huile de lin siccative, au moyen d'un oxyde autre que la litharge. Pour cela, il choisit le peroxyde de manganèse.

Cet oxyde ne présente pas, comme l'oxyde de plomb, l'inconvénient de se colorer en noir par les émanations sulfureuses : il n'est pas vénéneux, et enfin il communique parfaitement bien aux huiles la propriété de se dessécher à l'air.

Cette observation est basée sur l'emploi qu'on faisait autrefois de la terre d'ombre pour obtenir l'huile siccative.

La terre d'ombre est, ainsi que nous le montrerons plus loin, une combinaison d'oxyde de fer et d'oxyde de manganèse; tous les fabricants savent qu'elle entre dans la préparation de l'huile de lin, dite de la marmite. Il est donc parfaitement démontré que c'est sous l'influence de l'oxyde de manganèse contenu dans cette matière, que l'oxyde acquiert cette propriété.

Voici, d'après le *Manuel des peintures au blanc de zinc* (1), comment on prépare l'huile siccative manganesée :

« On concasse le manganèse (peroxyde de manganèse) en petits morceaux gros comme des pois; on le tamise pour en extraire le trop fin ; on le fait bien sécher sur une plaque de tôle posée sur un feu vif, en prenant soin de ne pas le calciner; on le met ensuite dans un sachet de toile forte bien fermé et sans l'entasser, et l'on pose ce sachet dans un petit panier en fil de fer à mailles très-serrées.

« On verse dans une chaudière, placée sur une plaque en fer, au-dessus d'un fourneau, de l'huile de lin bien épurée ; on plonge dans l'huile le panier renfermant le manganèse, en le tenant suspendu au moyen d'un fil de fer adapté à une tringle placée en travers sur la chaudière.

« On chauffe le fourneau, et on porte l'huile à une température un peu au-dessous de l'ébullition.

« Cette température doit être constamment la même ;

(1) Publié par la Société de la Vieille-Montagne.

si on chauffait trop, l'huile bouillonnerait et, sortant de la chaudière, s'enflammerait promptement.

« Quand on opère sur de grandes quantités, la cuisson dure vingt-quatre heures.

« On reconnaît que le travail a réussi lorsque l'huile prend une teinte rougeâtre.

« Quand la cuisson est faite, on laisse refroidir, on filtre et on porte dans des bouteilles de grès ou verre, qu'on bouche avec soin.

« Si on emploie le manganèse neuf, c'est-à-dire servant pour la première fois, on en met 10 kilogrammes pour 100 kilogrammes d'huile.

« Le manganèse sert indéfiniment, et devient meilleur quand il a été employé déjà.

« Avant de le réemployer, on le concasse dans un mortier ; on y ajoute du manganèse neuf, on le tamise ; puis on met 15 kilogrammes de ce mélange dans 100 kilogrammes d'huile.

« La première fois qu'on se sert du manganèse, on ne le met dans l'huile que le deuxième jour de la cuisson, parce que l'huile renfermant de l'humidité, le manganèse neuf s'emparerait de l'oxygène et causerait l'inflammation de la matière.

« Si le manganèse a déjà servi, on le met le premier jour dans l'huile avant d'allumer le feu.

« Il faut moins de temps de cuisson avec le manganèse neuf qu'avec le vieux.

« Dans l'un et l'autre cas, il faut toujours souffler modérément. Cette précaution est indispensable, ainsi que celle de placer le sachet dans la chaudière, de manière

qu'il ne touche aucune des parois, et à ce qu'il soit noyé complétement dans l'huile.

« Si le siccatif est trop épais par la forte cuisson, on incorpore de l'essence, mais alors que l'huile siccative est presque refroidie ou tiède; trop de chaleur pourrait encore causer l'inflammation.

« On met de l'essence en quantité suffisante, à l'effet de rendre le siccatif assez liquide pour l'employer et le conserver. »

Dans le but d'approprier ce siccatif à tous les genres de peinture et de le transporter avec facilité, on a imaginé de le mélanger avec de la chaux caustique et délitée : comme ce mélange retient encore beaucoup d'eau, on le chauffe à une température modérée et dans un courant d'air chaud, jusqu'à ce qu'on puisse le réduire en poudre. On obtient alors un véritable savon calcaire siccatif, qui, broyé avec les couleurs et de l'huile de lin ordinaire, remplace d'une manière très-avantageuse l'huile siccative. Quatre à six parties de savon siccatif en poudre suffisent pour cent parties d'huile.

Mais le peroxyde de manganèse, surtout lorsqu'il est en poudre, communique à l'huile une teinte rougeâtre assez désagréable pour la peinture blanche et fine.

Dans ces derniers temps, on a remedié à cet inconvénient en composant des siccatifs en poudre blanche dans lesquels le manganèse se trouve à l'état de combinaison, c'est-à-dire de sel.

L'expérience a démontré en effet que la plupart des sels solubles de protoxyde de manganèse et de zinc (sulfate, chlorure, acétate), broyés avec de l'huile de lin ordinaire

et du blanc de zinc, communiquent à ce dernier la propriété siccative qui lui manque.

Il est indispensable de priver préalablement ces différents sels de leur eau de combinaison; pour cela, on les expose sur des plaques chauffées à 80 ou 100°, jusqu'à ce qu'ils soient parfaitement blancs et opaques. On en fait alors des mélanges à parties égales, qu'on réduit en poudre fine.

Ces siccatifs, qui ont été brevetés, et dont la peinture au blanc de zinc fait un usage journalier, sont composés de sulfate de zinc et d'acétate de manganèse, ou bien encore de sulfate de manganèse et d'acétate de zinc; trois à quatre parties suffisent avec la quantité nécessaire d'huile de lin ordinaire pour cent parties de blanc de zinc.

OXYDE D'ANTIMOINE.

M. de Ruolz, auquel la chimie industrielle est redevable de plusieurs découvertes importantes, a soumis à l'expérience un grand nombre de substances minérales pour remplacer la céruse dans ses nombreuses applications.

Ce chimiste a présenté, dans le courant de l'année 1843, un Mémoire à l'Académie des sciences, dans lequel il annonce que l'oxyde blanc d'antimoine (acide antimonieux) réunit toutes les conditions d'économie et de salubrité, qu'il se mêle parfaitement aux huiles grasses, et enfin qu'il couvre aussi bien que la céruse.

Le procédé employé pour obtenir cette substance à un prix peu élevé et dans un parfait état de blancheur,

consiste à oxyder à l'air le sulfure naturel d'antimoine.

Pour arriver plus facilement à ce but, M. Rousseau a conseillé de faire réagir l'eau et l'air réunis à une température élevée sur le sulfure d'antimoine réduit en poudre.

Tout le soufre passe à l'état d'acide sulfureux, et l'antimoine s'oxyde, en formant une poudre impalpable d'une blancheur éclatante. Il a pour formule :

$$\underbrace{Sb^2}_{\text{Antimoine.}} + \underbrace{O^3}_{\text{Oxygène.}}$$

OXYDO-CHLORURE D'ANTIMOINE.

A l'oxyde d'antimoine, MM. Vallé et Barreswill substituent l'oxydo-chlorure de ce métal ou poudre d'algaroth qu'ils préparent de la manière suivante :

On réduit en poudre grossière le sulfure brut d'antimoine, et on le traite par l'acide chlorhydrique ordinaire ; il se forme, d'une part, de l'acide sulphydrique qu'on peut utiliser en le convertissant en acide sulfureux pour la préparation de l'acide sulfurique ; et d'une autre part, du proto-chlorure d'antimoine que l'on verse dans une grande quantité d'eau froide ou chaude. Celle-ci décompose le sel d'antimoine en donnant lieu à un précipité blanc caillebotté d'oxydo-chlorure d'antimoine. On lave avec de l'eau froide, puis on fait sécher à une douce température.

Cette couleur, dont la composition chimique est :

$$\underbrace{Sb^2 Cl^3}_{\text{Chlorure d'antimoine.}} + \underbrace{_2(Sb^2 O^3)}_{\text{Oxyde d'antimoine.}}$$

possède, comme l'oxyde d'antimoine, une teinte parfaitement blanche et une ténuité très-grande ; elle s'unit parfaitement aux corps gras et couvre aussi bien que la céruse.

L'oxyde et l'oxydo-chlorure d'antimoine n'ont pas eu tout le succès qu'on en attendait, d'abord parce que les peintures exécutées avec ces substances prennent assez promptement, par suite de leur exposition dans des endroits où se dégagent des gaz méphytiques, une teinte jaune assez prononcée ; ensuite, parce que leur emploi n'est pas sans quelque danger pour les industriels qui les fabriquent et pour les peintres qui les broyent.

BLENDE.

Comme succédané du blanc de plomb, on a encore conseillé de se servir, pour les peintures colorées, de la blende ou sulfure de zinc, que l'on trouve en très-grande quantité et très-pure au bourg d'Oisans (Isère). Dans son état le plus pur, elle se formule ainsi :

$$\underbrace{S}_{\text{Soufre.}} + \underbrace{Zn}_{\text{Zinc.}}$$

La blende en pierre est jaune de miel, et en poudre d'un blanc grisâtre. Pour l'approprier à l'usage de la peinture, il suffit de la choisir de belle qualité et de la réduire en poudre fine.

Broyée avec de l'huile siccative ou avec de l'essence de térébenthine, elle couvre aussi bien que la céruse et le blanc de zinc ; elle donne, dans la peinture des bâtiments, des résultats assez satisfaisants ; ainsi, avec l'ocre rouge,

elle fournit une teinte rosée très-belle, et avec le jaune de chrome, la nuance gris de perle; elle s'allie assez bien avec toutes les autres couleurs, et de plus, peut être livrée aux arts à un prix peu élevé. Néanmoins, elle est à peu près inconnue dans le commerce de la droguerie.

OXYDO-CHLORURE DE PLOMB.

Le proto-chlorure de plomb monobasique ou oxydo-chlorure de plomb dont la formule s'exprime par

$$\underbrace{Cl\,Pb}_{\text{Chlorure de plomb.}} + \underbrace{PbO}_{\text{Oxyde de plomb.}}$$

a été proposé par MM. Lugh et Pattinson, de Londres, pour remplacer la céruse : il est blanc, très-brillant, et d'une consistance très-forte.

Voici le procédé que ces industriels emploient pour l'obtenir en grand et à bas prix.

On commence par préparer de l'eau de chaux saturée en laissant de l'eau froide pendant un certain temps au contact de la chaux caustique délitée et en excès.

D'une autre part, on fait une dissolution de :

Chlorure de plomb cristallisé. 500 grammes (1).
Eau bouillante............ 4 litres.

La liqueur filtrée est mélangée avant son entier refroidissement avec son volume d'eau de chaux. Il se produit

(1) Le chlorure de plomb se prépare en faisant bouillir la litharge avec son équivalent d'acide hydrochlorique. La solution est évaporée jusqu'à siccité, la masse est lavée à plusieurs reprises pour la dépouiller des chlorures de fer et de manganèse contenus ordinairement dans la liqueur, et qui coloreraient le produit qu'on veut obtenir.

de l'oxydo-chlorure de plomb qui se précipite en poudre très-fine et très-blanche, et du chlorure de calcium qui reste dissous. On recueille le précipité qu'on fait sécher à la chaleur de l'étuve après l'avoir suffisamment lavé.

Dans cette préparation, il est très-important de ne mettre que la quantité d'eau de chaux strictement nécessaire pour effectuer la décomposition du chlorure de plomb. Sans cette précaution, il y a de l'oxyde de plomb non combiné qui colore d'autant plus le produit qu'on a agi à une température plus élevée.

Cet oxydo-chlorure peut encore s'obtenir en versant par petites quantités à la fois, et en agitant sans cesse, une solution de chlorure de sodium (sel marin) dans de l'acétate neutre de plomb dissous. Il se produit de l'acétate de soude qui reste dans la liqueur, et de l'oxydo-chlorure de plomb très-blanc et en poudre fine.

Cette couleur, pour laquelle il a été pris une patente à Londres, est encore très-peu connue dans le commerce français; outre qu'elle ne peut pas être vendue à un prix inférieur à celui de la céruse, elle ne paraît pas couvrir aussi bien que cette dernière, et noircit aussi rapidement par l'hydrogène sulfuré.

CARBONATE DE CHAUX.

Le carbonate de chaux, que l'on appelle encore *craie*, n'est jamais le produit de l'art; tout celui que l'on trouve dans le commerce se retire de la nature. Il forme la limite supérieure du terrain secondaire, et constitue les couches crétacées du terrain tertiaire.

Lorsqu'il est parfaitement pur, sa formule chimique se représente ainsi :

$$\underbrace{CO^2}_{\text{Acide carbonique.}} + \underbrace{CaO}_{\text{Chaux.}}$$

Très-souvent on le désigne sous le nom de la localité d'où on le tire ; ainsi on dit : *blanc d'Espagne, blanc de Meudon, blanc de Bougival, blanc de Troyes ou de Champagne,* pour distinguer autant d'espèces qui possèdent à peu près les mêmes propriétés physiques et la même composition chimique.

Dans le commerce de la droguerie française, on ne connaît que deux espèces de carbonate de chaux. La première, nommée blanc d'Espagne, blanc de Meudon, blanc de Bougival, provient des environs de Paris ; la seconde, que l'on connaît communément sous le nom de craie, est le blanc de Troyes ou de Champagne.

Le blanc d'Espagne, ou de Meudon, est en pains dont le poids varie de 200 à 500 grammes. Il possède une légère teinte grise ou jaunâtre. Il se délaye dans l'eau avec une grande facilité, se réduit très-rapidement en poudre, et enfin se dissout assez facilement dans les acides minéraux et végétaux. La craie au contraire est en masses plus considérables. Sa densité et sa blancheur sont en général plus grandes. Sa pulvérisation est un peu plus longue à effectuer ; enfin elle ne se délaye pas aussi facilement, et ne se dissout pas aussi rapidement dans les acides que le blanc d'Espagne.

Malgré ces différences dans leurs propriétés physiques, des expériences nous ont montré qu'étant dissous dans les

acides, ils donnaient l'un et l'autre un résidu pouvant s'élever à 3 ou 4 pour 100, et formé en partie de silice.

Le blanc d'Espagne et la craie se préparent de la même manière.

La terre extraite de la mine est mise dans l'eau pendant un certain temps, puis délayée le plus possible. On laisse déposer quelques minutes, et on sépare par décantation la partie la plus fine restée en suspension, des matières étrangères plus lourdes qui se précipitent les premières. Pour l'avoir en poudre impalpable, quelques fabricants font passer le lait de carbonate de chaux à travers un tamis à mailles très-serrées. Le produit séparé de la plus grande partie de l'eau qu'il contient est recueilli, et lorsqu'il est en consistance convenable, on en forme des cylindres ou des pains qu'on fait sécher à l'air.

Le blanc d'Espagne et la craie servent indistinctement pour la peinture en détrempe. Afin de détruire la teinte jaunâtre qu'ils possèdent, on est dans l'habitude d'y ajouter une petite quantité de noir de fumée ou d'ocre rouge.

Le carbonate de chaux est considéré comme la première matière blanche employée par les peintres de l'antiquité. Davy assure que les blancs de la Noce Aldobrandine et les fonds qui décoraient les salles de bains de Titus étaient obtenus avec cette substance.

C'est du reste une couleur assez solide et nullement vénéneuse.

SULFATE DE CHAUX.

La peinture des papiers consomme, pour faire les fonds blancs, une très-grande quantité de sulfate de chaux, dit encore sulfate atomique.

Sa formule chimique se représente ainsi :

$$\underbrace{SO^3}_{\text{Acide sulfurique.}} + \underbrace{CaO}_{\text{Chaux.}}$$

La préparation de cette substance est des plus simples.

Le sulfate de chaux naturel, nommé encore gypse, plâtre brut, est choisi aussi blanc que possible, réduit en poudre très-ténue au moyen de moulins particuliers, puis tamisé et enfin livré au commerce.

Il ne s'emploie qu'à la colle, et donne une peinture excessivement solide, nullement vénéneuse.

Comme il ne se vend pas plus de 9 à 10 francs les 100 kilogrammes, et qu'il possède la plupart des propriétés physiques du blanc de zinc, une partie de celui que le fabricant livre au commerce sert à falsifier ce dernier. (Voyez blanc de zinc.)

SULFATE DE BARYTE.

Le sulfate de baryte, nommé encore spath pesant, possède pour formule chimique :

$$\underbrace{SO^3}_{\text{Acide sulfurique.}} + \underbrace{BaO}_{\text{Baryte.}}$$

Il est très-abondant dans la nature, où il affecte plusieurs formes différentes.

Pour l'approprier aux besoins des arts, voici le procédé qu'on emploie :

Le minerai, aussi blanc que possible, est réduit en morceaux peu volumineux, puis chauffé dans des fours *ad hoc*.

L'action de la chaleur a pour but de détruire l'agrégation de ses molécules et de permettre sa pulvérisation. On le passe au moulin, et lorsqu'il est en poudre fine on le délaye dans de l'eau claire; on laisse déposer pendant une ou deux minutes, et lorsque l'eau est encore blanche comme du lait, on décante, puis on recueille le précipité qu'on fait sécher à l'air ou bien à l'étuve.

Lorsqu'il est parfaitement sec, il se présente sous la forme d'une poudre blanche, éclatante et très-lourde.

Il forme une couleur inoffensive, très-belle, excessivement solide, mais qui couvre mal. Une partie de celui que l'on prépare s'emploie pour la fabrication des papiers peints, et par conséquent à la colle. L'autre partie est employée pour falsifier le blanc de céruse, ou bien pour composer des mélanges. Ainsi, en Allemagne, on l'ajoute presque toujours à la céruse pour obtenir le blanc de plomb de Venise et le blanc de plomb de Hambourg, sur lesquels nous aurons l'occasion de revenir à l'article céruse.

En Autriche, il porte le nom de blanc de plomb du Tyrol.

CÉRUSE.

La céruse est une combinaison de l'acide carbonique avec l'oxyde de plomb.

Sa composition chimique, dans son état le plus pur, se représente par des équivalents égaux d'acide et d'oxyde que l'on formule ainsi :

$$\underbrace{CO^2}_{\text{Acide carbonique.}} + \underbrace{PbO}_{\text{Oxyde de plomb.}}$$

Mais telle qu'on l'obtient dans les fabriques, elle contient toujours des proportions variables d'oxyde qui en font un sel basique ; le plus ordinairement elle est constituée de la manière suivante :

$$\underbrace{CO^2}_{\text{Acide carbonique.}} + \underbrace{_2(PbO)}_{\text{Oxyde de plomb.}} + \underbrace{HO}_{\text{Eau.}}$$

Dans les Vosges, la Bohême, la Saxe, la Sibérie et le duché de Bade, on trouve du carbonate de plomb naturel qui est souvent associé à la galène ou sulfure de plomb ; mais on comprend qu'il ne se trouve jamais en quantité assez considérable pour être exploité avec quelque avantage. Tout celui que l'on emploie est donc le produit de l'art.

La céruse est une poudre blanche, inodore, insipide, insoluble dans l'eau, soluble dans les acides avec effervescence de gaz acide carbonique. L'hydrogène sulfuré la colore en noir ; exposée à l'action de la chaleur, elle commence par perdre la petite quantité d'eau qu'elle contient,

puis elle dégage de l'acide carbonique ; pour résidu elle donne d'abord du massicot, qui ne tarde pas à passer à l'état de minium, et enfin de litharge.

Les Grecs et les Romains, auxquels on attribue la découverte de la céruse, la préparaient, d'après Pline, en faisant macérer des lames de plomb dans des outres remplies de vinaigre qu'on tenait bouchées pendant huit jours ; au bout de ce temps, il s'est formé une crasse qu'on racle ; on replonge ensuite ces lames dans les outres, et on les racle de nouveau ; on continue cette opération jusqu'à ce que tout le plomb soit converti en céruse.

Nous verrons par la suite que le procédé dit Hollandais est basé sur le même principe.

La fabrication de la céruse était surtout pratiquée à Rhodes, à Corinthe et à Lacédémone ; elle passa ensuite chez les Arabes et successivement à Venise, à Krems, en Hollande, en Angleterre, puis en France.

Le procédé le plus anciennement connu et encore le plus généralement suivi, porte le nom de procédé hollandais ; il est basé sur l'action combinée que l'air, la chaleur, l'acide acétique et l'acide carbonique font éprouver au plomb métallique.

Voici la théorie de cette opération :

Sous l'influence de la chaleur, l'acide acétique se volatilise et vient former à la surface du plomb de l'acétate de plomb basique, qui est décomposé à son tour par l'acide carbonique ambiant en carbonate de plomb et en acétate neutre de plomb ; mais ce dernier ne tarde pas, par suite de l'oxydation d'une nouvelle quantité de plomb, par repasser à l'état d'acétate basique, qui à son tour est décom-

posé par l'acide carbonique. Ces mêmes réactions, réitérées un grand nombre de fois, finissent par faire passer tout le métal à l'état de carbonate.

Le plomb que l'on veut convertir en céruse doit être aussi pur que possible, et être surtout privé de fer. On lui fait subir une préparation préliminaire, qui a pour but de le rendre attaquable sur le plus grand nombre de points à la fois : pour cela, on le fait fondre en lames minces, ou bien on le coule à l'état de fusion dans une espèce de lingotière, où il prend la forme d'une grille à jour. On procède ensuite à la mise en pot.

Dans des vases de terre, de la contenance d'un litre environ, et contenant chacun un demi-litre de vinaigre ordinaire, on expose les lames de plomb qu'on maintient à la partie supérieure, soit par des saillies naturelles placées à l'intérieur, soit par des supports en bois.

On en met de la sorte un certain nombre dans une grande fosse en maçonnerie contenant un lit de fumier de cheval ou de tan épuisé provenant des tanneries; on les couvre avec un triple ou quadruple lit de lames de plomb étendues à plat, sur lesquelles on établit une plate-forme en planches rapprochées les unes des autres; on dispose de la sorte autant de lits de pots que la fosse peut en contenir, en ayant le soin d'établir, à l'aide de planches mal jointes, une communication qui permet à l'air de circuler librement entre les diverses couches; puis on recouvre le tout de fumier ou de tan.

Au bout de trente à quarante-cinq jours, si on s'est servi de fumier, et de soixante à quatre-vingt-dix jours, si on a employé le tan, on découvre la fosse, on sort les pots, et

on retire les lames de plomb qui sont presque entièrement attaquées et converties en céruse, et en une petite quantité d'acétate neutre de plomb.

On procède au battage.

Cette dangereuse opération se pratiquait autrefois en humectant légèrement les lames de plomb avec de l'eau, et en les frappant avec les mains au moyen de *battes*. Les graves maladies qu'occasionnent ce genre de travail ont fait inventer depuis plusieurs appareils qui permettent à l'ouvrier de travailler à l'abri de la poussière plombeuse.

Dans toutes les fabriques, on détache la céruse des lames de plomb au moyen d'un système mécanique à cylindres cannelés, placé dans une chambre hermétiquement fermée. Une autre machine faisant l'office de moulin, sert à pulvériser la céruse; en sortant de l'appareil, elle tombe dans une grande cuve contenant de l'eau. Dans cet état, elle est de nouveau passée au moulin, puis mise à sécher si on veut l'obtenir en poudre. Lorsqu'on désire la préparer en pain, on la tasse en pâte dans des pots coniques que l'on fait sécher, avec précaution, dans des étuves à courant d'air chaud.

On la livre ensuite au commerce.

On estime que toute la céruse qui sort des fabriques se vend de la sorte : deux parties en poudre, une partie en pains, et une autre partie broyée à l'huile. En Angleterre, on la trouve très-souvent broyée avec de l'huile de lin et de l'essence de térébenthine; les fabricants économisent par ce moyen la mise en pots et la dessiccation, toujours si lente, des pains dans les séchoirs.

La céruse obtenue par le procédé hollandais est d'autant plus belle que le plomb était privé de fer, et qu'on a remplacé le fumier par le tan pour produire l'élévation de température; ce qui donne une si grande valeur à la céruse de Krems et à celle de quelques fabriques d'Allemagne, c'est qu'on obtient la chaleur nécessaire (24 à 30° Réaumur) au moyen de poêles munis de tuyaux qui traversent en divers sens les étuves où on expose les pots. On évite alors le contact de l'hydrogène sulfuré qui se dégage incessamment du fumier et du tan en putréfaction. Quand elle possède une légère teinte jaunâtre, les fabricants y ajoutent pendant le broyage une petite quantité d'indigo.

A Clichy, près Paris, on obtient la céruse par un procédé qui a été indiqué pour la première fois par M. Thénard, et mis en pratique par M. Roard. Il est basé sur la réaction suivante :

L'acétate de plomb basique (sel de Saturne), traité par l'acide carbonique, perd une partie de son oxyde pour former du carbonate de plomb, et est ramené à l'état d'acétate neutre. Celui-ci, par l'addition d'une nouvelle quantité d'oxyde de plomb (litharge), repasse à l'état d'acétate basique.

Voici maintenant, en quelques mots, comment on opère :

On commence par faire une solution d'acétate de plomb basique, marquant 16 à 18° au pèse-sel, en faisant bouillir de l'acétate neutre de plomb avec de la litharge réduite en poudre et pure autant que possible.

On décante la liqueur, et on l'introduit dans un réci-

pient fermé où l'on fait arriver du gaz acide carbonique provenant, soit de la calcination de la craie, soit de la combustion du charbon. Lorsque tout l'oxyde de plomb qui constituait l'acétate à l'état basique est converti en carbonate, on laisse déposer, et le liquide qui surnage est séparé du dépôt pour servir à une nouvelle opération en le faisant bouillir avec de la litharge ; on voit que s'il ne se faisait pas de perte à chaque traitement, le même acétate pourrait servir indéfiniment.

La céruse obtenue après la décantation des liqueurs est lavée d'abord avec une petite quantité d'eau qu'on réunit à la solution d'acétate, puis avec une plus grande quantité qu'on rejette, et enfin jusqu'à ce que le précipité ne cède plus rien à ce liquide ; on met ensuite dans des pots et on fait sécher à l'étuve.

La céruse dont nous venons de faire connaître le mode de préparation porte le nom de blanc de céruse de Clichy ; elle est toujours en poudre impalpable et d'une blancheur éclatante ; mais on observe qu'elle a une densité moins grande, et qu'elle couvre moins bien que la céruse hollandaise.

Les procédés hollandais et de Clichy sont les plus usités en France ; mais il en existe d'autres que nous devons faire connaître. Ainsi, en Angleterre et dans les localités où le combustible est à bas prix, on trouve un grand avantage à l'obtenir de la manière suivante :

On humecte de la litharge avec de l'acétate de plomb basique délayé dans la plus petite quantité d'eau possible ; on introduit le mélange dans des tonneaux cerclés en fer, qu'on remplit aux deux tiers environ, puis on y

fait arriver du gaz acide carbonique au moyen d'une pompe, et on agite vivement. L'acide carbonique est rapidement absorbé, et convertit toute la litharge qui constituait le sel à l'état basique en carbonate de plomb très-beau. On le lave deux ou trois fois avec de l'eau froide, puis on fait sécher à la chaleur de l'étuve.

La céruse prend encore naissance par les moyens qui suivent, mais que l'industrie actuelle ne met plus en pratique ou rarement.

1° Par double décomposition à froid ou à chaud d'un sel de plomb (acétate, nitrate, chlorure, sulfate, etc.); par les carbonates alcalins (carbonates de soude, d'ammoniaque) : il se produit des acétate, nitrate, chlorure et sulfate de soude ou d'ammoniaque, et du carbonate de plomb, qui est souvent très-beau, et toujours en poudre impalpable; ces procédés ne sont généralement pas mis à exécution, parce qu'ils sont trop dispendieux;

2° En décomposant le chlorure de plomb par la craie, on obtient d'une part du chlorure de calcium soluble, et de l'autre de la céruse qui se précipite (procédé Pattinson);

3° En décomposant le chlorure de plomb par l'acide sulfurique, qui produit du sulfate de plomb, que l'on convertit à son tour en céruse par le carbonate de soude (procédé Chaptal);

4° En pulvérisant par la rotation et le frottement, à l'aide de la pierre de Volvic, du plomb en grenaille humecté, et en faisant arriver dans l'appareil de l'acide carbonique. D'après M. Versepuy, inventeur de ce mode de

fabrication, on obtient une céruse très-belle, et à un prix peu élevé ;

5° En réduisant le plomb du commerce en grenaille, l'humectant avec une solution acide de litharge dans l'acide acétique, puis faisant arriver un courant de gaz acide carbonique (procédé Vootrich) ;

6° Enfin, en traitant la litharge par le chlorure de potassium, puis par l'acide carbonique : il se forme d'abord du chlorure de plomb et de la potasse caustique qui, au contact de l'acide carbonique, produit du carbonate de potasse ; ce sel décompose à son tour le chlorure de plomb, en donnant naissance à du chlorure de potassium soluble et à du carbonate de plomb qui se précipite (procédé Chevremont).

L'expérience a montré depuis longtemps que de toutes les variétés de céruse, celle préparée par le procédé hollandais couvrait beaucoup mieux : peut-être doit-elle cette supériorité à ce qu'elle est moins hydratée, ou bien encore à ce qu'elle est plus basique.

Il y a quelques années encore, la fabrication de la céruse présentait des dangers si grands pour les ouvriers, que tout succédané qu'on annonçait était accepté avec empressement ; mais, de l'avis de tous les hommes compétents, à part son défaut bien reconnu de noircir lorsqu'elle est appliquée dans des endroits où il se dégage des gaz méphitiques, cette substance possède des propriétés que l'on ne retrouve pas dans toutes les autres couleurs blanches. C'est à ce point que quelques artistes la préfèrent encore au blanc de zinc pour certains ouvrages. Les relevés statistiques des principales fabriques de France montrent actuelle-

ment que les maladies et la mortalité des ouvriers cérusiers ne sont pas plus fréquentes que parmi le reste de la population. On doit ce résultat aux nombreux perfectionnements que ces fabricants apportent dans la construction de leurs machines. Nous citerons comme exemple la fabrique de M. Théodore Lefebvre, à Loos-les-Moulins, près Lille. Cet industriel a inventé, pour pulvériser la céruse, un appareil qui fait disparaître toutes les causes d'insalubrité. Il se sert pour cela de meules horizontales, renfermées de toutes parts par des planches. La céruse broyée se rend dans des blutoirs, où on l'enlève sans danger. Ce manufacturier exige en outre, de la part des ouvriers, certaines mesures d'hygiène, qui consistent principalement dans de grands soins de propreté lorsqu'ils commencent et finissent leurs travaux.

Mais si les ouvriers cérusiens sont moins sujets qu'autrefois à la colique de plomb, les peintres et les broyeurs de couleurs, de leur côté, n'en sont pas toujours exempts. Les relevés des hôpitaux montrent encore que les maladies occasionnées par l'usage des composés de plomb sont malheureusement assez fréquentes.

La céruse subit dans le commerce de détail un grand nombre de falsifications ; les substances qui servent le plus ordinairement pour cela, sont : 1° le sulfate de baryte ; 2° le sulfate de chaux ; 3° le sulfate de plomb ; 4° la craie.

Le sulfate de baryte passe pour être le plus souvent mélangé à la céruse. Ces deux substances possèdent en effet des propriétés physiques qui permettent assez de les confondre, surtout lorsqu'elles sont mélangées.

D'après un auteur, on trouverait communément dans le commerce les mélanges suivants :

	Céruse.	Sulfate de baryte.
Blanc de plomb surfin.	85	15
N° 1	70	30
N° 2	60	40
N° 3	40 à 50	60 à 50

La présence des sulfates de baryte et de plomb est très-facile à reconnaître ; pour cela, il suffit de traiter ces mélanges par de l'acide nitrique étendu de deux ou trois parties d'eau distillée. La céruse parfaitement pure se dissout en totalité, tandis que les sulfates de baryte et de plomb ne sont pas attaqués par ce véhicule.

Mais dans les essais de ce genre, il ne faut pas perdre de vue que dans le commerce il existe de la céruse mélangée exprès avec des quantités différentes de sulfate de baryte. Ainsi, dans la plupart des fabriques allemandes, on livre aux artistes de ces mélanges que l'on préfère à la céruse pure. Le *blanc de plomb de Venise* est préparé en pulvérisant parties égales de céruse et de sulfate de baryte. Une partie de céruse et deux parties de sulfate de baryte forment le *blanc de plomb de Hambourg.* Avec une partie de céruse et trois parties de sulfate de baryte, on obtient le *blanc de plomb hollandais.*

On reconnait la présence de la craie et du plâtre en faisant rougir fortement dans un creuset une petite quantité de céruse suspecte avec de l'huile et de la résine. Le plomb forme un culot métallique, tandis que la substance terreuse (chaux) reste sous forme d'une poudre blanchâtre.

Les usages de la céruse sont trop connus pour que nous entrions ici dans de plus grands détails. Tout le monde sait que, sous le rapport de l'emploi, elle est considérée comme le type de la bonne couleur; ainsi, elle s'allie parfaitement bien, et sans altérer la teinte, à toutes les autres substances colorantes; elle communique à un très-haut degré les propriétés siccative et couvrante qui manquent assez souvent à ces dernières; aussi la fait-on entrer dans presque toutes les couleurs destinées à la peinture à l'huile.

CÉRUSE DE MULHOUSE.

Dans le commerce de la droguerie, on trouve quelquefois, sous le nom de céruse de Mulhouse, du sulfate de plomb qui provient des manufactures d'indiennes.

Ce sel, dont la composition chimique se représente ainsi :

$$\underbrace{SO^3}_{\text{Acide sulfurique.}} + \underbrace{PbO}_{\text{Oxyde de plomb.}}$$

s'obtient comme résidu de différentes opérations chimiques, principalement quand on traite l'alun par l'acétate de plomb pour préparer l'acétate d'alumine.

Il y a la plus grande ressemblance avec la céruse véritable, mais il est loin de couvrir aussi bien. On le distingue de cette dernière en ce qu'il est très-peu soluble dans l'acide nitrique.

Lorsqu'on veut le fabriquer de toutes pièces, voici le procédé le plus économique qu'on emploie :

On commence par préparer de l'oxydo-chlorure de

plomb en abandonnant à lui-même, pendant cinq ou six jours, vingt parties de litharge réduite en poudre fine, et six parties de sel marin ; on fait une bouillie très-homogène avec une petite quantité d'eau qu'on place dans une chaudière de plomb avec de l'acide sulfurique en léger excès, puis on chauffe ; tout le sel de plomb se décompose en dégageant de l'acide chlorhydrique que l'on fait rendre au dehors au moyen d'une cheminée d'appel, et il se précipite du sulfate de plomb ; on lave le produit à plusieurs reprises avec de l'eau chaude, et on le fait sécher à l'étuve.

La céruse de Mulhouse a besoin d'être préparée avec beaucoup de soin pour être parfaitement blanche ; la plus petite quantité de matière organique lui fait prendre, pendant l'opération, une teinte grisâtre que l'on ne peut faire disparaître par les lavages les plus prolongés.

La plus grande partie de celle que les fabricants livrent au commerce sert pour falsifier la céruse ; c'est, du reste, une couleur dont l'emploi ne présente aucun avantage ; elle ne noircit pas aussi facilement que la céruse, mais elle couvre assez mal les objets sur lesquels on l'applique ; il en résulte qu'elle est très-peu usitée en peinture.

SULFITE DE PLOMB.

Il y a quelques années, on a conseillé comme succédané de la céruse, l'emploi du sulfite de plomb dans la peinture à l'huile.

Le sulfite de plomb s'exprime ainsi :

$$\underbrace{SO^2}_{\text{Acide sulfureux.}} + \underbrace{PbO}_{\text{Oxyde de plomb.}}$$

C'est une poudre blanche, lourde, insoluble, qui paraît couvrir assez bien, et qui, d'après M. Scoffern, ne noircit pas au contact de l'hydrogène sulfuré.

Pour l'obtenir, on fait rendre un courant de gaz sulfureux (provenant de la réaction de l'acide sulfurique sur la sciure de bois) dans une solution d'acétate basique de plomb. Il se forme du sulfite de plomb qui se précipite, et de l'acétate neutre de plomb qu'on ramène à l'état basique en le faisant bouillir avec de la litharge.

TUNGSTATE DE PLOMB.

Un industriel anglais, M. Spilsburg, a pris dans ces derniers temps une patente à Londres pour la fabrication de quelques couleurs blanches et rouges destinées à la peinture à la palette.

Les couleurs blanches sont le tungstate, l'antimonite et l'antimoniate de plomb, qu'il considère comme supérieurs à la céruse et à l'oxyde de zinc.

Voici comment on obtient le premier de ces sels.

On prend 50 kilogrammes de tungstate de soude du commerce (1), qu'on fait dissoudre à chaud dans la plus petite quantité d'eau possible ; d'une autre part, on fait

(1) Le tungstate de soude se trouve dans le commerce anglais à un prix assez bas, par suite de son emploi comme mordant dans les teintureries à la place des préparations d'étain.

également à chaud une solution très-concentrée d'acétate de plomb qu'on verse dans celle de tungstate, jusqu'à cessation de précipité. Après quelques heures de repos, on décante le liquide qui surnage, et on lave le précipité qu'on met à égoutter sur une toile; puis on fait sécher à l'étuve.

Par le fait de la double décomposition des deux sels, il s'est formé de l'acétate de soude soluble, et il s'est précipité du tungstate basique de plomb, qu'on traite de la manière suivante, pour le faire passer à l'état de tungstate acide.

Pour cela, on prend :

 Acide nitrique de 1,3 de densité.
 Ou acide acétique de 1,05 — 12 kilog.

On étend l'acide de son volume d'eau, puis on le verse sur le précipité; on laisse séjourner pendant deux heures environ, en agitant de temps à autre. Lorsque le précipité a pris la consistance de l'alumine hydratée, la réaction est achevée. On laisse déposer; on décante; les premières liqueurs sont mises à part pour en retirer l'oxyde de plomb qui se trouve dissous; on lave le précipité avec de l'eau froide; on le recueille sur des toiles et on en forme des pains qu'on fait sécher sur des pierres poreuses placées dans une étuve modérément chauffée.

ANTIMONITE DE PLOMB.

D'après la patente anglaise, l'antimonite de plomb se prépare de la manière suivante :

Si on fait bouillir sous la hotte d'une cheminée tirant bien, et dans une chaudière de plomb,

>Antimoine métallique..... 50 parties;
>Acide sulfurique concentré. 200 parties,

on obtient du gaz acide sulfureux qui se volatilise, et une masse blanche saline qui consiste en sulfate d'antimoine.

Ce sel, chauffé jusqu'à ce qu'il ne perde plus de vapeurs acides, est ramené à l'état d'acide antimonieux; pour cela on le pulvérise et on le mélange intimement avec 21 parties de carbonate de soude calciné. On fait fondre dans un creuset, et le produit de la fusion mis à bouillir avec de l'eau, donne une solution qu'on décompose par une suffisante quantité d'acétate neutre de plomb.

Au contact des deux sels (antimonite de soude et acétate de plomb), il se précipite de l'antimonite de plomb blanc, lourd, qui est lavé à plusieurs reprises avec de l'eau froide, et la liqueur contient de l'acétate de soude.

Le produit est recueilli sur des toiles, et lorsqu'il est encore en masse pâteuse, on en forme des pains qu'on fait sécher sur des briques absorbantes, dans une étuve chauffée à 50° Réaumur.

ANTIMONIATE DE PLOMB.

L'antimoniate de plomb est la troisième couleur proposée par M. Spilsburg pour remplacer la céruse dans la peinture fine.

Lorsqu'il est pur, il se présente sous la forme d'une poudre blanche, lourde, complétement insoluble dans

l'eau, et qui couvre assez bien. Exposé à une température élevée, il prend une teinte jaune très-belle, et forme alors le jaune de Naples que nous ferons connaître plus loin.

Obtenu par le procédé que M. Spilsburg indique, ce sel ne peut être considéré que comme un mélange d'antimoniate et de sulfate de plomb.

On fait un mélange de sulfure d'antimoine bien pulvérisé, une partie, et de nitrate de potasse, cinq parties, qu'on fait détoner dans un creuset chauffé au rouge, ou sur la sole d'un four à réverbère. Il se produit du sulfate et de l'antimoniate de potasse. Le produit de la calcination traité par l'eau bouillante se dissout à peu près entièrement. On verse dans la solution de l'acétate neutre de plomb qui donne lieu à un précipité qu'on fait sécher à la température de l'étuve.

Les trois couleurs que nous venons de décrire sont à peu près inconnues en France. Tout fait supposer que la peinture ne les emploiera pas; elles présentent en effet tous les inconvénients de la céruse, elles reviennent à un prix assez élevé et ne paraissent pas mieux couvrir que les autres composés de plomb.

La craie de Bologne, le blanc de coquilles d'œufs, la silice, le talc, les os calcinés, la marne, le kaolin, le carbonate de baryte, le carbonate de manganèse, l'alumine, le blanc de fard (sous-nitrate de bismuth) et l'oxyde d'étain, ont encore été conseillés pour la peinture à l'eau et à l'huile. Mais ces substances présentent si peu d'avantages, qu'on a à peu près renoncé à leur emploi.

CHAPITRE II

COULEURS JAUNES

OR.

Pour imiter la couleur de l'or, les peintres se servent quelquefois de blanc de céruse, mélangé avec des proportions variables de jaune de Naples, d'ocre de Berry, ou bien de réalgar. Mais le résultat qu'on obtient n'est jamais bien satisfaisant; aussi, pour les objets qui ont quelque valeur, remplace-t-on cette composition par de l'or véritable.

L'emploi de l'or constitue une branche spéciale dans l'art du peintre, la dorure. Pour approprier ce métal aux différents usages auxquels on le destine, on lui fait subir plusieurs préparations que nous allons faire connaître.

OR EN FEUILLE.

La préparation de l'or en feuille constituant une industrie particulière, celle du batteur d'or, nous n'aurons pas à nous en occuper ici.

Nous dirons cependant que le commerce livre aux artistes des feuilles d'or de différentes couleurs, qui sont des alliages d'or, d'argent et de cuivre dans les proportions suivantes :

Or vert Or fin.. 750. Argent 250.
Or jaune fin. Or ordinaire.
Or rouge.... Or fin.. 750. Cuivre rosette. 250.
Or blanc.... Or et argent, en proportions variables suivant les fabriques.

OR EN POUDRE.

La poudre d'or se prépare toujours en broyant dans un mortier ou sur un porphyre les rognures de feuilles d'or ou les feuilles défectueuses que les batteurs nomment *bactrioles*, avec du miel ou avec de la gomme arabique parfaitement purs. Lorsque l'opération est achevée, on lave la pâte par la décantation avec de l'eau chaude, jusqu'à ce qu'elle en sorte très-claire, on jette le résidu sur un filtre qu'on fait sécher à la chaleur de l'étuve.

On remarque que plus le broyage est prolongé, plus elle acquiert d'éclat. La poudre d'or existe dans le commerce sous deux aspects différents, à l'état jaune et à l'état vert.

OR EN CHAUX.

Lorsque dans l'affinage des métaux précieux on traite à chaud le minerai d'argent aurifère par l'acide sulfurique concentré, on obtient d'une part une dissolution acide de sulfate de cuivre et de sulfate d'argent, et d'une autre part un résidu d'or en poudre très-fine. Ce produit, auquel on donne le nom d'*or en chaux*, est lavé à plusieurs reprises avec de l'eau chaude; on le jette sur un filtre sans plis, puis on fait sécher à l'étuve.

OR EN COQUILLE.

La poudre d'or obtenue par les procédés que nous venons de faire connaître, délayée dans une solution concentrée de gomme arabique et étendue en couches minces dans l'intérieur de petits coquillages, forme les coquilles d'or dont l'enluminure fait un si fréquent usage.

Les coquilles qui servent à cet usage sont plus petites que les coquilles d'argent ; comme pour ces dernières, on dépose sur un point quelconque un morceau de pâte de la grosseur d'une petite lentille. La quantité d'or qui se trouve dans chacune d'elles est très-minime. Ainsi, deux coquilles prises dans le commerce nous ont donné 2 1/2 et 3 centigrammes d'or pur. 50 à 60 coquilles représentent donc un poids d'or équivalent à 5 fr.

OR D'ALLEMAGNE.

L'or d'Allemagne se prépare encore en coquille,

mais on ne doit pas le confondre avec le précédent.

C'est un alliage de cuivre et de zinc (laiton, clinquant, oripeau) réduit en feuilles très-minces par les batteurs d'or, puis broyé et étendu dans des coquilles comme nous l'avons déjà dit.

Cette composition n'est pas d'une longue durée, on l'emploie seulement pour colorier les estampes très-communes.

L'or d'Allemagne est quelquefois vendu pour de l'or pur : d'autres fois on les mélange ensemble.

Le moyen le plus simple pour reconnaître cette fraude, consiste à délayer le produit dans une petite quantité d'eau chaude, et à le verser dans un ballon contenant de l'acide sulfurique concentré. L'or pur ne se dissout pas, tandis que l'or d'Allemagne donne une liqueur colorée en bleu qui devient encore plus vive lorsqu'on la sursature par l'alcali volatil.

L'or de Manheim, que l'on emploie encore quelquefois, est un alliage de cuivre et d'étain.

L'or forme la couleur la plus solide que l'on connaisse ; on s'en sert principalement pour peindre les arabesques, les figures, et pour imiter les ouvrages de la Chine et du Japon.

MASSICOT (voyez Litharge).

OCRES JAUNE ET ROUGE.

Nous réunissons dans le même paragraphe l'ocre jaune et l'ocre rouge. On n'ignore pas, en effet, que la seconde s'obtient par la calcination de la première ; en faisant l'histoire de l'une, on fait donc l'histoire de l'autre.

En France, dans les départements de la Nièvre, du Cher et de l'Yonne, en Saxe, en Hollande, et enfin dans un grand nombre de localités où il y a des mines de fer, on trouve naturellement de l'argile colorée en jaune, plus rarement en rouge et en brun, par de l'oxyde de fer, à laquelle on donne le nom d'argile ocreuse ou *d'ocre*.

Dans ces derniers temps on a donné le nom d'ocre de chrome, d'ocre d'urane, à des combinaisons particulières d'argile avec les oxydes de chrome et d'urane. Nous pensons qu'il serait plus convenable de réserver exclusivement le nom d'ocre aux combinaisons de l'argile avec l'oxyde de fer. On éviterait par là la confusion qui peut résulter, dans le commerce, de substances si différentes sous le rapport de leur composition.

Les ocres, auxquelles il est difficile d'assigner des formules spéciales, en raison des proportions variables de leurs composants, peuvent cependant être considérées comme de véritables combinaisons chimiques d'argile et d'oxyde de fer. Ces deux oxydes sont combinés ensemble de la même manière que les matières colorantes se fixent sur les tissus, ou bien sur certains alcalis minéraux pour former des laques. La force qui unit ces deux oxydes est encore assez grande pour que tous les acides, modérément étendus, ne puissent les attaquer ; c'est seulement à chaud et avec des acides concentrés qu'on arrive à les décomposer d'une manière complète.

L'ocre jaune est la plus répandue dans la nature.

L'ocre rouge naturelle porte encore le nom de craie rouge ; on la trouve principalement en Bohème, en Thu-

ringe, et sert pour les crayons ; toutes celles du commerce sont produites par la calcination de l'ocre jaune.

L'ocre brune constitue la terre de Cologne que nous ferons connaître ailleurs.

L'ocre jaune résulte de la combinaison de l'alumine avec l'oxyde de fer hydraté. On la trouve à plusieurs mètres au-dessous du sol, où elle forme des bancs d'un à deux mètres d'épaisseur. Les carrières les plus remarquables sont situées dans le département du Cher, à Saint-Georges sur la Pré, dans le département de la Nièvre, à la Berjaterie, et surtout dans le département de l'Yonne, à Pourrain, à Diges et à Toucy : les quantités qu'on retire de ces trois localités sont très-considérables.

L'ocre de Saint-Georges sur la Pré se trouve à 20 mètres au-dessous du sol ; celle de la Berjaterie forme un banc d'un mètre d'épaisseur, et se rencontre à 8 ou 10 mètres du sol. Celle de Pourrain est encaissée dans un banc d'argile ferrugineuse ; toutes les trois possèdent des propriétés chimiques et physiques qui diffèrent peu. Cependant l'on s'accorde à dire que celle qui nous vient du département de l'Yonne est plus belle, et donne par sa calcination une ocre rouge plus vive.

M. Berthier, qui a fait l'analyse des ocres, a trouvé la composition suivante :

Ocre de Saint-Georges.		Ocre de la Berjaterie.	
Argile	69,5.	Argile	64,4.
Peroxyde de fer.	23,5.	Peroxyde de fer.	26,6.
Eau	7,0.	Eau	9,0.
	100,0.		100,0.

L'ocre de Pourrain a donné à M. Mérat-Guillot :

> Silice 92,2.
> Alumine..... 01,9.
> Chaux....... 03,2.
> Oxyde de fer. 02,6.
> ———
> 99,9.

L'ocre jaune, exposée à l'action d'une température élevée, dégage de l'eau et acquiert une teinte rouge très-vive ; c'est sur cette réaction qu'est basée la préparation de l'ocre rouge.

Pour être livrée au commerce, l'ocre jaune subit de la part de l'ouvrier diverses préparations, qui ont pour but d'en faire plusieurs variétés.

L'ocre la plus commune est celle qu'on extrait de la mine, puis qu'on tamise grossièrement après l'avoir fait sécher au soleil. Pour l'obtenir plus belle, on la passe à travers un tamis de soie très-fin. Mais la plus grande partie de celle qu'on trouve dans le commerce est purifiée de la manière suivante :

Lorsque la terre est retirée de la mine, on la passe au moulin afin de la réduire en poudre grossière, on la délaye dans de grandes cuves avec de l'eau, on laisse reposer pendant un temps plus ou moins long, puis on décante ; les parties les plus grossières se précipitent d'abord, et l'eau chargée d'ocre est reçue dans des bassins où elle se clarifie; on la fait ensuite écouler, et on recueille le précipité qu'on laisse sécher au soleil, lorsqu'on veut la livrer en poudre ; ou bien on en forme des pains qui sont séchés également au soleil.

L'ocre obtenue ainsi a toujours une teinte jaune terreuse : on remarque que celle qui a été lavée plusieurs fois est d'un jaune plus clair.

Pour convertir l'ocre jaune en ocre rouge, on réduit la terre en très-petits fragments, puis on la place sur une plaque métallique chauffée à rouge ; lorsqu'elle a acquis la couleur désirée, on la refroidit brusquement en la versant dans de l'eau froide. On sépare par décantation l'eau chargée d'ocre ; on laisse reposer, on décante de nouveau, et enfin on recueille le précipité qu'on fait sécher à l'air. L'ocre est d'un rouge d'autant plus vif que la terre contenait plus de fer et moins de substances organiques.

Sous l'influence de la chaleur, l'oxyde de fer hydraté perd son eau de constitution, et prend alors la teinte rouge qui lui appartient lorsqu'il est anhydre.

On la fabrique le plus souvent dans la localité même où se trouve la carrière.

Au lieu de purifier l'ocre jaune par le lavage et la décantation des terres, un industriel a construit un appareil qui lui permet de supprimer l'action de l'eau, et de l'obtenir toujours en poudre excessivement fine ; pour cela il emploie la ventilation telle qu'on la pratique pour la préparation du blanc de zinc.

Le minerai d'ocre broyé et tamisé est soumis au moyen d'un élévateur à godet à un fort courant d'air, qui conduit la poudre impalpable dans une chambre séparée vers le milieu par une toile serrée ; celle-ci ne laisse passer que le courant d'air entraînant avec lui la poudre d'ocre très-fine ; la partie la plus grossière tombe dans un compartiment où on la recueille, soit pour la soumettre à une

seconde pulvérisation, soit pour en faire une sorte inférieure.

Ce fabricant trouve préférable de préparer l'ocre rouge avec l'ocre jaune en poudre impalpable. Pour cela, un tube placé à la partie supérieure de la chambre conduit l'ocre volatilisée dans un fourneau où elle se déshydrate complétement : il se sert d'une plaque de fonte, chauffée au rouge, sur laquelle la substance se répand d'une manière uniforme au moyen d'un cylindre à hélice.

La calcination opérée, on recueille l'ocre rouge par un canal situé à la base même de la plaque métallique. Cette poudre, qu'il désigne sous le numéro 1, est humectée après le refroidissement avec une petite quantité d'eau. Cette opération a pour but, dit l'inventeur de ce procédé, pour lequel il a été pris un brevet, de suroxider le fer et de communiquer à l'ocre une teinte rouge plus vive.

L'ocre rouge est souvent désignée dans le commerce sous les noms de *brun rouge, rouge de Prusse, rouge de Nuremberg, terre rouge ;* mais on réserve plus spécialement le nom de *rouge de Prusse* à celle qui possède une teinte rouge vive, et on désigne les autres sous le nom commun d'*ocre rouge*.

Le rouge de Prusse et les ocres rouges sont en poudre grossière et en poudre fine. La première sorte est de l'ocre jaune calcinée, telle qu'on la tire de la mine ; la seconde est passée au tamis de soie ou bien lavée. Dans ce dernier cas, elle est en poudre impalpable ; mais on observe que sa teinte est un peu plus claire.

Le commerce de détail livre quelquefois de l'ocre rouge sous forme de pâte ; pour l'obtenir ainsi, on la broie avec

de l'eau à laquelle on ajoute une petite quantité de chlorure de calcium qui lui permet de conserver son humidité.

Les ocres jaune et rouge sont très-fréquemment employées dans la peinture à l'eau et à l'huile. Les historiens disent que les artistes de l'antiquité y avaient souvent recours. Il est certain que dans la plus grande partie des anciennes peintures soumises à l'analyse chimique, on a retrouvé la présence de ces substances. Ainsi, les teintes foncées que l'on observe dans les tableaux de Saint-Marc et de la Vénus, exposés dans la tribune de la galerie de Florence, sont obtenues avec de l'ocre jaune, de l'ocre rouge et des matières carbonacées.

Chaptal et Humphry Davy affirment que des pots de terre trouvés sous les ruines de Pompéia et dans les salles de bains de Titus, contenaient une certaine quantité d'ocre jaune; enfin, que les jaunes de la Noce Aldobrandine sont peints avec cette substance.

Les Grecs et les Romains connaissaient parfaitement la préparation de l'ocre rouge par la calcination de l'ocre jaune. Pline, Vitruve, Théophraste, disent qu'en brûlant des terres de Sinope, d'Arménie, et l'ocre jaune d'Afrique, on leur communique la teinte rouge. Cette réaction passa inaperçue jusqu'au moment où les Hollandais la mirent en pratique. Ces industriels ont conservé ce monopole pendant longtemps ; ils faisaient venir de France de l'ocre jaune pour nous la revendre ensuite sous le nom de rouge de Prusse.

Nos peintres actuels les emploient pour la peinture en détrempe, à la colle et à l'huile, le badigeonnage, et pour

la peinture des papiers. On les fait très-souvent servir pour la mise en couleur des carreaux d'appartements. Ce sont des produits nullement vénéneux et très-solides.

ROUGE DE VENISE, ROUGE D'ANVERS, TERRA ROSA.

Ces trois couleurs sont encore des ocres qui possèdent la même composition chimique que les ocres jaune et rouge proprement dites; leur préparation est aussi la même.

Le *rouge de Venise* nous vient de l'Italie ; sa teinte est plus belle que celle de l'ocre rouge, et la peinture qu'elle produit est aussi beaucoup plus éclatante.

Le *rouge d'Anvers* a la plus grande ressemblance avec le précédent ; il est livré au commerce de Paris par des fabricants de la Flandre, et surtout de Namur.

Sous le nom de *terra rosa*, on désigne une ocre d'un rouge lilas lorsqu'elle est en poudre, et d'un rouge vif lorsqu'elle est broyée avec de l'huile. Cette couleur, qui nous vient de l'Italie, est encore peu connue dans le commerce de la droguerie. On suppose que c'est de l'ocre jaune de Venise qui a été moins chauffée que l'ocre rouge ; il est certain qu'elle foisonne très-peu lorsqu'on l'emploie.

TERRE D'ITALIE ET OCRE DE RUE.

Nous réunissons ces deux substances dans un même paragraphe, parce que nous pensons, malgré leurs noms différents, qu'elles ont, sinon la même origine, du moins une composition identique.

Les auteurs s'accordent à dire que la terre d'Italie et l'ocre de rue nous viennent de l'Italie et de l'Angleterre.

Ce qui frappe dans leur examen, c'est leur grande ressemblance avec l'ocre jaune ordinaire; comme cette dernière, elles sont jaunes, mais d'une nuance un peu plus foncée; leurs principes constituants sont l'hydrate de sesquioxyde de fer, l'argile et la silice. Si on les calcine, elles fournissent une terre rouge qui, à part une richesse de ton moins grande, possède tous les caractères appartenant à l'ocre rouge.

Elles se préparent dans les localités où il existe des mines de fer.

L'une et l'autre se vendent dans le commerce à l'état naturel et à l'état calciné; elles sont en poudre grossière et en poudre fine ou lavée.

On les emploie aux mêmes usages que les ocres jaunes et rouges; elles sont très-solides et nullement vénéneuses.

JAUNE DE MARS.

Dans le but d'enlever à l'ocre jaune naturelle la teinte terreuse qu'elle possède toujours, quelques fabricants de couleurs ont essayé de l'obtenir artificiellement, en précipitant d'une manière incomplète certains sels de fer solubles par les alcalis (potasse, soude, chaux, alumine).

Voici, d'après M. Bourgeois, comment on l'obtient.

On fait dissoudre dans de l'eau distillée du sulfate de fer fait de toutes pièces, en dissolvant dans un matras des morceaux de fer doux et en excès par de l'acide sulfurique étendu de 4 à 5 parties d'eau; on le mêle avec

une partie égale de dissolution d'alun, puis on verse ce mélange dans une tinette en sapin, de manière à en couvrir le fond à 1 centimètre de haut ; on remplit alors cette tinette d'eau de Seine, bien claire, mais non filtrée au charbon, parce que cette eau, filtrée ainsi, contient une petite quantité d'acide carbonique qui altérerait l'oxyde de fer ; on précipite ensuite ce mélange par une solution de potasse d'Amérique ; on remue bien le tout, et l'on décante après vingt-quatre heures ; on ramasse le précipité avec un couteau non métallique ; on le filtre, puis on le met en trochisques sur du papier joseph.

La préparation de cette couleur présente des difficultés qu'une longue pratique peut seule surmonter ; M. Colcomb s'est acquis dans ce genre de fabrication une réputation signalée par tous les auteurs.

Le jaune de mars obtenu par le procédé ci-dessus est un mélange d'oxyde de fer hydraté, de carbonate de fer et d'alumine, dans des proportions qui varient avec la quantité de potasse qu'on a ajoutée ; il diffère beaucoup du suivant que nous allons faire connaître.

On fait dissoudre 1 kilogramme de sulfate de protoxyde de fer dans 20 litres d'eau froide. D'une autre part, on éteint un kilogramme de chaux vive parfaitement blanche dans 40 litres d'eau froide ; la bouillie qui en résulte est passée à travers un linge, de manière à permettre à la chaux la plus fine de passer ; on ajoute peu à peu et en agitant sans cesse la solution ferrugineuse dans le lait de chaux. Il se forme un précipité verdâtre qu'on lave à plusieurs reprises avec de l'eau froide, puis on l'expose pendant quelque temps à l'air, où il ne tarde pas à prendre

en séchant, et par le fait de la suroxydation de l'oxyde de fer, une teinte jaune assez prononcée.

Cette couleur est, ainsi que le montrent les substances qui ont servi à l'obtenir, un mélange de sulfate de chaux et de sous-sulfate de peroxyde de fer.

Il existe un troisième procédé, qui consiste à remplacer le sulfate de protoxyde de fer par le sulfate de sesquioxyde qu'on précipite au moyen du carbonate de soude ; il se dépose de l'hydrate de sesquioxyde, qui possède une teinte jaune rougeâtre. On lave, puis on fait sécher comme précédemment.

Cet oxyde n'a jamais une teinte jaune bien franche; aussi, pour corriger ce défaut, quelques fabricants ajoutent au sel de fer une petite quantité d'alun. L'alumine qui se précipite avec l'oxyde de fer, fait disparaître en partie la teinte rougeâtre qu'on reproche à ce produit.

Le jaune de mars bien préparé est une fort belle couleur, très-solide, que l'on emploie pour la peinture fine.

C'est par la calcination du jaune de mars à des températures différentes, et dans des conditions particulières, tenues secrètes par les fabricants de couleurs, que l'on obtient le *violet*, le *rouge*, le *brun* et l'*orangé* de fer ou de mars. Dans ces produits, l'oxyde de fer est en partie à l'état de sesquioxyde, mélangé plutôt que combiné à l'oxyde alcalin; ils partagent, comme le brun Vandick et le colcothar, la propriété d'être très-solides ; mais le prix élevé auquel le commerce les livre, fait qu'on ne les emploie guère que pour la peinture fine, le tableau, par exemple.

OR MUSSIF.

L'or mussif, nommé encore *or mosaïque, or de Judée, bronze des peintres, bisulfure d'étain,* a été, dit-on, inventé par les Phéniciens.

C'est une combinaison de soufre et d'étain dans les proportions suivantes :

Soufre. 35,37.
Etain.. 64,63.
———
100,00.

La formule chimique se représente ainsi :

$$\underbrace{S^2}_{\text{Soufre.}} + \underbrace{Sn}_{\text{Etain.}}$$

Il se présente sous la forme d'écailles brillantes, translucides, douces au toucher ; il est insipide, inodore, insoluble dans l'eau, l'alcool, l'éther et les huiles grasses et volatiles. L'eau régale est le seul acide qui le dissolve ; exposé à l'action d'une température très-élevée, il se décompose en partie, tandis qu'une autre portion se volatilise en cristaux d'un éclat très-vif.

On a indiqué un grand nombre de procédés pour obtenir l'or mussif, mais celui qu'on emploie le plus souvent, et qui fournit un produit d'une belle qualité, se pratique de la manière suivante :

On prend :

Etain pur................ 12 parties.
Mercure................ 6 »
Soufre en poudre........ 7 »
Sel ammoniac en poudre. 6 »

On commence par amalgamer l'étain avec le mercure, on broie le mélange avec le soufre et le sel ammoniac, puis on introduit dans un matras de verre très-résistant, et on chauffe doucement au bain de sable jusqu'à ce qu'il ne se dégage plus de vapeur blanche et que l'odeur de l'hydrogène sulfuré ne se fasse plus sentir. Arrivé à ce point, on élève la température jusqu'au rouge obscur, puis on laisse refroidir.

Lorsqu'on brise le matras, on trouve la plus grande partie de l'or mussif sous forme d'une masse écailleuse, recouverte d'une certaine quantité d'écailles cristallines, d'un éclat très-vif, qui proviennent de la sublimation d'une partie de la matière. Comme celles-ci sont toujours d'une qualité supérieure, on les recueille à part. Sur les parois supérieures du vase, il existe des cristaux de protochlorure de mercure et de sulfure de mercure, résultant de la réaction qui s'est opérée.

Voici ce qui se passe dans cette opération :

Le mercure et le sel ammoniac ne servent qu'à titre d'auxiliaire : le premier, à diviser l'étain, pour le rendre plus fusible, et enfin pour permettre le contact intime entre le soufre et ce métal ; le second, à prévenir l'élévation de la température, qui résulte de la combinaison du soufre avec l'étain. En effet, comme le sel ammoniac a besoin, pour entrer en vapeur, d'une certaine quantité de calorique, il en soustrait la plus grande partie au mélange, qui passerait sans cela à l'état de protosulfure d'étain.

Certains fabricants préparent encore l'or mussif avec les substances suivantes :

<div style="text-align:center">Mercure...... 4 parties.</div>

Etain......... 4 parties.
Soufre 3 »
Sel ammoniac. 2 »

Ou bien avec :

Mercure 3 parties.
Etain......... 7 »
Soufre 7 »
Sel ammoniac. 3 »

Dans le but d'éviter l'emploi du mercure, qui se trouve perdu, on a conseillé de l'obtenir en calcinant :

Soufre 1 partie.
Protoxyde d'étain. 2 »

Ou bien encore :

Soufre.......... 3 parties.
Protoxyde d'étain. 4 »
Sel ammoniac.... 2 »

Mais généralement on s'accorde à dire qu'avec l'amalgame de mercure et d'étain, le produit possède toujours une teinte jaune plus riche.

Il résulte de nos recherches, que la réussite de cette opération tient moins aux quantités de mercure, d'étain, de soufre et de sel ammoniac qu'on met en présence, qu'à la conduite du feu : tout l'art de cette fabrication réside là ; ainsi, lorsque la température n'est pas assez élevée, le produit est jaune clair ; en chauffant davantage, la teinte est jaune foncé ; enfin, en chauffant trop, il prend une teinte grisâtre.

L'or mussif sert dans la peinture à l'huile pour imiter

les tons et les reflets du bronze, ou bien encore pour dorer sur bois ; pour ce dernier usage, quelques industriels lui font subir une seconde calcination au rouge dans un matras en verre. Une certaine quantité se décompose en soufre, sel ammoniac et cinabre ; mais une autre partie se sublime sous la forme de lames très-éclatantes, d'un jaune très-vif : c'est une couleur médiocrement solide et assez vénéneuse.

ORPIMENT.

Le soufre et l'arsenic peuvent s'unir en un grand nombre de proportions.

La nature nous offre plusieurs échantillons de sulfures d'arsenic, dont deux sont employés dans la peinture : ce sont le bisulfure ou réalgar, et le trisulfure ou orpiment ; mais on ne les rencontre jamais en quantités assez considérables pour satisfaire aux besoins des arts ; ceux qui existent dans le commerce sont produits artificiellement. Le premier est rouge, le second est jaune ; c'est de ce dernier que nous allons nous occuper ici.

L'orpiment, orpin, sulfure jaune d'arsenic, *auripigmentum*, est connu depuis la plus haute antiquité. Théophraste, qui vivait 315 ans avant Jésus-Christ, est le premier auteur qui en parle.

Il est formé de :

> Arsenic. 60,98.
> Soufre.. 39,02.
> ─────
> 100,00.

Sa formule chimique se représente ainsi :

$$\underbrace{S^3}_{\text{Soufre.}} + \underbrace{As}_{\text{Arsenic.}}$$

A l'état naturel, l'orpiment est en masses lamelleuses, ou bien cristallisé en prismes rhomboïdaux obliques, d'un jaune citron très-vif et très-éclatant. Son éclat est métallique ; il est inodore, transparent, d'une dureté assez faible pour qu'on puisse le couper au couteau. Réduit en poudre, il possède une teinte jaune plus claire que lorsqu'il est en masse ; insoluble dans l'eau, l'alcool, l'éther et les huiles. La plupart des acides sont sans action sur lui ; cependant l'acide nitrique et l'eau régale le décomposent. Il est fusible, volatil, sans décomposition lorsqu'on le chauffe en vase clos ; mais dans des vases ouverts, il se détruit en acide sulfureux et acide arsénieux (arsenic blanc) ; par le frottement il acquiert l'électricité résineuse.

L'orpiment se trouve naturellement dans les terrains secondaires, souvent mélangé au réalgar. Les localités où on le rencontre en certaine quantité sont : la Souabe, la Hongrie, la Syrie, la Valachie, la Bohême, le Pérou, la Chine, la Perse, et enfin dans une grande partie de l'Orient.

L'orpiment artificiel partage, sous le rapport des propriétés physiques, quelques caractères de l'orpiment naturel, mais sous le rapport chimique il en diffère complétement.

Il résulte des expériences de M. Guibourt, que l'orpiment fait de toutes pièces est un mélange d'acide arsénieux et de sulfure d'arsenic, dans les proportions de

96 parties du premier et de 6 parties du second ; aussi est-il beaucoup plus vénéneux que celui qu'on trouve dans la nature.

L'orpiment artificiel se fabrique principalement en Allemagne, il ne s'en importe pas moins de 300,000 kilogr. En France, le mode de fabrication varie beaucoup. Le plus ordinairement on chauffe, après les avoir pulvérisés et parfaitement mélangés, 1 kilogr. de fleur soufre et 2 kilogr. d'acide arsénieux dans un creuset de terre, muni à la partie supérieure d'un chapiteau qui permet de recueillir le produit sublimé.

Obtenu ainsi, l'orpiment est en masse opaque, ayant l'éclat de l'acide arsénieux, et formé de couches superposées, dont la teinte varie depuis le rouge jusqu'au jaune clair. Cette différence de couleur provient de la combinaison plus ou moins intime du soufre et de l'arsenic. On obtient une teinte plus uniforme en laissant la sublimation s'effectuer lentement; d'autres fabricants ajoutent un peu moins de soufre; ils obtiennent un produit qui tient le milieu entre l'orpiment ordinaire et le réalgar.

L'orpiment est d'un usage journalier dans la peinture à l'huile, mais il ne réunit aucune des qualités d'une bonne couleur; ainsi, il est très peu solide, très-vénéneux, et de plus il décompose un grand nombre de couleurs métalliques, avec lesquelles il forme des sulfures diversement colorés.

Mélangé au bleu de Prusse, il fournit une couleur verte assez belle.

Il y a quelques années, on a conseillé son emploi pour la peinture sur marbre; lorsqu'il est dissous dans l'am-

moniaque, il pénètre rapidement le marbre sur lequel on l'applique et produit une couleur jaune, qui se fonce d'autant plus qu'on l'expose davantage à l'air.

IODURE DE PLOMB.

L'iodure de plomb, que la peinture à l'huile emploie quelquefois, résulte de la combinaison de l'iode avec le plomb; sa formule chimique se représente ainsi :

$$\underbrace{I}_{\text{Iode}} + \underbrace{Pb}_{\text{Plomb.}}$$

C'est une couleur d'un beau jaune citron, pulvérulente, insoluble dans l'eau froide et dans l'alcool; l'eau bouillante en dissout $1/192^e$, qui se précipite par le refroidissement en paillettes d'un vif éclat.

Le procédé le plus économique pour l'obtenir a été indiqué par M. Huraut, habile pharmacien de Paris.

On prend :

Iode	100 parties.
Limaille de fer.	15 »
Chaux vive	25 »
Eau	Quantité suffisante.

On fait une bouillie des substances que nous venons de nommer; on chauffe doucement en agitant sans cesse, et lorsque la combinaison est opérée, ce qu'on reconnaît à la disparition complète de l'iode, la matière est étendue d'eau, on laisse déposer; on décante; on traite le résidu par une nouvelle quantité d'eau, puis on filtre les liqueurs

réunies. Celles-ci contiennent de l'iodure de calcium, qu'on décompose par une solution de 152 parties d'acétate neutre de plomb, ou bien de 132 parties de nitrate de plomb. Le précipité qui prend naissance est lavé à deux ou trois eaux seulement, puis séché à une température modérée. Avec les quantités ci-dessus indiquées, on obtient 175 parties d'iodure de plomb micacé et d'un jaune orange magnifique.

Cette couleur fournit à la peinture à l'huile des résultats d'autant plus satisfaisants, qu'on ne l'expose pas aux rayons solaires; mais sous l'influence de ces derniers, elle ne tarde pas à se décomposer. Cependant Davy dit que de l'iodure de plomb étendu en couches minces, puis exposé pendant plusieurs mois à l'air et à la lumière, a conservé sa teinte sans altération; il partage du reste tous les défauts et toutes les qualités des composés plombiques.

JAUNE DE CADMIUM.

En décrivant l'histoire du cadmium et de ses composés, Stromeyer émit l'opinion, qui s'est confirmée depuis, que le sulfure de cadmium, pour la beauté et la fixité de sa teinte, pouvait être d'un emploi avantageux dans la peinture à l'huile.

Ce composé, dont la formule chimique se représente ainsi :

$$\underbrace{S}_{\text{Soufre.}} + \underbrace{Cd}_{\text{Cadmium.}}$$

possède une teinte jaune fort belle. Vu en masse, il est

ordinairement jaune rougeâtre ; mais réduit en poudre fine, il est d'un très-beau jaune foncé.

Lorsqu'on le chauffe, il passe au rouge cramoisi, et reprend par le refroidissement sa teinte naturelle ; il ne fond qu'à une température très-élevée et cristallise par le refroidissement en lames jaunes micacées.

On peut l'obtenir de deux manières différentes :

1° En chauffant dans un creuset fermé, de l'oxyde de cadmium avec de la fleur de soufre en excès ;

2° En faisant passer un courant d'hydrogène sulfuré à travers une solution de sulfate ou de nitrate de cadmium. Le précipité qui se produit dans cette circonstance est lavé, recueilli sur un filtre, puis séché à l'étuve. Il possède une teinte jaune beaucoup plus belle que le précédent, et comme il est en poudre impalpable, sa propriété couvrante est aussi plus grande.

Le jaune de cadmium est une fort belle couleur qui, avec les couleurs bleues, donne des verts très-riches et très-solides. Mais de même que beaucoup de sulfures métalliques, on doit éviter de le mélanger avec certaines couleurs minérales, la céruse, par exemple, qu'il décompose en donnant naissance à des sulfures plus ou moins colorés.

Étant à un prix assez élevé, on ne l'emploie guère que pour les travaux d'art ; il a peu d'action sur l'économie animale.

LAQUE MINÉRALE.

Dans le cours de l'année 1836, M. Malaguti, professeur de chimie à Rennes, fit connaître une substance d'une

belle couleur lilas, qui peut être employée avec beaucoup d'avantage pour l'impression des papiers peints et pour la peinture à l'huile.

Ce chimiste conseille de se servir de cette couleur pour remplacer le mélange de laques végétales que les peintres sont obligés de faire pour obtenir la nuance lilas, aussi lui a-t-il donné le nom de laque minérale.

La laque minérale est une combinaison de l'oxyde de chrome avec le bioxyde d'étain (acide stannique); elle forme la base du pinkcolour, qui sert comme on sait à peindre la faïence et la porcelaine au-dessous de la couverte.

Voici comment M. Malaguti la prépare :
On prend :

> Acide stannique.. 100 parties.
> Oxyde de chrome. 2 »

On fait un mélange aussi intime que possible, et on calcine dans un creuset de terre jusqu'à la température du rouge sombre : après le refroidissement, la matière se présente sous la forme d'une masse vitrifiée brillante qui, réduite en poudre, possède une couleur lilas très-belle.

Le docteur Lüdersdorff (1), qui a répété les expériences de M. Malaguti, a toujours obtenu une matière qui avait un ton un peu grisâtre. Il chercha à se procurer un chromate basique d'étain et à le modifier par la calcination, de manière à obtenir la couleur désirée : voici comment il y est parvenu :

(1) *Revue scientifique et industrielle*, t. xx, p. 291.

On fait dissoudre du chromate neutre de potasse dans cinq à six fois son poids d'eau, et on verse dans la liqueur une solution de bichlorure d'étain tant qu'il continue à se produire un précipité, on le lave bien dans le vase même où il s'est formé, et on le recueille sur un filtre. Quand toute l'eau est égouttée, on broie le précipité encore humide dans une capsule, avec la moitié de son volume de sel de nitre pulvérisé, et ou laisse la matière sécher en place; arrivé à ce point, on la pulvérise finement et on la jette par petites portions dans du nitrate de potasse chauffé au rouge faible : la décomposition a lieu comme à l'ordinaire; le creuset est retiré du feu, on y laisse la matière en repos pendant quelque temps, afin que la combinaison que l'on cherche à obtenir puisse se déposer au fond. Le nitrate de potasse liquide est décanté, et on détache du creuset le chromate basique d'étain formé, en le détrempant avec de l'eau chaude ; enfin, on le soumet au lavage tant que l'eau employée à cette opération continue à offrir une réaction alcaline.

Le chromate basique d'étain ainsi obtenu est d'une couleur jaune pâle terne : il s'agit maintenant de lui faire subir les modifications qui doivent en faire la couleur que l'on a en vue : il n'y a pas d'autre chose à faire qu'à le soumettre à une forte calcination pendant une ou deux heures, ce qui se fait en couvrant de charbons (de coke préférablement) le creuset, qui naturellement doit être luté et chauffé dans un four à réverbère. Si on le place dans un four à porcelaine, il vaut mieux le couvrir tout simplement sans le luter, et si la quantité de matière à calciner est plus considérable, il est nécessaire de le ren-

fermer dans une capsule plus haute que large, afin de ménager à l'air un accès plus facile.

Après la calcination, la substance est ferme et offre çà et là un léger brillant ; sa couleur est d'un beau rose de fleur de pêcher ; elle est très-dure, mais cependant se réduit facilement en poudre, sur laquelle l'humidité, l'air, la lumière et le gaz sulphydrique sont sans action.

JAUNE MINÉRAL.

OXYDOCHLORURE DE PLOMB SURBASIQUE.

Sous les noms de *mendipite*, *berzelite*, *kérasine*, on désigne en minéralogie plusieurs combinaisons naturelles du chlore avec le protoxyde de plomb. Toutes ces espèces minérales, assez rares il est vrai, possèdent une teinte jaune plus ou moins prononcée. La plus belle a pour formule :

$$\underbrace{Cl\ Pb}_{\text{Chlorure de plomb.}} + \underbrace{PbO}_{\text{Oxyde de plomb.}}$$

Tout celui que les arts emploient est obtenu par la voie artificielle ; il forme un grand nombre de variétés qui portent dans le commerce les noms de *jaune de Turner*, *jaune de Kassler* ou de *Cassel*, *jaune de Paris* et *jaune de Vérone*.

Aucun de ces produits ne possède exactement la composition que nous avons donnée ci-dessus ; tous résultent de la combinaison du protochlorure de plomb avec des proportions variables d'oxyde de plomb.

Le jaune minéral a été découvert en Angleterre par un

nommé Turner, qui l'obtint en faisant digérer le minium avec la moitié de son poids de sel marin, puis chauffant dans un creuset à une température élevée le mélange réduit en bouillie, à l'aide d'une petite quantité d'eau. Ce procédé, tenu secret pendant très-longtemps par son auteur, a été dévoilé par le docteur Hahnemann, qui conseille d'opérer de la manière suivante :

Mélangez ensemble 21 parties de minium et 2 parties de sel ammoniac ; chauffez dans un creuset jusqu'à fusion ; puis coulez sur une table de marbre uni, et pulvérisez sans résidu.

La plupart des modes opératoires indiqués jusqu'ici ne sont que des variantes de celui d'Hahnemann ; presque tous consistent à faire fondre de la litharge, du minium ou de la céruse avec du sel marin ou du sel ammoniac (chlorhydrate d'ammoniaque).

M. Mérimée a indiqué un procédé qui fournit un produit d'une teinte jaune très-riche, mais d'une composition bien différente ; aussi le décrirons-nous à part.

Voici comment on prépare ordinairement la couleur qui nous occupe.

Dans un mortier de marbre très-propre, on mélange très-intimement 4 parties de minium avec une partie de sel ammoniac ; on ajoute une petite quantité d'eau pour former une espèce de pâte ferme qu'on place dans un vase de grès, recouvert intérieurement d'une couche d'argile.

On place le vase sur un support en brique réfractaire, et dans un fourneau à réverbère analogue à celui employé par les essayeurs ; on chauffe d'abord lentement, puis au rouge sombre. Lorsque la fusion est opérée, on

retire le vase de l'appareil, et on coule la matière dans un vase de fer poli intérieurement et bien chaud. On obtient alors une substance dure, pesante, comme cristallisée, qu'on réduit en poudre fine pour la livrer au commerce.

Chaptal avait fondé à Montpellier une fabrique de jaune minéral qu'il préparait de la manière suivante, et qu'il livrait sous le nom de jaune de Montpellier.

On prend 400 parties de litharge réduite en poudre fine; d'une autre part, on fait dissoudre 100 parties de chlorure de sodium dans 400 parties d'eau; on fait, avec la litharge, une pâte claire qu'on agite continuellement, afin qu'elle ne durcisse pas pendant cette opération; on ajoute un peu de la dissolution de sel marin tenu en réserve; après vingt-quatre heures de contact, la pâte est ordinairement exempte de grumeaux.

Lorsque le mélange est d'une blancheur uniforme, on le lave avec de l'eau froide pour enlever l'alcali (soude) qui a été mis à nu; on l'exprime dans des sacs, puis on le chauffe au rouge dans des creusets, où il prend en fondant une belle teinte jaune brillante. La litharge s'empare du chlore du sel marin, passe à l'état d'oxydochlorure, et la soude est mise en liberté.

Il existe encore d'autres procédés pour obtenir cette couleur : ainsi, quelques fabricants la préparent, 1° en fondant ensemble une partie de chlorure de plomb avec 4 parties de minium; 2° en chauffant 10 parties de massicot avec une partie de sel ammoniac; après la fusion de la matière, on trouve deux couches, une inférieure de plomb métallique provenant de la réduction d'une certaine quantité d'oxyde par l'hydrogène de l'ammoniaque,

et une autre, supérieure, qui consiste en jaune minéral très-pur et très-brillant; 3° en maintenant pendant quelque temps en fusion, et à l'air, du chlorure de plomb neutre; une partie de sel est décomposée, du chlore se dégage, et le métal mis à nu forme de l'oxyde de plomb qui se combine au chlorure non altéré. On arrête l'opération lorsque le produit a acquis la teinte désirée.

L'éclat et la solidité qu'on recherche dans le jaune minéral, paraissent tenir à des proportions inconnues jusqu'à présent de chlore et d'oxyde de plomb nécessaires pour former un sel basique de composition définie, et à la température à laquelle on doit soumettre le mélange.

En général, la teinte est d'autant plus foncée qu'on a pris moins de chlorure alcalin. Si la nuance est trop claire, on fait subir à la couleur une seconde fusion: si, au contraire, elle est trop foncée, on la fait refondre en y ajoutant une petite quantité de sel ammoniac.

Quel que soit le mode opératoire mis en pratique, il est très-important d'apporter pendant l'exécution la plus scrupuleuse propreté, et d'avoir un fourneau construit de manière que les cendres et le charbon ne puissent tomber dans le creuset. En négligeant ces précautions, il se fait une réduction partielle de l'oxyde de plomb, qui donne à la substance une teinte brune.

Le jaune minéral se trouve dans le commerce quelquefois fondu, mais le plus souvent en trochisques ou en poudre. Sa nuance varie depuis le jaune clair jusqu'au jaune brun. C'est surtout pour la peinture des décors et des équipages qu'on l'emploie; il a une très-grande solidité; mais comme sa teinte est, en général, un peu

9

claire, on est dans l'habitude de la remonter avec le jaune de chrome. De même que la plupart des composés de plomb, il couvre assez bien les objets sur lesquels on l'applique, et noircit, faiblement il est vrai, au contact des émanations sulfureuses.

JAUNE MINÉRAL MÉRIMÉE.

Dans le but d'apporter un perfectionnement à la fabrication du jaune minéral, M. Mérimée a fait connaître un procédé qui fournit une matière jaune très-belle, que les artistes emploient sous le nom de *jaune d'antimoine*.

Cette couleur, à laquelle nous croyons devoir donner le nom de son auteur, est un mélange d'antimoniate de plomb et d'oxydo-chlorures de plomb et de bismuth.

Voici comment on l'obtient :

On fait un mélange de

>30 parties de bismuth métallique.
>240 parties de sulfure d'antimoine.
>640 parties de sel de nitre.

Les trois substances sont réduites en poudre très-fine, puis intimement mélangées et placées dans un creuset que l'on chauffe jusqu'à la fusion. Lorsque la masse ne dégage plus de vapeurs nitreuses, on la projette dans un vase contenant de l'eau froide ; on délaye pendant le temps nécessaire, et on lave par décantation jusqu'à ce que l'eau n'ait plus de saveur.

Pendant cette opération, l'antimoine et le bismuth s'oxydent et produisent de l'antimoniate de bismuth, qui

se précipite dans l'eau sous forme d'une poudre jaune sale qu'on fait sécher.

D'une autre part, on fait un mélange de 16 parties de litharge, une partie de sel ammoniac, et 1/8° d'antimoniate de bismuth ; on place le tout dans un creuset, et on chauffe jusqu'à la fusion ; après quoi on coule sur une plaque de fer poli et chaude, et enfin on pulvérise.

Sous l'influence de la litharge et du sel ammoniac, l'antimoniate de bismuth se convertit en antimoniate de plomb (jaune de Naples ordinaire) et en oxydochlorures de plomb et de bismuth.

Cette couleur tient, comme on voit, du jaune de Naples et du jaune minéral. A une très-grande solidité, elle joint une richesse de ton qui la fait surtout rechercher pour la peinture fine. Le commerce la vend sous les noms de jaune d'antimoine et de jaune minéral surfin.

CHROMATE DE CHAUX.

Lorsqu'on traite un sel soluble de chaux (chlorure, nitrate) par du chromate de potasse et de soude, on obtient un précipité jaune de chromate de chaux, dont la composition se représente ainsi :

$$\underbrace{CrO^3}_{\text{Acide chromique.}} + \underbrace{CaO}_{\text{Chaux.}}$$

On commence par préparer du chromate de potasse et de soude, en versant jusqu'à saturation du carbonate de soude (cristaux de soude) dans du bichromate de potasse dissous dans suffisante quantité d'eau. On verse peu à peu

et en agitant sans cesse du chlorure de calcium provenant du traitement de la craie par l'acide chlorhydrique. Une fois le chromate alcalin décomposé, on laisse reposer, on décante, on lave et on recueille le précipité sur une toile très-serrée ou sur un filtre de papier joseph, puis on fait sécher à l'étuve.

Obtenue par ce moyen, cette substance possède une teinte jaune clair; mais si on fait la précipitation avec des liqueurs bouillantes, le précipité acquiert une teinte encore plus belle.

Le chromate de chaux peut être employé comme la craie pour la peinture en détrempe et pour les papiers peints; mais la plus grande partie de celui que les fabricants livrent au commerce de détail sert pour adultérer le jaune de chrome (chromate de plomb) qu'on veut vendre à bas prix. C'est une couleur d'un très-beau jaune, et qui n'a pas, comme le dernier, le défaut de noircir avec le temps; mais elle couvre mal les objets sur lesquels on l'applique.

CHROMATE DE BARYTE.

Le nitrate de baryte et de chlorure de baryum, traités par le chromate neutre de potasse, fournissent du chromate de baryte qui se représente ainsi :

$$\underbrace{CrO^3}_{\text{Acide chromique.}} + \underbrace{BaO}_{\text{Baryte.}}$$

Cette couleur, assez peu employée maintenant, porte encore le nom de *jaune d'outremer*. De même que le chromate de chaux, elle sert souvent à falsifier le jaune de

chrome ; cependant elle peut être employée avec beaucoup d'avantage pour la fabrication des papiers peints ; outre qu'elle couvre assez bien, elle n'a pas l'inconvénient de noircir à l'air.

Voici comment on l'obtient :

On commence par préparer du chromate double de potasse et de soude, en saturant le bichromate de potasse du commerce par des cristaux de soude. La solution est évaporée jusqu'à cristallisation.

D'une autre part, on décompose du carbonate de baryte par de l'acide chlorhydrique concentré ; il se produit du chlorure de baryum qu'on fait évaporer, puis cristalliser. On prend 25 kilogr. de chromate alcalin et 20 kilogr. de chlorure de baryum. Les deux sels dissous séparément, dans une suffisante quantité d'eau, sont ensuite mélangés en agitant sans discontinuer. Il se précipite du chromate de baryte d'un beau jaune citron, qu'on lave par décantation avec de l'eau tiède. Le produit, parfaitement égoutté, est jeté sur une toile serrée et enfin séché à l'étuve.

Si au lieu d'opérer à la température ordinaire, on mélange les solutions chauffées à $100°+0$, le chromate de baryte acquiert une teinte jaune plus prononcée et une densité plus grande.

C'est une couleur peu vénéneuse et très-solide.

SULFATE DE PLOMB BASIQUE.

Dans le commerce de la droguerie, on donne quelquefois pour du jaune minéral du sous-sulfate de plomb, qu'on obtient en chauffant le sulfate de plomb, provenant

des fabriques d'indiennes, avec son poids de litharge. Lorsque la matière est à l'état de fusion tranquille, on la coule sur une table de marbre et on la pulvérise.

Cette couleur, que les auteurs décrivent sous le nom de *jaune paille minéral*, possède une teinte jaune assez belle. Outre qu'elle est très-solide, elle couvre parfaitement bien ; mais comme la plupart des composés plombiques, elle noircit au contact des émanations sulphydriques, et est assez vénéneuse.

Sa composition chimique, lorsqu'elle est très-pure, s'exprime par

$$\underbrace{SO^3\, PbO}_{\text{Sulfate de plomb.}} + \underbrace{PbO}_{\text{Oxyde de plomb.}}$$

Mais toute celle du commerce contient une plus grande proportion d'oxyde de plomb. Aussi sa teinte est-elle très-variable, ainsi que sa composition.

TURBITH MINÉRAL.

Le produit que les peintres emploient sous les noms de *jaune minéral*, de *turbith minéral*, est du sous-sulfate de mercure qui s'exprime ainsi :

$$\underbrace{SO^3}_{\text{Acide sulfurique.}} \quad \underbrace{3\,(Hg\,O)}_{\text{Oxyde de mercure.}}$$

Voici comment on l'obtient.
On prend :

 Mercure métallique.... 1,000 grammes.
 Acide sulfurique à 66°. 2,000 »

On met ces substances dans une cornue de grès qu'on

place dans un fourneau à réverbère, puis on chauffe. Pendant tout le temps que dure l'opération, il se dégage de l'acide sulfureux provenant de la décomposition d'une partie de l'acide sulfurique. Lorsque la réaction est achevée, on brise la cornue, et on trouve une masse blanche sèche de sulfate acide de mercure qu'on délaye dans de l'eau bouillante. Par suite de la décomposition qui s'opère, la matière prend une teinte jaune ; on la lave à plusieurs reprises avec de l'eau chaude, et lorsque celle-ci ne présente plus de réaction acide au papier de tournesol, on recueille le précipité qu'on fait sécher à une basse température.

Le jaune minéral se présente sous la forme d'une poudre d'un beau jaune citron, insoluble dans l'eau, l'alcool, et l'éther. Son emploi paraît être actuellement très-restreint ; en effet, s'il possède un ton assez riche, et s'il couvre assez bien, il ne paraît pas doué d'une longue conservation, principalement lorsqu'il est exposé dans des endroits où des gaz méphitiques se dégagent ; mais mélangé avec d'autres couleurs, il donne, dans certains cas, des résultats très-satisfaisants.

Broyé avec du bleu de Prusse, il donne des verts magnifiques ; il est assez vénéneux.

Nous avons montré ailleurs (1) qu'en faisant évaporer une solution aussi peu acide que possible de sulfate de bioxyde de mercure, on obtenait après le refroidissement des cristaux rhomboédriques transparents d'un très-beau jaune. Nous nous demandons si sous cette forme il ne

(1) *Recherches sur les sulfates de mercure.*

posséderait pas, comme le rouge d'iode de Heller que nous décrirons plus loin, la propriété de se conserver plus longtemps à l'air sans altération ?

ARSÉNITE DE PLOMB.

Quelques peintres remplacent l'orpiment par l'arsénite de plomb, substance d'un jaune très-riche et très-solide, qui a pour composition chimique :

$$\underbrace{AsO^3}_{\text{Acide arsénieux.}} + \underbrace{_2 PbO}_{\text{Oxyde de plomb.}}$$

On l'obtient de la manière suivante :

On fait un mélange très-intime de 10 parties d'acide arsénieux avec 7 parties de litharge qu'on met dans un creuset, et enfin dans un fourneau à réverbère placé sous la hotte d'une cheminée tirant parfaitement; on chauffe au rouge, et lorsque la matière est en fusion tranquille, on la coule sur une table de marbre ; après le refroidissement, on la réduit en poudre fine.

La quantité d'acide arsénieux et d'oxyde de plomb que nous donnons est suffisante pour obtenir un arsénite d'une très-grande beauté. Si on ajoute une plus grande proportion de litharge, il se forme de l'arsénite de plomb basique, qui possède une teinte jaune rougeâtre d'autant plus prononcée que l'action de la chaleur a été plus longtemps prolongée, et que la dose de litharge est plus forte.

L'arsénite de plomb est une couleur qui couvre parfaitement bien, mais très-vénéneuse.

JAUNE DE NAPLES.

Jusque dans ces derniers temps, la composition chimique du jaune de Naples était inconnue ; c'est à M. Brunner, de Berne, que l'on doit de savoir que ce produit résulte de la combinaison de l'acide antimonique avec l'oxyde de plomb en proportions diverses.

Il a été découvert à Naples vers le milieu du siècle dernier. Le premier auteur qui en parle est Fougeroux de Bauderoy : voici comment il conseille de le préparer.

« Mélangez ensemble 12 parties de céruse, 3 d'antimo-
« niate de potasse (antimoine diaphorétique), 1 de sel am-
« moniac et 1 d'alun ; broyez le tout ensemble et chauffez
« dans un creuset, d'abord faiblement, puis au rouge pen-
« dant trois heures. »

Depuis cette époque, il n'a pas été donné moins de dix à douze procédés, qui consistent tous à calciner l'antimoine libre ou combiné avec le plomb métallique, oxydé ou carbonaté.

Ainsi, on l'obtient :

1° En fondant à une température aussi basse que possible 3 parties de massicot et 1 partie d'oxyde d'antimoine ;

2° En fondant 2 parties de minium, 3 parties d'antimoine métallique réduit en poudre et 1 partie de calamine ;

3° 5 à 6 parties de plomb, 2 à 4 parties d'antimoine et 1 partie de sel de tartre (carbonate de potasse) ;

4° 16 parties de plomb, 16 parties d'antimoine, 2 parties de sel de tartre et 1 partie de sel marin ;

5° 12 parties de blanc de plomb, 3 parties d'antimo-

niate de potasse, 1 partie d'alun et 1 partie de sel ammoniac (ce procédé est attribué à Fougeroux);

6° 5 parties de litharge, 2 parties d'antimoniate de potasse et 1 partie de sel ammoniac;

7° 2 parties de minium et 1 partie d'antimoniate de potasse (procédé Guimet);

8° M. Brunner, qui a fait un grand nombre d'expériences à cet égard, s'est arrêté au suivant, comme fournissant le produit le plus beau.

On mélange très-intimement une partie de tartrate de potasse et d'antimoine ou émétique, purifié par des cristallisations répétées, avec 2 parties de nitrate de plomb exempt de fer et de cuivre; on y ajoute ensuite 4 parties de sel marin, et on forme ainsi un mélange exact et homogène. On calcine doucement dans un creuset de Hesse jusqu'à la fusion. Après le refroidissement, la masse se détache facilement lorsqu'on frappe extérieurement sur le creuset renversé; on la broie et on l'épuise par l'eau pour enlever tout le sel marin qui forme à la partie supérieure une couche fondue. Dans cette opération, le sel marin n'agit que comme corps auxiliaire, en ce qu'il évite la réduction du sel d'antimoine.

Toute la réussite de cette préparation réside dans la conduite du feu; ainsi, une chaleur trop forte l'altère complétement; mais lorsqu'on retire le creuset en temps opportun, le jaune de Naples qu'on obtient est toujours très-beau. Disons aussi que la beauté de cette couleur repose beaucoup sur un certain degré de saturation qu'on n'a pas encore déterminé. L'antimoniate de plomb n'est pas à l'état neutre; il contient toujours un excès d'oxyde

de plomb qui paraît tantôt nuisible, tantôt nécessaire à sa formation. Si on suppose qu'il y a un grand excès d'oxyde, on le traite par l'acide hydrochlorique qui l'avive plus ou moins, en formant du chlorure de plomb soluble qu'on enlève par des lavages réitérés à l'eau froide.

Le jaune de Naples fournit à la peinture des tons jaunes très-riches et très-solides ; mais il doit être broyé pour cela sur une table de porphyre et ramassé avec un couteau d'ivoire ; le fer et la pierre lui faisant prendre assez rapidement une teinte verte désagréable. On l'emploie surtout pour imiter le ton de l'or; mélangé avec le blanc de plomb et un peu de vermillon, il fournit la nuance chamois.

C'est une couleur peu vénéneuse, qui ne noircit pas à l'air, et qui couvre assez bien.

JAUNE BOUTON-D'OR.

MM. Leclaire et Barruel, qui ont entrepris en commun un grand nombre d'expériences pour remplacer l'oxyde de plomb par l'oxyde de zinc dans tous les produits chimiques employés en peinture, ont remarqué que le chromate de zinc, préparé dans de certaines conditions, remplaçait avec avantage le chromate de plomb (jaune de chrome).

Le chromate de zinc chimiquement pur, se formule ainsi :

$$\underbrace{CrO^3}_{\text{Acide chromique.}} + \underbrace{ZnO}_{\text{Oxyde de zinc.}}$$

Cette couleur, à laquelle MM. Leclaire et Barruel ont donné le nom de *jaune bouton-d'or*, s'obtient de deux manières différentes :

1° On commence par préparer du chromate de potasse et de soude en saturant du bichromate de potasse par du carbonate de soude. D'une autre part, on prend du sulfate de zinc aussi neutre que possible; on le fait dissoudre dans de l'eau avec une petite quantité d'oxyde de zinc; on arrive par ce moyen à dépouiller le sel de zinc de l'oxyde de fer qu'il contient toujours (1).

Les deux liqueurs filtrées séparément sont mélangées, puis brassées à plusieurs reprises. On obtient un précipité abondant de chromate de zinc; on lave par décantation, on fait égoutter sur une toile, et lorsqu'il est en consistance convenable, on en forme des pains qu'on fait sécher à l'étuve.

2° Le second procédé consiste à saturer directement l'acide du bichromate de potasse par l'oxyde de zinc. Pour cela, on prend :

Bichromate de potasse....... 10 kilogr.
Oxyde de zinc privé de fer..... 40 »

On fait dissoudre le bichromate de potasse dans de l'eau; d'une autre part, on délaye l'oxyde de zinc dans la plus petite quantité d'eau possible; on mélange, puis on fait bouillir le tout jusqu'à ce que le précipité ait acquis

(1) Avant de faire le mélange des liqueurs, il est indispensable de s'assurer que tout l'oxyde de fer a été déplacé par l'oxyde de zinc; pour cela, on verse dans la solution de sulfate de zinc un peu de cyanure jaune de potassium et de fer, qui ne doit donner lieu à aucune coloration.

la teinte jaune désirée ; on recueille le précipité ; on lave et on fait sécher ainsi que nous venons de le dire.

Comme les liqueurs qui proviennent de cette opération contiennent encore une grande quantité de sel de chrome, on les traite par du sulfate de zinc, qui donnera du chromate de zinc jaune paille. Enfin, les premières eaux-mères de cette seconde opération sont évaporées jusqu'à siccité, et le résidu est calciné dans un creuset de terre avec de la fleur de soufre ; il se produit du sulfure de potasse soluble et de l'oxyde vert de chrome insoluble.

Le chromate de zinc, pour lequel on a pris un brevet, forme une couleur très-belle qui s'allie bien aux autres produits employés dans la peinture à l'huile ; il couvre parfaitement, et jouit de toutes les propriétés du blanc de zinc ; il mérite, sous tous les rapports, de remplacer le jaune de chrome qui noircit assez rapidement à l'air.

JAUNE DE CHROME.

Dans son état le plus pur, le *jaune de chrome*, dont la découverte est due à Vauquelin, résulte de la combinaison de l'acide chromique avec l'oxyde de plomb, à équivalents égaux. Sa formule chimique est :

$$\underbrace{CrO^3}_{\text{Acide chromique.}} + \underbrace{PbO}_{\text{Oxide de plomb.}}$$

On l'obtient toutes les fois qu'on mélange un chromate alcalin (chromate de potasse et de soude) avec un sel de plomb neutre (acétate ou nitrate). Le précipité qui prend naissance se présente sous la forme de lamelles très-

brillantes et excessivement fines, qui se déroulent en tous sens dans la liqueur. Lorsqu'il est sec, il est en poudre impalpable, d'un jaune éclatant et couvrant parfaitement bien.

Mais ce composé n'existe pas dans le commerce ; tout celui que les peintres emploient n'est qu'un mélange de chromate de plomb, de chromates de chaux et de baryte, et de sulfate de plomb. Pour les qualités inférieures, on ajoute une certaine quantité d'alumine qui, d'après M. Mérimée, leur fait conserver beaucoup plus longtemps leur brillant.

Chaque fabricant possède une recette particulière pour la préparation du jaune de chrome ; aussi est-il difficile de trouver dans le commerce de détail deux échantillons qui possèdent exactement la même teinte, la même densité, et enfin la même composition. Dans le moment actuel, la variété la plus belle et la plus recherchée porte le nom de jaune de chrome Spooner, qui forme lui-même six numéros particuliers, et possédant des teintes qui varient depuis le jaune clair jusqu'au jaune orangé.

Pour obtenir cette couleur parfaitement neutre, et d'une teinte très-riche, voici comment on opère :

On prépare une dissolution de chromate neutre de potasse en faisant dissoudre 10 kilogr. de sel dans 100 litres d'eau chaude. D'une autre part, on fait une dissolution, également à chaud, de 20 kilogr. d'acétate de plomb neutre dans 50 litres d'eau.

Lorsque la solution de chromate est en pleine ébullition, on y verse celle d'acétate, après quoi on laisse déposer. Le précipité est lavé à plusieurs reprises par dé-

cantation, puis recueilli et égoutté jusqu'en consistance de pâte ferme ; on en forme des pains qu'on dessèche dans une étuve. Quelques fabricants remplacent l'acétate par le nitrate de plomb ; ils prétendent que le chromate possède une teinte jaune plus vive. En effet, si l'acétate de plomb se trouve en léger excès par rapport au chromate, il se forme du chromate basique de plomb, qui change la belle teinte jaune clair du chromate neutre. On évite ce désagrément en ajoutant un petit excès de chromate de potasse ; le produit qu'on obtient alors ne le cède en rien à celui préparé avec le nitrate de plomb.

M. Liébig conseille, pour obtenir du jaune de chrome aussi lourd que la céruse, le moyen suivant :

On prend du sulfate de plomb humide, provenant des teintureries ; on le fait digérer à froid, ou mieux à chaud, avec une solution de chromate neutre de potasse ; on agite de temps à autre : après quelques instants de contact, il se forme du sulfate de potasse soluble et du chromate de plomb insoluble ; on lave par décantation, on fait égoutter, et lorsque le précipité est en consistance convenable, on en forme des pains oblongs que l'on fait sécher dans une étuve, à 50°.

Ce chromate contient toujours, quel que soit le temps pendant lequel la digestion a eu lieu, une certaine quantité de sulfate de plomb qui a échappé à la décomposition et qui explique jusqu'à un certain point sa grande densité, mais sa teinte n'en est pas moins très-belle ; il couvre parfaitement, et enfin revient à un prix peu élevé.

Tout ce que nous venons de dire se rapporte au jaune de chrome neutre, dont la nuance est jaune citron ; celui

qui possède une teinte jaune rougeâtre, et que pour cela on désigne sous le nom de *jaune-d'or* ou *pâle orange*, s'obtient d'une manière particulière, et a une composition chimique un peu différente.

En effet, l'acide chromique et l'oxyde de plomb, combinés en diverses proportions, donnent des composés basiques qui possèdent des teintes jaunes rougeâtres assez belles lorsqu'ils sont déshydratés. Ainsi, en traitant trois parties de chromate de plomb neutre avec deux parties d'oxyde de plomb, ou bien en versant du nitrate de plomb dans une dissolution de chromate de potasse contenant un excès de potasse ou de soude caustique, et chauffant à une température élevée, il se produit des précipités qui ont quelque ressemblance avec le vermillon.

Voici les autres procédés que l'on connaît :

1° On fait bouillir pendant quelques heures des poids égaux de céruse et de chromate de potasse. Par suite de la double décomposition qui s'opère, il se forme du carbonate de potasse soluble et du chromate de plomb basique, sous forme d'une poudre pesante d'un beau jaune rougeâtre, que l'on chauffe dans un creuset, jusqu'à ce qu'on ait obtenu la nuance écarlate.

2° MM. Liébig et Woëhler font fondre, dans un creuset de terre, une certaine quantité de sel de nitre, puis y ajoutent par petites portions du chromate de plomb parfaitement sec et réduit en poudre fine. Il se dégage d'abondantes vapeurs nitreuses qu'on fait rendre sous la hotte d'une cheminée, et il se produit du chromate de potasse et du chromate de plomb basique ; celui-ci gagne le fond du creuset, tandis que le sel de potasse vient for-

mer à la surface une couche plus ou moins épaisse, qu'on décante lorsqu'elle est encore liquide. On laisse refroidir, et on lessive avec de l'eau qu'on renouvelle souvent. Le sel de plomb reste sous la forme d'une poudre d'un rouge cinabre magnifique ; on le recueille sur une toile, et on le fait sécher à l'étuve.

3° Mais de tous les procédés, celui qui est le plus économique et qui fournit un produit non moins beau, se pratique de la manière suivante :

On fait bouillir, pendant une heure ou une heure et demie, 15 parties de chromate de plomb avec 2 parties de chaux caustique, préalablement délitée et délayée dans une petite quantité d'eau. Il se forme du chromate de chaux soluble et du chromate basique de plomb, qui est lavé, recueilli et séché, et enfin calciné comme nous l'avons déjà dit.

Le jaune de chrome jonquille du docteur Winterfeld est du jaune de chrome basique qui n'a pas subi la calcination. L'oxyde de plomb, qui le constitue à l'état basique, est hydraté, souvent même carbonaté, tandis que dans les précédents il est anhydre. On le prépare ainsi :

On fait une dissolution filtrée de 33 parties d'acétate de plomb neutre dans 100 parties d'eau pure.

D'une autre part, on dissout 22 parties de carbonate de soude dans 60 parties d'eau pure, et on filtre.

On met dans une grande cuve la dissolution d'acétate, on y verse peu à peu, et en agitant continuellement, la solution de carbonate. On obtient au contact des deux liqueurs un précipité blanc, volumineux, de carbonate de plomb ou céruse ; on laisse déposer, on décante le liquide

surnageant, on lave le dépôt à froid, jusqu'à ce que les eaux qui en sortent n'aient plus de saveur.

Pendant que cette opération s'exécute, on fait dissoudre dans 50 parties d'eau 17 parties de chromate neutre de potasse qu'on verse dans la cuve contenant le précipité de carbonate de plomb, sous forme d'une masse pâteuse. On agite à plusieurs reprises, et lorsque le liquide qui surnage est tout à fait incolore, on le soutire ; on lave le précipité à plusieurs eaux, puis on le jette sur un filtre pour le faire égoutter; on le met à la presse, et on en forme des pains cubiques qu'on fait sécher à l'étuve.

Cette couleur possède une teinte d'autant plus pâle qu'on a ajouté une plus grande quantité d'acétate de plomb.

Les chromates de plomb avec excès de base, et auxquels on ne peut assigner des formules particulières, existent dans le commerce sous une foule de variétés ; leurs teintes varient depuis le jaune rougeâtre jusqu'au rouge vermillon. Ils contiennent presque toujours du sulfate de plomb, et souvent des chromates de chaux et de baryte, de l'alumine et de la silice.

Uni au sulfate de chaux et au sulfate de plomb, le jaune de chrome proprement dit forme la couleur dite *jaune de Cologne*, que l'on rencontre le plus souvent dans le commerce sous forme de trochisques.

M. Boutron, qui l'a analysée, la trouva composée ainsi :

 Sulfate de chaux.... 60 parties.
 Sulfate de plomb.... 15 »
 Chromate de plomb. 25 »
 ─────
 100

Ce chimiste dit qu'on peut l'obtenir en décomposant du sulfate de chaux et du chromate de plomb par une solution de sulfate de soude; ou bien encore en délayant du sulfate de chaux en poudre très-fine dans une solution de chromate de potasse, et précipitant par l'acétate neutre de plomb.

Cette couleur est employée pour la peinture en détrempe; à un grand éclat, elle joint une grande solidité.

Le jaune de chrome est d'un emploi journalier dans la peinture à l'huile, principalement pour les équipages; il entre dans la fabrication des papiers peints et des vernis colorés. Mélangé au vermillon, il donne la teinte chamois; à la céruse, le jaune paille et le jaune jonquille.

Le jaune de chrome basique est surtout employé pour les teintes orange et jaune d'or.

Ces trois espèces de couleurs couvrent très-bien, et conservent pendant longtemps leurs teintes; elles sont vénéneuses au même titre que tous les composés plombiques.

Les qualités essentielles des jaunes de chrome sont: 1° d'être denses; 2° d'avoir une belle teinte jaune; 3° de haper le moins possible à la langue; 4° enfin d'être doux au toucher.

Les substances étrangères (sulfate de chaux, sulfate de plomb, alumine, amidon, céruse, craie) que l'on trouve dans le jaune de chrome n'y sont pas toujours ajoutées dans le but de le falsifier, mais bien pour l'approprier aux usages auxquels on le destine: ainsi, le chromate de plomb parfaitement pur, qui donne des résultats très-satisfaisants pour la peinture à l'huile, ne pourrait servir pour la

peinture à l'eau. Dans ce dernier cas, l'addition du sulfate de chaux et de l'alumine devient indispensable; sans cela la couleur manque de corps.

Comme il se peut qu'on ait besoin de reconnaître dans cette couleur les sulfates de baryte, de chaux et de plomb, voici le procédé qu'on suit pour cela :

Le jaune de chrome neutre ou basique se dissout, sans résidu appréciable, dans les acides nitrique et chlorhydrique bouillants; un précipité quelconque indique d'une manière certaine la présence du sulfate de baryte sur lequel tous les acides sont sans action; et si dans la liqueur acide le chlorure de baryum fait naître un précipité blanc, on peut être certain qu'il y avait du sulfate de chaux ou du sulfate de plomb. Il ne s'agit plus maintenant que de distinguer ces deux sels.

Le jaune de chrome suspect, mélangé avec de l'acide chlorhydrique ordinaire et une petite quantité d'alcool, donne une liqueur verte qui consiste en chlorure de chrome soluble, et en un précipité blanc de chlorure de plomb, et de sulfates de chaux et de baryte.

Ce dépôt mixte est mis à bouillir dans un matras avec une solution concentrée de carbonate de soude : il se forme du chlorure de sodium et du sulfate de soude solubles, et un précipité de carbonate de plomb et de carbonate de chaux. Ce dépôt, dissous de nouveau dans l'acide chlorhydrique, et la solution traitée par un excès d'alcali volatil, abandonne de l'oxyde de plomb parfaitement reconnaissable à ses caractères, tandis que la liqueur surnageante dans laquelle on verse de l'ammoniaque précipite de l'oxalate de chaux.

L'amidon, que l'on trouve quelquefois dans le jaune de chrome commun, est facile à reconnaître au moyen de la teinture d'iode qui le colore en bleu violet.

Enfin, les carbonates de chaux et de plomb se décèleront au moyen de l'acide nitrique, qui donne d'abord lieu à une effervescence de gaz acide carbonique ; puis à une solution de laquelle l'hydrogène sulfuré précipite du sulfure de plomb noir ; la liqueur qui surnage, filtrée et saturée par de l'ammoniaque liquide, donne avec l'oxalate d'ammoniaque de l'oxalate de chaux.

STIL DE GRAIN.

Les Hollandais passent généralement pour être les inventeurs des différentes espèces de laques.

Lorsque la préparation de ces couleurs était encore à l'état de secret, on les désignait toutes sous le nom de stil de grain ; ainsi, on avait le stil de grain de graine d'Avignon, de gaude, de baies de nerprun (vert de vessie), de feuilles de bouleau, de châtaignier rose, etc. ; mais, depuis, l'usage a consacré d'une manière exclusive le nom de stil de grain à la laque du nerprun des teinturiers, ou graine d'Avignon.

Avant de faire connaître le stil de grain, nous allons exposer en vertu de quelle réaction les matières colorantes végétales se fixent sur les substances minérales, qui font l'office de corps précipitants, et les caractères généraux qui appartiennent aux laques.

La plupart des principes colorants provenant du règne végétal et du règne animal possèdent la propriété, lors-

qu'ils sont en dissolution ou en suspension dans l'eau, d'être précipités par les oxydes métalliques, avec lesquels ils contractent des combinaisons particulières insolubles désignées dans les arts sous le nom de *laque*.

Les laques contiennent la matière colorante primitive modifiée d'une manière quelquefois très-différente ; ainsi, la décoction rouge de cochenille vire au rouge violet, et la décoction rouge et brunâtre de garance prend une teinte rouge cramoisi lorsqu'on les met l'une et l'autre au contact des alcalis et des oxydes métalliques.

La force d'affinité qui unit ces principes colorants aux oxydes métalliques est très-grande ; à ce sujet, les auteurs se sont demandé à quel genre de combinaison on devait rattacher les laques.

On pense généralement que la matière colorante proprement dite contracte avec l'oxyde, par le fait seul de l'affinité capillaire, une véritable combinaison qui présente, sous l'influence des réactifs chimiques (eau, acides, alcalis), tous les caractères d'une combinaison intime plutôt que d'un mélange. M. Preisser, allant encore plus loin, a émis l'idée, dans ces derniers temps, que les laques pouvaient être considérées comme de véritables sels en proportions constantes.

Les laques sont presque toujours à base d'alumine ; quelquefois, cependant, elles contiennent des oxydes de plomb, d'étain, de la chaux et de la magnésie. L'alumine possède, par-dessus tous ces derniers, la propriété de précipiter la matière colorante de leurs dissolutions.

Au dire des historiens, ces couleurs sont connues depuis une époque très-éloignée de nous ; mais on ignore de

quelle manière on les préparait. On suppose qu'il en existait de plusieurs espèces et de plusieurs qualités ; car quelques-unes ont conservé une richesse de ton que l'on retrouve seulement dans les belles couleurs métalliques ; telles sont celles qui ornent les gabarres des momies égyptiennes. D'autres, au contraire, étaient obtenues avec des matières colorantes très-peu solides ; aussi ont-elles perdu la plus grande partie de leur brillant ; de ce nombre sont celles qui ont servi à peindre les fresques du Vatican.

On peut dire d'une manière générale que les laques sont loin de constituer des couleurs solides. Toutes subissent, à des degrés différents, de la part des rayons lumineux et solaires des altérations profondes. Aussi ne conviennent-elles pas à tous les genres de peinture, comme le bâtiment et le tableau ; mais pour la miniature et certaines décorations, elles fournissent, par la richesse de leurs teintes, des résultats qu'on retrouve difficilement ailleurs. Elles ont encore le grave défaut de manquer de corps. C'est pourquoi, dans la plupart, on ajoute, pendant leur préparation, soit de l'amidon, soit de la gomme arabique ; on peut d'autant moins obvier à cet inconvénient, qu'elles ne peuvent être mélangées avec la plus grande partie des couleurs minérales, qui les altèrent presque toutes.

Avant de décrire la préparation de chaque laque en particulier, nous indiquerons les conditions essentielles pour obtenir des produits très-beaux.

Les substances qu'on se propose de traiter doivent être de première qualité et parfaitement sèches ; on les réduit

en poudre aussi ténue que possible, et on les fait bouillir dans un vase étamé avec de l'eau bien pure. La décoction, chargée de tout le principe colorant, est clarifiée soit par la filtration, soit par tout autre moyen.

Les corps précipitants (alun, alumine, acétate de plomb, protochlorure d'étain, etc.) (1), ne doivent pas contenir de fer ou d'alcalis susceptibles de faire changer la couleur qu'on désire obtenir. Il faut verser, toutes les fois qu'on le peut, l'excipient ou la liqueur qui doit mettre l'oxyde en liberté dans la liqueur bouillante. Ce *modus faciendi* procure des avantages incontestables ; ainsi, le précipité étant moins volumineux, devient plus facile à laver, et la matière colorante étant dispersée dans une masse moins grande, fournit une laque dont la teinte est toujours plus foncée que lorsqu'on opère avec des liqueurs froides.

Les lavages se font le plus ordinairement par décantation et avec de l'eau chaude, privée autant que possible de sels de chaux.

On recueille le précipité sur une toile serrée ou sur du papier joseph posé à plat sur une toile, placée elle-même sur un carré de bois. Lorsqu'il est en consistance pâteuse, on l'introduit dans un entonnoir de fer-blanc, ou mieux de verre, dont l'extrémité effilée traverse une planchette. Chaque secousse qu'on imprime à cet appareil en détache une petite masse qu'on reçoit sur une feuille de papier joseph.

(1) L'oxyde d'étain n'entre guère que dans la composition de la laque de cochenille. Outre qu'il fait l'office d'excipient, il sert encore à développer une belle et riche teinte.

La température à laquelle on fait sécher les trochisques n'est pas indifférente. C'est toujours à l'air libre et à l'ombre, ou bien dans une étuve modérément chauffée qu'on doit les priver de leur eau.

Quelquefois, on fait subir aux différentes espèces de laques un commencement de torréfaction, qui a pour but de détruire la matière colorante primitive et de leur communiquer une teinte brunâtre. Ces couleurs, auxquelles on donne le nom de laques brûlées, tendent de plus en plus à disparaître de l'atelier du peintre. Cependant, au dire de certains artistes, elles possèdent une assez grande solidité.

Voici comment on prépare ces dernières.

Dans une cuiller de fer, chauffée au rouge naissant, on verse par petites portions et en remuant sans cesse, de la laque réduite en poudre fine. Lorsqu'elle a acquis la teinte désirée, on la retire du feu pour l'employer dans cet état.

Revenons maintenant au stil de grain.

Le nerprun des teinturiers (*rhamnus infectorius*) croît dans le midi de la France et de l'Europe, et contient une matière colorante jaune, la rhamnine, qui prend une teinte jaune foncé avec l'alun, et brune jaunâtre avec les carbonates alcalins.

D'autres espèces de nerpruns qui croissent en Orient, produisent encore des graines jaunes, connues sous le nom de *graine* de *Perse*, d'*Andrinople*, de *Turquie* et de *Morée;* celles-ci contiennent des quantités plus considérables de principe colorant; mais le prix élevé auquel le commerce les livre, fait que l'on préfère la

graine du nerprun qui croît en France, à Avignon, en Espagne et en Italie.

Le stil de grain se prépare de la manière suivante :

Les fruits de nerprun, cueillis un peu avant leur complète maturité, sont écrasés, puis placés dans une chaudière avec 4 ou 5 parties d'eau pure et 1/5ᵉ d'alun. Après une demi-heure d'ébullition, on obtient une liqueur jaunâtre que l'on filtre. Pendant cette opération, on délaye, dans une petite quantité d'eau, 1/2 à 3/4 de craie très-blanche. On sépare, à l'aide d'un tamis, les parties grossières, et on verse la bouillie qui en résulte dans la décoction. On agite à plusieurs reprises, puis on abandonne au repos à l'air pendant une journée. On décante le liquide, et le précipité lavé est mis à égoutter sur une toile tendue à l'aide d'un châssis de bois. Lorsqu'il est en consistance convenable, on en forme des trochisques qu'on fait sécher à une basse température et à l'ombre.

Le stil de grain, préparé exclusivement avec la graine d'Avignon, est assez rare dans le commerce. Le plus souvent on donne, sous ce nom, une laque que l'on obtient en faisant bouillir des proportions très-variables de gaude, de quercitron, de carthame, de curcuma, de bois jaune, etc., en ajoutant dans la décoction de l'alun, de la potasse et de la craie, jusqu'à ce que tout le principe colorant soit précipité.

Le stil de grain possède une teinte jaune très-belle, on l'emploie pour peindre les parquets et les décors de théâtre ; mais il ne jouit pas d'une grande solidité : il n'est pas vénéneux.

LAQUE DE GAUDE.

Les feuilles, les tiges et les semences de gaude (*reseda luteola*) contiennent entre autres principes colorants, une matière jaune pâle, à laquelle M. Chevreul a donné le nom de lutéoline.

Cette matière colorante réside en plus grande quantité dans l'extrémité supérieure des tiges que dans les racines ; elle est la couleur jaune la plus solide et la plus brillante, et enfin la moins susceptible de s'altérer au contact de l'air et de l'humidité.

La lutéoline est entièrement soluble dans l'eau ; elle prend, sous l'influence des alcalis, potasse, soude, ammoniaque, chaux, baryte, une couleur jaune foncé très-belle.

La laque de gaude est une combinaison de lutéoline et d'alumine pure ; ou bien de chaux, de lutéoline et d'alumine. Voici comment on l'obtient dans le premier cas :

Les sommités de gaude, cueillies au moment de la floraison, époque à laquelle elles contiennent le plus de matière colorante, sont desséchées en plein air, et hachées ou mieux contusées grossièrement. On les place dans un grand vase vernissé, avec une quantité d'eau suffisante pour qu'elles baignent entièrement, et un poids d'alun égal à celui de la gaude ; puis on soumet le tout, pendant un quart d'heure environ, à une température de 70 à 80°$+$0 ; on filtre la liqueur chaude et l'on y verse immédiatement et peu à peu une solution de carbonate de potasse (sel de tartre), jusqu'à ce qu'il ne se dégage plus d'acide

carbonique; le précipité lavé par décantation avec de l'eau chaude, est recueilli sur des filtres posés à plat sur des châssis de toile; lorsqu'il est en consistance pâteuse, on en forme des trochisques qu'on fait sécher à une basse température.

Deux industriels anglais, Colard et Farber, ont conseillé de préparer la laque de gaude par le procédé suivant :

Les tiges, les feuilles et les semences de gaude sont placées dans une grande chaudière de cuivre, les sommités en bas, avec une certaine quantité d'eau; on fait bouillir pendant un quart d'heure, et après avoir sorti la plante de la chaudière, on la fait égoutter sur une claie d'osier. La liqueur qui en découle est recueillie dans une cuve en bois, filtrée, puis réunie à celle de la chaudière. On obtient de la sorte une décoction jaune verdâtre que l'on traite ensuite par le mélange suivant :

On se procure de la craie parfaitement blanche et ne contenant pas d'oxyde ou de carbonate de fer, car la gaude contient du tannin, qui communiquerait au produit une teinte jaune brunâtre; après l'avoir dépouillée par décantation de toutes les matières étrangères qu'elle peut contenir, on la délaye dans son poids d'eau, puis on la fait bouillir pendant quelques minutes; lorsque la craie est parfaitement délayée, on y ajoute 1/5ᵉ de son poids d'alun réduit en poudre et complètement privé de fer; il s'opère une décomposition qui a pour but de former du sulfate de chaux et de l'alumine en gelée, en même temps qu'il se dégage de l'acide carbonique. Lorsque l'effervescence est achevée, et pendant que le mélange est encore chaud, on ajoute, par petites portions à la fois, la décoction de

gaude, jusqu'à ce que tout le principe colorant jaune soit précipité.

A l'aide d'un robinet placé à la partie inférieure de la chaudière, on transvase la matière dans une cuve en bois, et on l'abandonne à elle-même pendant vingt-quatre heures; au bout de ce temps, on décante le liquide et on recueille le précipité sur des filtres ou bien sur des tables de craie qui absorbent l'eau très-rapidement. Lorsque la matière est en consistance pâteuse, on en forme des trochisques, qu'on livre au commerce après leur dessiccation à une basse température.

La France a été pendant très-longtemps tributaire de la Hollande pour la préparation de la belle laque de gaude.

Le commerce en forme deux espèces différentes : la laque surfine et la laque n° 1 ; elle est employée, assez rarement, il est vrai, dans la peinture à l'eau et à l'huile. Comme la plupart des matières colorantes végétales, elle ne jouit pas d'une très-grande solidité. Les fabricants de papiers peints sont ceux qui l'emploient en plus grande quantité; elle n'est pas vénéneuse.

GOMME-GUTTE.

Il existe sur la nature des végétaux qui produisent la gomme-gutte, un doute et une obscurité que les travaux d'hommes très-célèbres n'ont pu encore éclaircir.

Attribuée tour à tour à *l'esula indica*, au *garcinia cambogia*, au *stalagmitis cambogioïdes*, la gomme-gutte du commerce ou officinale proviendrait, d'après Graham, de *l'hebradendron cambogioïdes*, arbre qui

croît dans l'île de Ceylan, et d'après Kœnig, du *guttæfera vera*, qui croît à Camboge et à Ceylan.

Tout porte à croire que les différents végétaux que nous venons de nommer fournissent des sucs jaunes qui possèdent tous les caractères de la gomme-gutte ordinaire.

C'est de Camboge et de Siam, par la voie de Chine et de Singapore, que nous arrive toute celle employée dans les arts et la médecine.

Son nom, au dire de quelques voyageurs, lui viendrait de la manière de l'obtenir. A Siam, on brise les jeunes rameaux de l'arbre et on recueille *goutte à goutte* le suc qui s'écoule. A Ceylan, on pratique des incisions profondes à l'arbre, et on recueille, dans des chaumes de bambou, le suc qui s'écoule ; en se desséchant, il prend la forme cylindrique sous laquelle on le livre au commerce. Mais, d'après M. Robert Christison, auquel la science est redevable d'une très-bonne monographie sur cette substance, la gomme-gutte de Ceylan serait inconnue dans le commerce. Toute celle que nous possédons proviendrait de Siam, où on la prépare soit en brisant les jeunes rameaux, soit en faisant des incisions à l'écorce. Dans l'un comme dans l'autre cas, le suc recueilli est séché au soleil, et mis sous la forme de cylindres ou bien de gâteaux.

Ce qui ferait supposer cependant que ces sucs ne sont pas mélangés, c'est que la gomme-gutte en cylindre est toujours à un prix plus élevé, et est réellement plus belle que celle qui est en gâteaux. Il est probable que celle recueillie goutte à goutte des jeunes branches est mise sous

une forme particulière, et différente de celle qu'on obtient par les incisions du tronc de l'arbre.

La gomme-gutte possède les caractères suivants :

Masses cylindriques opaques, brunes jaunâtres à l'extérieur, rouges orangées à l'intérieur ; très-dures, fragiles, brillantes dans leur cassure ; la poudre est d'un jaune très-riche. Elle est inodore, et possède une saveur légèrement âcre ; insoluble dans l'eau, avec laquelle elle forme, à la manière des gommes résines, une véritable émulsion, et soluble en totalité dans l'alcool et en partie dans l'éther.

Cette couleur est composée en moyenne de 80 pour cent de résine, et 20 pour cent de gomme. On l'emploie principalement pour la peinture à l'aquarelle, la gouache et la miniature ; mais pour la peinture à l'huile, on lui reproche de n'avoir pas de corps, défaut qui provient de la gomme qu'elle contient.

On a souvent cherché à isoler la résine jaune pour la faire servir dans la peinture à l'huile ; on a conseillé de la traiter par l'éther, qui la dissout parfaitement bien, mais le prix élevé auquel elle revient ne permet pas de l'employer aussi souvent qu'on le désirerait.

Des expériences entreprises par nous à ce sujet, il résulte qu'au moyen de l'essence de térébenthine rectifiée, on parvient très-bien à dissoudre la résine sans toucher à la gomme. La solution soumise à la distillation, pour en retirer la plus grande partie de l'essence, puis évaporée jusqu'en consistance d'extrait à une douce température, donne une résine rouge hyacinthe lorsqu'elle est en masse, jaune vif lorsqu'elle est pulvérisée, et qui se délaye très-bien dans les huiles.

Nous avons quelque espoir qu'avec ce procédé on parviendra à obtenir la résine de gomme-gutte à un prix assez peu élevé pour que les artistes puissent l'employer dans la peinture à l'huile; outre qu'elle se conserve parfaitement à l'air, elle est très-peu vénéneuse, mais purgative à un haut degré.

LAQUE DE GOMME-GUTTE.

On trouve dans quelques traités de couleurs, la description d'une laque de gomme-gutte que l'on obtient de la manière suivante :

On prend 100 grammes de gomme-gutte qu'on réduit en poudre grossière ; on les fait macérer pendant vingt-quatre heures dans un vase de porcelaine, avec 3 ou 4 litres d'eau froide; puis on ajoute 200 grammes d'acide nitrique.

D'un autre côté, on dissout à chaud 1 kil. 200 grammes d'alun dans 6 litres d'eau ; on mélange les deux liqueurs ; on laisse déposer le précipité que l'on recueille ensuite sur un filtre, pour le laver et le sécher.

Il suffit d'étudier avec quelque attention la réaction qui s'opère dans ce cas-là, pour s'apercevoir que la formation d'une laque est impossible.

En effet, si l'on examine le dépôt qui s'est formé, on trouve qu'il ne contient pas d'alumine, et qu'il est formé uniquement de gomme-gutte. L'acide nitrique, en effet, ne précipite pas l'alumine de l'alun. Le liquide tient en suspension, pendant des mois entiers, de la poudre de gomme-gutte que l'on ne peut recueillir à l'aide du papier joseph, car elle passe à travers les pores du filtre.

Nous doutons donc que l'inventeur de cette couleur ait donné le véritable procédé à l'aide duquel il l'obtient. Il est vrai aussi de dire qu'elle est à peu près inconnue dans le commerce des couleurs.

CURCUMA.

Le curcuma, nommé encore *terra merita*, est la racine, ou mieux le rhizome de *l'amomum curcuma* ou du *curcuma tinctoria*, var. *longa*, de la famille des amomées.

Cette racine nous arrive sèche des Indes orientales, où elle sert comme assaisonnement ; elle est en tubercules cylindriques, durs, comme cornés, gris à l'extérieur, et jaune foncé à l'intérieur ; sa saveur et son odeur sont aromatiques et agréables ; elle donne une poudre jaune orangé.

Le curcuma contient entre autres principes immédiats, de la curcumine, substance neutre indifférente, d'un jaune très-beau, mais malheureusement peu solide ; on parvient à l'isoler au moyen de l'éther, qui le dissout entièrement sans toucher au reste.

On emploie quelquefois le curcuma pour la mise en couleur des parquets. Il fournit une teinte jaune orangé fort belle ; mais le plus ordinairement, on le mélange avec d'autres substances, comme le grain d'Avignon et le carthame qui, tout en rehaussant encore sa nuance, lui donnent une plus grande solidité.

JAUNE INDIEN.

Depuis une vingtaine d'années environ, on trouve dans

le commerce de la droguerie une matière colorante jaune sur l'origine de laquelle il règne encore quelque obscurité.

Cette substance, que l'on emploie quelquefois pour la peinture à l'aquarelle, nous vient de la Chine et de l'Inde. En Angleterre, elle porte le nom de *purree*, et en France, celui de *jaune indien*.

D'après quelques auteurs, le jaune indien serait l'extrait d'urine de buffle desséchée au soleil. L'odeur urineuse qu'elle répand permet de supposer qu'elle est d'origine animale ; mais d'après Erdman, il constituerait le dépôt de l'urine de chameaux qui ont été nourris avec les fruits du *mangostana mangifer*, dont le principe colorant est entraîné par l'urine et s'en dépose par l'évacuation. On recueille le dépôt, on le pétrit pendant qu'il est humide, de manière à lui donner la forme d'une masse ronde de la grosseur du poing ; on le fait sécher, puis on le livre au commerce.

On le trouve à l'état brut et lavé.

A l'état brut, il est en morceaux arrondis, du poids de 100 à 150 grammes, d'un vert brun à l'extérieur, et d'un jaune orangé très-riche à l'intérieur ; il exhale une odeur analogue à celle du castoréum ; l'eau froide le dissout en petite quantité ; l'alcool et l'éther sont sans action sur lui.

Lorsqu'il est lavé, il se présente sous la forme de morceaux plats légers, d'une épaisseur de 2 à 3 millimètres environ, et du poids de quelques décigrammes. Pour l'obtenir de la sorte, on réduit la matière en poudre et on l'épuise par l'eau bouillante ; dès que l'eau sort incolore,

on recueille la masse qu'on soumet à la presse, puis on la fait sécher à une basse température.

Le jaune indien lavé a une teinte jaune plus claire et plus riche que celui qui est brut.

D'après M. Stenhouse, ce produit serait une combinaison de magnésie avec un acide organique particulier, auquel il a donné le nom d'acide purréique ; il y a trouvé aussi de petites quantités de carbonates de potasse et de chaux, et du chlorure de potassium.

Le jaune indien ne vaut pas moins de 200 francs le kilogramme ; on le trouve assez souvent sophistiqué avec du jaune de chrome et d'autres matières colorantes jaunes.

D'après M. Haro fils, habile fabricant de couleurs à Paris, le jaune indien parfaitement pur brûle comme de l'amadou, en laissant un résidu peu considérable ; celui qui est falsifié brûle plus difficilement, en abandonnant un résidu dans lequel l'analyse décèle les matières minérales.

Il fournit à la peinture une couleur aussi belle que durable et nullement vénéneuse. Dans les Indes orientales, on l'emploie journellement pour la peinture commune ; mais il a le défaut de sécher lentement. Il est sans action sur l'économie animale.

CHAPITRE III

COULEURS ROUGES

MASSICOT, MINIUM, LITHARGE.

Le plomb métallique forme, avec l'oxygène, deux composés, un protoxyde qui a pour formule :

$$Pb\,O$$

Et un bioxyde qui se représente ainsi :

$$Pb\,O^2$$

Le protoxyde se présente sous deux aspects différents. Quand il est en poudre jaune, il porte le nom de massicot, et lorsqu'il est fondu, celui de litharge.

Le bioxyde de plomb ou oxyde puce de plomb, sera étudié ailleurs.

Le protoxyde et le bioxyde de plomb mélangés, ou plutôt combinés ensemble, constituent le minium.

Pour bien comprendre la formation de ces différents oxydes, il suffit d'examiner attentivement les changements que le plomb métallique fondu subit au contact de l'air.

MASSICOT.

Lorsque, dans un four à réverbère dont l'aire est concave, et sur les côtés duquel se trouvent deux foyers placés au niveau de cette aire, on maintient du plomb métallique à l'état de fusion, on observe qu'il perd son éclat métallique ; il se forme sur la surface une crasse grisâtre que les alchimistes appelaient *chaux grise* ou *cendres de plomb* ; cette matière ne tarde pas à changer de couleur et à prendre une teinte jaunâtre bien prononcée. Si on agite alors la matière avec un ringard, tout le métal se convertit en oxyde d'un beau jaune ; c'est le massicot, premier degré d'oxydation du métal, que la peinture emploie quelquefois pour les tons jaunes.

Cet oxyde a le grand défaut de n'avoir pas toujours une teinte uniforme, et d'être d'un jaune rougeâtre d'autant plus foncé que la chaleur a été plus prolongée.

MINIUM.

Pour préparer le minium, il suffit de pulvériser le massicot et de le chauffer de nouveau au rouge dans un four

à réverbère. Il se fait une nouvelle absorption d'oxygène, et une partie de protoxyde passe à l'état de bioxyde. C'est, ainsi que nous l'avons déjà dit, le mélange de ces deux oxydes qui forme le minium.

Chauffé à deux et trois reprises différentes, on obtient le minium à deux et trois feux, qui possède des teintes rouges très-riches.

Tel qu'il sort du four, le minium est en masse poreuse, peu cohérente; il donne, par la pulvérisation, une poudre rouge orangé très-éclatante.

Outre ce mode de fabrication, il en existe un autre non plus dispendieux et qui fournit un produit très-beau; nous voulons parler de la décomposition à une température élevée du carbonate de plomb ou céruse. Ce sel perd son acide carbonique et laisse pour résidu un oxyde de plomb auquel on réserve particulièrement le nom de *mine orange*.

Dans la mine orange comme dans le minium, le plomb se trouve à l'état de proto et de bioxyde. Plus la quantité de bioxyde est considérable, plus ils possèdent une teinte rouge foncé. D'après M. Dumas, le minium et la mine orange sont des combinaisons définies de 2 parties de protoxyde et de 1 partie de bioxyde; la mine orange devrait sa teinte particulière à une certaine quantité de carbonate de plomb qui a échappé à la décomposition. D'après Mulder, sa composition chimique se représente ainsi :

$$\underbrace{2(PbO)}_{\text{Protoxyde de plomb.}} + \underbrace{PbO^2}_{\text{Bioxyde de plomb.}}$$

Et en centièmes,

> Protoxyde de plomb. 73.
> Bioxyde de plomb... 25.
> Acide carbonique... 2.
> —
> 100.

La mine orange s'obtenait déjà du temps des Romains par la calcination de la céruse ; elle était employée comme fard.

LITHARGE.

Si l'on chauffe le minium jusqu'à la fusion, on remarque qu'il perd sa couleur rouge. Une partie de l'oxygène qu'il avait absorbé se dégage, et tout ce qui était à l'état de bioxyde passe à l'état de protoxyde fondu ou *litharge*.

La litharge qu'on trouve dans le commerce n'est pas préparée exprès ; presque toujours elle provient de la coupellation du plomb argentifère ou plomb d'œuvre.

La coupellation repose sur la propriété qu'a l'air d'oxyder le plomb à une haute température sans toucher à l'argent.

L'oxydation est produite par un courant d'air forcé que l'on projette à la surface du bain.

Cette opération se pratique dans des creusets ou coupelles fabriquées avec des os calcinés, que l'on chauffe à une très-haute température dans un fourneau à réverbère. Au fur et à mesure que le plomb s'oxyde, il vient former au-dessus du bain d'argent une couche liquide qui s'écoule par une échancrure pratiquée à la partie supérieure

du creuset. On le reçoit dans un bassin particulier, où il acquiert de l'opacité en se refroidissant, et se divise en lames micacées, qui ont la couleur et l'éclat métallique de l'or.

La litharge n'est pas de l'oxyde de plomb pur ; elle contient toujours de l'oxyde de fer, du minium, qui lui donnent une teinte rougeâtre, et presque toujours du cuivre. Il en existe deux sortes dans le commerce : la litharge d'Angleterre et la litharge d'Allemagne ; la première est toujours à un prix supérieur et plus recherchée que la seconde ; elle possède, en effet, une teinte plus belle et est plus pure que la litharge d'Allemagne.

Autrefois, on connaissait la litharge d'or ou rouge et la litharge d'argent ou jaune. On pensait que ces deux variétés contenaient, l'une de l'or, et l'autre de l'argent. Pendant longtemps, on a supposé que cette différence tenait à une proportion variable de minium qui s'est formé pendant l'écoulement et le refroidissement de la litharge. Il résulte des expériences de M. Leblanc que la litharge jaune et la litharge rouge possèdent la même composition chimique, mais qu'elles sont dans un état moléculaire différent. Il est certain que cet oxyde étant en fusion, tient, d'après M. Pernolet, directeur des mines de Poullaouen, du gaz en dissolution en proportion variable, suivant la période de l'opération, et que ce gaz tend à se dégager au moment de la solidification. Lorsqu'il est refroidi brusquement, il reste jaune, tandis que celui dont on diminue la vitesse de refroidissement et de solidification devient rouge.

Le massicot, le minium et la litharge sont quelquefois

falsifiés, dans le commerce de détail, avec du sulfate de baryte, la sanguine, les ocres jaune et rouge et la brique pilée. Ces fraudes se reconnaissent au moyen de l'acétate de plomb neutre, qui dissout tout le protoxyde de plomb, et qui, si le minium est pur, ne laisse pour résidu que de l'oxyde puce ou bioxyde de plomb. La brique pilée, que l'on rencontre assez souvent dans le minium et la litharge, se décèle à l'aide de l'acide chlorhydrique qui s'empare des oxydes de plomb et laisse la brique indissoute.

COLCOTHAR.

ROUGE D'ANGLETERRE.

Sous ces noms on désigne, dans les arts, de l'oxyde rouge de fer ou sesquioxyde de fer que l'on obtient le plus ordinairement par la calcination du sulfate de fer ou couperose verte. Dans leur état le plus pur, ils se représentent ainsi :

$$\underbrace{Fe^2}_{\text{Fer.}} + \underbrace{O^3}_{\text{Oxygène.}}$$

Voici le procédé qu'on emploie.

On prend du sulfate de fer du commerce contenant le moins possible du sulfate de cuivre ; on l'expose pendant un certain temps au-dessus de plaques de fonte chaudes pour lui faire perdre toute son eau de combinaison ; on reconnaît qu'il est arrivé à ce point, lorsque de vert qu'il était primitivement, il est devenu tout à fait blanc ; on le pulvérise et on l'introduit dans de grandes cornues de

grès, munies de tubes qui permettent de recueillir le produit de la distillation, puis on chauffe jusqu'au rouge.

Sous l'influence de la chaleur, il se volatilise une certaine quantité d'acide sulfurique anhydre, qu'on reçoit dans des vases placés dans des mélanges réfrigérants. Ce produit liquide est principalement utilisé sous les noms d'*huile de vitriol glacial, acide sulfurique de Saxe* et de *Nordhausen* pour dissoudre l'indigo. L'autre partie d'acide sulfurique se convertit en acide sulfureux qui s'échappe à l'état de gaz, et en oxygène qui se fixe sur le fer, de manière à le faire passer au degré d'oxydation le plus avancé.

Le résidu des cornues appelé, comme tous les résidus de distillation, *caput mortuum* par les anciens chimistes, est sous forme de masses très-dures et brunes. Il constitue le colcothar entier ou brut.

Pour l'approprier aux besoins des arts, on le réduit en poudre grossière et on le lave avec de l'eau pour le dépouiller de tout le sel de fer qui a échappé à la décomposition. On le fait sécher et on le réduit en poudre à l'aide de meules, puis on le livre au commerce, après l'avoir passé au tamis. Pour l'obtenir en poudre impalpable, on le délaye dans l'eau, et on décante après l'avoir laissé déposer quelques minutes; le produit qu'on recueille après la précipitation est séché à l'étuve.

Dans cet état, le colcothar possède une teinte rouge-brun, que certains fabricants avivent par une nouvelle calcination; on remarque, en effet, que la chaleur lui fait subir des modifications que les peintres recherchent beaucoup.

On peut encore obtenir du sesquioxyde de fer propre à la peinture et en poudre très-ténue par d'autres moyens que nous allons indiquer.

Au lieu de calciner le sulfate de fer, quelques fabricants le préparent par double décomposition à froid du sulfate de protoxyde de fer et du carbonate de soude préalablement dissous ; il se fait du sulfate de soude et du carbonate de protoxyde de fer, qui ne tarde pas à se décomposer à l'air et à former de l'hydrate de sesquioxyde de fer qu'on lave, sèche et calcine jusqu'au rouge dans des creusets en terre.

Ce procédé a le grand inconvénient de fournir un produit difficile à laver et d'une teinte rouge pâle. Mais si au lieu d'opérer à froid on fait la précipitation avec des liqueurs bouillantes, l'oxyde qui en résulte possède une densité plus grande, et de plus, une teinte rouge assez vive.

Nous pensons qu'il y aurait avantage à remplacer le carbonate de soude par le bicarbonate de même base ; pour cela voici comment nous conseillons d'opérer :

Lorsqu'on mélange des solutions faites à froid de sulfate de fer et de bicarbonate de soude dans des proportions équivalentes pour obtenir une décomposition complète, une partie de l'oxyde de fer se précipite à l'état de carbonate neutre de fer-blanc verdâtre, tandis que l'autre reste dissoute à l'état de bicarbonate de fer. Si on vient à chauffer cette solution, tout le bicarbonate est décomposé en acide carbonique qui se dégage, et en carbonate neutre de fer qui se précipite comme le précédent. Les deux précipités, très-faciles à laver, sont recueillis, mélangés, séchés, puis calcinés au rouge.

Préparé de cette manière, l'oxyde de fer est en poudre extrêmement fine, comme veloutée; sa densité est à peu près égale à celle du colcothar, et enfin il possède une teinte rouge très-riche.

Soit qu'il provienne de la calcination du sulfate de fer, soit qu'il ait été préparé par la voie humide, à froid ou à chaud, l'oxyde de fer a toujours la même composition; il est complétement insoluble dans l'eau, l'alcool, l'éther et les huiles; les acides bouillants le dissolvent sans résidu. Ce dernier caractère permet de reconnaître la brique pilée avec laquelle on le falsifie quelquefois. Il fournit à la peinture une couleur rouge très-durable, et qui s'allie très-bien aux autres produits. Lorsqu'on le mélange intimement avec du noir de fumée, et qu'on le chauffe dans des creusets en terre, il se fait une réduction partielle de l'oxyde de fer; de l'oxyde noir de fer prend naissance, et on obtient un oxyde brun d'une très-grande solidité et très-beau.

Le colcothar et le rouge d'Angleterre ne sont pas vénéneux.

BOL D'ARMÉNIE.

Le bol d'Arménie, nommé encore *argile ocreuse, bol oriental, bol rouge, terre de Lemnos,* possède, quant à ses propriétés physiques, la plus grande ressemblance avec l'ocre rouge proprement dite. Il est formé d'argile, d'oxyde de fer, en quantités variables, de silice, de chaux et de magnésie. Cette substance était tirée autrefois de la Perse et de l'Arménie, mais toute celle que les arts emploient nous vient des environs de Blois, de Saumur, de la Bourgogne,

de Meudon et de Baville, aux environs de Paris. On le rencontre en très-grande quantité dans le voisinage des anciens volcans, et surtout dans les îles de l'Archipel, qui sont toutes volcanisées.

A l'état brut, le bol d'Arménie se présente sous la forme de masses compactes, pesantes, douces au toucher, d'une teinte rouge-jaune, difficiles à délayer dans l'eau pure par la seule immersion, et contenant ordinairement du gravier, qui se précipite lorsqu'il est en suspension dans ce liquide.

Pour l'approprier aux besoins des arts, voici le procédé qu'on emploie.

Après avoir séparé de la terre argileuse les morceaux les plus rouges et les moins graveleux, on les concasse grossièrement, puis on les jette dans un baquet contenant une suffisante quantité d'eau pour qu'ils baignent entièrement. Après vingt-quatre heures de contact environ, on pétrit la masse avec la main, jusqu'à ce qu'elle soit parfaitement divisée. On achève de remplir le baquet d'eau ; on agite, et après quelques instants de repos, on décante tout le liquide dans un tonneau défoncé par un bout ; on réitère cette opération tant que l'eau se colore. Le produit des différentes décantations est jeté sur un tamis de soie, pour séparer les parties les plus grossières. Le liquide rouge jaunâtre qui s'écoule est abandonné à lui-même dans des baquets disposés *ad hoc*, et lorsque le précipité est parfaitement formé, on soutire le liquide clair ; on obtient alors une matière demi-solide que l'on fait sécher au soleil, ou bien qu'on réduit en trochisques ou en petites boules aplaties de dif-

férentes grosseurs, portant l'empreinte d'un cachet particulier.

Le bol d'Arménie est employé dans la peinture comme couleur d'application ; mais comme il ne possède jamais une teinte rouge bien belle, son usage est assez restreint.

On doit toujours le choisir d'un rouge luisant, non graveleux, gras au toucher et happant fortement à la langue.

Comme tous les composés à base d'oxyde de fer, il fournit une peinture très-solide et nullement vénéneuse.

ROUGE-BRUN.

L'oxyde rouge de fer, la litharge ou le minium mélangés très-intimement dans les proportions d'une partie du premier pour dix du second, puis chauffés jusqu'à la fusion dans un creuset de terre, donnent une matière d'un brun foncé qui prend, lorsqu'on la pulvérise, une teinte rougeâtre assez belle.

Le rouge-brun est quelquefois employé dans la peinture à l'huile ; il forme une couleur assez belle et d'une très-grande solidité ; le coloris en fait usage, rarement il est vrai, pour repiquer les demi-teintes et les ombres. Il est vénéneux au même degré que les oxydes de plomb. Sa formule chimique n'a pas encore été indiquée. On ignore même s'il se fait une combinaison définie ou un mélange de ces deux oxydes.

ROSE DE COBALT.

Les sels de cobalt calcinés avec l'oxyde de magnesium,

donnent une couleur rose que l'on prépare de la manière suivante :

On délaye une certaine quantité de carbonate de magnésie dans une solution concentrée de nitrate de cobalt. La pâte qui en résulte est desséchée dans une étuve, puis calcinée dans un creuset de porcelaine. On obtient alors un produit d'un rose plus ou moins foncé, suivant qu'il contient plus ou moins d'oxyde de cobalt.

Cette matière est un mélange plutôt qu'une combinaison des deux oxydes; elle possède, comme couleur, une très-grande solidité; mais son prix élevé fait qu'on ne l'emploie guère que pour la peinture fine, les fleurs artificielles, par exemple.

RÉALGAR.

De même que l'orpiment, le réalgar, *rubis d'arsenic*, se trouve dans la nature; mais la plus grande partie de celui du commerce est le produit de l'art. C'est un bisulfure d'arsenic qui est formé de :

Arsenic. 70.
Soufre.. 30.
—————
100.

Sa formule chimique se représente ainsi :

$$\underbrace{S^2 + As}_{\text{Soufre. Arsenic.}}$$

Le réalgar naturel se rencontre dans les terrains primordiaux, au milieu des roches, dans le Gneiss, dans les

environs des anciens volcans ; et au Hartz, dans la forêt Noire ; en Bohême, en Hongrie et dans la Transylvanie.

Il cristallise en prismes obliques d'un rouge aurore plus ou moins foncé ; réduit en poudre fine, il est jaune rougeâtre, insoluble dans l'eau, l'alcool, l'éther, et dans la plupart des acides, mais décomposable par l'eau régale.

Exposé à l'action de la chaleur en vase clos, il fond plus facilement que l'orpiment ; mais, comme ce dernier, il se volatilise entièrement. Si on opère au contact de l'air, il fournit des acides arsénieux et sulfureux volatils.

Le réalgar est beaucoup moins employé dans la peinture que l'orpiment. On le prépare de toutes pièces en chauffant dans des creusets *ad hoc*, 8 parties d'acide arsénieux avec 4 parties de fleur de soufre ; l'acide arsénieux est réduit à l'état d'arsenic métallique, et l'oxygène combiné avec une partie du soufre se dégage à l'état d'acide sulfureux. Après le refroidissement des creusets, on obtient une masse dure, cassante, opaque, d'un très-beau rouge orangé, qui possède la plupart des propriétés de l'orpiment artificiel.

Le réalgar naturel est très-loin d'être aussi vénéneux que celui préparé artificiellement ; on dit que les Chinois se purgent en avalant un liquide acide qu'ils laissent séjourner dans des vases de réalgar natif.

Le réalgar artificiel paraît couvrir assez bien les objets sur lesquels on l'applique ; réduit en poudre très-fine, il a une teinte qui se rapproche assez de celle du chromate de plomb basique, mais il ne possède pas une solidité très-grande, et de plus, ne peut s'allier avec certaines couleurs à base de plomb et de mercure, car il les décompose en don-

nant naissance à des sulfures métalliques plus ou moins colorés; il est très-vénéneux.

SCARLETT.

La magnifique teinte rouge que possède le biiodure de mercure, a donné l'idée aux anglais de l'utiliser comme couleur dans la peinture à l'huile. C'est d'abord sous le nom de *scarlett* (écarlate) qu'il a été répandu, il y a vingt ans environ, dans le commerce de la droguerie.

Le biiodure de mercure, dont la formule chimique se représente ainsi :

$$\underset{\text{Iode.}}{I} + \underset{\text{Mercure.}}{Hg}$$

se présente sous la forme d'une poudre rouge écarlate qui tient le milieu entre le cinabre et le minium.

Exposé à l'action de la chaleur, il jaunit, fond et se sublime en cristaux jaunes, qui deviennent rouges en se refroidissant. Il est insoluble dans l'eau; l'alcool bouillant le dissout en quantité notable, mais ses meilleurs dissolvants sont les chlorures et les iodures alcalins, avec lesquels il forme des combinaisons salines doubles.

On le prépare de la manière suivante :

On fait deux solutions aqueuses étendues, l'une contenant 80 parties de bichlorure de mercure, ou sublimé corrosif, l'autre 100 parties d'iodure de potassium. On mélange les deux liqueurs; il se précipite immédiatement du biiodure de mercure qu'on lave avec de l'eau distillée froide ; on jette le précipité sur un filtre, on fait sécher à

une basse température, et on le conserve dans un flacon en verre noir.

Cette couleur, qui eut une très-grande vogue lorsqu'on la proposa pour la peinture à l'huile, n'a pas donné tout le résultat qu'on en attendait ; en effet, sous l'influence des rayons lumineux, elle se décompose, jaunit, puis noircit complètement ; aussi est-elle très-rarement employée maintenant ; mais pour l'aquarelle, elle fournit une teinte écarlate qu'on ne retrouve pas dans les autres couleurs.

Dans le but de lui donner plus de fixité, le docteur Heller a conseillé de l'obtenir de la manière suivante :

On commence par faire dissoudre à chaud, et jusqu'à refus du biiodure de mercure dans une solution concentrée d'hydrochlorate d'ammoniaque (sel ammoniac), on décante le liquide bouillant, et on laisse refroidir. Le biiodure de mercure ne tarde pas à se déposer en partie sous la forme de très-beaux cristaux de couleur pourpre, qu'on lave pour les dépouiller de tout le sel ammoniac qu'ils peuvent retenir, puis on les réduit en poudre fine.

De nombreuses expériences ont été entreprises dans le but de rechercher si réellement le biiodure de mercure préparé de cette manière résistait plus longtemps à l'air que celui obtenu par précipitation et alors en poudre fine. La majorité s'accorde à dire, sans cependant lui attribuer une fixité très-grande, que le biiodure de Heller résiste un peu plus longtemps au contact des rayons lumineux, et que sa teinte est plus riche. Cette propriété repose évidemment sur une agrégation moléculaire identique à celle du cinabre, qui, obtenu par sublimation, possède une fixité

et une richesse de ton plus grandes que celui préparé par la voie humide.

La nature des composants du biiodure de mercure permet d'assurer que pour la peinture en général, et pour la peinture à l'huile en particulier, cette couleur ne peut fournir des résultats satisfaisants; elle est en outre à un prix très-élevé dans le commerce : elle a le défaut de s'allier assez mal avec les autres produits qui la décomposent, et est de plus très-vénéneuse.

CINABRE.

Le soufre et le mercure produisent, en se combinant ensemble, le sulfure rouge de mercure qui porte, lorsqu'il est en masse cristalline, le nom de *cinabre*, et en poudre, celui de *vermillon*.

Sa formule chimique est :

$$\underbrace{S}_{\text{Soufre}} + \underbrace{Hg}_{\text{Mercure.}}$$

Le cinabre est connu depuis la plus haute antiquité; les Grecs et les Romains l'employaient sous les noms de *millos* et de *minium*, pour se peindre le corps. Les anciens Egyptiens l'utilisaient déjà comme couleur, car la plupart des tableaux qui décoraient leurs tombeaux étaient peints avec cette substance. Les censeurs de Rome en faisaient peindre, pour les jours de fête, la face de la statue de Jupiter; les généraux romains, témoin Camille, avaient la coutume de s'en barbouiller le visage pendant leur triomphe; les bains de Titus, la niche de la chambre

dans laquelle fut trouvée la statue de Laocoon, étaient peints avec des couleurs dont le cinabre formait la base.

Le sulfure rouge de mercure qu'on employait alors provenait des mines d'Espagne, d'où on le tire encore en grande quantité. Les mines actuelles les plus importantes sont : en Europe, celles d'Idria, de Carynthie et d'Almaden en Espagne; en Amérique, celle de Huanca Velica au Pérou. On ne trouve en France que des traces de ce minerai. Jusqu'à présent on ne l'a observé que dans le département de la Manche, à Ménildot ; et dans le département de l'Isère, à la Mure.

Le sulfure de mercure naturel sert en partie à obtenir le mercure métallique; cependant, à Almaden, on recueille celui qui est cristallisé et pur pour le faire servir à la peinture. Mais la plus grande partie de celui qu'on trouve dans le commerce s'obtient par des moyens particuliers que nous allons faire connaître maintenant.

La préparation du cinabre remonte au treizième siècle. Cette découverte fut faite par Albert le Grand, qui vit qu'en faisant fondre du soufre avec du mercure, il obtenait un produit identique au cinabre natif.

La France a été pendant très-longtemps tributaire de l'Allemagne pour le vermillon de qualité supérieure ; mais, depuis trente ans environ, il s'en fabrique dans le département de la Seine plus de 12,000 kilogr., qui ne le cède en rien à celui de l'étranger, tant sous le rapport de la qualité que du prix de revient.

Le cinabre se présente sous la forme de masse d'un rouge de sang : sa forme cristalline est celle du rhomboèdre. Exposé à l'action de la chaleur et à l'air, il se dé-

compose en acide sulfureux et mercure métallique. Chauffé en vase clos, il se volatilise sans résidu. Il est inodore, insipide, insoluble dans l'eau, l'alcool, l'éther et les huiles; les réactifs ordinaires ont peu d'action sur lui; l'eau régale seule le dissout en totalité.

La fabrique la plus importante de cinabre était située, il y a quelques années, en Hollande, à Amsterdam, aux portes d'Utrecht, et appartenait à M. Brand.

Voici, d'après M. Tuckert, comment on le préparait :

Les conditions essentielles pour obtenir un produit très-beau sont : 1° d'opérer en grand, et avec du mercure et du soufre purs autant que possible; 2° de chauffer au degré convenable; 3° de volatiliser tout le soufre non combiné.

On commence par faire un mélange intime de 75 kilogr. de fleur de soufre tamisé et de 540 kilogr. de mercure, que l'on fait passer à travers une peau de chamois pour le diviser; on met le tout dans une grande chaudière de fer plate et polie; on chauffe à un feu modéré jusqu'à usion de la matière.

Le produit noir qui résulte de cette opération est de l'éthiops, mélangé de soufre et de bisulfure de mercure.

Lorsqu'il est refroidi, on le casse en petits morceaux, on le broie et on le place dans des flacons de verre pouvant contenir 3 ou 400 grammes d'eau environ. On remplit trente ou quarante de ces flacons pour s'en servir au besoin.

Pendant que cette opération s'exécute, on chauffe jusqu'au rouge sombre trois vases sublimatoires qui consistent en grands pots de terre enduits d'avance d'une cou-

che de lut, et placés sur trois fourneaux isolés les uns des autres. On verse dans le premier vaisseau un flacon d'éthiops, ensuite dans le second, puis dans le troisième. On peut même en verser de suite deux ou trois à la fois. A chaque projection, la matière s'enflamme subitement par la combustion d'une petite quantité de soufre libre. Lorsque la flamme a diminué, on recouvre l'embouchure des pots avec une plaque de fer très-épaisse qui s'y applique parfaitement. On introduit ainsi dans les trois pots toute la matière préparée; ce qui fait pour chacun 180 kilogr. de mercure et 25 kilogr. de soufre. On continue ensuite le feu au degré convenable, et on laisse éteindre quand tout est sublimé, ce qui exige trente-six heures de travail.

Le degré de température nécessaire se règle à l'élévation de la flamme lorsqu'on enlève le couvercle. Quand le feu est trop fort, la flamme dépasse le vase de quelques pieds; quand il est trop faible, elle ne paraît pas à l'embouchure du pot; mais quand il est suffisant, elle s'élève seulement de 10 à 12 centim. au-dessus du bord du vase.

Dans les dernières trente-six heures, on remue fortement la masse toutes les demi-heures ou tous les quarts d'heure avec une tringle en fer pour accélérer la sublimation.

Toutes les quatre ou cinq heures, suivant que le travail va vite ou lentement, on verse des flacons de sulfure noir de mercure (éthiops), jusqu'à ce que tout soit sublimé; c'est par suite de cette addition que les pains de cinabre se trouvent formés de différentes couches séparées entre elles par une petite pellicule fine.

Le cinabre se dépose sur les parois internes des vases. Lorsque tout est refroidi, on enlève les pots, on les casse, et le cinabre qu'on retire est broyé à l'eau entre des meules à moudre. Plus la poudre est ténue, plus le vermillon est clair et brillant. D'autres fois, on le pulvérise par décantation; il est alors en poudre impalpable et possède un éclat très-vif.

Chaque pot contient 200 kilos de sulfure de mercure ou cinabre, ce qui fait 600 kilos pour les trois; il se perd 5 kilos de matière pour chacun pendant le chauffage.

Il y a une quinzaine d'années environ, la fabrique de M. Brand ne fournissait pas moins au commerce de 24,000 kilos de cinabre par an. Quatre ouvriers seulement étaient employés pour cette fabrication.

D'après Ritter, le beau vermillon de Hollande se fabriquerait de la manière suivante :

1 partie de soufre et 2 parties de mercure sont broyés ensemble jusqu'à ce qu'on n'aperçoive plus de globules de mercure à l'œil. A chaque quintal d'éthiops qui s'est formé, on ajoute 2 kil. 500 gr. de plomb en grenaille ou de minium.

On chauffe des pots de terre à sublimation, et quand ils sont rouges, on y met 100 kilos de matière pour chaque pot, puis on procède à la sublimation comme il a été dit plus haut.

Quand l'opération est terminée, on laisse éteindre le feu et refroidir les pots pendant dix-huit heures; ceux-ci sont cassés, et le cinabre qu'on y trouve est broyé au moulin. Le plomb sert à enlever à l'éthiops tout le soufre inutile à la production du cinabre. On le trouve en partie

au fond des vases à l'état de sulfure, tandis que le cinabre vient se sublimer sur les parois supérieures.

A Idria, on fabrique du cinabre en broyant d'une manière parfaite, dans des tonneaux tournant sur leur axe, 85 parties de mercure avec 15 parties de soufre. L'éthiops formé est placé dans des vases en fonte surmontés de chapiteaux en terre cuite ; par l'action de la chaleur, le cinabre vient se condenser dans ces derniers.

Nous avons dit, en commençant, que dans le commerce de la droguerie on donnait le nom de cinabre au sulfure de mercure entier, et qu'on réservait à sa poudre le nom de vermillon ; on peut, pour obtenir ce dernier, broyer le cinabre avec de l'eau, de manière à le réduire en poudre très-ténue ; mais, comme il n'acquiert jamais par ce moyen une belle teinte rouge, on préfère le préparer par la voie humide.

VERMILLON PAR LA VOIE HUMIDE.

G. Schulze, dans l'année 1687, indiqua pour la première fois que le sulfure rouge de mercure pouvait être obtenu en poudre fine par la voie humide. Après lui, Kirchoff, Bucholz, MM. Brunner de Berne, Jacquelin de Paris et M. Verhle, donnèrent d'autres procédés qui sont plus ou moins suivis.

Le vermillon de la Chine est, de toutes les espèces répandues dans le commerce, le plus beau et le plus estimé.

Le procédé qu'emploient les Chinois n'est pas encore connu, et s'il nous était permis de juger par analogie, nous dirions que tout porte à croire qu'il est préparé avec

un plus grand nombre de substances qu'en France et en Allemagne ; nous citerons comme exemple le calomel, que les fabricants de produits chimiques français obtiennent très-pur et très-beau avec du mercure et du sublimé corrosif, et qui est préparé par les Chinois avec huit substances différentes, dont une partie ne concourt pas à la réaction. Mais cela se comprend dans un pays où la fabrication des produits de cette nature se fait sans raisonnement théorique, et où la coutume seule sert de guide.

La combinaison du soufre avec le mercure se fait par l'intermédiaire d'un alcali caustique (potasse).

La formation de ce composé a donné lieu à un grand nombre de théories. Depuis longtemps, Hoffmann avait remarqué qu'en faisant digérer du mercure avec des sulfures alcalins, il obtenait du cinabre. Ce serait donc en ramenant incessamment le polysulfure de potassium qui se produit à l'état de monosulfure, que le sulfure de mercure prendrait naissance. C'est cette théorie qui nous paraît la plus vraisemblable.

Voici maintenant le procédé que Kirchoff de Saint-Pétersbourg conseille de suivre.

On broie dans un mortier de porcelaine 300 parties de mercure avec 68 parties de fleur de soufre humecté avec quelques gouttes de potasse caustique. Lorsque le métal est parfaitement divisé, le mélange, auquel on donne le nom d'éthiops minéral, devient tout à fait noir. Celui-ci est mêlé avec 160 parties de potasse caustique dissoute dans une petite quantité d'eau. On chauffe au bain de sable pendant demi-heure, en agitant sans cesse et en renouvelant l'eau au fur et à mesure de son évaporation.

Après ce temps, on n'ajoute plus d'eau et on laisse concentrer en continuant toujours de remuer. La matière prend d'abord une teinte brune et une consistance gélatineuse; arrivée à ce point, elle acquiert rapidement une très-belle couleur rouge. Le précipité est jeté sur un filtre, lavé à plusieurs eaux et séché à une basse température.

On ne trouve nulle part indiqué le degré de température auquel on doit soumettre la matière; et comme le vermillon perd très-facilement sa teinte rouge lorsqu'il a été trop chauffé, il en résulte que le procédé de Kirchoff est d'une pratique très-délicate. M. le comte de Mussin Pushkin a fait observer que l'on peut prévenir le changement de teinte en retirant le mélange du feu lorsqu'il a acquis une belle couleur rouge, et de le porter dans une étuve en remuant de temps à autre; ou bien encore en faisant digérer le vermillon dans la potasse caustique.

PROCÉDÉ BRUNNER.

M. le professeur Brunner obtient un vermillon beaucoup plus beau en augmentant la dose du soufre et en diminuant celle de l'alcali.

Pour cela il prend :

<div style="text-align:center">

Mercure 300 grammes.
Soufre............ 114 »
Hydrate de potasse. 75 »
Eau.............. 450 »

</div>

La potasse est dissoute dans l'eau, le mercure et le soufre sont broyés ensemble dans un mortier de porcelaine, jusqu'à ce qu'on ne puisse plus apercevoir de bulle

de mercure au microscope. On verse sur l'éthiops minéral qui s'est produit la solution de potasse caustique par petites portions à la fois, et en agitant continuellement. La matière mise dans un vase de terre ou de porcelaine et même de fonte, si on opère en grand, est chauffée au bain de sable à la température de 45 à 50°.

Après huit heures environ d'exposition à cette température, pendant lesquelles on a renouvelé l'eau à mesure de son évaporation, le produit, qui était noir, se colore en rouge-brun, puis passe rapidement au rouge écarlate. Lorsque la teinte est à son maximum d'intensité, on retire ce vase du feu, et on laisse digérer encore quelque temps à une douce chaleur, après quoi le cinabre est lavé à plusieurs eaux et séparé par décantation du mercure non combiné ; le vermillon qu'on obtient dans ce cas pèse 330 grammes, et possède généralement un éclat très-vif.

Pour que cette opération réussisse, il est essentiel que la température ne dépasse pas 45°, et que le sulfure reste toujours à l'état pulvérulent. Ce dernier résultat s'obtient en ajoutant une quantité d'eau nécessaire pour éviter que la masse se prenne en gelée.

PROCÉDÉ JACQUELIN.

M. Jacquelin obtient le vermillon avec :

Mercure	60	grammes.
Soufre	30	»
Hydrate de potasse.	20	»
Eau	30	»

La potasse est dissoute dans la quantité d'eau prescrite ;

d'une autre part, on place le mercure et le soufre dans une marmite de fonte de la forme d'une capsule évasée, et plongeant dans l'eau froide pour éviter l'élévation de température qui résulte de la combinaison. On verse peu à peu sur le mélange la solution alcaline, en agitant continuellement au moyen d'un pilon à large tête. Au bout d'un quart d'heure, on remarque déjà que la matière prend une teinte orangée très-prononcée. Lorsque toute la potasse est ajoutée, on chauffe la marmite à 80° pendant une heure environ, en ayant le soin de remplacer l'eau qui s'évapore. Au bout de ce temps, le vermillon qui s'est produit est délayé dans quatre à cinq fois son poids d'eau chaude, et on décante avant le refroidissement des liqueurs, pour empêcher la précipitation du soufre non combiné. On lessive à l'eau froide jusqu'à complète élimination des sulfures alcalins. On recueille sur un filtre en toile, et l'on sèche à l'ombre.

PROCÉDÉ WERHLE.

M. Werhle prépare le vermillon de la manière suivante :

Le cinabre du commerce est réduit en poudre fine et mélangé avec la centième partie de son poids de sulfure d'antimoine pulvérisé. Le mélange, placé dans une bassine de fonte, est mis à bouillir à plusieurs reprises, avec une dissolution de 3 parties de sulfure de potasse (polysulfure de potassium). Après ce temps, le précipité, lavé avec de l'eau ordinaire, est mis à digérer avec de l'acide chlorhydrique, et enfin lavé de nouveau avec de l'eau ordinaire.

Le vermillon perd, sous l'influence de certaines circonstances, de la chaleur, par exemple, une partie de sa riche couleur.

On peut, jusqu'à un certain point, la lui restituer, soit en l'arrosant avec de l'eau et le laissant quelque temps en contact avec ce liquide, soit en le traitant par l'acide nitrique concentré, et lavant bien ensuite.

Quelques auteurs assurent qu'en Hollande on avive la couleur du vermillon en le faisant digérer avec de l'urine ou avec de l'alcool.

Les falsifications qu'on fait subir au vermillon sont assez communes. Les substances qu'on emploie pour cela sont: le *minium*, la *mine orange*, le *colcothar*, la *brique pilée*, le *sang-dragon*, le *réalgar*, l'*ocre rouge*.

Lorsqu'il contient du minium, l'acide nitrique lui fait prendre une teinte brune par suite de l'oxyde puce de plomb (bioxyde) mis à nu. Chauffé en vase clos, il se volatilise entièrement en abandonnant le minium, la brique pilée, le colcothar, le sang-dragon et l'ocre rouge.

Le réalgar se décèle par l'odeur alliacée qui se dégage lorsqu'on projette du vermillon suspect sur des charbons ardents.

Le cinabre, et surtout le vermillon, sont d'un emploi journalier dans la peinture à l'eau et à l'huile; malheureusement, les tons riches qu'ils donnent ne sont pas d'une longue durée; sous l'influence des rayons solaires et des gaz méphitiques, ils ne tardent pas à passer au noir.

C'est une couleur très-vénéneuse, qui nécessite de la part de celui qui l'emploie beaucoup d'attention.

CHAUX MÉTALLIQUE.

La teinte rose ou rouge que possèdent en général les sels de cobalt, a été mise à profit par certains industriels anglais pour préparer une couleur très-belle et très-solide inconnue en France, mais d'un usage journalier dans toute l'Angleterre, où elle porte le nom de *chaux métallique*.

Cette substance est de l'arséniate de cobalt que l'on trouve dans la nature; mais le plus souvent on la prépare de toutes pièces par l'oxydation à l'air de l'arséniure de cobalt.

En Suède, en Norwège, en Silésie, on rencontre entre autres minerais de cobalt, de l'érythrine ou arséniate de cobalt et de fer, en masse terreuse, d'un rouge-violet, tirant sur la couleur fleur de pêcher, qu'on purifie de la manière suivante :

La mine réduite en poudre est traitée par l'acide nitrique bouillant; la dissolution ne tarde pas à s'effectuer; on laisse déposer; on décante la liqueur dans laquelle on verse une solution de potasse par petites portions à la fois. Le premier précipité qui se forme est blanc; il est formé en partie d'arséniate de fer ; on laisse déposer, on décante la partie liquide, et on la précipite par une nouvelle quantité de solution potassique. Le dépôt qui se forme est lavé, séché, puis réduit en poudre fine. C'est là l'arséniate de cobalt naturel dont la formule chimique se représente par :

$$\underbrace{As O^5}_{\text{Acide arsenique}} + \underbrace{3 (CoO)}_{\text{Protoxyde de cobalt}}.$$

Pour l'obtenir par la voie artificielle, voici comment on opère :

On prend du cobalt gris, ou arsénio-sulfure de cobalt ; on le réduit en poudre aussi fine que possible ; on le mélange avec deux fois son poids de potasse et un peu de sable, puis on le place dans un creuset de terre et on chauffe jusqu'à la fusion. Le soufre de la mine se combine avec la potasse ; il se produit du sulfure de potassium qui entraîne avec lui du fer, du cuivre et de l'arsenic. Ces substances forment à la surface de la matière une couche de scories qu'on enlève et qu'on jette ; au-dessous, on trouve de l'arséniure blanc de cobalt, qu'on refond de nouveau avec de la potasse, après l'avoir pulvérisé. Il se forme encore des scories d'un bleu clair que l'on fait servir à la préparation du smalt, et qui recouvrent un culot d'arséniure de cobalt pur de tous métaux étrangers. On pulvérise celui-ci, et on le grille à l'air avec précaution, à une douce chaleur d'abord, puis très-forte. Au fur et à mesure que l'oxygène est absorbé, l'arsenic passe à l'état d'acide arsénique, et le mélange prend une belle teinte rougeâtre foncée, qui est encore plus vive après la pulvérisation.

La chaux métallique est très-employée pour la peinture à l'huile ; elle donne des tons rouges très-riches et très-solides ; mais elle est très-vénéneuse.

Cette couleur à l'étranger à un prix assez modique.

Nul doute que si les minerais de cobalt existaient en France en plus grande quantité, elle ne tarderait pas à s'y répandre.

MARRON ROUGEATRE.

Les chromates de potasse et de soude, versés dans les sels solubles de cuivre, donnent à froid des précipités rouges de chromate de cuivre qui ont la plus grande ressemblance avec l'ocre ferrugineuse. Mais si on opère avec des liqueurs bouillantes, on obtient un beau précipité brun chocolat qui mérite, sous tous les rapports, d'être mieux connu ; car outre sa teinte qui est fort belle, il possède une grande fixité.

Voici comment on prépare ce sel :

On fait séparement deux solutions de chromate neutre de potasse, ou de chromate de potasse et de soude (en saturant le bichromate de potasse par le carbonate de soude) et de sulfate de cuivre : on les porte à l'ébullition, et on verse goutte à goutte le sel de cuivre dans le chromate alcalin. Lorsque la décomposition est complète, on lave le dépôt par décantation avec de l'eau chaude, jusqu'à ce que celle-ci ne se colore plus : la matière est jetée sur un filtre, puis séchée à l'étuve.

Cette couleur est un sous-chromate de cuivre qui possède la formule chimique suivante :

$$\underbrace{CrO^3}_{\text{Acide chromique.}} + \underbrace{4\,CuO}_{\text{Oxyde de cuivre.}} + \underbrace{5\,HO}_{\text{Eau.}}$$

Elle est encore trop peu connue pour que nous nous appesantissions sur son emploi. Tout nous porte à croire qu'elle se mélange bien aux huiles grasses, et qu'elle peut rendre à la peinture fine de grands services.

Elle est vénéneuse au même degré que tous les composés insolubles de cuivre.

ROUGE POURPRE.

Le bichromate de potasse, décomposé par le nitrate de bioxyde de mercure, donne lieu à du chromate de bioxyde de mercure, dont la teinte rouge pourpre a été mise à profit pour la peinture des décors.

La préparation de cette couleur n'est pas à l'abri de quelques difficultés.

D'après M. Millon, on peut obtenir deux chromates de bioxyde de mercure, qui diffèrent d'une manière notable et par leur composition chimique et par leur teinte.

Lorsque dans une solution de nitrate de bioxyde de mercure (1) on verse du bichromate de potasse dissous, jusqu'à cessation de précipité, on obtient une poudre pesante d'un rouge brique très-foncé, qu'on lave à plusieurs reprises par décantation, puis qu'on fait sécher à l'air, à l'abri des rayons solaires.

Ce composé possède la position chimique suivante :

$$\underbrace{CrO^3}_{\text{Acide chromique.}} + \underbrace{3\,(HgO)}_{\text{Bioxyde de mercure.}}$$

Le second chromate de mercure, d'une belle teinte rouge violacée, se prépare ainsi :

On fait bouillir pendant longtemps de l'oxyde rouge de

(1) On ne peut dans cette opération remplacer le nitrate de mercure par le sublimé corrosif, car il se forme avec ce dernier un sel double soluble qui a été signalé pour la première fois par M. Millon.

mercure (précipité *per se*) avec une solution concentrée de bichromate de potasse. Lorsque le précipité a acquis la teinte rouge désirée, on sépare le liquide par décantation, on lave à plusieurs reprises avec de l'eau chaude, et on fait sécher à l'air dans un endroit obscur. Il se représente par :

$$\underbrace{CrO^3}_{\text{Acide chromique.}} + \underbrace{4(HgO)}_{\text{Bioxyde de mercure.}}$$

M. Millon, qui a étudié ces composés avec beaucoup de soin, a observé qu'on n'obtenait pas toujours ce dernier d'une teinte uniforme ; tantôt il est d'un rouge violacé très-beau ; tantôt, au contraire, il est brun et sans éclat.

Mais si les chromates de mercure peuvent fournir à la peinture de fort belles couleurs, leur peu de fixité et leur prix de revient doivent en faire restreindre de plus en plus l'emploi ; ils ne peuvent guère servir que pour la peinture des décors qui sont exposés dans des endroits sombres. Les rayons lumineux et solaires les décomposent avec une grande facilité. Ils prennent alors une teinte brune qui n'a rien d'agréable.

On donne encore le nom de rouge pourpre à la combinaison que l'acide chromique fournit avec l'oxyde d'argent. Cette couleur, d'un prix assez élevé et très-rarement employée, s'obtient en versant, à froid, 30 grammes de nitrate d'argent cristallisé dans 30 grammes de chromate de potasse neutre, dissous l'un et l'autre dans une suffisante quantité d'eau distillée. Le précipité qui se forme possède une très-belle teinte rouge pourpre. On le lave avec de l'eau distillée, puis on le jette sur un filtre et on fait sécher à l'ombre.

Le chromate d'argent qui se formule ainsi :

$$\underbrace{CrO^3}_{\text{Acide chromique.}} + \underbrace{AgO}_{\text{Oxyde d'argent.}}$$

est employé seulement pour la peinture en miniature. Sa teinte n'est pas du tout en rapport avec sa fixité, aussi trouve-t-on à le remplacer par d'autres couleurs aussi belles et beaucoup plus solides.

LAQUE DE GARANCE.

La laque de garance, disent les auteurs, a été découverte en 1771 par le chimiste prussien Margraff ; mais il est certain qu'elle était déjà connue au temps des Grecs et des Romains. Vitruve et Pline attribuent sa découverte aux tentatives entreprises dans le but d'imiter la pourpre des Grecs ; ces historiens disent qu'en imprégnant de la craie argileuse avec de la garance et de l'*hyginum* (pastel), on obtient une couleur qui possède la plus grande ressemblance avec la pourpre proprement dite.

La racine de garance, qui sert à la préparer, est une plante appartenant au genre *rubia,* de la famille des rubiacées : elle forme l'espèce *rubia tinctorum* ou garance des teinturiers.

La laque de garance est toujours à base d'alumine, elle doit en partie sa teinte à l'alizarine, matière cristalline d'une couleur rouge fort belle, isolée pour la première fois par MM. Robiquet et Colin.

La préparation des diverses espèces de laques répan-

dues dans le commerce est assez délicate ; or, comme de la qualité de la garance dépend la beauté du produit qu'on veut obtenir, nous allons faire connaître aussi succinctement que possible les propriétés générales de cette plante, et les caractères qui permettent de distinguer une racine de bonne qualité de celles qui lui ressemblent, ou bien de celles qui ont subi des altérations.

La plupart des végétaux qui sont classés dans le genre *rubia* possèdent, après leur dessiccation, plusieurs principes colorants qui ont quelque analogie avec ceux contenus dans la garance des teinturiers : tels sont le *rubia cordata* du Japon, le *rubia perigrina* et le *rubia lucida* des environs de Paris ; mais aucun d'eux ne fournit une matière colorante aussi belle que le *rubia tinctorum*. A l'état frais, aucune partie de la plante ne contient de matière colorante rouge, on y trouve un liquide jaune qui, par la dessiccation, devient rouge, puis brun, lorsque la plante vieillit. Dans ce dernier cas, elle a perdu une partie de sa propriété tinctoriale. C'est dans la racine que le principe colorant est plus particulièrement accumulé.

Lorsqu'elle est entière, la garance porte le nom d'alizari ou de lizari ; réduite en poudre, elle est connue sous le nom générique de garance.

Les meilleures garances nous venaient autrefois du Levant ou bien de la Hollande ; mais les droits élevés dont notre gouvernement les a frappées, principalement cette dernière ; les soins apportés en France à la culture, à la récolte et à la conservation de cette plante, les ont fait disparaître presque complétement de nos marchés.

La plus grande partie de celle que l'on emploie nous

vient d'Avignon, qui en exporte à l'étranger pour des sommes considérables.

Les fabricants la livrent sous deux aspects différents : tantôt elle a une couleur rouge sombre pur, agréable à l'œil, tantôt elle est d'un rouge clair, tirant un peu sur le jaune. Dans le premier cas, elle est désignée sous le nom de garance *palus*, et dans le second, sous celui de *rosée*. On attribue ces différences à la nature du sol dans lequel la plante a crû. Ainsi, la garance *palus* se récolte principalement dans les terres autrefois couvertes de marécages. Ces terres, contenant beaucoup de détritus végétaux et animaux, fournissent au végétal des carbonates alcalins qui favorisent la formation de la matière colorante rouge. La garance *rosée* provient des terrains légers ou contenant très-peu d'humus.

La garance d'Avignon porte dans le commerce une marque particulière qui sert à évaluer sa richesse en matière colorante. Ainsi elle est :

O, ou nulle, c'est-à-dire de mauvaise qualité.
P, ou palus.
PP, ou palus pur.
R, ou rosée.
PR, ou mi-palus, mi-rosée.

Mais comme chacune de celles-ci peuvent être graduées, on les distingue de la manière suivante :

Fine......... FF....
Surfine SF....
Surfifine..... SFF...
Surfififine.... SFFF..
Extra-fine.... EXTF..
Extra-surfine. EXTSF.

A chacune de ces marques, on ajoute les lettres P, PP, R, PR, pour palus, palus pur rosée, moitié palus, moitié rosée, sans dictinction.

Lorsqu'on se propose d'obtenir de la laque de belle qualité, on prendra donc de préférence la garance palus extra-surfine.

Les fabricants devront se mettre en garde contre une adultération qui consiste à communiquer à la garance rosée la teinte rouge de la garance palus. Pour cela, on lui fait subir une véritable fermentation en l'arrosant avec une petite quantité d'eau-de-vie, ou bien encore en la saupoudrant de 2 à 3 millièmes de sel ammoniac, puis d'une quantité équivalente de chaux délitée. Sous l'influence de l'acide acétique qui se produit dans le premier cas, et qu'on expulse en exposant la poudre à une température de 60 à 70°/0, et du gaz ammoniac dans le second, la teinte rouge est exaltée d'une manière évidente; mais la laque qu'on en retire n'est jamais aussi belle que lorsqu'on s'est servi de belle garance palus.

La garance fermentée se reconnaît par l'usage. Ainsi employée à teindre des mordants d'alumine et de fer, elle fournit une couleur qui disparaît plus ou moins complétement à l'avivage. Quant à celle qui a subi l'action du gaz ammoniac, il suffit de la lessiver avec de l'eau froide; on obtient une liqueur qui, après avoir été filtrée, se colore en bleu foncé par l'addition de quelques gouttes de sulfate de cuivre.

Si l'histoire de la garance laisse peu de chose à désirer sous le rapport de son application à la teinture, il n'en est pas de même lorsqu'on l'envisage sous le rapport chimique.

Son importance industrielle a donné lieu à de nombreux travaux. Malgré cela, les chimistes sont encore à

se demander si elle contient plusieurs principes colorants de nature différente, ou bien si les diverses substances connues sous le nom de *xanthine, purpurine, rouge de garance,* auxquelles on a assigné des compositions particulières, ne sont pas des modifications d'une seule et même matière, l'*alizarine,* par exemple, sur l'existence de laquelle tout le monde savant s'accorde.

Dans l'état actuel de la science, il nous serait donc impossible de décider si la matière rouge qui forme la laque avec l'alumine est une substance unique, ou bien un mélange de plusieurs principes colorants. Tout porte à croire, cependant, que l'alizarine forme la base des laques de garance.

La garance traitée par l'eau froide ou chaude, ne se dépouille pas de tout son principe rouge; mais si on ajoute une petite quantité d'alun, on obtient une liqueur rouge très-intense qui produit, avec l'alumine précipitée par les alcalis, une laque d'autant plus belle que la poudre était de meilleure qualité et en quantité plus considérable.

D'après les recherches de M. Kulmann, elle contient une matière colorante fauve qu'il est indispensable de séparer; pour cela, il suffit de la faire macérer à deux ou trois reprises différentes, pendant quelque temps, dans l'eau froide, et à soumettre le résidu à la presse. Dans cet état, elle est très-propre à céder son principe colorant.

La laque de garance s'obtient par les procédés suivants :

On prend, d'après MM. Robiquet et Colin, 2 kilogr. de garance préparée comme nous venons de le dire; on la fait chauffer au bain-marie pendant deux ou trois heures

avec une solution de 1 kilogr. d'alun dans 12 kilogr. d'eau ; on filtre, et, dans la liqueur, on verse par petites portions à la fois une solution de carbonate de soude pur jusqu'à cessation de précipité. La laque qui se dépose dans le premier temps de l'opération est très-belle, aussi est-elle est recueillie à part : en continuant la précipitation on obtient de nouveau une laque qu'on lave à grande eau par décantation, et, lorsque la liqueur qui en provient ne présente plus de réaction acide, on jette le précipité sur un filtre, puis on en forme des trochisques que l'on met sécher à l'air libre dans un endroit exempt de poussière.

Quelques industriels remplacent le carbonate de soude par le borax ou par la potasse caustique.

M. Persoz a donné, dans son *Traité de l'impression des tissus*, un procédé qui permet de préparer de très-belles laques avec des garances qui n'ont point encore servi, ou bien avec celles qui ont déjà été employées en teinture.

« Si l'on veut faire usage d'une garance qui n'ait point servi, il est bon de commencer par la soumettre à la fermentation, ou de la laver dans une eau tenant en dissolution une certaine quantité de sulfate de soude, afin de la débarrasser, sans perte, des substances sucrées et mucilagineuses qu'elle renferme encore, et dont la présence a presque toujours pour effet de ralentir les lavages. Lorsqu'on utilise les résidus de garance, ces précautions sont inutiles. Quelle que soit la garance qu'on emploie, on en traite toujours une partie, pendant 15 à 20 minutes, par 10 fois son poids d'une dissolution bouillante,

renfermant sur 10 parties d'eau une partie d'alun. On filtre le tout au travers d'une chausse, et l'on obtient une liqueur qu'on peut considérer comme une solution d'alun tenant en dissolution de la matière colorante. Quand la température de cette solution n'est plus qu'à 35 ou 40°, on la neutralise par le carbonate de soude, pour former de l'alun cubique. Ce carbonate doit constituer la 8e ou 10e partie de l'alun employé, selon l'état de saturation de ce dernier. Quand un pareil alun cubique est formé, on porte la liqueur à l'ébullition pour en opérer la décomposition; il se forme alors du sulfate tri-aluminique qui entraîne, en se précipitant, la matière colorante en présence de laquelle il se trouve, et donne naissance à une laque qui n'a plus besoin que d'être lavée pour servir à tous les usages auxquels on destine cette matière colorante. Elle a, sur les autres laques, l'avantage de se présenter sous la forme d'un précipité non gélatineux, prompt à se former, facile à laver et à recueillir; elle a surtout le mérite de se dissoudre très-promptement dans l'acide acétique. Comme la garance ne peut être entièrement épuisée par un pareil traitement, il convient de la traiter une seconde et même une troisième fois par l'alun; mais les liqueurs qu'on retire de ces manipulations servent généralement à épuiser les garances qui n'ont point encore été soumises à l'action de l'eau alunée, ou, si elles sont précipitées, pour constituer des laques, il faut n'ajouter que la moitié ou même le tiers du carbonate de soude nécessaire à la saturation de l'alun, afin que ce carbonate ne précipite qu'une portion de l'alumine sous forme de sulfate tribasique, et que celui-ci rencontre

assez de matière colorante durant sa précipitation pour en être saturé et former une laque de la nuance voulue. Comme les eaux au sein desquelles se forme le sulfate tribasique renferment encore de l'alun, elles ne doivent pas être négligées ; on les utilise en les jetant sur de la garance ou sur des résidus de cette garance, et en portant le tout à l'ébullition, afin de dissoudre une nouvelle quantité de matière colorante ; une fois qu'elles en sont chargées, on les sature de nouveau, pour en précipiter ensuite par l'ébulition une nouvelle quantité de laque colorée. »

M. Persoz, au lieu de se servir de carbonate de soude pour la saturation de la liqueur alunée, a employé une quantité équivalente d'acétate plombique dont la base est immédiatement précipitée sous forme de sulfate insoluble. Il a obtenu de la sorte une laque d'une intensité et d'une pureté qu'on atteint moins facilement à l'aide du carbonate de soude.

Dans le courant de l'année 1827, MM. Robiquet et Colin découvrirent qu'en traitant la garance par les deux tiers de son poids d'acide sulfurique concentré, on obtenait une matière noirâtre charbonneuse qui contient, sans altération aucune, tout le principe colorant rouge de la racine.

Cette substance se trouve en très-grande quantité dans le commerce, où elle porte le nom de *charbon sulfurique de garance* ou *de garancine*. Elle possède une richesse tinctoriale trois fois plus grande que les bonnes garances ; aussi a-t-elle complétement remplacé cette racine dans les fabriques d'indiennes.

Nous avons eu l'occasion de faire servir la garancine à la fabrication de la laque de garance, et voici les résultats que nous avons obtenus.

Dans une chaudière bien étamée on met 1 kilogr. de garancine, 2 kilog. d'alun et 18 litres d'eau pure, on fait bouillir pendant un quart d'heure ou vingt minutes; on filtre, et dans la liqueur encore chaude on verse une solution de carbonate de soude jusqu'à décoloration. En fractionnant le précipité qui se forme, on obtient des laques qui sont plus belles dans le commencement de l'opération que vers la fin. Après un repos de quelques heures, on décante le liquide clair et on lave jusqu'à ce que les eaux sortent parfaitement claires et insipides. Le précipité, recueilli sur un châssis de toile serrée, est mis à égoutter, puis converti en trochisques qu'on fait sécher à l'ombre.

Nous avons tout lieu de supposer que la plupart des belles laques de garance qu'on emploie en peinture sont obtenues avec la garancine. En prenant des quantités déterminées à l'avance de cette substance, d'alun et d'eau, on précipite des laques dont la teinte varie depuis le rouge foncé jusqu'au rose clair.

La laque de garance se trouve dans le commerce à l'état rose, rouge et brun; elle constitue une couleur d'une grande solidité; on l'emploie à l'eau et à l'huile, principalement pour la peinture en miniature; elle n'est pas vénéneuse.

Les laques de garance sont quelquefois falsifiées avec la laque de bois du Brésil, ou bien rehaussées avec du carmin et de la laque carminée. Voici textuellement le

procédé qu'indique M. Watin pour déceler ces mélanges.

« On porphyrise à sec une quantité quelconque de
« rouge de garance, et pour reconnaître d'abord si cette
« couleur est falsifiée avec une laque de Brésil, on en
« jette une pincée dans un demi-verre d'eau claire et
« chaude, et il arrive alors que l'eau reste teinte de la
« couleur de cette laque. Si l'on soupçonne dans ces ga-
« rances un mélange de carmin et de laque carminée, il
« suffit encore de jeter une pincée de ces rouges dans une
« petite quantité d'ammoniaque liquide ou de potasse
« caustique; auquel cas le principe colorant de la coche-
« nille reste en dissolution dans ces alcalis. »

Mais le moyen le plus rapide, sinon le plus économi-
que et qui fournit une laque de très-belle qualité, con-
siste à substituer la garancine à la racine de garance.

Les plus belles laques nous viennent de l'Italie. A
Rome, on fabrique une laque de garance rose tendre qui
possède une teinte très-riche; mais elle a le défaut de
brunir légèrement par son mélange avec l'huile.

CARMIN DE GARANCE.

Dans le courant de l'année 1816, M. Bourgeois est par-
venu à préparer, par un procédé tenu secret encore main-
tenant, du carmin de garance qui, sous un très-petit
volume, réunit tous les principes colorants de la garance.
Cette substance possède en effet une teinte rouge extrê-
mement vive et une solidité qui égale celle de la laque
de la même matière.

Voici, d'après nos propres recherches, comment on

peut préparer du carmin de garance très-pur et très-beau :

On sait que la plupart des matières colorantes végétales possèdent la propriété de se dissoudre, avec ou sans altération, dans l'acide sulfurique concentré, et d'en être précipitées lorsqu'on étend les liqueurs d'une grande quantité d'eau.

On prend de la garance extra-fine d'Avignon ; on la place dans un lieu humide, de manière à lui faire subir la fermentation. Lorsqu'on juge que les substances mucilagineuses sucrées et amères sont détruites, et que la fermentation dite acide commence à se produire, on la désagrége, puis on la verse dans quatre fois son poids d'acide sulfurique du commerce, ramené à 55° B. par une suffisante quantité d'eau.

Le vase dans lequel se fait ce mélange doit être en plomb et placé dans de l'eau froide, pour éviter la trop grande élévation de température. On obtient de la sorte une espèce de bouillie qu'on abandonne à elle-même pendant trois heures environ. Après ce temps, on ajoute 4 ou 5 parties d'eau ; on filtre à travers un lit de verre pilé placé dans un entonnoir de verre ou de plomb, et on reçoit la liqueur dans un vase contenant une très-grande quantité d'eau et chargée le moins possible de sels de chaux, de magnésie et de fer. Le carmin ne tarde pas à se précipiter ; on le recueille sur un filtre de papier, puis on le lave et on le fait sécher à la manière ordinaire.

Cette couleur remplace d'une manière avantageuse toutes les couleurs de même nuance tirées de la cochenille. On l'emploie principalement pour la miniature et

dans les tableaux de chevalet. Elle est complétement inoffensive.

LAQUE DE FERNAMBOUC.

La laque de Fernambouc s'obtient en combinant le principe colorant de divers bois rouges, connus sous les noms de bois de Brésil, de Brésillet, de Sainte-Marthe, et enfin de Fernambouc, avec l'alumine, la gélatine, la craie et l'amidon.

La matière colorante de ces différentes espèces de bois, à laquelle M. Chevreul a donné le nom de brésiline, possède une teinte rouge cramoisi fort belle ; lorsqu'elle est précipitée par l'alumine, elle conserve sa couleur primitive ; mais si on ajoute une certaine quantité de protochlorure d'étain, elle tend à passer au rose vif.

Voici le procédé le plus anciennement connu pour l'obtenir :

On fait bouillir, pendant une heure ou deux, une partie de bois de Fernambouc réduit en copeaux ou mieux en poudre, dans 10 parties d'eau et une 1/2 partie de sel de tartre. D'une autre part, on fait dissoudre une partie d'alun dans une suffisante quantité d'eau. Les liqueurs filtrées sont mélangées en agitant sans cesse. On obtient alors un beau précipité rouge foncé ; on le lave à plusieurs reprises avec de l'eau froide, puis on le fait sécher à la manière ordinaire, après l'avoir converti en trochisques.

En ajoutant à la décoction une petite quantité de protochlorure d'étain, on obtient une laque rose d'un ton très-riche.

D'après M. Girardin (1), voici comment on obtient habituellement les différentes espèces de laques qui sortent des fabriques de Paris, de Schweinfurt, de Cassel, de Vienne et de Venise.

On fait bouillir, pendant un certain temps, du bois de Fernambouc divisé en copeaux avec une suffisante quantité d'eau. On délaye, dans la liqueur filtrée, un mélange de craie et d'amidon tenus en suspension dans une dissolution d'alun. La pâte colorée qu'on obtient, lavée à plusieurs reprises avec de l'eau froide, est mise à égoutter, puis moulée en cubes ou en pains coniques après y avoir ajouté un peu de colle d'amidon et d'une dissolution de résine dans l'essence pour en lier les parties.

La *laque en boules de Venise*, qui était uniquement préparée autrefois dans cette ville, s'obtient par des procédés encore inconnus. On parvient jusqu'à un certain point à l'imiter en teignant des mélanges d'argile, de craie et d'amidon avec une décoction de cochenille et de fernambouc, avivée avec de l'alun ou bien du protochlorure d'étain. Nemnich assure que la véritable laque de Venise est préparée avec de la laine tondue très-fine, qui, par l'ébullition en présence de la potasse, se convertit en masse pâteuse qu'on colore avec certains bois colorants. Ainsi, pour la plus fine, on prendrait du bois de Fernambouc, et pour la plus commune, du bois de Sainte-Marthe et de Brésil. Viegleb indique de précipiter une décoction de fernambouc avec du sel d'étain, de mêler le précipité avec de la semence de lycopode, de la gomme adragante et de mettre en boules.

(1) Leçons de chimie élémentaire.

D'après M. Girardin, on peut encore préparer la laque en boules de Venise, « en pétrissant un mélange de géla-
« tine et d'alumine en gelée dans une forte décoction de
« bois de Brésil qu'on renouvelle jusqu'à ce que la nuance
« soit assez foncée. » On en avive la couleur par l'alun ; on lui donne un reflet violet au moyen du savon. On la met en boules de la grosseur d'un marron.

La laque de Fernambouc est employée à l'eau et à l'huile pour la peinture en décors ; c'est une couleur inoffensive qui ne jouit pas d'une très-grande solidité, surtout lorsque les ouvrages sont exposés au contact des rayons solaires.

La *laque plate d'Italie* est une combinaison d'alumine et de chaux avec la matière colorante rouge du bois de Fernambouc et du bois de Sainte-Marthe.

Elle se présente dans le commerce sous la forme de morceaux de différentes grosseurs. C'est une belle couleur rouge qui, malheureusement, ne possède pas une grande solidité. On l'emploie généralement pour la peinture des décors.

CARTHAME.

Le *carthamus tinctorius*, petite plante annuelle de la famille des synanthérées, que l'on cultive en France et en Allemagne pour les besoins des arts et pour l'ornement des jardins, est pourvu de fleurons d'un beau jaune orangé qui ont la plus grande ressemblance avec le safran.

Cette fausse ressemblance lui a valu les noms de *sa-*

fran d'Allemagne, de *safran* et de *safranum*, et est mise à profit par les falsificateurs pour le mélanger au safran véritable.

L'industrie le tire de la Provence et de l'Alsace, mais les teinturiers, qui l'emploient en plus grande quantité que les peintres, donnent la préférence à celui du Levant.

Le carthame contient entre autres principes (alumine, résine, cire, ligneux) deux matières colorantes, l'une jaune soluble dans l'eau; l'autre rouge insoluble dans ce liquide, mais très-soluble dans l'alcool et les solutions alcalines. C'est le mélange de ces deux couleurs, surtout la première, que les peintres emploient pour la mise en couleur des parquets d'appartements; pour cela ils font bouillir le carthame avec de l'eau contenant une petite quantité d'alun, on obtient alors une décoction jaune orangée très-belle, dans laquelle on fait fondre de la colle.

Il est rare que le carthame soit employé seul pour cela, presque toujours on le mélange avec parties égales de curcuma ou terra merita.

Le carthame possède un éclat très-beau, mais malheureusement peu solide; les rayons lumineux et solaires, l'humidité, la chaleur l'altèrent avec une grande rapidité, aussi son emploi est-il assez borné.

ROUGE DE CARTHAME.

Le rouge de carthame, auquel les chimistes ont donné les noms de *carthamine* et d'*acide carthamique*, et les industriels les noms de *rouge végétal*, *rouge d'Espa-*

gne, *rouge portugais, rouge en tasse, rouge en assiette, rouge en feuille, fard de la Chine,* est formé du principe colorant des fleurons de carthame.

Voici comment on l'obtient :

Les fleurons de carthame placés dans un appareil à déplacement sont traités par de l'eau froide contenant 1/100ᵉ de son poids d'acide acétique faible ou de vinaigre blanc très-fort ; cette opération a pour but de dissoudre la matière colorante jaune qui accompagne, comme nous avons dit, la matière colorante rouge des fleurs.

Lorsque le liquide qui s'écoule est à peu près incolore, on retire la masse du vase et on la pétrit avec son poids d'eau froide, contenant 15 pour 100 de carbonate de soude. On passe la liqueur à travers une toile serrée, et on soumet le résidu à la presse : après deux ou trois traitements successifs, le carthame est complétement dépouillé de son principe colorant et rejeté comme inutile.

On reçoit les liqueurs dans une cuve en bois très-propre et on y met des chiffons de laine et de coton qui s'imprègnent de toute la carthamine dissoute. On rince bien les linges dans l'eau pure et on les fait macérer dans de l'eau contenant 1/10ᵉ de son poids de carbonate de soude. Le principe colorant ne tarde pas à se dissoudre, on verse dans la solution de l'acide citrique pur et dissous jusqu'à cessation de précipité.

La carthamine se dépose sous la forme de flocons très-volumineux qui sont lavés à plusieurs reprises par décantation avec de l'eau froide. On recueille le précipité sur un filtre de papier joseph, sans plis, et on fait sécher à l'abri des rayons lumineux.

Par la dessiccation, le rouge de carthame acquiert un éclat métallique qui, vu en masse, est d'un beau vert; et en couches minces, d'un rouge pourpre magnifique. Il se comporte tout à fait comme un acide; ainsi il rougit la teinture bleue de tournesol et se dissout dans les alcalis en donnant des dissolutions incolores ou jaunâtres susceptibles de cristalliser. Il est insoluble dans l'eau et dans les acides ; l'alcool et l'éther le dissolvent en petite quantité : les liqueurs qui en résultent sont d'un rouge pourpre.

Le rouge de carthame est à un prix très-élevé dans le commerce, 1 kilog. de fleurs n'en donne pas plus de 6 à 7 grammes.

Son emploi est assez restreint ; outre qu'il ne fournit pas une couleur durable, il s'allie difficilement aux différents véhicules.

On en fait usage dans l'enluminure pour imiter les carnations. Les fabricants de fleurs artificielles trouvent souvent l'occasion de l'utiliser : il fournit, suivant son état de division et sa qualité, des tons rouges ou roses d'un très-grand éclat, et n'est pas vénéneux.

CARMIN DE COCHENILLE.

Le carmin est bien certainement la matière colorante qui se trouve dans le commerce sous le plus grand nombre de variétés. Il ne forme pas moins de 12 numéros qui représentent autant de nuances différentes, et, par une bizarrerie qu'on ne trouve pas ailleurs, c'est le n° le plus élevé, le n° 40, qui forme l'espèce la plus belle.

La découverte du carmin est attribuée à un moine fran-

ciscain de Pise. Homberg, en 1656, est le premier qui en fit connaître la préparation.

C'est un composé de carmine, principale matière colorante de la cochenille, isolée par MM. Pelletier et Caventou; d'une matière animale contenue également dans la cochenille, et enfin d'un acide ou d'un oxyde alcalin qui sert à déterminer la précipitation.

La préparation du carmin a été tenue secrète pendant de longues années; maintenant encore, beaucoup de fabricants se gardent bien de divulguer les procédés qu'ils emploient pour l'obtenir. Ce genre de fabrication est d'une délicatesse extrême et ne réussit bien que dans des mains très-exercées.

Ainsi, l'ouvrier doit saisir 1° le moment dans la précipitation où la couleur est la plus vive;

2° Choisir de préférence la cochenille noire ou fine qui contient le plus de matière colorante, et enfin prendre de l'alun exempt de fer;

3° Observer à l'égard des ustensiles la plus grande propreté;

4° Se servir, pour faire bouillir la cochenille, de vases de porcelaine, de verre ou de cuivre bien étamés;

5° Ne se servir que de l'eau de pluie ou de rivière, et mieux encore d'eau distillée, mais point d'eau de puits;

6° Ne filtrer les liqueurs que dans des linges qui ont été lavés avec de l'eau pure.

On trouve décrits, dans différents traités de chimie, les procédés suivants :

CARMIN ORDINAIRE.

On prend :

> Cochenille en poudre . 1,000.
> Carbonate de potasse. 30.
> Alun pulvérisé 60.
> Colle de poisson. 30.

On fait dissoudre le carbonate de potasse dans une chaudière de cuivre contenant 20 litres d'eau ; on modère l'ébullition par de l'eau froide. Après une ébullition de quelques minutes, on enlève la chaudière du feu, et on la place sur une table, en l'inclinant de manière à pouvoir transvaser commodément la liqueur.

On y délaye l'alun pulvérisé et on remue le tout avec précaution ; par l'addition de ce dernier, la liqueur, auparavant d'un rouge cendré foncé, prend une couleur rouge très-vive de carmin : on laisse le tout reposer pendant un quart d'heure : pendant ce temps la cochenille s'est complétement déposée au fond du vase, et la liqueur est tout aussi claire que si elle avait été filtrée ; on la décante alors dans une autre chaudière de même capacité que l'on reporte sur le feu ; on y délaye la colle de poisson préalablement dissoute dans une grande quantité d'eau et passée au tamis de crin (1).

Aussitôt que la liqueur est en pleine ébullition, le car-

(1) Voici comment on prépare la dissolution de colle de poisson :
Après avoir coupé la colle de poisson en lanières très-minces, on la fait tremper dans l'eau froide pendant une journée ; elle se gonfle de manière à former une gelée très-consistante. On pilе dans un mortier, puis on délaye la masse dans de l'eau chaude, où elle ne tarde pas à se dissoudre.

min monte à la surface sous la forme d'écume. On enlève aussitôt la chaudière du feu et on agite la couleur avec une spatule, puis on l'abandonne à elle-même ; après quinze ou vingt minutes, le carmin est déposé : on tire la liqueur claire, on fait égoutter sur une toile de lin serrée et on fait sécher.

La liqueur d'où le carmin s'est précipité est très-fortement colorée en rouge, et peut être avantageusement employée à la préparation de la laque carminée.

Lorsque l'opération est bien conduite, on obtient du carmin très-beau qui se laisse facilement écraser sous les doigts lorsqu'il est sec.

PROCÉDÉ DIT DE L'ANCIENNE ENCYCLOPÉDIE FRANÇAISE.

On prend 20 grammes de cochenille, 2 grammes de graine de chouan (*abanasis tamariscifolia*, L.), 72 grammes d'écorce d'autour, et 1 gramme d'alun de roche. On réduit chacune de ces substances en poudre fine. On fait bouillir 1 kilogr. 500 grammes d'eau de rivière ou de pluie ; on y met, pendant qu'elle bout, la poudre de chouan, et on donne trois ébullitions, en agitant continuellement le liquide avec une spatule de bois ; on passe ensuite à travers une toile propre ; on remet le liquide sur le feu, et lorsqu'il est bouillant, on y ajoute la cochenille. Après trois ébullitions, on introduit l'écorce, et, après un bouillon, on y ajoute l'alun ; on verse alors la liqueur sur une toile tendue sur un vase plat de porcelaine ou de faïence, sans exprimer le linge ; on laisse le liquide rouge sept à huit jours en repos. On décante et on fait sécher

le sédiment au soleil ou dans une étuve ; on le détache avec un pinceau ou avec une plume : c'est le carmin.

Dans un temps froid, le carmin ne se dépose pas ; le liquide forme une espèce de gelée et se gâte.

La cochenille restée sur la toile peut être mise en ébullition une seconde fois ; elle donne un carmin inférieur. Outre l'écorce d'autour et les graines de chouan, quelques personnes y ajoutent encore du roucou.

PROCÉDÉ ALLEMAND DIT PAR L'ALUN.

On fait bouillir 6 litres d'eau de rivière dans une bassine de cuivre ; on y projette 60 grammes de cochenille en poudre ; on remue bien ; après six minutes d'ébullition, on y ajoute 3 grammes d'alun en poudre, et l'on fait bouillir encore trois minutes. On ôte la bassine du feu ; on enlève la liqueur avec un siphon ; on filtre ou bien on décante, et on laisse la liqueur trois jours dans des vases de porcelaine : pendant ce temps, il se précipite une matière rouge que l'on sépare et que l'on fait sécher à l'ombre : On obtient ainsi du carmin assez beau.

La liqueur, au bout de trois autres jours, dépose encore une sorte plus inférieure de carmin ; mais on peut utiliser cette solution pour faire de la laque carminée.

PROCÉDÉ DIT PAR L'ALUN ET LE TARTRE.

Dans 512 grammes d'eau de rivière, qu'on chauffe jusqu'à l'ébullition, on ajoute 32 grammes de poudre de cochenille, puis 2 grammes de crème de tartre ; après huit minutes d'ébullition, on ajoute 3 grammes d'alun pulvérisé ;

on laisse bouillir encore une ou deux minutes; on retire du feu, on filtre et on laisse reposer tranquillement jusqu'à ce que le carmin se soit déposé; alors on décante et on fait sécher à l'ombre.

PROCÉDÉ CHINOIS DIT PAR L'ÉTAIN.

On fait bouillir 625 grammes de cochenille pulvérisée, et 3 ou 4 grammes d'alun dans un seau d'eau de rivière; après sept ou huit minutes d'ébullition, on retire la chaudière du feu, on filtre et on laisse reposer pendant quelque temps. On prépare d'un autre côté une eau régale avec 320 grammes de sel de cuisine et 500 grammes d'acide nitrique, dans laquelle on dissout 120 grammes d'étain de Malaca, réduit en grenailles; puis on verse cette dissolution goutte à goutte dans la décoction de cochenille, qu'on a réchauffée jusqu'à l'ébullition; le carmin ne tarde pas à se précipiter; on sépare le liquide par décantation, et on recueille le précipité sur un filtre qu'on fait sécher à l'ombre.

PROCÉDÉ DIT PAR LA LAQUE.

On fait un bain de cochenille avec

Cochenille 250 grammes.
Alun 1 kilogr.
Crème de tartre. 250 grammes.
Son de froment. 250 »

Toutes ces matières réduites en poudre sont versées dans une chaudière de cuivre étamée, contenant 20 litres d'eau en pleine ébullition : on y ajoute 500 grammes de

laine blanche. Lorsque cette dernière est d'une belle teinte rouge, on la retire du bain, on la laisse égoutter pendant quelques heures sur une claie d'osier, puis on la trempe encore humide dans une solution de potasse, rendue caustique par la chaux et parfaitement claire.

Voici ce qui se passe dans cette opération :

La potasse s'empare de la matière colorante rouge et d'une partie de l'alun combiné avec elle dans la première opération ; la liqueur rouge foncée qu'elle forme est filtrée, puis traitée par une dissolution d'alun jusqu'à cessation de précipité : on laisse reposer. Le carmin est lavé à plusieurs reprises par décantation, puis jeté sur un filtre où on le lave de nouveau avec de l'eau distillée ; on le fait sécher à l'ombre, comme nous avons déjà eu l'occasion de le dire.

Comme le bain de cochenille contient encore une grande quantité de matière colorante, on le traite par du carbonate de soude pour obtenir la laque carminée.

Le carmin possède la propriété d'être à peu près entièrement soluble dans l'ammoniaque caustique concentré, et de prendre, sous l'influence de cet agent, une teinte rouge plus belle.

Les arts se sont emparés de cette réaction pour préparer, soit de la cochenille ammoniacale qu'on livre dans le commerce en pâte ou en tablettes ; soit pour aviver la teinte du carmin ordinaire.

Voici comment on parvient à communiquer au carmin une teinte rouge très-riche :

Dans un flacon bouchant hermétiquement, on met du

carmin avec cinq ou six fois son poids d'ammoniaque caustique du commerce. Après plusieurs jours d'exposition au soleil, et en agitant sans cesse, on observe que l'alcali a dissout toute la matière colorante du carmin ; la liqueur rouge est filtrée, et on précipite par l'acide acétique et l'alcool : on lave avec de l'alcool faible, et on fait sécher à l'ombre.

Le carmin est la plus belle couleur rouge que nous possédions ; on l'emploie principalement pour la peinture en miniature, pour les aquarelles, pour la fabrication des fleurs artificielles, etc.

Dissous dans l'ammoniaque et abandonné à l'air libre jusqu'à ce que l'excès d'alcali soit volatilisé, il forme le carmin liquide dont les artistes font un fréquent usage.

LAQUE CARMINÉE.

La préparation de la laque carminée se lie de la manière la plus étroite à la préparation du carmin ; c'est en effet des liqueurs qui ont servi à obtenir cette substance qu'on retire le plus souvent la laque carminée.

Cette matière résulte de la combinaison d'une partie de la matière animale et du principe colorant de la cochenille avec l'alumine.

Dans l'origine, la laque carminée, dont la découverte remonte à une époque très-éloignée de nous, se préparait à Florence et à Venise avec le kermès (*coccus ilicis*), insecte de l'ordre des hémyptères. Vers l'année 1686, on remplaça le kermès par la cochenille. C'est postérieurement qu'on en prépara à Vienne et à Paris, d'où les noms de

laque de Vienne et de Paris qu'on lui donne quelquefois.

Le principe colorant de la cochenille possède pour l'alumine une attraction qu'on ne retrouve pas à un aussi haut degré dans les autres matières colorantes végétales. Aussi, les plus belles laques s'obtiennent-elles en délayant des proportions déterminées à l'avance d'alumine dans une dissolution de carmin.

Les conditions essentielles pour obtenir une laque carminée d'un ton très-riche, consistent :

A choisir, comme pour le carmin, la cochenille variété noire ou grise ;

A opérer avec une décoction de cochenille chargée, autant que possible, de principe colorant et de matière animale ;

N'employer que de l'alumine bien lavée et de l'alun complétement privé d'oxyde de fer.

Nous allons maintenant faire connaître le mode opératoire qu'on suit le plus ordinairement lorsqu'on se sert de cochenille non déjà travaillée.

On fait bouillir pendant vingt minutes ou une demi-heure 20 parties de cochenille réduite en poudre fine, 10 parties de crème de tartre avec 400 ou 500 parties d'eau pure. Lorsque la décoction est achevée, on la filtre, et dans la liqueur filtrée on verse une solution contenant 300 parties d'alun et une très-petite quantité de proto-chlorure d'étain.

Après quelques instants de repos, il se forme un précipité peu abondant, il est vrai, mais d'une teinte excessivement riche. On recueille cette laque à part et on lui assigne un numéro particulier.

Dans la liqueur, on verse par petites portions à la fois, et en agitant sans discontinuer, une solution de carbonate de potasse selon la nuance qu'on veut obtenir.

Le précipité, lavé à plusieurs reprises avec de l'eau bouillante, est jeté sur un filtre, converti en trochisques, puis séché à une basse température.

Nous avons dit ailleurs que la décoction de cochenille d'où le carmin s'est précipité contenait encore une grande quantité de principe colorant.

Lorsqu'on verse une dissolution d'alun dans cette liqueur, ou bien lorsqu'on y délaye une certaine quantité d'alumine récemment précipitée, on obtient dans l'un et l'autre cas une laque d'autant plus belle qu'on a moins employé d'alun ou d'alumine. Si l'opérateur ne trouve pas que la nuance soit assez riche, il ajoute quelques grammes de protochlorure d'étain qui sert à aviver la teinte. Le précipité est lavé et converti en trochisques, puis séché. Les laques carminées de qualités inférieures contiennent, outre de l'oxyde d'étain, des quantités plus ou moins considérables d'amidon qui sert à leur donner plus de corps, et disons aussi le mot, pour les allonger.

Les laques qu'on obtient avec les bois colorants possèdent assez de ressemblance avec certaines variétés de laque carminée pour qu'on ait pensé à les mélanger dans le commerce.

Des expériences auxquelles je me suis livré pour reconnaître ce genre de falsification, il résulte que les acides minéraux, les alcalis et les chlorures décolorants réagissent sur elles à peu près de la même manière. On remarque cependant que les acides concentrés

convertissent la plus grande partie de la laque carminée en une matière rouge poisseuse. Les laques de bois rouges ne présentent rien de semblable. Mais nous avons trouvé un autre moyen qui permet, dans l'espace de quelques instants et d'une manière très-sûre, de déceler ce genre de fraude.

Les laques carminées et de bois colorants délayées dans une petite quantité d'eau distillée bouillante donnent des liqueurs d'un rouge vif que le perchlorure de fer fait virer au rouge-brun sale.

Si on fait bouillir ces laques avec quelques cristaux d'acide oxalique, on observe que les premières reprennent leur couleur rouge primitive, tandis que les secondes passent au jaune foncé.

Lorsqu'on a affaire à un mélange de ces deux espèces de laques, la solution, après le traitement par l'acide oxalique, prend une teinte rouge verdâtre d'autant moins vive que les laques de bois existaient en plus grande quantité.

La laque carminée est souvent employée pour le tableau et pour la décoration. C'est une couleur complétement inoffensive qui fournit une peinture assez belle et assez solide. Mais elle a besoin pour cela d'être de bonne qualité.

POURPRE DE CASSIUS.

André Cassius, médecin à Hombourg, qui vivait dans le dix-septième siècle, remarqua qu'en plongeant une lame d'étain dans une solution de chlorure d'or, il se produisait

une poudre pourpre dont il ne fit jamais connaître le mode de préparation.

D'après quelques auteurs, d'autres alchimistes, tels que le prêtre Florentin Neri, Glauber et Kunkel, avaient connaissance de la production de cette substance ; mais la manière de l'obtenir n'a été publiée pour la première fois que par le fils de Cassius, dans l'année 1681, qui lui a donné le nom sous lequel on la connaît encore aujourd'hui.

Le pourpre de Cassius à l'état humide est brun foncé ; desséché et en masse, il est brun clair ; sa poudre est bleuâtre ; chauffé à une haute température, il perd de l'eau, mais la couleur ne s'altère pas. La plupart des acides le décomposent. L'alcali volatil le dissout seulement, surtout lorsqu'il est à l'état humide. La potasse et la soude sont sans action sur lui. Il se dissout dans le verre fondu qu'il colore en rouge rose ou en rouge rubis foncé, suivant la quantité qu'on y ajoute.

Le pourpre de Cassius a été examiné par un grand nombre de chimistes. Pendant très-longtemps il n'existait aucune donnée pour l'obtenir pur et d'une nuance toujours identique. Fucks est le premier qui ait indiqué le moyen de le préparer d'une manière rationnelle, en versant du bichlorure d'or dans du protochlorure d'étain. C'est seulement à partir de cette époque que les chimistes entreprirent de faire connaître sa composition chimique. Tous les travaux exécutés dans ce but ne conduisirent pas à des résultats satisfaisants; lorsqu'il y a quelques années, M. Louis Figuier, par des expériences très-concluantes, arriva à démontrer que cette substance était un

stannate de protoxyde d'or, dont la formule chimique est :

$$\underbrace{3\,(SnO^2)}_{\text{Acide stannique.}} + \underbrace{Au^2O}_{\text{Oxyde d'or.}} + \underbrace{4HO}_{\text{Eau.}}$$

M. Figuier a comparé les divers modes de préparation indiqués jusqu'à ce jour, et il a observé qu'au moyen du procédé suivant, on obtenait toujours un produit de composition définie.

On prépare du bichlorure d'or en faisant dissoudre 20 grammes d'or dans 100 parties d'eau régale, faite avec 4 parties d'acide chlorydrique et 1 partie d'acide nitrique. On évapore au bain-marie jusqu'à siccité pour chasser l'excès d'acide. Le chlorure d'or formé est dissous dans trois quarts de litre d'eau environ. Dans la liqueur filtrée on introduit de l'étain en grenaille, parfaitement pur. Au bout de quelques minutes, la liqueur se trouble et brunit. Après quelques jours de repos, tout le sel d'or se trouve précipité à l'état de stannate, qu'on sépare par décantation de l'étain non attaqué. On recueille le produit sur un filtre sans plis, on lave avec soin et on dessèche à une douce chaleur.

La décantation des liqueurs doit se faire avec beaucoup de précaution, car au fond du vase on trouve toujours des particules d'étain sous forme d'une poudre noire pesante qui se mélange au pourpre : mais comme ce dernier est plus léger, on parvient à le séparer par décantation. La poudre noire d'étain, contenant une petite quantité d'or, est employée pour une autre opération.

Il arrive quelquefois que le pourpre reste en suspension

dans la liqueur; pour l'en précipiter, il suffit de décanter pour séparer l'étain, ajouter une petite quantité de sel marin et chauffer légèrement.

Obtenu de la sorte, le pourpre de Cassius possède une composition toujours identique et une teinte pourpre fort belle. Mais la quantité n'est jamais aussi considérable que par le procédé suivant, indiqué par M. Buisson, procédé qui exige de la part de celui qui l'exécute une très-grande habileté.

On prépare du protochlorure d'étain en faisant dissoudre une partie d'étain en grenailles dans une quantité suffisante d'acide chlorhydrique. D'une autre part, on fait du bichlorure d'étain en dissolvant 2 parties d'étain dans de l'eau régale composée de 3 parties d'acide nitrique et 1 partie d'acide chlorhydrique. On fait chauffer pour chasser la plus grande partie de l'acide en excès. On dissout 7 parties d'or dans de l'eau régale composée de 1 partie d'acide nitrique et 6 parties d'acide chlorhydrique. On fait encore bouillir pour chasser l'excès d'acide; la dissolution d'or est étendue de 3 litres 1/2 d'eau; on ajoute la dissolution de bichlorure d'étain, et enfin celle de protochlorure d'étain. Cette dernière est versée goutte à goutte jusqu'à ce que le précipité ait acquis la teinte pourpre. Il est très-important de s'arrêter lorsque le précipité a pris son maximum d'intensité, car un excès de protochlorure d'étain lui ferait prendre une teinte brune.

Le produit, lavé avec soin par décantation, est séché dans une étuve à une basse température.

Le pourpre préparé par ce dernier procédé n'a pas, comme celui de M. Figuier, une composition définie.

Outre l'acide stannique et l'oxyde d'or combinés ensemble en proportion variable, il contient toujours de l'acide stannique et du protoxyde d'étain à l'état de mélange.

Cette couleur est très-rarement employée pour la peinture à l'huile ; cependant, quelques artistes la font servir à la peinture en miniature ; son usage est beaucoup plus fréquent pour la peinture sur porcelaine et sur verre.

VIOLET VÉGÉTAL.

La matière colorante du bois de campêche (hématoxyline) prend, par son mélange avec les sels de plomb, une teinte violette fort belle que l'on utilise pour la fabrication d'une couleur employée dans l'enluminure sous le nom de *violet végétal*.

On l'obtient de la manière suivante :

On prend 600 grammes de bois de campêche qu'on fait bouillir pendant une demi-heure dans 5 litres d'eau ; lorsque la décoction est refroidie, on la passe à travers un linge fin.

D'une autre part, on fait une solution de 300 grammes d'alun dans un litre d'eau chaude ; on y ajoute 250 grammes d'acétate de plomb cristallisé et dissous dans la plus petite quantité d'eau possible. Il se forme, par suite de la décomposition des deux sels, du sulfate de plomb qui se précipite, et de l'acétate d'alumine qui reste en dissolution ; mais comme le sel de plomb s'y trouve en quantité plus que suffisante, par rapport au sel d'alumine, il en résulte que le liquide contient encore une notable quantité d'acétate de plomb.

On mélange 100 parties de la décoction de bois de campêche avec 10 parties de la solution saline, puis on ajoute une solution de gomme arabique en quantité variable, selon la teinte que l'on cherche à produire.

Cette couleur n'est pas employée à l'état sec, car la chaleur lui fait perdre une partie de ses propriétés ; mais comme elle ne peut se conserver pendant longtemps à l'état liquide, les coloristes la préparent au moment de s'en servir, en mélangeant des volumes égaux de décoction de campêche et de dissolution saline.

Le violet végétal est une fort belle couleur qui ne doit pas être exposée aux rayons lumineux ; elle possède une teinte violette qu'on ne retrouve pas dans les autres substances de même nature, et enfin, elle est tout-à-fait inoffensive.

CHAPITRE IV

COULEURS BRUNES

BRUN DE MANGANÈSE.

Les analyses des anciennes peintures romaines démontrent que l'oxyde de manganèse était connu alors, et qu'on l'employait pour obtenir la nuance brune.

A ce sujet, nous avons fait quelques expériences qui nous permettent d'avancer que le bioxyde de manganèse, MnO^2, donne, avec l'huile, une teinte brune très-belle et très-solide.

Si cet oxyde devait prendre place un jour parmi les produits destinés à la peinture, voici comment je conseillerais de l'obtenir à très-bas prix.

Le protochlorure de manganèse provenant de la prépa-

ration des chlorures d'oxydes, ou bien le protosulfate obtenu par la calcination du peroxyde de manganèse avec le sulfate de fer, est dissous dans une certaine quantité d'eau et soumis à une température de 30 à 40° $+$ O.

On verse dans cette liqueur du chlorure d'oxyde de sodium (chlorure de Labarraque) ou de potassium (eau de javelle), contenant une petite quantité de carbonate de soude, jusqu'à ce que le précipité qui se forme ne change plus de teinte.

Lorsqu'on juge que tout le protosel de manganèse a été suroxydé, on décante et on lave le précipité avec de l'eau aiguisée d'acide sulfurique (1 partie d'acide pour 50 d'eau), puis avec de l'eau ordinaire, jusqu'à ce qu'elle en sorte insipide; le bioxyde de manganèse, qui prend naissance dans cette circonstance, recueilli et séché à la température de l'étuve, se présente sous la forme d'une poudre brune foncée, impalpable, d'une teinte très-riche, couvrant aussi bien que le blanc de zinc, et enfin nullement vénéneuse.

BRUN VANDICK.

Le brun Vandick, dont la peinture à l'huile fait un si fréquent usage, possède, suivant la manière de le préparer, deux compositions bien distinctes.

Dans le premier cas, c'est de l'ocre jaune provenant du midi de la France et de l'Italie que l'on calcine à plusieurs reprises différentes, afin de lui donner la teinte désirée; il porte alors, dans le commerce, le nom de brun Vandick ordinaire, et se vend en morceaux ou bien en grains et en poudre impalpable; il est composé d'argile et de sable

colorés par de l'oxyde de fer ; aussi les acides ont-ils peu d'action sur lui. Dans le second cas, c'est du colcothar auquel on a fait subir plusieurs calcinations pour lui communiquer une teinte brune particulière ; cette qualité porte dans les arts le nom de la localité où on le prépare : ainsi, on connaît les bruns Vandick de Suède et d'Angleterre. L'un et l'autre proviennent de la calcination du sulfate de fer à une très-haute température. Comme il est uniquement formé d'oxyde de fer, sa dissolution, dans les acides concentrés et bouillants, s'effectue avec la plus grande facilité.

Le commerce a peu d'intérêt à falsifier le brun Vandick provenant de la calcination des terres avec celui que l'on retire de la calcination du sulfate de fer : leur prix, à l'état brut, est à peu de chose près le même ; mais comme ce dernier est plus difficile à réduire en poudre, il possède dans cet état une valeur pécuniaire beaucoup plus grande que le second. L'action différente des acides, sur ces deux qualités, permet aisément de reconnaître la fraude.

Le brun Vandick s'emploie à l'eau, mais principalement à l'huile, et fournit une couleur nullement vénéneuse, et certainement la plus solide que nous possédions.

BRUN DORÉ DE PLOMB.

Le bioxyde de plomb, de même que le bioxyde de magnésie, est susceptible, lorsqu'il est bien préparé, de fournir à la peinture une couleur fort belle et d'une solidité à toute épreuve.

Il a pour formule chimique :

$$\underbrace{Pb}_{\text{Plomb.}} + \underbrace{O^2}_{\text{Oxygène.}}$$

Un industriel a conseillé de l'obtenir de la manière suivante :

On prend une certaine quantité de litharge, de minium ou de mine orange réduits en poudre très-fine, qu'on place dans une chaudière sur un fourneau, et on y verse immédiatement, par petites portions, à la fois et en agitant sans cesse du chlorure d'oxyde de sodium, ou bien encore de l'eau de javelle.

Lorsque la matière a acquis une teinte brune, on la lave par décantation avec de l'eau chaude, puis on fait sécher à la manière ordinaire.

Des expériences nous ont montré qu'avec la céruse, on obtenait un produit d'une plus belle qualité. Voici comment nous opérons :

On prend 20 kilogr. de belle céruse parfaitement pure, on la délaye dans une petite quantité d'eau contenant 1 kilogr. de cristaux de soude ; on jette la bouillie qui en résulte sur un tamis, afin de séparer les parties les plus grossières ; on place le tout dans une bassine, et on chauffe doucement. Après quelques instants de contact, on verse peu à peu, et en remuant continuellement, du chlorure d'oxyde de sodium (liqueur de Labarraque) qui fait passer tout le protoxyde de plomb à l'état de bioxyde.

Lorsque celui-ci a acquis une teinte brune très-foncée, on n'ajoute plus de chlorure, on laisse former le dépôt, on lave à plusieurs reprises avec de l'eau chaude, puis on

y verse 1 kilogr. d'acide nitrique du commerce pour dissoudre tout le protoxyde de plomb qui a échappé à l'oxydation. Il se produit du nitrate de plomb soluble, que l'on peut convertir de nouveau en céruse, par le moyen du carbonate de soude. Le précipité est lavé jusqu'à ce qu'il ait perdu toute saveur acide, et enfin séché à l'étuve.

Par ce procédé, le brun doré de plomb revient à un prix un peu plus élevé, mais sa teinte est beaucoup plus belle.

Cette couleur mérite, à tous égards, d'être mieux connue dans son emploi. Elle est toujours en poudre impalpable, et jouit de toutes les qualités de la céruse. Elle est vénéneuse au même titre que cette dernière.

TERRE D'OMBRE.

La terre d'Ombre tire son nom de l'Ombrie, province des États romains, d'où on la faisait venir anciennement; mais il paraît que toute celle qu'on trouve dans le commerce a une autre origine; on la fait venir de l'île de Chypre, où elle porte le nom de *terre fine de Turquie.*

Elle se présente en fragments bruns, happant à la langue; d'un aspect gras à l'intérieur, sa cassure est conchoïde et à bords obtus. Elle tache fortement le papier et se délaye facilement dans l'eau. Lorsqu'elle a été dépouillée par le lavage des matières étrangères qui la souillent, elle est en fragments rectangulaires ou bien en poudre brune légère, d'une teinte très-belle, mais qui a le défaut de rougir à l'air.

La terre d'Ombre, d'après Klaproth, est formée de :

 Oxyde de fer hydraté. 48.
 Oxyde de manganèse.. 20.
 Silice................ 13.
 Alumine 3.
 Eau 14.
 98.

Les arts l'emploient à l'état naturel et à l'état calciné.

Exposée à l'action de la chaleur, elle prend une teinte brune rougeâtre; tout l'oxyde de fer se déshydrate, et l'oxyde de manganèse se suroxyde ; si on élève la température au rouge sombre, pendant un certain temps, elle se ramollit et finit par fondre.

Cette couleur est rarement employée seule; elle se mélange très-bien avec les autres substances colorantes. On en fait usage comme couleur d'application avec la chaux délitée, et elle conserve très-longtemps sa nuance. Elle n'est pas vénéneuse.

On la désigne quelquefois sous le nom de bistre, mais nous ferons voir qu'elle en diffère assez.

TERRE DE SIENNE.

La terre de Sienne nous vient des environs de Sienne, ville du grand-duché de Toscane.

Sa composition chimique est encore inconnue ; on sait seulement que l'oxyde de fer hydraté entre pour la plus grande partie dans sa constitution.

Le commerce la connaît : 1° à l'état naturel, entière et

en poudre, 2° brûlée ou calcinée, entière et en poudre.

La terre de Sienne naturelle et entière se présente sous la forme de morceaux d'inégale grosseur ; elle est d'un jaune foncé à l'extérieur et jaune clair à l'intérieur. Frottée avec l'ongle, elle prend une espèce de poli ; l'action de l'air paraît avoir sur elle une action très-grande, car, lorsqu'elle est réduite en poudre, elle prend une teinte jaune olive.

La terre de Sienne calcinée et entière n'a pas une teinte homogène dans toutes ses parties. Elle est en général rouge foncé, mais elle offre à l'œil beaucoup de points d'un rouge plus clair ; réduite en poudre, elle possède une teinte rouge foncé particulière que les peintres recherchent beaucoup, surtout pour la peinture en bâtiment, pour imiter la nuance et les veines du bois d'acajou. Elle est sans action sur l'économie animale et se mélange assez bien aux autres couleurs.

TERRE DE COLOGNE.

A Bruhl et à Liblar, près de Cologne, on trouve dans les terrains sédimentaires où elle forme des couches d'une étendue quelquefois très-considérable et d'une épaisseur de 7 à 8 mètres, une substance que l'on peut considérer comme intermédiaire entre le bois et le charbon de terre. C'est le lignite ferreux ou pulvérulent que, dans le commerce, on désigne sous les noms de *terre de Cologne* et de *terre de Cassel*.

Comme cette matière a encore porté le nom de *terre d'Ombre de Cologne,* certains auteurs ont cru que la terre d'Ombre proprement dite et la terre de Cologne n'étaient

qu'une seule et même substance. Cette confusion, qui n'existe pas dans le commerce, ne peut être permise en présence de leur composition chimique différente, car la véritable terre de Cologne peut être regardée comme du bois en décomposition avancée, tandis que la terre d'Ombre est une argile silicieuse ferro-manganifère.

Telle qu'on l'extrait de la mine, la terre de Cologne est en masse terreuse à grains fins, friable, douce au toucher, presque aussi légère que l'eau, d'un noir brunâtre, souillée par une certaine quantité de sable et de bois non décomposé.

Exposée à l'action de la chaleur, elle brûle à la manière de l'amadou, en répandant une odeur résineuse désagréable et en laissant 2 % environ de son poids de cendre blanche.

Pour l'approprier aux besoins de la peinture, on la délaye dans de l'eau et on la sépare par décantation des substances étrangères qui se précipitent les premières, on en forme dans des vases des cônes tronqués qu'on livre au commerce, ou bien encore on la réduit en poudre ou en trochisques. Elle fournit, pour la peinture en détrempe et à l'huile, une couleur brune très-belle, très-solide et inoffensive.

Sa composition se représente ainsi :

> Charbon.............. 37,40.
> Cendres.............. 5,70.
> Matière volatile liquide. 31,30.
> Matière volatile gazeuze. 25,60.
> —————
> 100,00.

BRUN DE PRUSSE.

Lorsqu'on chauffe du bleu de Prusse à l'abri du contact de l'air, on obtient du carbure de fer ou *noir de bleu de Prusse*. Mais si, pendant la calcination, l'oxygène de l'air intervient, on observe que le bleu de Prusse brûle comme de l'amadou ; une partie du fer passe à l'état d'oxyde rouge, tandis que l'autre se convertit en carbure de fer. C'est le mélange de ces deux substances qui forme le brun de Prusse.

Cette couleur, qui a été inventée par le peintre Tœffer, s'obtient, d'après M. Bouvier, de la manière suivante :

« Mettez sur un feu assez vif une cuiller de fer, faites-
« la rougir, jettez-y quelques morceaux de bleu de Prusse
« de la grosseur d'une noisette à peu près ; bientôt chaque
« morceau éclatera de lui-même et se réduira en écailles
« à mesure qu'il s'échauffera, jusqu'à devenir rouge lui-
« même. Retirez la cuiller du feu et faites-la refroidir ; si
« vous la laissiez plus longtemps sur le feu, vous n'auriez
« pas la teinte désirée. Quand vous concasserez la couleur,
« il s'y trouvera des parties noirâtres et d'autres brunes
« jaunâtres ; c'est précisément ce qu'il faut. Broyez le tout
« ensemble, il en résultera un brun couleur de bistre ou
« d'asphalte fort transparent. »

On peut reprocher à cette couleur de n'être jamais d'une teinte uniforme ; elle est d'autant plus foncée que la chaleur aura été plus vive et qu'on aura mis moins de temps pour arriver à la température rouge.

C'est du reste une fort bonne et assez belle couleur, qui

se marie très-agréablement. Elle est très-solide et très-fixe, couvre très-bien et sèche plus promptement que la plupart des autres couleurs transparentes et légères.

Le brun de Prusse convient pour tous les genres de peinture et n'est pas vénéneux.

BITUME.

Pour obtenir la nuance momie, les peintres emploient quelquefois le *bitume* ou *asphalte*.

Cette substance est un produit naturel qui nous vient de la mer Morte ou lac Asphaltite, en Judée. On la trouve flottant à la surface de l'eau.

L'origine du bitume est encore peu connue ; d'après quelques auteurs il proviendrait de la décomposition de certains végétaux enfouis dans la terre : d'autres pensent qu'il est le produit de la distillation lente, à une basse température, des amas de houille ; enfin quelques minéralogistes lui attribuent une origine volcanique.

Le bitume, tel qu'on le trouve dans le commerce de la droguerie, est solide, friable, opaque, noir avec une teinte brune, d'une odeur dite bitumineuse qui se manifeste surtout par le frottement ou par l'action de la chaleur. Comme il est composé d'une très-grande quantité de carbone et d'hydrogène et d'une petite quantité d'oxygène, il s'enflamme très-facilement et brûle avec une flamme longue fuligineuse, en donnant beaucoup de noir de fumée, qui a la plus grande analogie avec le noir de fumée de houille.

Le bitume se réduit assez facilement en poudre. Le commerce le livre en morceaux, en poudre ou bien broyé à

l'huile. Il entre dans la composition des vernis noirs ; certains auteurs affirment qu'il fait partie du beau vernis chinois qu'on nomme laque.

BISTRE.

Le bistre est une couleur brune que l'on retire de la suie de certains bois, particulièrement de celui de hêtre ; on le confond quelquefois dans le commerce avec la terre d'Ombre.

Voici comment on le prépare :

Les morceaux de suie les plus brillants et les plus durs sont pulvérisés et passés à travers un tamis de soie. On verse sur la poudre une certaine quantité d'eau chaude, et on laisse macérer pendant vingt-quatre heures environ, en agitant sans cesse. On lave à plusieurs reprises par décantation, jusqu'à ce que l'eau n'ait plus de couleur ; on jette le précipité sur un filtre, ou bien on sépare par décantation les parties fines. Lorsqu'il est encore à l'état de pâte, on le délaye dans de l'eau gommée et on le porte à l'étuve. Lorsque la matière possède la consistance de la cire molle, on la retire pour la livrer au commerce. Dans cet état le bistre se délaye assez bien dans l'eau ; mais si on a poussé trop loin l'évaporation, il éprouve quelque difficulté à faire corps avec l'eau.

Le bistre n'est pas employé dans la peinture à l'huile, mais il est excellent pour la peinture à l'eau ; souvent on le préfère à l'encre de Chine pour les teintes plates.

ULMINE.

On a proposé dans ces derniers temps pour la peinture fine, et principalement pour la miniature, la matière brune qu'on obtient lorsqu'on abandonne pendant un certain temps de la potasse caustique avec de l'alcool concentré.

Cette couleur, à laquelle les chimistes ont donné le nom d'*ulmine*, prend naissance toutes les fois que les alcalis ou les acides concentrés sont mis au contact des substances organiques non azotées.

Elle a été indiquée pour la première fois comme matière colorante par M. Duménil. Voici comment on l'obtient :

On chauffe dans un matras une certaine quantité de potasse caustique réduite en poudre avec de l'alcool pur et très-concentré. La liqueur, après quelques heures, brunit fortement et dépose une poudre très-fine. Lorsqu'on juge que l'alcali ne réagit plus, on l'étend d'eau froide contenant de l'acide chlorhydrique en quantité suffisante pour saturer complétement la potasse. On jette sur un filtre, et on lave le précipité tant que les eaux de lavage possèdent une réaction acide. On recueille ensuite le produit qu'on fait sécher à la température de l'étuve.

Mais cette substance peut se préparer par des moyens beaucoup plus simples; ainsi en traitant la tourbe, la fibre ligneuse (le coton), les lignites, par les alcalis; ou bien encore en chauffant du sucre, de la fécule avec des acides concentrés, on l'obtient en quantité plus considérable et d'une qualité pour le moins aussi belle.

Un autre procédé moins dispendieux que nous avons eu l'occasion de mettre en pratique, et qui donne un produit d'une teinte brune très-riche, consiste à traiter le bistre surfin (suie des cheminées réduite en poudre fine) par de la potasse caustique ; la poudre qu'on obtient de la sorte, lavée avec de l'eau acidulée par de l'acide chlorhydrique, recueillie et séchée, ne le cède en rien à celle de M. Duménil.

L'ulmine est une belle couleur qui s'étend assez bien sous le pinceau, s'alliant très-bien aux autres matières colorantes, et enfin nullement vénéneuse.

BRUN DE CHICORÉE.

La racine de chicorée brûlée dans des appareils *ad hoc*, réduite en poudre fine, bouillie pendant quelques heures avec de l'eau, fournit une liqueur qui, évaporée à l'étuve dans des assiettes, donne la couleur chicorée.

Cette matière possède une teinte brune d'autant plus foncée que la racine a été plus chauffée. Lorsqu'elle a été bien préparée, elle fournit pour le paysage à l'aquarelle, et pour terminer les premiers plans, une couleur d'un ton très-riche et d'une grande solidité. Mais étant très-soluble dans l'eau, elle présente l'inconvénient de ne pouvoir supporter une autre couleur sans se détacher d'une manière plus ou moins complète ; elle ne peut, sous ce rapport, servir aux coloristes que dans des cas excessivement rares.

Il se peut qu'en formant une laque avec ce principe colorant, on parvienne à lui donner plus de fixité.

SÉPIA.

La sèche (*sepia officinalis, ioligo et tunicata*) mollusque céphalopode très-commune dans la Méditerranée, l'Adriatique, l'océan Atlantique et la Manche, possède près du cœur une vessie remplie d'une liqueur brune ou noire qui, desséchée, fournit la couleur brune connue sous le nom de *sépia*.

Au dire d'Aristote, cette liqueur sert à l'animal à troubler l'eau qui l'environne pour échapper à la poursuite de ses ennemis.

La sépia, lorsqu'elle est fraîche, ne tarde pas à entrer en putréfaction; aussi les pêcheurs ont-ils l'habitude de faire sécher le plus vite possible les vessies au soleil. Ils en forment des espèces de chapelets qu'on livre à l'industrie.

Dans le commerce de la droguerie, on la trouve en nature ou en poudre impalpable.

Voici comment on obtient cette seconde sorte :

Le suc épaissi, retiré de son enveloppe, est réduit en poudre fine, broyé avec une solution concentrée de carbonate de potasse ; on fait bouillir pendant 20 minutes environ ; on filtre la liqueur et on sature l'alcali par un acide. Arrivé à ce point, la matière colorante se dépose ; on lave par décantation, puis on la jette sur un filtre où on achève les lavages, et enfin on la fait sécher à une douce chaleur.

Dans cet état, la sépia se présente sous la forme d'une poudre brune presque noire, impalpable, insoluble dans

l'eau et l'alcool ; l'éther sulfurique la dissout en partie ; les alcalis caustiques la dissolvent sans l'altérer ; les acides étendus d'eau ont peu d'action sur elle ; cependant, l'acide nitrique la décolore sensiblement.

La nature de la sépia n'a encore été l'objet d'aucun examen chimique : on sait seulement qu'elle contient de la gélatine, du phosphate de chaux et quelques autres terres. De Blainville croit qu'elle doit sa couleur à une matière animale qui a quelque analogie avec la matière urinaire. Quelques zoologistes trouvent qu'elle ressemble beaucoup à la matière brune qui existe dans le pigmentum de l'œil.

La sépia est une couleur fort belle et très-solide ; on ne l'emploie guère que pour la peinture élégante et toujours à l'eau ; elle n'est pas vénéneuse et présente l'avantage sur l'encre de Chine, de sécher moins vite.

Il est rare que les tons bruns s'obtiennent sans mélange. Les couleurs les plus solides se préparent en combinant le brun Vandick avec le noir de fumée ou le noir d'ivoire fin. M. Serbat a fait l'expérience qu'en mêlant en proportions variables de l'ocre rouge, du bioxyde de manganèse et du brun Vandick, on obtenait des bruns d'une très-grande solidité et qui ne nécessitaient pas l'addition de siccatifs. Ce mélange jouit de tous les avantages d'une bonne couleur et n'est pas vénéneux.

CHAPITRE V

COULEURS NOIRES

CHARBON VÉGÉTAL.

Les différentes espèces de charbons qui proviennent de la combustion des substances organiques et organisées ; les noirs de fumée qu'on retire de certains végétaux et de la houille, sont constitués par une seule et même substance, le *carbone,* dans un plus ou moins grand état de pureté.

L'usage a consacré le nom de charbon au produit fixe qui résulte de la combustion en vase clos des bois non résineux et de certaines parties d'animaux (os, rognures d'ivoire); et celui de noir de fumée au carbone entraîné par la vapeur qui provient de la combustion incomplète des matières résineuses, bitumineuses ou grasses ; cette

fumée, en se refroidissant, laisse déposer le carbone partout où il trouve un point fixe.

NOIR DE CHARBON.

Le bois et les matières animales, chauffés en vase clos, éprouvent différentes modifications dans leurs molécules, qui ont pour but de mettre une partie du carbone à nu, et de laisser échapper, sous forme de gaz, divers produits de composition très-complexe, dans lesquels on remarque plus particulièrement du goudron, de l'acide acétique, de l'esprit de bois, des carbures d'hydrogène et des gaz ammoniacaux.

La nature du bois influe beaucoup sur celle du charbon qui en provient. Ainsi, lorsqu'il est dense, il fournit un charbon lourd et pesant. Les bois blancs, au contraire, donnent toujours du charbon léger. Le rendement en charbon varie avec le bois employé. Ainsi, pour ceux qui nous occupent, on trouve que :

Le bois de hêtre donne 35 à 36 p. % de carbone.
Le bois de vigne, de... 36 à 37 —
Le liége, de.............. 62 à 65 —

Les matières animales qu'on utilise pour la fabrication du charbon animal, sont les rognures de l'ivoire mises au rebut par les tabletiers, ou bien les os des grands animaux.

Le mode de carbonisation de ces matières est le même que pour la préparation du charbon végétal : les gaz qui se dégagent sont tout à fait différents ; ils sont beaucoup plus combustibles. La température n'a pas besoin d'être aussi élevée ; car dès que les gaz s'enflamment, la

chaleur produite devient assez forte pour continuer la carbonisation.

CHARBONS VÉGÉTAUX.

NOIR DE PÊCHE.

Les noyaux de pêches, d'abricots, d'amandes, brûlés en vase clos, donnent le noir de pêche ; couleur d'un assez beau noir, dense, très-employée par les Anglais, qui la broyent avec l'huile et la céruse pour obtenir la teinte vieux-gris ou *old Gray*.

NOIR DE HÊTRE.

Les jeunes rameaux du hêtre, coupés en morceaux menus et brûlés de la même manière, fournissent un charbon léger qui, mélangé à la céruse et à l'huile, donne le *bleu de hêtre*, couleur gris-d'argent, tirant sur le bleu. Ce noir est très-estimé.

NOIR DE LIÉGE.

Ce charbon, nommé encore *noir d'Espagne*, provient de la carbonisation, à l'abri du contact de l'air, des rognures de liége : c'est le plus léger de tous ceux que l'on connaît.

NOIR DE VIGNE.

Le charbon de vigne s'obtient comme les précédents, avec de jeunes pousses de vigne. Sa teinte est bleuâtre ; il est généralement regardé comme le plus beau de tous les noirs. Son éclat est d'autant plus grand qu'il est en

poudre plus fine ; broyé à l'huile avec le blanc-d'argent, il donne la nuance gris-d'argent.

NOIR DE CHATAIGNE.

Les enveloppes vertes et brunes de châtaignes donnent un charbon noir très-fin, que l'on emploie quelquefois en Allemagne pour la peinture à l'huile et à l'eau.

NOIR DE FRANCFORT.

Le noir de Francfort, qu'il ne faut pas confondre avec le noir d'Allemagne, dont nous ferons connaître plus bas la préparation, s'obtient par la calcination en vase clos de la lie de vin, préalablement débarrassée par des lavages à l'eau du tartrate de potasse qu'elle contient. Ce charbon est d'un beau noir, doux et d'un aspect velouté.

NOIR D'ALLEMAGNE.

Ce charbon, qu'on emploie surtout dans l'imprimerie en taille-douce, provient de la carbonisation d'un mélange de grappes de raisin, de lie de vin desséchée, de noyaux de pêche et de débris d'os ou de râpures d'ivoire en proportions variables, suivant qu'on veut obtenir un noir à reflet bleuâtre ou jaunâtre ; comme il contient toujours une certaine quantité de carbonate de potasse, on le lave avant de l'employer.

Enfin, on emploie pour certaines peintures du *noir de charbon* ou *charbon de bois* qui provient de la calcination en vase clos de toutes les espèces de bois denses. Le charbon qu'on obtient possède toujours une teinte

bleuâtre plus ou moins prononcée et a besoin d'être lessivé, après avoir été réduit en poudre fine, afin de lui enlever les sels solubles qu'il contient.

CHARBON ANIMAL.

NOIR D'IVOIRE.

Ce charbon provient de la calcination en vase clos des tournures d'ivoire. Lorsqu'il a été réellement obtenu avec cette matière, il possède une teinte noire très-riche, mais le plus souvent on lui substitue le noir d'os ou le noir de corne de cerf. Il porte encore les noms de *noir de Cassel, de Cologne, de velours*. Il a le défaut de sécher assez difficilement ; aussi est-on obligé, lorsqu'on veut l'employer à l'huile, de faire bouillir celle-ci. Avec la céruse et l'huile, il donne la nuance gris-perle.

NOIR D'OS.

Les os que l'on emploie pour la fabrication du noir, après avoir été chauffés dans des appareils distillatoires, afin d'en extraire les matières grasses volatiles, sont concassés, puis mis dans des marmites de fonte placées les unes au-dessus des autres, dans des fours de grande dimension ; on chauffe jusqu'à la destruction de la matière organique, après quoi on retire le charbon qui a conservé la forme des os. On pulvérise et on passe à travers des tamis de soie de différentes grosseurs.

Ce noir possède en général une teinte rougeâtre qui est due au phosphate de chaux qu'il contient toujours. Il

est assez digne de remarque que plus les os sont durs, plus le noir est beau ; plus ils sont poreux, plus la teinte rougeâtre est prononcée. On peut, il est vrai, faire disparaître ce défaut en chauffant le noir calcaire avec de l'acide chlorydrique étendu, lavant, puis calcinant de nouveau.

Les noirs végétaux et animaux sont d'un usage fréquent en peinture ; les premiers sont en général plus propres pour la peinture à l'eau, tandis que les seconds sont généralement préférés pour la peinture à l'huile.

NOIR DE FUMÉE.

De même que les noirs de charbon, les noirs de fumée tirent leurs noms de la substance qui les fournit. C'est ainsi qu'on connaît les noirs de fumée de résine, de lampe, de houille, de goudron et de différents bois. Ces deux dernières variétés sont assez peu employées.

Ils sont en général plus impurs que les noirs de charbon et contiennent presque toujours de la matière qui a servi à les obtenir. Leur odeur est désagréable. Pour les priver de ces différentes substances, il suffit de les calciner jusqu'au rouge dans des creusets munis de couvercles, ou bien encore de les laver avec une lessive de potasse très-étendue et chaude. On laisse déposer, on décante, on lave jusqu'à ce que l'eau n'ait plus d'odeur ni de saveur, et enfin on fait sécher à l'étuve.

Cette opération, qui s'appelle *dégraisser le noir*, fournit un produit très-beau et très-léger.

NOIR DE FUMÉE DE RÉSINE.

Cette couleur, à laquelle on donne plus communément le nom de *noir de fumée,* se fabrique en France, dans les Landes bordelaises, en brûlant des matières résineuses et du brai sec dans une chambre de bois de sapin tapissée de grosses toiles ou de peaux de moutons, pour faciliter le dépôt des flocons.

La substance résineuse est placée dans une marmite de fonte ou dans des pots de terre qu'on met dans le foyer d'un fourneau extérieur. On brûle la matière et on tient la chambre fermée tant que dure la combustion ; il se produit alors une fumée épaisse qui dépose sur la toile ou sur les peaux le noir, qu'on enlève de temps à autre.

Obtenu par ce procédé, le noir de fumée est toujours souillé par des matières grasses, huileuses, qui communiquent aux couleurs et aux vernis la propriété de *graisser*. Les toiles, qui servent à condenser la vapeur charbonneuse, se bouchent parfois, au point de ne plus permettre aux gaz carbonés de se dégager, d'où il résulte des explosions et des incendies encore assez fréquents.

C'est pour obvier à ces différents inconvénients qu'un fabricant a imaginé, il y a quelques temps, de préparer le noir de fumée par un procédé qui lui permet, outre d'éviter toutes les chances de perte, d'obtenir un produit plus pur et à meilleur marché.

Il se sert, pour cela, d'un appareil qui a quelque ressemblance avec celui qu'on emploie pour le blanc de zinc. Il se compose d'un fourneau construit en maçonne-

rie, dans lequel on brûle chaque fois 20 kilogrammes environ de produits gras ou résineux, ou bien encore du goudron provenant de la préparation de l'acide pyroligneux. Un tube de fonte, recourbé et très-large, sert de chapiteau et de conduit pour faire rendre le noir dans une chambre en maçonnerie, munie d'une porte sur l'un de ses côtés. Un tube de fonte, et de la même dimension, relie le tout à une seconde chambre beaucoup plus grande, munie également d'une porte et surmontée à son extrémité supérieure d'une cheminée d'appel peu élevée. Une seule toile, placée près de la cheminée, et qui coupe la chambre en deux dans toute sa hauteur, arrête la vapeur charbonneuse. Une ouverture, pratiquée dans le fourneau même où se fait la combustion, permet l'introduction d'un courant d'air que l'on règle à volonté et qui vient sortir, dépouillé de noir, par la cheminée. Au fur et à mesure de sa production, le noir de fumée s'accumule dans les deux chambres d'une manière uniforme, et on l'en retire à l'aide des portes.

Voici maintenant les avantages de ce procédé, pour lequel il a été pris un brevet :

La toile ne s'oppose jamais au dégagement du gaz, l'éloignement du fourneau des chambres évite toute chance d'incendie ; le noir ne contient jamais autant de produits huileux, et enfin on utilise comme combustible le résidu charbonneux resté dans le fourneau, ce qui diminue d'autant les frais de fabrication.

Chaque opération dure quelques heures, et se fait avec 10 ou 25 kilogrammes de matière organique à la fois.

NOIR DE LAMPE.

Le noir de lampe est préparé en brûlant l'huile distillée des os, ou bien des graisses communes liquéfiées, dans de grosses lampes à niveau constant. Le produit fuligineux qui se volatilise vient se condenser d'abord dans un cylindre de tôle qui retient la plus grande partie des impuretés, puis dans une série de cylindres de toile très-serrée communiquant les uns avec les autres. Le charbon condensé dans ces derniers est très-divisé et d'un beau noir.

Dans quelques fabriques moins importantes, on se sert de lampes, dont la mèche longue rend l'huile fuligineuse ; pour récipient, on emploie des plaques de tôle ou des pots de terre. De temps à autre, on recueille le noir qui s'est déposé ; le noir de lampe, par ce dernier procédé, n'est pas aussi pur que le précédent.

En Chine, où l'on fabrique beaucoup de noir de lampe, la condensation se fait dans des chambres divisées en compartiments, ou l'on allume des lampes ; on brûle plusieurs espèces d'huiles qui donnent des noirs de différentes qualités, mais en général très-beaux.

Le noir de lampe est assez employé en peinture ; il est toujours en poudre très-fine, légère et très-brillante.

NOIR DE FUMÉE DE HOUILLE.

Cette variété de noir se fabrique dans les environs de Sarrebruck.

Dans une chambre spacieuse, munie d'un cabinet que

surmonte une cheminée couverte à sa partie inférieure par un sac de toile grossière, on fait rendre la vapeur qui se dégage de la houille en combustion. Le noir de fumée se dépose d'abord dans la chambre, puis dans le cabinet, et la fumée, avant de se rendre dans la cheminée, se tamise au travers du sac de toile qui arrête les particules charbonneuses. Pour que le sac ne s'obstrue pas, on l'agite de temps à autre, au moyen d'une corde qui passe sur des poulies et se termine près du foyer. Par ce moyen, le chauffeur peut remuer le sac quand il reconnaît, par la diminution du feu, que l'orifice d'écoulement est bouché.

Le noir de houille est peu estimé, il ne sert guère que pour la marine et pour toutes les peintures qui n'exigent pas une couleur fine. Il est plus dense que le noir de fumée de résine, mais il est loin de posséder une teinte noire aussi belle.

NOIR DE BOUGIE.

Le noir de bougie s'obtient, ainsi que l'indique son nom, en brûlant des bougies de stéarine au-dessous d'une plaque de métal. Il possède une teinte noire très-belle, et une grande légèreté.

Enfin, on désigne sous le *nom de fumée de Russie*, le charbon qui provient de la combustion sous des tentes des copeaux de bois résineux, et les vieux arbres eux-mêmes ; le noir s'attache aux parois de la tente où on le recueille ; il diffère très-peu du noir de résine proprement dit.

Nous terminerons la série des couleurs noires par une substance dont la composition s'éloigne tout à fait du noir de charbon et du noir de fumée : c'est le *noir de composition*.

Lorsqu'on chauffe du bleu de Prusse, ou bien les divers produits cyanurés résultant de la préparation du bleu de Prusse, dans un creuset muni de son couvercle, il se dégage des gaz ammoniacaux et cyanurés qu'on fait rendre sous la hotte d'une cheminée tirant bien. Pour résidu, on obtient une matière d'un beau noir bleu, très-siccative et assez solide.

Le noir de composition est uniquement constitué par du carbure de fer : mélangé à la céruse, il donne la nuance gris-d'argent et gris-perle.

ENCRE DE CHINE.

L'encre de la Chine, que les coloristes emploient si fréquemment pour les lavis, est connue depuis un temps immémorial. Les historiens disent qu'on en faisait déjà usage 300 ans avant Jésus-Christ.

Cette couleur a pour base le carbone très-divisé, relié par une matière adhésive, la gomme arabique ou la gélatine.

La préparation de l'encre de la Chine a très-souvent exercé la sagacité des inventeurs ; et les nombreuses contradictions qu'on remarque dans les écrits des auteurs, montrent que s'il est facile de l'obtenir très-belle, par des moyens différents, on ignore encore le mode que les Chinois mettent en pratique. Jusqu'à présent, on suppose

qu'on la préparait autrefois avec du noir de fumée, de la gélatine, de la gomme arabique et quelques aromates, comme le camphre et le musc.

La véritable encre, venant de la Chine, a perdu beaucoup de sa réputation, car l'industrie française est arrivée à la livrer aux artistes sous une qualité qui ne laisse rien à désirer, et à un prix peu élevé.

Actuellement chaque fabricant se sert d'un charbon particulier qu'il prépare et purifie à sa manière, au moyen de dissolvants énergiques, comme la potasse, les acides et l'alcool. On s'accorde généralement à dire que le noir de fumée fourni par la combustion des corps gras et des résines donne une encre d'un très-beau noir, et qui ne tourne pas au brun lorsqu'elle est exposée à l'air. Il est certain que de la nature du charbon dépend la qualité de l'encre. Aussi en existe-t-il une très-grande variété dans le commerce que l'artiste doit savoir distinguer.

Voici les caractères généraux qui appartiennent à la belle qualité :

Elle existe toujours en bâtons ou en pains solides de différentes grosseurs, d'un beau noir foncé tirant sur le bleu ou bien sur le noir roussâtre. La plus grande partie porte en relief des caractères chinois recouverts d'une mince feuille d'or. La sorte la plus belle est légère ; sa cassure est nette et d'un très-beau noir brillant. La pâte en est fine, parfaitement homogène et non fendillée.

Mise au contact de l'eau, elle se délaye facilement sans fournir de précipité ni d'aspérités au toucher.

Etendue sur du papier, elle doit sécher rapidement, en laissant une pellicule d'aspect métallique. Un pinceau

imprégné d'eau que l'on passe sur les traits qu'on a formés, ne doit pas les enlever ni les élargir; enfin elle ne doit répandre aucune mauvaise odeur.

M. Merimée indique le procédé suivant pour l'obtenir (1).

« La colle la meilleure est celle qui, trempée dans l'eau,
« ne fait que se gonfler sans rien laisser dissoudre. On
« en trouve rarement de pareille dans le commerce, mais
« à son défaut, on peut se servir de la colle de Flandre.

« Après l'avoir fait tremper pendant quelques heures
« dans environ trois fois son poids d'eau acidulée par
« 1/10ᵉ d'acide sulfurique, on jette l'eau qui contient la
« portion très-soluble de la colle, et on la remplace par
« de l'eau légèrement acidulée. On fait bouillir cette colle
« pendant une heure ou deux, et l'ébullition la modifie
« au point qu'elle ne se prend plus en gelée en réfroi-
« dissant.

« On sature ensuite l'acide avec la craie que l'on pro-
« jette peu à peu, jusqu'à ce que le papier réactif indique
« que la saturation est complète. On filtre à travers du
« papier, et la dissolution qui passe est parfaitement
« transparente.

« On prend environ le quart de cette colle, sur laquelle
« on verse une dissolution concentrée de noix de galle.
« La gélatine est aussitôt précipitée et produit une ma-
« tière élastique résiniforme.

« On lave cette matière avec de l'eau chaude et on la
« dissout à chaud dans la colle clarifiée; on filtre encore

(1) *Dictionnaire des arts et manufactures.*

« cette colle et on la fait rapprocher au point convenable,
« afin qu'en l'incorporant avec le noir de fumée, on ne
« soit pas obligé d'attendre longtemps que la pâte ait ac-
« quis la consistance nécessaire pour être moulée.

« Le principe astringent contenu dans les sucs végé-
« taux ne précipite plus la gélatine lorsqu'on a saturé l'a-
« cide qu'il contient. On peut donc faire bouillir avec de
« la magnésie ou de la chaux la noix de galle ou tout
« autre végétal abondant en principe astringent, et mêler
« ensuite à la colle la décoction filtrée ; il n'y aura pas de
« précipité, et la colle, ainsi préparée, sera d'autant moins
« soluble après sa dessiccation qu'elle contiendra plus
« d'astringent.

« Ce n'est que par tâtonnement qu'on arrivera à con-
« naître la proportion la plus convenable de matière as-
« tringente qu'il faut combiner avec la colle. »

L'excipient qui est mêlé au noir doit être tellement
clarifié, qu'en le délayant dans beaucoup d'eau il ne laisse
rien précipiter. Il n'y aura plus qu'à le concentrer par
l'évaporation au point convenable.

C'est aussi par tâtonnements qu'on pourra déterminer
les proportions relatives de noir (1) et de colle, puisque
cette colle pourra être plus ou moins concentrée ; mais
on parviendra sans peine à trouver la meilleure propor-
tion en faisant les deux essais suivants.

On appliquera au pinceau une légère couche d'encre
sur de la porcelaine, et avec une plume on écrira sur le
papier. Si l'encre est luisante sur la porcelaine, c'est une

(1) Le noir de fumée léger, provenant de la combustion de l'huile
ou de la graisse, est considéré comme le plus propre à cet usage.

preuve qu'elle est suffisamment collée : si, après la dessiccation sur le papier on ne la détrempe pas avec un pinceau imprégné d'eau, c'est une preuve qu'il n'y a pas trop de colle.

En Chine, les moules sont en bois; on peut les avoir en argile cuite; cette terre se moule parfaitement, et lorsqu'elle n'a pas été demi-vitrifiée par le feu, elle happe fortement à la langue. Elle absorbe en peu de temps une partie de l'humidité de la pâte; ce qui facilite sa sortie des moules peu après qu'elle y a été comprimée. On place ensuite les bâtons d'encre sous la cendre, afin qu'en séchant ils ne puissent se fendre, et l'on fait sécher les moules au soleil ou dans une étuve. Si après un certain temps les pores des moules se trouvaient bouchés au point de ne plus absorber l'humidité, on les ferait bouillir dans une lessive caustique et sécher ensuite, ou bien on les exposerait à l'action d'une température élevée.

Le père Duhalde assure qu'en Chine, on prépare l'encre en faisant bouillir dans de l'eau du suc de gingembre et des extraits de plantes particulières inconnues de nos botanistes.

On est parvenu à imiter ce procédé de la manière suivante :

Noir de fumée... 1 partie.
Suc de réglisse.. 1 »
Colle de poisson. 6 »
Eau............ 12 »

On fait dissoudre séparément le suc de réglisse dans une petite quantité d'eau; d'une autre part on coupe la

colle de poisson en lanières très-minces et on la fait bouillir jusqu'à dissolution dans le reste du liquide. On mélange les deux liqueurs, puis on y delaye le noir de fumée ; on obtient de la sorte une pâte qu'on place dans des moules enduits de cire, pour prévenir toute adhérence, et on fait sécher à l'étuve, au soleil, ou bien encore sous la cendre.

CHAPITRE VI

COULEURS BLEUES

OUTREMER DE COBALT.

L'*outremer de cobalt* ou *de Gahn*, du nom de son inventeur, est une combinaison de l'oxyde de cobalt avec l'alumine en proportion qui varie avec les fabriques.

Si dans une liqueur contenant du sulfate de potasse et d'alumine (alun) et un sel de cobalt (nitrate, sulfate ou chlorure), on verse une solution de carbonate de potasse ou de soude, on obtient un précipité blanc rosé très-volumineux de carbonate de cobalt et d'alumine hydratée.

Ce mélange, débarrassé par les lavages à l'eau chaude du sel soluble alcalin qui a pris naissance, est recueilli,

desséché, puis chauffé dans un creuset de terre à une haute température.

Après le refroidissement, on obtient un produit qui, réduit en poudre fine, donne une couleur d'une belle teinte bleue comparable à l'outremer surfin.

En variant les proportions de cobalt, on produit des nuances bleues plus ou moins foncées, mais il est essentiel que les sels ne contiennent pas de fer et de nickel.

Cette couleur, qui remplace jusqu'à un certain point l'outremer-Guimet, a le grave défaut de paraître violette à la lumière. Elle se mélange assez bien avec les autres produits employés dans la peinture à l'huile, est très-fine et enfin médiocrement vénéneuse.

BLEU DE PRUSSE.

Dans le courant de l'année 1720, un fabricant de couleurs prussien, nommé Diesbach, préparant dans le laboratoire de Dieppel, pharmacien à Berlin, de la laque florentine, au moyen de carbonate de potasse qui avait été calciné avec des matières animales, obtint un précipité bleu au lieu d'un précipité rose qu'il attendait. Il fit part de ce résultat à Dippel, qui se rappela que la potasse employée avait été calcinée avec du sang et avait servi à la préparation de l'huile empyreumatique qui porte son nom. Il pensa que la formation de ce précipité bleu était due à l'action de la potasse sur l'alun et le vitriol que Diesbach avait mis en présence. Cette découverte fut annoncée peu de temps après à l'Académie des sciences

de Berlin, mais sans l'indication du mode de préparation.

Suivant une autre version, Diesbach aurait observé, pour la première fois, la production de cette couleur bleue en jetant comme inutile de la potasse calcinée avec des matières animales, dans une cour où l'on avait répandu du sulfate de fer.

A cette époque, l'indigo était la seule couleur bleue connue ; aussi la découverte du bleu de Prusse, que Diesbach et Dippel tenaient secrète, fit-elle entreprendre beaucoup de recherches. En 1724, le docteur Woodward fit connaître le premier, dans les *Transactions philosophiques*, un procédé qui, à part de légères modifications, est encore suivi dans les fabriques. Ce mode, que l'on dit lui avoir été communiqué par un de ses amis, consistait à traiter un mélange de sulfate d'alumine et de sulfate de fer par de la potasse préalablement calcinée avec du sang.

Après Woodwart, Brown démontra que l'on pouvait remplacer le sang par d'autres matières animales, et que l'alun n'était pas nécessaire à la production de la couleur bleue.

Si les chimistes étaient d'accord sur la préparation du bleu de Prusse, la théorie en vertu de laquelle il prenait naissance était loin d'être connue.

Une année après la découverte de Woodwart, Geoffroy annonça que le bleu de Prusse se formait au moyen du phlogistique qui revivifiait le fer du vitriol vert. Cette théorie fut admise jusqu'en 1752, époque à laquelle Macquer publia, à l'Académie des sciences de Paris, que cette subs-

tance était une combinaison de fer avec une matière particulière que les alcalis enlèvent aux produits charbonneux. En 1772, Guyton de Morveau admit que la formation du bleu de Prusse était due à un acide que contenait l'alcali phlogistiqué, acide que Sage suppose être l'acide phosphorique. Mais il était réservé à l'illustre Scheele de faire connaître que la substance qui donnait naissance à cette couleur se formait toujours dans la calcination des alcalis avec les matières animales, substance qu'il désigne sous le nom de *materia tingens*, et Guyton de Morveau, acide prussique.

Les recherches de Scheele et de Guyton de Morveau furent poursuivies par Proust, Bertholliet, Porret, Vauquelin, Robiquet et Berzelius. Tous ces savants émirent, sur la composition du bleu de Prusse et sur la production de la couleur bleue, différentes théories qui ne furent plus admises lors de la découverte du cyanogène, par Gay-Lussac.

Tous les chimistes actuels s'accordent à regarder ce composé comme une combinaison de protocyanure avec le sesquicyanure de fer.

Dans le bleu de Prusse, le fer se trouve combiné au cyanogène sous deux états différents : l'un, qui constitue les protosels de fer, et que nous nommerons *ferrosum*, se représente par le symbole Fe.; l'autre, qui forme les persels, et que nous désignerons sous le nom de *ferricum*, se représente par Fe^2. Ces deux cyanures de fer ont la propriété de s'unir en un grand nombre de proportions que l'on connaît généralement sous le nom de *bleu de Prusse*, mais qui, le plus souvent, n'ont pas une compo-

sition constante. On donne au bleu de Prusse la formule suivante :

$$\underbrace{3\,(CyFe)}_{\text{Protocyanure de fer.}} + \underbrace{2\,(Cy^3Fe^2)}_{\text{Sesquicyanure de fer.}} + \underbrace{9HO}_{\text{Eau.}}$$

Nous ne serions pas éloignés de croire que tous ces composés bleus peuvent se rattacher à une formule générale représentée par un cyanure ferroso-ferrique. Ce produit bleu, d'une très-belle teinte, s'obtient toutes les fois qu'on verse du cyanure de potassium simple dans un sel soluble de fer, et il est ainsi formulé :

$$\underbrace{Cy}_{\text{Cyanogène.}}\ \underbrace{Fe}_{\text{Fer.}} + \underbrace{3Cy}_{\text{Cyanogène.}}\ \underbrace{Fe^2}_{\text{Fer.}} + \underbrace{4HO}_{\text{Eau.}}$$

Le bleu de Prusse, proprement dit, tel que les arts l'emploient, forme différentes qualités qui résultent du plus ou moins de soin apporté pendant sa préparation et de la qualité des matières premières. Les principales sortes portent les noms de *bleu de Berlin*, *bleu de Paris* ou *de Turnbull*. Il n'a, dans aucun cas, de tendance à revêtir une forme cristalline. Lorsqu'il est récemment précipité, il se présente sous la forme de flocons volumineux, d'une couleur bleue tellement foncée, qu'ils paraissent noirs. dessiccation le contracte extraordinairement ; il présente alors l'aspect de morceaux compactes presque noirs. Dans le commerce, il est en pains ou en morceaux d'un beau bleu foncé à reflets rougeâtres ; sa cassure est conchoïde ; il est insipide, inodore, insoluble dans l'eau, l'alcool, l'huile et les acides étendus, mais décomposable par plusieurs métaux, tels que l'étain et le fer, les acides con-

centrés et les alcalis, le bioxyde de mercure, et par la plupart des oxydes métalliques; exposé à l'action de la chaleur, il commence à perdre une certaine quantité d'eau d'interposition, puis de combinaison; mais il en retient toujours une petite quantité qui ne peut se dégager que par la dissociation de ses éléments. Chauffé plus fortement, il brûle comme de l'amadou en donnant des produits ammoniacaux et cyanurés volatils; pour résidu, on obtient du carbure de fer, lorsqu'on opère en vase clos; et du sesquioxyde de fer, lorsque la calcination se fait à l'air.

Exposé à l'air, le bleu de Prusse se décolore; aussi ne ne constitue-t-il pas en peinture une couleur durable. M. Chevreul, auquel on est redevable de belles expériences sur l'action que l'oxygène de l'air fait éprouver aux étoffes teintes avec le bleu de Prusse, a montré que cette couleur se décolorait à l'air et redevenait bleue lorsqu'on la plaçait dans l'obscurité. Il attribue ce résultat à une absorption d'oxygène qui remplace le cyanogène déplacé par les rayons lumineux.

Le bleu de Prusse chimiquement pur s'obtient dans les laboratoires toutes les fois qu'on verse du cyanure jaune de potassium et de fer (prussiate de potasse) dans un sel de sesquioxyde de fer; mais dans les arts, on le prépare par un moyen moins dispendieux; pour cela, on se sert de cyanure de potassium produit par la calcination du carbonate de potasse avec certaines matières animales.

Le sang desséché, les poils, la laine, les cheveux, les rognures de peaux, la viande, les huiles animales, la suie, le charbon animal provenant de la préparation du sel ammoniac, ont été proposés tour à tour pour cet usage;

mais de toutes ces substances, aucune ne fournit des résultats aussi satisfaisants que le sang desséché. M. Robiquet attribue cela au fer que ce fluide contient normalement.

Voici comment on opère :

Dans une chaudière de fonte ou de tôle, peu profonde et très-évasée, on fait évaporer du sang presque à siccité, en le chauffant rapidement et agitant sans cesse avec une large spatule ou un ringard en fer. Lorsque la matière est à l'état de grumeaux, on l'étale sur de grandes tables, et on l'expose au soleil, où elle achève de se dessécher; on la réduit en poudre, et on la conserve dans un endroit sec, et dans des vases ouverts pour l'employer au fur et à mesure du besoin. On fait dissoudre 1 partie de carbonate de potasse, privée, autant que possible, de sulfate de potasse et de chlorure de potassium, dans une très-petite quantité d'eau; on y ajoute 1/100e de limaille de fer, et on arrose, avec cette solution, 10 parties de poudre de sang. Le tout étant bien mélangé, on le place dans un creuset ou une marmite de fonte, que l'on chauffe au rouge pendant sept à huit heures environ. Pendant les premières heures de la calcination, il se dégage une fumée très-forte, d'une odeur repoussante, qui disparait ensuite pour faire place à une flamme d'un blanc rougeâtre. On remue la matière à plusieurs reprises, et lorsqu'elle est à l'état de fusion tranquille et qu'elle ne dégage plus de gaz inflammable, on recouvre le creuset, on chauffe encore pendant une heure ou deux, puis on laisse refroidir.

Le produit qu'on obtient est lessivé avec de l'eau chaude, jusqu'à épuisement de toute matière soluble. La

liqueur qui en résulte, et à laquelle on donne le nom de *lessive de sang*, est jaune clair, et répand une odeur très-forte d'acide prussique. Elle contient du cyanure de potassium, du cyanure de fer, du carbonate de potasse, des sulfates et phosphates de potasse et de chaux, du sulfure de potassium, etc. Lorsqu'elle est trop étendue, on la fait concentrer en y ajoutant une petite quantité du sulfate de fer, qui s'oppose à la décomposition d'une certaine quantité de cyanure de potassium.

Un point essentiel dans la fabrication du bleu de Prusse, réside dans la préparation de la lessive de sang. Le temps pendant lequel la calcination du sang avec la potasse et la limaille de fer a lieu, n'est pas indifférent. Car, ainsi que le fait observer Robiquet : « S'il importe au succès
« de l'opération d'atteindre un degré de température élevé
« pour déterminer la formation du cyanogène, il n'est pas
« moins essentiel de ne pas outrepasser certaines limites,
« car alors le cyanure de fer ne peut résister, il se détruit,
« et il ne reste que du cyanure de potassium, qui, par sa
« dissolution dans l'eau, ne fournit que du cyanure de
« potassium, et non du prussiate jaune de potasse, indis-
« pensable à la formation du bleu de Prusse. »

La lessive de sang concentrée à point et filtrée, est versée peu à peu dans une dissolution chaude, faite avec 1/2 partie de vitriol vert, exempt de sulfate de cuivre (1), et une quantité d'alun variable, selon la qualité du bleu

(1) Le sulfate de cuivre communique au bleu de Prusse une teinte brune prononcée. Pour séparer ce métal du vitriol, il suffit d'ajouter des rognures de fer à la dissolution ferrugineuse; tout le cuivre se précipite à l'état métallique.

qu'on veut obtenir. Le bleu de Prusse fin s'obtient avec 1 partie d'alun et 7 à 8 parties de sulfate de fer; pour le bleu ordinaire, on met 1 d'alun sur 2 à 3 de sulfate de fer, et pour les qualités inférieures, parties égales de ces deux sels. A chaque affusion de la liqueur alcaline, il se fait une vive effervescence due au dégagement de l'acide carbonique et de l'acide sulfhydrique : on brasse continuellement avec un bâton. Le précipité qui se forme possède une teinte vert-brunâtre; on le lave à plusieurs reprises avec de l'eau de pluie ou de rivière, jusqu'à ce qu'il ait acquis une belle couleur bleue. Arrivé à ce point, on laisse déposer; on soutire à l'aide d'un siphon l'eau qui surnage, on jette le dépôt sur une toile, et on l'arrose avec de l'eau acidulée par de l'acide sulfurique, en renouvelant les surfaces de temps en temps. On laisse égoutter, on le soumet à la presse dans des caisses, pour lui enlever la plus grande partie de son eau, puis on divise la masse en petits parallélogrammes qu'on laisse sécher à l'air libre sur des tablettes placées à l'ombre ou dans une étuve chauffée de 25 à 30° au plus.

Le procédé que nous venons d'indiquer est le plus anciennement connu, et encore le plus généralement pratiqué. Mais plusieurs fabricants lui font subir diverses modifications qui ont pour but : 1° D'activer l'absorption de l'oxygène pour que le produit arrive dans le moins de temps possible à la teinte bleue foncée; 2° de débarrasser le produit de l'oxyde de fer qu'il contient toujours.

Pour que le bleu de Prusse possède une teinte bleue foncée, il est indispensable que le fer s'y trouve, ainsi que nous l'avons déjà dit, partie à l'état de *ferrosum*, partie à

l'état de *ferricum* ; c'est sur cette propriété qu'est basé le procédé à l'aide duquel on obtient le beau bleu de Turnbull. Pour cela, on traite du vitriol vert par du cyanure rouge de potassium et de fer. La combinaison bleue violette qui se forme dans cette circonstance porte en Angleterre le nom de *Turnbulls bleue*, et en France, celui de *bleu de Paris*. Sa formule chimique se représente ainsi :

$$\underbrace{3\,(Cy\,fe)}_{\text{Protocyanure de fer.}} + \underbrace{Cy\,fe^2}_{\text{Sesquicyanure de fer.}}$$

On arrive, jusqu'à un certain point, à obtenir du bleu de Prusse comparable au bleu de Turnbull par les moyens que nous allons indiquer.

1° Le précipité qu'on obtient par le traitement du vitriol avec la lessive de sang, dépouillé par quelques lavages à l'eau ordinaire du sulfate de potasse qu'il contient, est traité par du chlorure de chaux (hypochlorite de chaux) dissous dans de l'eau froide. Sous l'influence de cet oxydant, le bleu de Prusse prend de suite une belle teinte bleue foncée ; on le lave ensuite avec de l'acide chlorhydrique étendu, puis avec de l'eau ordinaire.

2° On fait dissoudre séparément, dans 15 parties d'eau ordinaire, 6 parties de vitriol vert et 6 parties de prussiate jaune de potasse ; on mélange les deux liqueurs, et on y verse, en agitant continuellement, 1 partie d'acide sulfurique ordinaire et 24 parties d'acide chlorhydrique fumant ; on brasse bien le tout, et après quelques heures de digestion, on ajoute une dissolution filtrée de 1 partie de chlorure de chaux dissous dans 80 parties d'eau. Cette solution doit être versée par petites portions à la fois, et

on s'arrête dès qu'on observe une effervescence produite par un dégagement de chlore. On laisse déposer le précipité ; on le lave à plusieurs reprises par décantation ; on le recueille sur une toile, puis on le fait chauffer modérément avec de l'acide nitrique étendu, jusqu'à ce qu'il ait pris une belle couleur bleue foncée.

M. Raymond a observé qu'en substituant le nitrate de sesquioxyde de fer au vitriol vert et au sulfate de sesquioxyde, on obtenait, avec le cyanure jaune de potassium ou avec la lessive de sang, du bleu de Prusse qui ne laissait rien à désirer.

Quel que soit le mode de purification qu'on fasse subir au bleu de Prusse, il contient toujours une certaine quantité de potassium ; on remarque que sa couleur est d'autant plus violacée et d'un bleu moins foncé que la quantité de ce métal est plus grande. Pendant longtemps, les chimistes ont pensé que le potassium faisait partie de ce composé ; mais il est parfaitement démontré maintenant qu'on peut obtenir du bleu de Prusse très-beau avec des substances qui ne contiennent pas de traces de potassium (cyanure de mercure et sulfates de proto et de sesquioxyde de fer).

Les matières étrangères qu'on trouve dans le bleu de Prusse, et qui nuisent à ses propriétés, sont : l'alumine, lorsqu'on a ajouté de l'alun au vitriol vert, et de l'oxyde de fer qui provient de la décomposition du vitriol par la potasse.

L'alumine est employée à la fabrication du bleu de Berlin ; elle sert de véhicule à la matière colorante ; mais on doit la regarder comme une falsification ; elle com-

munique au précipité de bleu de Prusse une teinte plus ou moins claire ; aussi certains fabricants, pour obtenir un bleu foncé, suppriment-ils l'alun. Quand à l'oxyde de fer, il se produit toutes les fois qu'on fait la précipitation avec des liqueurs neutres ou alcalines. Il est toujours facile de dépouiller le bleu de Prusse de ces deux oxydes ; pour cela, il suffit de le faire digérer pendant un certain temps avec de l'acide sulfurique étendu qui les dissout sans toucher au bleu de Prusse.

Jusqu'à présent, nous avons fait connaître le bleu de Prusse tel qu'on l'emploie habituellement dans les arts ; mais il en existe plusieurs autres espèces dont l'usage aurait besoin d'être plus répandu pour qu'on puisse se prononcer sur leur valeur. Ainsi, le bleu de Prusse peut s'unir avec l'ammoniaque et former un composé que M. Monthiers, son inventeur, trouve plus stable que le bleu de Prusse ordinaire. Voici comment ce chimiste conseille d'opérer : on sature de l'acide chlorhydrique pur par du fer ; la solution de protochlorure de fer est mélangée avec de l'ammoniaque en excès ; on filtre et on recueille la liqueur dans une dissolution de prussiate de potasse ; on obtient un précipité blanc qui est recueilli sur un filtre et abandonné à l'air, où il ne tarde pas à prendre une belle teinte bleue. Comme le produit contient un excès d'oxyde de fer, M. Monthiers l'arrose avec du tartrate d'ammoniaque qui dissout l'oxyde de fer et ne touche pas au bleu de Prusse ammoniacal ; celui-ci est lavé jusqu'à ce que l'eau ne dissolve plus rien, puis séché à une basse température.

Cette variété de bleu de Prusse a pour caractère essentiel de ne pas se dissoudre dans le tartrate d'ammoniaque,

qui dissout entièrement le bleu de Prusse ordinaire en donnant une dissolution bleue-violette.

Le bleu de Prusse, préparé avec une quantité plus que suffisante de prussiate de potasse, peut devenir soluble dans l'eau ; pour cela, il suffit de traiter du nitrate ou du sulfate de sesquioxyde de fer par un grand excès de prussiate de potasse. Il se forme un précipité très-soluble dans l'eau pure, mais qui ne se dissout pas dans une eau chargée de différents sels. Cette propriété est mise à profit pour le recueillir.

On peut encore obtenir le bleu de Prusse soluble de la manière suivante : le bleu du commerce mis à digérer pendant un certain temps dans de l'acide chlorhydrique étendu pour lui enlever l'alumine et l'oxyde de fer qu'il contient ; le résidu broyé avec 1/6e de son poids d'acide oxalique et un peu d'eau, devient soluble au point de filtrer à travers le papier joseph.

Enfin le bleu de Prusse peut exister à l'état basique.

Pour cela, on verse du prussiate jaune de potasse dans du vitriol vert. On obtient un précipité blanc qui ne tarde pas à bleuir à l'air. Ce produit, auquel les chimistes ont trouvé une composition particulière, n'est pas employé dans les arts.

Le bleu de Prusse est beaucoup plus employé pour la peinture à l'aquarelle que pour la peinture à l'huile. Les fabricants de papiers peints en consomment une grande quantité, surtout à l'état de pâte. On a remarqué que celui préparé en France tendait à prendre une teinte verte, ce qui n'arrive pas avec le bleu de Berlin. Mélangé avec d'autres couleurs, il rend de nombreux services. Ainsi,

avec la céruse, il fournit, s'il est de bonne qualité, différentes nuances qui sont très-recherchées. On s'en sert fréquemment pour rehausser les teintes des autres bleus qui ont plus de fixité que lui ; mais son emploi mérite, de la part de celui qui l'applique, des soins particuliers. Ainsi, on ne doit jamais l'unir aux jaunes avec lesquels il fournit la nuance verte. Broyé à l'huile depuis quelque temps, il se graisse et ne s'étend pas aussi facilement que lorsqu'il est récemment préparé. Enfin, il ne doit pas être appliqué sur les murs qui ont la propriété de fournir du salpêtre, et sur les objets continuellement exposés aux rayons solaires.

Les matières qui servent à falsifier le bleu de Prusse sont : l'amidon, le carbonate et le sulfate de chaux, l'alumine et le sulfate de baryte.

L'amidon se décèle en versant de l'eau iodée dans de l'eau qui a servi à faire bouillir le bleu de Prusse. La coloration bleue qui se produit est un indice certain de la présence de cette substance. On peut dire que tous les échantillons de bleu de Prusse du commerce contiennent de l'amidon. On emploie de préférence l'amidon de grain, qui est en poudre toujours plus fine que la fécule de pomme de terre.

L'acide qu'on verse sur du bleu de Prusse délayé dans de l'eau distillée, ne doit pas donner lieu à un dégagement de gaz. Si un pareil résultat se produisait, on devrait l'attribuer à un carbonate ; et si, de plus, l'oxalate d'ammoniaque versé dans la dissolution filtrée fournissait un précipité blanc d'oxalate de chaux, on serait assuré d'avoir affaire à du carbonate de chaux.

Le sulfate de chaux (plâtre) peut être découvert de la manière suivante : on fait bouillir le bleu de Prusse avec de l'eau légèrement acidulée par de l'acide nitrique pur ; la dissolution filtrée est traitée par le chlorure de barium, qui fournit un précipité blanc de sulfate de baryte, si la substance était falsifiée par du plâtre.

Pour reconnaître l'alumine, il faut traiter le bleu de Prusse par de l'acide sulfurique étendu de 8 à 10 fois son poids d'eau, faire digérer, puis filtrer. On verse dans la liqueur qu'on obtient un excès d'ammoniaque liquide qui donne lieu à un volumineux précipité blanc rougeâtre, composé d'alumine et d'oxyde de fer ; pour séparer ces deux oxydes, on traite le produit par de la potasse caustique qui dissout l'alumine et ne touche pas à l'oxyde de fer. Au moyen d'une nouvelle addition d'ammoniaque dans la dissolution potassique, on décèle la présence de l'alumine qui se précipite à l'état de gelée blanche très-volumineuse.

La propriété que possède le bleu de Prusse de devenir soluble lorsqu'on le traite par l'acide chlorhydrique et l'acide oxalique, est mise à profit pour reconnaître le sulfate de baryte. La liqueur filtrée ne doit pas fournir de dépôt blanc insoluble dans l'eau et dans tous les acides ; caractère qui appartient au sulfate de baryte.

BLEU MINÉRAL.

Le bleu minéral, nommé encore bleu d'Anvers, est du bleu de Prusse contenant des proportions variables d'alumine, de carbonate de magnésie et de carbonate de zinc.

Sa teinte varie depuis le bleu foncé jusqu'au bleu clair.

On le prépare dans le même temps que le bleu de Prusse; pour cela il suffit de verser du sulfate de magnésie, du sulfate de zinc et de l'alun dans la lessive de sang. Le précipité est lavé, recueilli et séché à la manière ordinaire.

Le bleu minéral s'emploie aux mêmes usages que le bleu de Prusse; il passe pour couvrir davantage que ce dernier.

On le broie à l'huile et à l'eau. Il entre surtout dans la fabrication des papiers peints.

On assure que dans le commerce il existe du bleu minéral préparé en colorant des terres blanches avec de l'indigo ou bien avec de l'oxyde de cuivre hydraté.

On reconnaît cette fraude au moyen de l'acide sulfurique fumant, qui décompose le bleu de Prusse et qui dissout l'indigo sans l'altérer. Quant à l'oxyde de cuivre, on le décèle au moyen de l'alcali volatil, qui forme une liqueur bleue foncée d'ammoniure de cuivre.

OUTREMER.

Le bleu d'outremer, dont nous allons tracer ici l'histoire, est, sans contredit, le produit qui a le plus exercé la sagacité des chimistes manufacturiers.

A une richesse de ton très-grande, il joint une solidité qu'on retrouve rarement dans les autres couleurs. Il peut servir pour tous les genres de peinture, et de plus s'allie à toutes les matières colorantes sans les décomposer.

Il y a trente ans, le bleu d'outremer était un produit naturel assez rare. Le prix élevé auquel le commerce de détail le livrait alors aux artistes, faisait qu'on l'employait seulement dans la peinture fine. Mais depuis que l'industrie est arrivée à le préparer de toutes pièces, aussi beau et aussi solide, il est devenu d'un usage journalier, principalement pour la peinture à l'huile.

L'outremer naturel était connu des Grecs et des Romains, qui le désignaient sous le nom de *saphyr*, mais, comme couleur, il ne paraît avoir été employé que vers la fin du xv° siècle.

Il existe tout formé dans le *lapis lazuli* ou *lazulite bleu-d'azur*, minéral appartenant aux terrains granitiques que l'on trouve en certaine quantité en Perse, en Chine et dans la Grande-Bucharie.

Voici le procédé qu'on employait autrefois pour l'extraire :

On commence par faire rougir la pierre dans des creusets et on la jette encore chaude dans du vinaigre, afin de détruire son agrégation moléculaire, en un mot, pour l'*étonner*, et la rendre par là, pulvérulente. On la retire du véhicule, on la fait sécher, puis on la réduit en poudre très-fine et on la fait macérer pendant plusieurs jours dans du vinaigre très-fort, afin de permettre à la chaux de se dissoudre. Après ce traitement, la poudre est recueillie et mélangée avec un mastic de résine, de cire et d'huile de lin cuite. On soumet la pâte à un lavage à l'eau tiède, on pétrit à plusieurs reprises et on recueille la pâte à différentes époques pour obtenir des produits de qualités diverses.

Sous l'influence de l'eau, l'outremer ayant moins d'adhérence à la masse résineuse que les autres matières existant dans le lapis, se délaye le premier.

La première eau est généralement rejetée ; la seconde fournit, après un repos suffisant, un bleu de qualité supérieure ; le produit de la troisième eau est déjà moins beau ; enfin celui de la quatrième et de celles qui sont nécessaires pour épuiser la masse, donnent un bleu de qualité inférieure. Dans ce dernier état, il porte le nom de *cendre d'outremer*.

Les différents produits de ces manipulations étant recueillis et séchés, donnent l'outremer naturel.

De nos jours, l'industrie n'a plus besoin de recourir à un semblable moyen pour obtenir cette substance.

Avant l'année 1828, l'outremer naturel de qualité supérieure ne valait pas moins de 200 fr. les 30 grammes. Dès l'année 1824, la Société d'encouragement pour l'industrie nationale proposa un prix de 6,000 fr. pour la fabrication artificielle du bleu d'outremer.

Dans les relations de son voyage en Italie, Goethe raconte qu'en 1767, étant à Palerme, il trouva dans les fours à chaux siciliens une production ignée, une sorte de flux vitreux, d'une couleur variant du bleu clair au bleu foncé, qui est employée comme pierre d'azur par les artistes de cette contrée pour le placage des autels.

Mais la possibilité d'obtenir cette matière colorante par la voie artificielle, ne date véritablement que de la découverte que fit M. Tassaert, en 1814, à la manufacture de glace de Saint-Gobain, d'une matière bleue qu'il avait trouvée en démolissant la sole d'un de ses fours à soude.

Vauquelin, qui en fit l'analyse, lui trouva toutes les propriétés du lapis-lazuli, et dit en terminant son travail, *que l'on doit espérer de parvenir quelque jour à imiter la nature dans la formation de cette couleur précieuse ;* heureuse idée que l'illustre savant eut le bonheur de voir réaliser quatorze ans plus tard.

Un ingénieur des ponts et chaussées, M. Guimet, fit connaître, dans le courant de l'année 1827, a l'Institut, qu'il avait trouvé le moyen de fabriquer de l'outremer de toutes pièces, par un procédé qu'il a toujours tenu secret jusqu'à ce jour ; cette découverte était à peine annoncée, qu'un chimiste de Tubingue, M. Gmelin, publia qu'il était arrivé de son côté à préparer le bleu d'outremer par un procédé qu'il fit connaître. Aux recherches de M. Gmelin, n'ont pas tardé à succéder d'autres travaux de la part de MM. Persoz, Robiquet, Brunner, qui ont eu pour but, soit de faire connaître d'autres modes d'obtention, soit d'étudier la composition chimique du nouveau produit ; de ces divers travaux, il est résulté la certitude que l'outremer le plus pur devait être envisagé comme une combinaison de silicate d'alumine, de silicate de soude et de sulfure de sodium en proportions variables.

L'outremer artificiel se présente, d'une manière générale, sous la forme d'une poudre de couleur bleue brillante. Il en existe dans le commerce un grand nombre de sortes, dont le prix varie de 2 à 50 fr. le kilogr. Il est inaltérable à l'air, insoluble dans l'eau, l'alcool, l'éther, les huiles grasses et volatiles ; les acides le décomposent immédiatement : soumis à l'action d'une haute température, il entre en fusion et donne un verre incolore ou très-peu

coloré. Si la calcination a lieu au contact de l'air, sa teinte passe au vert.

Voici maintenant les différents procédés indiqués jusqu'à ce jour pour l'obtenir :

PROCÉDÉ GMELIN.

On commence, pour préparer de la silice gélatineuse, en décomposant par l'acide chlorydrique du silicate de soude obtenu en fondant ensemble 1 partie de quartz bien pulvérisé avec 4 parties de carbonate de potasse.

D'autre part, on précipite une solution d'alun par de l'ammoniaque caustique.

Lorsqu'on a bien lavé ces deux hydrates, on les fait sécher, et par une analyse sur une petite quantité, on détermine la quantité de silice ou d'alumine qu'ils peuvent contenir à l'état anhydre.

On fait une solution de soude caustique dans laquelle on ajoute à chaud autant de silice gélatineuse qu'elle peut en dissoudre, et on détermine la quantité de terre dissoute. Sur 72 parties de silice anhydre, on prend une quantité d'alumine hydratée qui contienne 70 parties d'alumine anhydre. On l'ajoute à la dissolution de la silice et on évapore le tout ensemble jusqu'à siccité.

Dans un creuset de Hesse, fermant bien, on chauffe jusqu'au rouge sombre un mélange de 2 parties de fleur de soufre avec 1 partie de carbonate de soude anhydre. Lorsque la matière est en fusion tranquille, on projette le mélange ci-dessus, en très-petite quantité à la fois ; on maintient le creuset une heure environ au rouge sombre,

puis on le retire du feu et on le laisse refroidir. La masse calcinée est traitée par l'eau froide qui dissout le sulfure de sodium formé et laisse de l'outremer en poudre bleue verdâtre.

Après M. Gmelin, M. Robiquet conseilla d'obtenir le bleu d'outremer par la calcination du kaolin avec du soufre et du carbonate de soude; mais ce procédé ne fournit pas un produit de belle qualité.

PROCÉDÉ TIREMON.

M. Tiremon, capitaine du génie, prépare le bleu d'outremer de la manière suivante :

Il prend :

Argile crue de Dreux en poudre.	100 parties.
Alumine en gélée, réprésentée par alumine anhydre.............	7 »
Cristaux de soude...............	1,075 »
Fleur de soufre................	221 »
Sulfure d'arsenic..............	5 »

On mélange ces substances avec le plus grand soin; on fait liquéfier le carbonate de soude dans son eau de cristallisation, puis on ajoute le sulfure d'arsenic; un instant après l'alumine en gelée, et enfin l'argile et la fleur de soufre préalablement mélangées. On fait évaporer jusqu'à siccité, et le mélange est placé dans un creuset qu'on chauffe jusqu'au rouge, sans cependant aller jusqu'à la fusion de la matière.

Après le refroidissement, on chauffe de nouveau le creuset, afin de chasser la plus grande partie du soufre,

puis la matière est broyée et délayée dans l'eau de rivière. La poudre, qui reste en suspension dans l'eau, est recueillie sur un filtre, et mise à sécher.

L'outremer qu'on obtient de la sorte est d'un beau vert bleuâtre. On le place dans un têt à rôtir et on le chauffe au contact de l'air, en le remuant sans cesse; alors il ne tarde pas à prendre une teinte bleue très-belle.

M. Pruckner, de Hof (Bavière), a publié, sur la fabrication du bleu d'outremer de Nuremberg, une note que nous empruntons à peu près en entier à la *Revue scientifique* du docteur Quesneville. Ce procédé est employé par MM. Zeltner et Heine, fabricants à Nuremberg, qui préparent cette substance sur une grande échelle.

Disons d'abord quelques mots sur le choix des matières premières, qui sont : de l'argile, du sulfate de soude, du charbon et un sel de fer, ordinairement du vitriol vert.

« L'argile, employée à la fabrication de l'outremer factice, a la plus grande influence sur la couleur produite, et, probablement, la non-réussite de beaucoup d'essais tient à l'emploi d'une argile qui était trop ferrugineuse. J'emploie une argile blanche qui ne se colore pas au feu, et qui, par suite, ne renferme que très-peu de fer; c'est une sorte de kaolin de couleur mate, happant à la langue, et formant avec de l'eau une pâte très-courte, qui se trouve dans la principauté de Reus, aux environs de Roschitz, et qui sert à la fabrication de la porcelaine. Cette argile renferme 42 à 43 p. %, d'alumine. Il va sans dire que, toutes choses égales d'ailleurs, on doit donner la préférence à l'argile la plus alumineuse.

« Dans la fabrique de Nuremberg, on emploie surtout

une terre sigillaire blanche (*bolus alba* des pharmaciens), qui vient de Tischenrenth, dans le Haut-Palatinat.

« A Nuremberg, on emploie le sulfate de soude impur, résidu des fabriques d'acide muriatique, que l'on raffine dans l'usine même ou que l'on achète tout raffiné. Cette opération, sur laquelle nous reviendrons plus loin, a principalement pour objet d'en séparer l'acide muriatique libre et les sels de fer, qui altéreraient et pourraient même complétement détruire la couleur bleue de l'outremer obtenu.

« Le soufre en canon est trop connu pour qu'il soit nécessaire de s'y arrêter.

« Comme charbon, le charbon de bois sec remplit parfaitement le but que l'on se propose d'atteindre. On emploie aussi quelquefois de la houille ; dans ce cas, on la choisit sèche, riche en carbone, et donnant le moins possible de cendres blanches ou grisâtres non-ferrugineuses.

« La calcination des mélanges s'opère dans des moufles placés dans des fourneaux à réverbère, où il est beaucoup plus facile de régler la température et de surveiller la marche que dans les creusets. Ces fourneaux à moufle ont intérieurement $0^m,90$ à $1^m,00$ de largeur, et autant de profondeur ; les moufles qu'ils renferment ont intérieurement $0^m,55$ à $0^m,60$ de largeur, et $0^m,30$ à $0^m,37$ de hauteur ; on peut, pour économiser le combustible, en placer deux ou trois dans le même fourneau. Ils sont construits en argile réfractaire, de la même manière que les pots de verrerie, et leur ouverture antérieure peut être fermée par une porte en fonte à coulisse, glissant sur des roulettes, qui, ainsi que leur fond, est percée d'une fente

étroite, servant à observer l'opération et à donner l'accès à l'air. Il va sans dire que les fourneaux sont munis de registres qui permettent d'en régler à volonté la température. On augmente la durée des moufles, en les soutenant sur trois rangées de briques placées sur la sole, et espacées entre elles pour laisser passage à la flamme, de manière à partager le foyer en deux chauffes, ayant chacune $0^m,20$ à $0^m,23$ de largeur, et autant de hauteur. Lorsqu'on emploie comme combustible du charbon de bois, on peut le charger par une porte placée à la partie supérieure, comme dans les fourneaux d'essai.

« Outre le fourneau à moufle, on se sert, pour la conversion du sulfate de soude en sulfure de sodium, d'un fourneau analogue à ceux employés dans la fabrication de la soude. Dans nos fabriques, j'ai seulement remplacé le foyer latéral unique que l'on emploie ordinairement, par deux foyers plus petits, placés vis-à-vis l'un de l'autre ; l'expérience m'a démontré que l'on réalisait ainsi une économie notable de temps et de combustible, surtout pour les fourneaux ou la longueur de la sole dépasse 2 mètres.

« Passons maintenant à la fabrication des matières premières, et à la fabrication de l'outremer artificiel.

« On met l'argile sèche, concassée en morceaux avec un pilon en bois, dans des cuves rectangulaires de 2 mètres de long sur 1 mètre de large ; on l'arrose d'eau, et on l'abandonne à elle-même pendant quelques jours. Elle se délite et se réduit en bouillie, que l'on purifie par lévigation en dépôt, de la même manière que dans les fabriques de porcelaine, pour en séparer le sable et les par-

ties les plus grosses. On la conserve ensuite dans des cuves placées sous un hangar couvert, à l'état d'une pâte molle, dont on détermine rigoureusement, par un essai, la teneur en argile sèche, chaque fois qu'on veut s'en servir pour la préparation de l'outremer.

« Pour préparer le sulfate de soude, on se sert, comme nous l'avons dit, des résidus de la fabrication de l'acide muriatique, que l'on calcine dans un fourneau à réverbère pour en chasser l'acide muriatique libre, qu'ils renferment. On le concasse en morceaux de 1 décimètre cube environ, que l'on plonge un instant dans l'eau, parce que l'expérience a prouvé que l'acide libre se dégage beaucoup plus aisément d'un sel humide que d'un sel desséché; puis on les charge sur la sole du fourneau, que l'on remplit presque jusqu'à la voûte, en disposant les morceaux de sorte que la flamme puisse circuler aisément sur leurs faces. On chauffe graduellement jusqu'au rouge naissant, et jusqu'à ce que tout l'acide libre ait été expulsé. Le sel calciné est aussitôt pulvérisé au bocard ou entre des meules, en grains, de la grosseur de ceux de la poudre de mine, et mélangé dans un tonneau tournant sur son axe, avec du charbon et de la chaux éteinte, dans les proportions suivantes :

> Sulfate de soude......... 100 parties.
> Charbon de bois pulvérisé. 33 »
> Chaux éteinte à l'air...... 10 »

« Ce mélange est introduit sur la sole du fourneau à réverbère, et recouvert de 3 à 4 centimètres de chaux éteinte, que l'on tasse dessus avec une pelle en fer; on ferme alors

toutes les portes du fourneau, et dès que la masse est en pleine fusion, on la brasse vivement, en y rejetant quelques pelletées de charbon pulvérisé ; puis, on laisse reposer quelque temps, jusqu'à ce qu'il ne se dégage plus de gaz enflammé de la surface du bain ; on puise alors le sulfure de sodium avec des poches, et on le verse dans des moules plats en fonte, où il se solidifie. »

« On dissout dans l'eau bouillante le sulfure de sodium, mélangé de carbonate de soude, ainsi obtenu, puis on laisse clarifier la dissolution à l'abri du contact de l'air, dans des cuves de dépôt, où elle abandonne du carbonate et un peu de sulfate de soude cristallisé, qui est calciné et retraité comme il vient d'être dit, et du charbon très-divisé, qui ne se dépose qu'au bout de quelques jours. Il est très-important de le laisser reposer le plus longtemps possible, parce que les moindres particules de charbon suffisent pour altérer le feu de l'outremer. On sature ensuite à chaud cette dissolution, décantée avec du soufre réduit en poudre, et on la concentre par l'ébullition jusqu'à ce qu'elle renferme 25 p. % de bisulfure de sodium sec : elle a alors une densité d'environ 1/2, et marque 25° à l'aréomètre de Baumé. On emploie 40 à 50 parties de soufre pour 100 de sulfure de sodium fondu.

« Après avoir laissé déposer à la dissolution de sulfure de sodium le léger excès de soufre qu'elle renferme, on la transvase dans des grandes cruches en verre, que l'on bouche avec soin, pour la préserver du contact de l'air, et on la conserve jusqu'au moment de l'employer.

« Les matières premières étant préparées, on procède comme il suit à la fabrication de l'outremer : on évapore

jusqu'à consistance sirupeuse, dans une chaudière plate en fonte, 50 kilogr. de la dissolution de sulfure de sodium ci-dessus, puis on y ajoute une quantité d'argile lavée, encore humide, correspondant à 12 kilogr. et demi d'argile sèche, et on mélange le tout aussi intimement que possible, à l'aide d'une forte spatule en fer. Pendant que la masse se laisse encore brasser aisément, on y ajoute, par petites portions, une dissolution de 150 grammes de sulfate de fer cristallisé, complétement exempt de cuivre, et on mélange le tout avec le plus grand soin. On peut, si l'on veut, ajouter d'abord la dissolution de sulfate de fer, puis ensuite l'argile; aussitôt après l'addition du sulfate de fer, le mélange prend une couleur vert-jaunâtre, due à la formation du sulfure de fer; on continue à le brasser jusqu'à complète évaporation à siccité, et après l'avoir détaché de la chaudière, on le réduit de suite en poudre, aussi ténue que possible.

« Cette poudre est chargée dans les moufles, de manière à y former une couche de 6 à 8 centimètres d'épaisseur, ce qui correspond, pour chaque moufle, à un poids de 15 à 20 kilogr.; on continue le feu jusqu'à ce que toute la masse soit rouge, et on la laisse dans cet état pendant trois quarts d'heure à une heure, en renouvelant fréquemment les surfaces et en donnant libre accès à l'air. La masse se colore successivement en brun de foie, rouge, vert et bleu. Cette opération réclame beaucoup d'attention et d'habitude : une trop faible chaleur ne produit point d'outremer, tandis qu'une chaleur trop forte et trop longtemps prolongée en altère la beauté.

« On retire alors la matière du moufle, et on l'épuise en

la lavant avec de l'eau. Les eaux de lavage, qui renferment du sulfure et du sulfate de soude, n'ont jusqu'ici reçu aucun emploi, mais on pourrait s'en servir pour préparer du sulfure de sodium. Les résidus du lavage sont égouttés dans des chausses en toile serrée, puis desséchés à l'étuve. Leur couleur est ordinairement d'un vert ou d'un bleu noirâtre.

« La masse desséchée est ensuite finement pulvérisée et passée au tamis de soie, puis calcinée de nouveau par portions de 5 à 7 kilogrammes dans des moufles qui ne servent qu'à cette opération, et qui ont de $0^m,45$ à $0^m,50$ de large sur $0^m,80$ à $0^m,90$ de profondeur. On entretient un feu modéré, et une chaleur rouge peu intense suffit pour produire la chaleur désirée. Aussitôt que la couleur bleue commence à paraître, on renouvelle constamment les surfaces avec un ringard en fer, jusqu'au moment où la couleur est devenue d'un beau bleu pur. L'opération dure d'une demi-heure à trois quarts d'heure; il n'y a aucun avantage à la prolonger ou à augmenter l'intensité du feu. On retire la poudre et on la laisse refroidir au contact de l'air sur des plaques de granit. Il arrive souvent, mais pas toujours, que la couleur acquiert, en refroidissant, bien plus de feu et de beauté.

« L'outremer est ensuite broyé sous des meules en granit de $1^m,50$ de diamètre, puis lavé et séparé, suivant la finesse, en divers degrés qui portent les n°s °/₀ 1, 2, 3, 4, etc.

« Un excellent procédé pour reconnaître la qualité de l'outremer, consiste à le chauffer sur la lampe à esprit-de-vin, dans un tube de verre où l'on fait passer un cou-

rant d'hydrogène. L'outremer sera d'autant plus inaltérable et sa qualité d'autant supérieure, que la couleur bleue sera plus longtemps à disparaître. L'outremer naturel ne perd sa couleur qu'au bout d'une et même deux heures et quelquefois plus ; l'outremer factice de Nuremberg marque 0 au bout d'un peu plus de demi-heure, et l'outremer le plus commun marque 5 au bout de quelques minutes. »

M. Brunner, qui a fait une étude suivie de l'outremer, a donné le moyen suivant pour l'obtenir.

Les matières qu'il emploie, et auxquelles il fait subir quelques opérations préliminaires, sont : le charbon de bois, la fleur de soufre, le carbonate de soude anhydre, l'alumine et la silice.

Ainsi, il se sert pour les premières calcinations de fleur de soufre, mais pour les dernières, il préfère le soufre qu'il distille exprès. Il fait dissoudre et cristalliser de nouveau le carbonate de soude du commerce, qu'il calcine, pour lui enlever toute son eau. L'alumine provient de l'alun du commerce, calciné à une haute température. Pour la silice, M. Brunner se sert d'un sable quartzeux qu'on trouve près de Lenguau, dans le canton de Berne, et qui est formé de :

Silice..........	94,25.
Alumine........	3,03.
Chaux..........	1,61.
Peroxyde de fer.	0,94.
Perte..........	0,17.
	100,00.

On prend maintenant :

Sable quartzeux................	70 parties.
Alun calciné	240 »
Fleur de soufre...........	144 »
Carbonate de soude calciné.	240 »
Charbon de bois..........	48 »

Ces substances, parfaitement réduites en poudre, sont mélangées et broyées dans un tonneau au moyen de balles de fer, puis passées au tamis de soie. Cette opération doit être faite avec tout le soin possible, car c'est de la perfection des mélanges que dépend le succès de la fabrication.

On introduit la matière dans un creuset de Hesse, on lute le couvercle, puis on chauffe en élevant le plus promptement possible la température jusqu'au rouge, sans cependant faire entrer la masse en fusion. M. Brunner a observé qu'une heure et demie de température au rouge sombre était nécessaire. Lorsque le creuset est refroidi, on obtient une masse, médiocrement tassée, jaune verdâtre, ayant quelque ressemblance avec le foie de soufre, et occupant les 2/5 du volume primitif.

Cette matière, qui se détache facilement du creuset, est mise dans un vase, puis arrosée avec de l'eau froide. Du sulfure de sodium se dissout, et il se précipite une poudre d'un bleu verdâtre qu'on jette sur un filtre et qu'on lave à l'eau chaude, jusqu'à ce que l'eau de lavage n'ait plus d'odeur. Après avoir été séchée, elle se présente sous la forme d'une poudre légère, d'un gris de cendre clair.

Pour s'assurer de la qualité, on en mélange une petite quantité avec de la fleur de soufre, qu'on chauffe sur un morceau de porcelaine ; lorsqu'elle prend une teinte bleue, on passe à la seconde opération.

On prend parties égales de la poudre de la première opération et de soufre distillé ; on ajoute une fois et demie son poids de carbonate de soude calciné, et on mélange le tout de la même manière que nous avons déjà indiquée ; on introduit dans un creuset de Hesse et on chauffe comme précédemment. Après le refroidissement, on lave la masse qu'on fait ensuite sécher ; on l'essaye de nouveau par le soufre, puis on lui fait subir une troisième calcination avec le soufre et le carbonate de soude. On remarque qu'après cette opération, le produit possède une couleur bleue très-belle. Dans le cas où sa teinte ne serait pas assez riche, on passerait à une quatrième calcination.

Le dernier traitement consiste à étendre sur une plaque de fonte une couche de soufre sublimé, d'une ligne d'épaisseur environ, à tamiser par-dessus une couche égale ou un peu plus épaisse de la poudre, à chauffer la plaque de fer de manière que le soufre s'allume, et à chasser ainsi tout le soufre à la température la plus basse possible.

On réitère le traitement au soufre trois ou quatre fois avec la même poudre, qu'on pulvérise après chaque opération. Le produit qu'on obtient se présente alors sous la forme d'une poudre légère d'un beau bleu ; on remarque qu'après chaque traitement par le soufre, la poudre augmente de poids, et que, lorsqu'elle a acquis son maximum d'intensité, cette augmentation n'a plus lieu.

D'après l'auteur de ce procédé, si on remplace la soude par la potasse, le produit qu'on obtient possède la même composition chimique, mais il est incolore. Obtenu par le procédé Brunner, l'outremer est composé de la manière suivante :

Silice..................	32,544.
Alumine...............	25,255.
Chaux.................	2,377.
Oxyde de fer..........	2,246.
Sodium................	16,910.
Soufre.................	11,629.
Oxygène comme perte.	9,039.

M. Varrentrapp et M. Guimet, qui ont fait l'analyse de l'outremer de Nuremberg et de celui de Paris, leur ont trouvé une composition différente :

	Outremer de Meissen. (Varrentrapp.)	Outremer de Paris. (Guimet.)
Silice............	45,00	47,30.
Alumine.........	23,20	22,09.
Potasse	1,75	12,06.
Soude	21,47	
Chaux...........	0,02	1,54.
Soufre...........	1,69	0,18.
Fer..............	1,06	0,00.
Acide sulfurique.	3,83	4,67.
	98,02.	87,84.

La chaux, d'après M. Brunner, ne concourrait en aucune manière à la composition de l'outremer. Le fer n'aurait pas non plus d'influence sur la formation de la cou-

leur bleue. Il paraîtrait cependant, d'après M. Elsner, que ce métal serait tout à fait essentiel à la préparation.

Depuis bien longtemps déjà, les chimistes se sont demandé à quelle substance on devait attribuer la coloration bleue de l'outremer.

Margraff est le premier chimiste qui se soit occupé du soin de résoudre cette question. Avant lui, on présumait que le cuivre seul communiquait à l'outremer la couleur bleue ; mais par des analyses très-concluantes, il prouva que ce métal était tout à fait étranger à la composition de cette substance ; et comme il trouva une certaine quantité d'oxyde de fer, il attribua la coloration au fer métallique. Valérius l'attribuait à l'argent.

Guyton de Morveau ayant obtenu une coloration bleue en calcinant du sulfate de fer avec des terres, avança que la matière colorante provenait du sulfure de fer.

Enfin, Clément et Desormes pensèrent que le soufre était la cause de cette couleur.

Cette question, restée dans l'oubli pendant un certain nombre d'années, a été de nouveau soulevée, il y a quelque temps, par M. Elsner, qui a annoncé que la matière colorante bleue est un silicate double de soude et d'alumine contenant, sous forme de combinaison chimique, un sulfure double de sodium et de fer.

Il y a quelques années encore, le bleu d'outremer nous arrivait à peu près exclusivement de l'Allemagne ; mais maintenant, il existe en France des fabriques qui livrent cette matière colorante en quantité assez grande, et d'une qualité qui ne laisse rien à désirer.

Pour connaître d'une manière très-approximative la ri-

chesse de teinte des outremers, M. Barreswil a indiqué le moyen suivant.

On prépare du sulfate de baryte artificiel en décomposant du nitrate de baryte ou du chlorure de baryum par de l'acide sulfurique ; on lave avec soin et on sèche exactement. On fait deux pesées de 20 grammes chacune de sulfate de baryte qu'on met dans deux mortiers, et on tare exactement, dans deux petites capsules, les deux échantillons d'outremer dont on désire comparer les teintes (environ 1/2 gr. à 1 gr.) : avec une partie de l'un de ces échantillons que l'on verse dans un mortier, on compose, avec le sulfate de baryte, une teinte d'un bleu clair ; et avec l'autre, versé peu à peu dans le second mortier, on fait une teinte aussi rapprochée que possible ; les deux capsules, portées dans la balance, indiquent par la perte du poids la quantité d'outremer employé ; la comparaison des poids donne la valeur comparative des outremers.

L'outremer est d'un usage journalier pour l'azurage du papier, des tissus, des bougies, du savon, de l'amidon, du sucre ; il sert dans l'impression sur étoffes et sur papier. Enfin il est employé pour la peinture à l'huile et pour l'aquarelle.

Le prix assez élevé auquel le commerce le livre a excité la convoitise des falsificateurs, aussi n'est-il pas rare de le rencontrer falsifié, soit avec les cendres bleues, soit avec l'amidon.

Les cendres bleues se reconnaissent au moyen de l'ammoniaque, elles se dissolvent en colorant ce véhicule en bleu très-intense. L'outremer pur, au contact de ce réac-

tif ne fournit rien de semblable. La fécule se décèle au moyen de la teinture d'iode, qui la colore en bleu.

BLEU DE COBALT OU BLEU THÉNARD.

Lorsque les arts étaient obligés de recourir au lapis-lazuli pour se procurer le bleu d'azur, M. Thénard fit connaître, dans le cours de l'année 1804, une couleur bleue qui eut jusqu'à l'époque de la découverte de l'outremer artificiel une très-grande vogue, et qui est encore souvent employée de nos jours. En effet, outre qu'on peut la livrer à un prix aussi bas que l'outremer artificiel, elle possède, de plus que cette couleur, des propriétés que les peintres estiment beaucoup : ainsi elle ne perd pas aussi facilement l'éclat de son ton lorsqu'elle a été exposée pendant un certain temps à l'air ; dans quelque lieu qu'on la place, elle conserve pendant fort longtemps sa belle teinte, et couvre parfaitement les objets sur lesquels on l'applique ; avantages que l'outremer ne possède pas à un aussi haut degré. Le seul reproche qu'on peut lui faire, c'est de fournir une peinture qui paraît violette vue à la lumière d'une bougie.

Cette substance, à laquelle le public reconnaissant a donné le nom de son inventeur, possède une composition chimique qui varie avec le procédé employé pour l'obtenir. Elle peut être regardée comme un mélange en proportions diverses de phosphate d'alumine et d'oxyde de cobalt, contenant presque toujours une certaine quantité d'arséniate de cobalt.

M. Thénard l'obtient de la manière suivante :

On commence par préparer du phosphate de cobalt en traitant du minerai de cobalt par l'acide nitrique et décomposant le nitrate formé par du phosphate de soude, qui fournit du phosphate de cobalt insoluble et du nitrate de soude soluble.

D'autre part, on précipite une solution d'alun de potasse ou d'ammoniaque par de l'alcali volatil ; l'hydrate d'alumine, qui a pris naissance, est lavé avec soin et réduit à l'état de gelée.

On fait ensuite un mélange de 1 partie de phosphate de cobalt avec 1/5 2 ou 3 parties d'alumine récemment précipitée, on broye dans un mortier jusqu'à ce qu'on n'aperçoive plus aucun point bleu ou plus foncé que le reste de la masse ; on sèche ensuite le mélange, on le place dans un creuset, on l'expose à une température un peu au-dessus du rouge cerise. Après refroidissement, on obtient le bleu de cobalt en fragments qui se désagrégent facilement. On le réduit en poudre fine et on le livre au commerce.

La beauté du produit dépend uniquement de la quantité d'alumine qu'on ajoute. Ainsi, en employant parties égales de phosphate de cobalt et d'hydrate d'alumine, on obtient une couleur bleue qui tire sur le vert, et avec 4 ou 5 parties d'alumine pour 1 de phosphate de cobalt, la couleur passe au bleu clair.

M. Thénard a recherché si, en remplaçant le phosphate de cobalt par l'arséniate, on n'obtiendrait pas un produit d'une teinte plus belle ; ses expériences ont montré qu'en opérant avec parties égales d'arséniate de cobalt et d'alumine, on obtenait un bleu vif foncé pur,

mais jamais d'une nuance aussi belle qu'avec le phosphate.

Comme le minerai de cobalt contient toujours une assez forte dose d'arsenic, qui forme de l'arséniate de cobalt, lorsqu'on précipite la solution nitrique par le phosphate de soude, M. Payen a conseillé de faire subir au minerai un grillage préliminaire, qui a pour but d'expulser la plus grande partie de l'arsenic. Cette opération fournit un avantage incontestable; malgré cela, presque tous les bleus de cobalt du commerce contiennent de l'arséniate de cobalt, en très-petite quantité, il est vrai.

M. Boullai Marillac a apporté au procédé de M. Thénard une modification qui consiste à remplacer l'alumine par la chaux; il obtient alors du phosphate de chaux et de l'oxyde de cobalt qui, au dire de son inventeur, possède une teinte bleue plus riche, et est d'un aspect plus velouté que le bleu Thénard. Sous cette forme, il convient parfaitement pour la peinture en miniature.

Les acides phosphorique et arsénique sont-ils nécessaires à la production du bleu Thénard? Nous ne le pensons pas.

Ce qui le prouve, c'est qu'en calcinant au rouge cerise un mélange à parties égales d'alumine gélatineuse et de nitrate de cobalt, on obtient une couleur bleue aussi belle que la précédente.

Le bleu Thénard ne serait donc, à proprement parler, qu'une combinaison d'alumine et d'oxyde de cobalt à un degré d'oxydation encore inconnu.

Le procédé que M. Binder a publié dernièrement dans la *Revue scientifique,* sur la préparation de cette couleur,

qu'il nomme *outremer cobaltique,* vient à l'appui de cette manière de voir.

Voici comment M. Binder conseille d'opérer :

« Je fais dissoudre 6 kilogrammes d'alun exempt de fer dans un vase de terre ou de plomb, je filtre la dissolution bouillante dans une cuve haute de 1 mètre 70 centimètres, large de 1 mètre, que je remplis au tiers d'eau parfaitement pure et débarrassée de toute trace de fer, afin d'empêcher l'alun de cristalliser. Ensuite je précipite l'alumine au moyen d'une dissolution de potasse, je remplis la cuve d'eau, et après avoir laissé déposer le liquide et décanté l'eau claire qui surnage, je le remplace par une nouvelle quantité ; je continue de la même manière jusqu'à ce que le chlorure de baryum ne fasse plus reconnaître la moindre trace d'acide sulfurique.

« Je fais dissoudre 500 grammes de sesquioxyde de cobalt dans 1,500 grammes d'acide chlorydrique marquant 22° à l'aréomètre de Baumé, j'évapore la dissolution à siccité ; je fais de nouveau dissoudre le résidu dans 3 kilogrammes d'acide chlorydrique et je soumets la dissolution à l'action de l'acide sulphydrique, pour en séparer les métaux étrangers qui pourraient s'y trouver ; je filtre, j'évapore de nouveau à siccité, et enfin je fais dissoudre le résidu dans l'eau, de manière à obtenir 9 ou 10 livres de dissolution.

« Une fois ces deux opérations préliminaires faites, je précipite, au moyen de l'ammoniaque, 6, 8, 10 ou 12 livres de cette dissolution cobaltique, plus ou moins, selon que la nuance doit être plus ou moins foncée. Mais il faut avoir bien soin de ne pas verser trop d'ammoniaque,

sans quoi le cobalt se redissoudrait dans un excès de réactif. Après avoir bien lavé le précipité, je le verse dans de l'eau, tenant en suspension l'alumine extrêmement divisée dont il a été question plus haut. Il faut remuer le mélange, sans interruption, pendant une demi-heure, afin que les deux précipités se mêlent d'une manière bien intime.

« Lorsque le liquide qui surnage présente, après avoir reposé, une couleur rougeâtre, c'est une preuve qu'un peu de cobalt s'y est dissous ; alors on ajoute encore un peu d'ammoniaque, on laisse reposer, on décante et l'on ajoute de la nouvelle eau à différentes reprises. On enveloppe le précipité d'un linge fin, on le suspend pour le faire égoutter, on l'exprime, on le fait sécher à l'étuve dans des vases, et on le chauffe au rouge pendant deux heures ou deux heures et demie dans des creusets de terre.

« Après le refroidissement, l'outremer est finement broyé à la meule, desséché, porphyrisé et passé au tamis. 12 livres de dissolution cobaltique donnent l'outremer le plus fin ; celui dont la couleur est la plus claire s'obtient avec 6 livres de dissolution. Le produit est de 2 livres en moyenne, et pour les deux premières sortes, il s'élève souvent à 2 ou 3 onces au plus. »

Le bleu Thénard est vendu dans le commerce en poudre et entier ; il possède une teinte bleue qui se confond avec celle de l'outremer factice. Sa couleur résiste parfaitement à l'action de la chaleur, à la lumière, aux acides, à l'acide sulphydrique, au chlore et aux alcalis. Broyé à l'huile, il couvre aussi bien que l'outremer, avec une nuance légèrement violâtre.

Quand, par suite de certaines circonstances, cette couleur a perdu la vivacité de sa teinte, on la lui rend facilement en la chauffant à l'air et en l'agitant continuellement, ou bien encore on la mélange avec une petite quantité de bioxyde de mercure (oxyde rouge, précipité *per se*), et on chauffe ; le mercure se volatilise à l'état métallique, tandis que l'oxygène se fixe sur la matière à laquelle il rend tout son éclat primitif. La fixation de l'oxygène sur le bleu de cobalt décoloré, démontre que l'oxyde de cobalt y est à un certain état d'oxydation, indispensable pour la production de sa teinte bleue.

SMALT.

Le smalt, nommé encore *bleu d'azur, bleu de smalt, bleu de Saxe, bleu de safre, bleu d'émail, bleu d'empois* et enfin *verre de cobalt*, a été considéré jusque dans ces derniers temps comme un verre coloré par de l'oxyde de cobalt ; mais il résulte des expériences d'un inspecteur des fabriques d'Allemagne, M. Ludwig, qu'il peut être regardé comme un silicate double de potasse et de cobalt, de la formule :

$$2 \text{SiO}^3 + \text{KO} + 2(\text{SiO}^3) + \text{CoO},$$

mélangé avec des quantités très-variables d'oxydes terreux et métalliques, parmi lesquels on remarque la chaux, l'alumine, la magnésie, l'oxyde de fer et l'oxyde de nickel, et parfois des acides arsénique, carbonique, et de l'eau.

La découverte du bleu de smalt est attribuée à un verrier saxon, nommé Christophe Schüiver, qui était établi à Neudek vers le milieu du seizième siècle. Il l'obtint en

faisant fondre du verre avec du minerai de cobalt de Scheeberg. Pendant quelque temps il le vendit comme émail bleu aux potiers du voisinage. Son procédé ne tarda pas à être connu des fabricants de Nuremberg, qui l'exploitèrent en Hollande. La fabrication passa ensuite à Venise.

Mais il est certain que cette couleur avait été employée par les peintres de l'antiquité, car les Grecs et les Romains s'en servaient, sous le nom de *fritte d'Alexandrie*, pour la décoration de leurs vases. Ainsi, Davy l'a retrouvée dans des fragments de peinture à la fresque tirés des ruines du monument de Caïus Cestius, et dans des pots enfouis sous les ruines de Pompéia. C'est cette couleur qui forme les bleus de la Noce Aldobrandine.

D'après M. Ludwig, l'intensité de la couleur du smalt dépendrait de l'abondance plus ou moins grande du silicate double de potasse et de cobalt. Voici la composition chimique qu'il a trouvée à trois échantillons provenant de sources différentes.

	Smalt de modum de qualité supérieure.	Smalt d'Eschel.	Smalt commun.
Silice	70,86	66,20	72,12.
Alumine	0,43	8,64	1,80.
Protoxyde de fer	0,24	1,36	1,40.
Chaux	»	»	1,92.
Protoxyde de cobalt	6,49	6,75	1,95.
Potasse et soude	21,41	16,31	20,04.
Protoxyde de nickel	»	»	Traces.
Acide arsénique	Traces	»	0,07.
— carbonique	} 0,57 {	0,25	0,46.
Eau		0,67	Traces.
	100,00.	100,18.	99,76.

La plus grande partie de smalt qu'on emploie tant en France qu'à l'étranger se fabrique en Saxe et dans la Hesse.

Les matières premières qu'on emploie pour cela sont :

>Du minerai de cobalt.
>Du sable.
>De la potasse.

Le minerai de cobalt, qui sert le plus ordinairement à cette fabrication, est le speisz ou arséniure de cobalt et de fer, auquel on fait subir une opération préliminaire qui a pour but de volatiliser l'eau et l'arsenic qu'il contient, de suroxyder les oxydes de cobalt et de fer, et enfin de rendre ses parties terreuses propres à la vitrification.

Dans un fourneau à réverbère, garni d'une grande cheminée et chauffé au rouge, on projette le minerai réduit en morceaux peu volumineux. Lorsqu'il ne se dégage plus de vapeurs blanches, et lorsqu'au moyen d'un ringard on s'aperçoit que la matière commence à s'agglomérer, on la retire du feu. La mine de cobalt, après son entier refroidissement, est réduite en poudre, puis passée au tamis de soie.

Dans cet état, elle porte le nom de *safre*.

La durée de la calcination dépend beaucoup de la nature du minerai qu'on a à sa disposition ; ce n'est que par des essais en petit qu'on parvient à régler l'intensité de la chaleur et le temps nécessaire à cette opération.

Le sable provient du quartz, privé, autant que possible, de talc, de mica, de craie et de fer ; on calcine la pierre en plein air, et lorsqu'elle est encore rouge, on l'é-

tonne en la plongeant dans de l'eau froide, on la met en poudre fine qu'on lave avec de l'acide chlorhydrique étendu, puis on la fait sécher et on la passe au tamis.

La potasse doit être privée, autant que possible, de chlorure de sodium, de chaux et de sable ; celle qui provient de la calcination du tartre blanc convient parfaitement pour cet usage ; on la calcine avant de l'employer, puis on la met en poudre.

Une fois les matières premières préparées, on procède au mélange.

La proportion de celles-ci est fort difficile à indiquer. Chaque fabricant est obligé d'opérer avec des quantités qui dépendent de la nature du minerai de cobalt qu'il peut se procurer.

Le sable et le cobalt sont d'abord mélangés entièrement, puis on ajoute la potasse ; on place la matière dans des pots faits d'argile et de sable, et percés à leur partie inférieure d'un trou qu'on bouche à volonté. On en place ainsi un certain nombre dans un four à verrerie ordinaire que l'on chauffe au rouge blanc avec du bois, plus rarement avec du charbon de terre.

Ordinairement, après quatre ou six heures de calcination, la matière se trouve en fusion tranquille ; on observe qu'elle forme trois couches : une inférieure, qui consiste en minerai de cobalt non attaqué, mais fondu ; une supérieure, nommée fiel de verre, formée de sulfate et d'arséniate de potasse et de chlorure de potassium ; enfin une troisième intermédiaire, qui constitue le *verre bleu*.

Au moyen de grandes cuillers de fer chaudes, on en-

lève avec précaution la plus grande partie du fiel, puis on débouche les trous des pots afin de faire écouler le speisz fondu. On rebouche aussitôt, et avec la cuiller de fer on prend le verre fondu qu'on verse dans une auge contenant de l'eau froide. On recharge de nouveau les pots, et on procède à une nouvelle opération.

Dans une fabrique de smalt en activité, l'opération marche jour et nuit, sans discontinuer pendant des années entières. Mais cette fabrication ne laisse pas que d'être très-dangereuse pour les ouvriers. Continuellement exposés aux vapeurs arsénicales et à l'action d'une température très-élevée, on a remarqué qu'en général ils n'arrivaient pas à un âge avancé.

Le smalt que l'on retire de l'eau est recueilli, séché, puis pulvérisé sous des meules horizontales. On le lave par décantation, ce qui permet de l'obtenir sous divers degrés de finesse, qu'on désigne sous les noms de smalt de premier, de second, de troisième et de quatrième feu. Ou bien encore on lui donne une marque spéciale qui se rapporte à sa finesse et à sa teinte.

Le smalt possède une teinte bleue d'autant plus foncée que le minerai de cobalt contenait moins d'arsenic. C'est pour arriver à ce but qu'on a conseillé de l'obtenir avec de l'oxyde de cobalt pur.

Pour cela on réduit le minerai en poudre aussi fine que possible, et on l'arrose avec de l'acide nitrique bouillant; sous l'influence de cet agent, il se forme de l'acide arsénique et des nitrates de cobalt et de fer. On décante la liqueur, on l'étend d'eau, puis on y verse une solution de carbonate de soude. De l'arséniate de soude prend nais-

sance, et il se précipite des carbonates de cobalt et de fer qu'on recueille et qu'on lave avec soin. Ce précipité, séché à l'étuve, puis calciné, fournit de l'oxyde de cobalt contenant une certaine quantité d'oxyde de fer qu'on mélange avec du sable et avec de la potasse. Le smalt qu'on obtient par ce moyen possède une teinte bleue qui ne laisse rien à désirer; mais il revient à un prix beaucoup plus élevé que les autres espèces; d'abord en raison de la préparation de l'oxyde de cobalt, et ensuite parce qu'on est obligé de chauffer les creusets pendant plus longtemps, l'arsenic ayant la propriété, dans la fabrication des smalts ordinaires, de communiquer au verre une plus grande fusibilité.

Il est peu de couleurs qui possèdent des nuances aussi variées que le smalt; entre les deux limites extrêmes du bleu foncé et du blanc bleuâtre, il existe un très-grand nombre de teintes, désignées dans les fabriques par des marques particulières que nous ferons connaître plus loin.

Outre les smalts proprement dits, il en existe une autre espèce d'une teinte bleue assez foncée, et d'un grain très-fin, qu'on désigne communément sous le nom de *bleu de blanchisseuse* ou de *bleu d'Eschel*.

Cette variété s'obtient de toutes pièces, en mélangeant du safre, réduit en poudre fine, avec du smalt de bonne qualité; on le distingue du smalt véritable en le délayant dans l'eau; après quelques secondes de repos, le safre se précipite le premier, tandis que le smalt reste en suspension dans le liquide.

Nous arrivons maintenant aux propriétés générales du smalt.

Ainsi que nous l'avons déjà dit, sa teinte varie depuis le bleu clair jusqu'au bleu foncé ; sa densité est de 2,65° en moyenne ; exposé à l'action de la chaleur, il peut supporter une très-haute température sans se décomposer. Il entre en fusion à 1,200°.

Pour être de bonne qualité, le smalt ne doit pas être sablonneux, il doit s'agglomérer comme de la farine.

Vu au microscope, il doit présenter des grains de même dimension et de la même nuance.

Délayé dans de l'eau, le dépôt qui se forme doit avoir la même couleur dans toute son épaisseur.

Il doit être exempt de substances étrangères, telles que du plâtre, du sable, du spath pesant, de l'outremer, etc.

Le smalt est employé pour plusieurs usages.

La variété la plus grosse sert, comme sable, à sécher l'écriture. Comme couleur, il est d'un emploi journalier pour le papier, le linge et les étoffes blanchies ; comme couleur d'application, il ne fournit pas toujours des résultats très-satisfaisants, il présente quelquefois l'inconvénient de verdir et de noircir ; sa nature siliceuse s'oppose à ce qu'on puisse le mélanger d'une manière convenable avec les huiles ; mais pour le badigeonnage, il donne une couleur très-belle et très-résistante.

Chaque fabricant possède des échantillons fondamentaux, désignés par des marques particulières ; c'est par la finesse du grain et sa richesse en cobalt qu'on parvient à établir une échelle qui permet de classer les différents produits qu'on obtient. Ainsi en Saxe, le smalt est généralement connu sous les initiales suivantes :

H.... Smalt commun.

E.... Variété Eschel.
B.... Smalt de Bohême.
CF... Couleur fondamentale.
FC... Fine couleur.
FCB. Fine couleur de Bohême.
FE.. Eschel fin.
MC.. Couleur moyenne.
MCB. Couleur moyenne de Bohême.
ME.. Eschel moyen.
OC.. Couleur ordinaire.
OCB. Couleur ordinaire de Bohême.
OE.. Eschel ordinaire.

Les lettres F M et O se rapportent à la convenance en cobalt. C. CB, se rapportent au grain.

Pour désigner du smalt qui contient plus de cobalt que F, on ajoute plusieurs F, c'est ainsi que FFFC sera à un prix plus élevé que FFC, et celui-ci vaudra plus d'argent que FC. Si, au contraire, le bleu contient moins de cobalt que OC, couleur ordinaire, on ajoute à la marque en exposant, par exemple, OC^2 OC^3, pour indiquer que le smalt contient la moitié ou le tiers de cobalt de la qualité ordinaire.

BLEU DE MONTAGNE.

Le bleu de montagne, nommé encore *azurite, pierre d'Arménie*, est un carbonate de cuivre basique qui ne diffère du vert de montagne ou malachite que par des proportions d'eau et d'acide carbonique. Sa formule se représente ainsi :

$$2(CO^2) + 3(CuO) + HO$$

Acide carbonique. Oxyde de cuivre. Eau.

Cette substance se trouve dans la nature à l'état terreux ou bien engagée dans du quartz ; dans le premier cas, elle porte plus particulièrement le nom de *bleu de montagne* ou *chrysocolle bleu;* tandis que dans le second, on lui réserve le nom de *pierre d'Arménie.*

On rencontre le bleu de montagne dans les montages stratifiées, en Sibérie, dans les monts Ourals, dans le Tyrol, où il sert à peindre les jouets d'enfants ; en Bohême, en Saxe, au Hartz, dans la Hesse, à Salzbourg, en Angleterre, et enfin en France, à Chessy, près de Lyon, où on l'exploite pour la préparation du cuivre métallique ; il possède une teinte bleue céleste, très-riche, qu'il conserve dans l'huile.

A l'état de pureté, le bleu de montagne est très-rare ; le plus ordinairement, il est souillé par de la malachite qui lui communique une nuance verdâtre.

Le peu qu'on emploie dans les arts nous vient en partie du Tyrol ; son extraction consiste à réduire le minerai en poudre fine dans des moulins ; à le délayer dans de l'eau, et à le séparer par décantation des matières étrangères. Les premières eaux sont recueillies à part, comme contenant le vert le plus pur.

La richesse de ton du bleu de montagne a fait rechercher depuis très-longtemps le moyen de l'obtenir par la voie artificielle.

On n'est pas encore parvenu, en France, à le préparer parfaitement pur.

Quelques fabricants anglais ont seuls le secret de cette fabrication ; et le produit qu'ils nous livrent possède, à quelques centièmes près, la même composition que celui

que l'on trouve dans la nature, tandis que le bleu de montagne français, nommé *cendres bleues*, *bleu de chaux*, *bleu de cuivre*, contient toujours des proportions plus ou moins grandes de chaux caustique et de sulfate de chaux. Aucune formule ne lui est applicable.

L'illustre Pelletier est le premier qui, après un grand nombre d'expériences, soit arrivé à obtenir un carbonate basique de cuivre dont la teinte se rapproche un peu du bleu de montagne anglais, mais qui en diffère essentiellement par la composition.

Voici le procédé, tel que Pelletier l'a publié à l'Académie des sciences, en 1791 :

« Je fais dissoudre à froid du cuivre dans de l'acide nitrique affaibli, afin d'avoir une dissolution cuivreuse, pareille à celle que l'on obtient dans les travaux du départ. J'ajoute ensuite à cette liqueur de la chaux en poudre, et j'ai soin d'agiter le mélange, pour faciliter la décomposition du nitrate de cuivre ; j'ai soin encore de mettre un petit excès de nitrate de cuivre, afin que toute la chaux soit absorbée, et afin que le précipité qui a lieu (dans l'instant même du mélange) soit un pur précipité de cuivre ; je laisse déposer le précipité, je décante la liqueur qui le surnage (qui est du nitrate de chaux), je le lave à plusieurs reprises, jusqu'à ce qu'enfin il se trouve bien édulcoré ; je mets alors le tout sur un linge, pour que ce précipité puisse s'égoutter. C'est avec ce précipité, qui est d'une couleur d'un vert tendre, que je prépare les cendres bleues. Pour cet effet, j'en prends une certaine quantité que je mets sur une pierre à broyer, ou bien dans un grand mortier ; j'y ajoute ensuite un peu de chaux vive en pou-

24

dre; ce mélange prend par la trituration, et dans l'instant, une couleur bleue très-vive. Si le précipité était trop sec ou même tout à fait sec, j'ajoute une très-petite quantité d'eau, afin que le mélange forme une espèce de pâte molle et facile à broyer. La quantité de chaux que j'emploie est de 7 à 10 p. % de précipité. Je fais ensuite sécher le tout.

Voici maintenant le procédé le plus généralement connu (M. Payen, *Dictionnaire technologique*) :

On se sert de chlorure de cuivre qu'on obtient de la manière suivante :

On fait une solution de sulfate de cuivre, marquant à chaud 36°, on verse du chlorure de calcium liquide (provenant du traitement de la craie par l'acide chlorhydrique) marquant 40° à l'aréomètre de Baumé. Il se produit du chlorure de cuivre qui reste dissous et du sulfate de chaux qui se précipite. Pour obtenir la presque saturation des liqueurs, on a calculé qu'il fallait 240 litres de solution de sulfate de cuivre pour 180 litres de chlorure de calcium. Nous disons *presque saturation*, parce que la présence d'un petit excès de sel de cuivre est indispensable au succès de l'opération.

Le précipité de sulfate de chaux est lavé à plusieurs reprises par décantation avec de l'eau froide, puis on le jette sur des filtres de toile écrue, et on l'arrose de nouveau pour lui enlever tout le sel de cuivre qu'il peut retenir.

Avec les proportions que nous indiquons, on obtient 680 litres environ d'une liqueur verte qui marque 20° Baumé.

Le chlorure de cuivre parfaitement clair est placé dans quatre cuves ou tonneaux défoncés par le bout.

D'une autre part, on délaye dans 300 litres d'eau 90 ou 100 kilogr. de chaux caustique parfaitement blanche. La bouillie qui en résulte est broyée dans un moulin en bois, et lorsqu'elle ne contient plus de grumeaux, on la jette sur un tamis de toile métallique en cuivre à mailles très-serrées.

On prend une quantité de lait de chaux qui varie entre 70 et 85 kilogr.; on la répartit dans les quatres cuves de chlorure de cuivre. On agite pendant longtemps avec un râble en bois et on laisse reposer. La liqueur qui surnage le précipité, essayée par l'ammoniaque caustique, ne doit produire qu'une teinte bleuâtre très-claire. Si elle était foncée, il faudrait ajouter une autre dose de lait de chaux et brasser de nouveau, jusqu'à ce que le précipité ait acquis une teinte uniforme. Après quelques heures de repos, on décante la liqueur claire, on la recueille à part. Comme elle contient une grande quantité de chlorure de calcium, on la fait évaporer à 40° Baumé pour la faire servir à la préparation du chlorure de cuivre. On lave le précipité par décantation, d'abord avec les secondes eaux d'une précédente opération, qu'on met encore à part pour utiliser le chlorure de calcium qu'elles contiennent, puis avec de l'eau pure. La première addition d'eau sert d'*eaux secondes* pour une autre opération. Après quelques minutes de repos, on jette le précipité sur des filtres placés sur des chassis de toile. On obtient 500 à 550 kilogr. d'une pâte molle, verte, que l'on expose dans un endroit à l'abri de la poussière et des émanations méphitiques.

On obtient dans cette première période de l'opération du carbonate bibasique de cuivre. On peut déjà juger par

la teinte du précipité de la beauté du produit qu'on obtiendra.

L'opération qui suit a pour but de mettre en liberté une certaine quantité d'oxyde de cuivre hydraté. Pour cela on se sert d'un lait de chaux fait dans les proportions que nous avons indiquées et d'une solution de potasse perlasse du commerce, marquant 15° Baumé. Mais il est indispensable de connaître auparavant la quantité d'eau que la pâte contient. On en prend 10 à 20 grammes, on la fait sécher vers 90 à 100°, et lorsqu'une balance très-sensible indique qu'elle ne perd plus rien, on la pèse, et par le poids du résidu on obtient la quantité d'eau qui s'est dégagée. Une pâte bien préparée ne doit pas perdre au delà 73 à 75 % d'eau. La précaution que nous indiquons là n'est pas toujours très-exactement suivie, certains ouvriers parfaitement exercés à ce genre de fabrication connaissant, par la consistance de la pâte, la quantité d'eau qu'elle renferme.

Le poids du résidu sec indique la quantité d'eau de chaux et de potasse qu'il faut employer; ainsi, lorsqu'il s'élève à 25 ou 27 %, on en met 12 kilogr. dans un baquet de bois dont la capacité est de 20 litres environ, on y ajoute 1 kilogr. de bouillie de chaux et on brasse vivement pendant plusieurs minutes. Lorsque le mélange a acquis une teinte uniforme, on verse 0 litres 7 de la solution de potasse et on agite de nouveau. Le mélange est porté dans un moulin à couleur et broyé rapidement. Tous les fabricants de cendres bleues attribuent à la promptitude avec laquelle ce broyage est fait, la beauté du produit.

Pendant que cette opération s'exécute, un autre ouvrier fait deux solutions contenant chacune, dans 4 litres d'eau, 500 grammes de sulfate de cuivre et 250 grammes de sel ammoniac. On fait couler la pâte broyée dans une tourille en grès ou une grande bouteille en verre, puis on y ajoute les deux solutions ; on bouche le vase avec un bouchon de liége que l'on mastique, puis on secoue fortement. La matière est abandonnée au repos pendant trois, quatre ou cinq jours, puis on débouche les bouteilles et on verse le contenu dans un tonneau doublé en plomb, défoncé par un bout et rempli aux deux tiers d'eau très-limpide et aussi pure que possible. On brasse bien le tout avec un râble en bois ; on laisse reposer. Une cannelle, placée à quelques centimètres du précipité, permet de soutirer la partie liquide ; on lave ensuite par décantation jusqu'à ce que l'eau décantée ne fasse plus virer au rouge la couleur du papier de curcuma.

On peut faire par ce procédé, et avec les mêmes outils, 3 bouteilles par heure et 24 par jour.

Le précipité suffisamment lavé, et auquel les Anglais donnent le nom de *verditer* en pâte, est mis à égoutter sur des filtres en toile de chanvre. La fabrique des papiers peints l'emploie en très-grande quantité dans cet état. Lorsqu'on veut l'obtenir sec, on le fait dessécher à l'ombre et à une douce chaleur ; il porte alors le nom de *cendre bleue en poudre*.

Le bleu en pâte et les cendres bleues proprement dites, forment dans le commerce trois numéros. Avec les proportions que nous venons d'indiquer, on obtient le n° 3 ou le bleu superfin. Si on ajoute 500 grammes de lait de

chaux de plus, le produit possède une teinte bleue plus pâle et se vend sous le nom de bleu fin ou n° 2. La qualité inférieure ou n° 1, est préparée avec 2 kilogr. de bouillie de chaux au lieu de 1 kilogr., et 500 grammes de sel ammoniac au lieu de 250 grammes.

On fait rarement sécher le bleu n° 1, car il prend une teinte bleue très-pâle qui ne pourrait pas fournir à la peinture un ton riche.

Nous avons dit en commençant, qu'en Angleterre seulement on était arrivé, par un procédé tenu secret depuis très-longtemps, à préparer des cendres bleues identiques par leur composition chimique et la plupart de leurs propriétés physiques au bleu de montagne naturel. Quelques auteurs pensent que l'on se sert de nitrate de cuivre, qui provient de la dissolution du cuivre dans l'acide nitrique concentré, ou bien du traitement des matières d'or et d'argent.

Les cendres bleues anglaises sont à un prix plus élevé que les cendres bleues françaises, d'abord parce qu'elles possèdent une teinte plus belle, et ensuite parce qu'elles sont plus solides.

Nous considérons le procédé indiqué par Pelletier, quoique donnant un produit moins beau, comme infiniment préférable sous le rapport de la solidité à celui généralement décrit dans les auteurs. Voici pourquoi.

L'emploi du sulfate de cuivre et du sel ammoniac dans la mise en bouteille, a pour but de former de l'ammoniure de cuivre, composé bleu d'une très-grande beauté, mais d'une solidité plus que douteuse. C'est bien évidemment à la présence de cette substance dans les cendres

bleues destinées à la peinture sur papier, qu'il faut attribuer le peu de fixité dont jouit généralement la couleur bleue de nos papiers d'appartements, surtout lorsqu'on se sert de bleu n° 1 ou inférieur, nommé encore bleu de chaux.

La fabrication des cendres bleues nécessite de la part de l'ouvrier une pratique très-longue. La qualité des substances qu'on emploie et la propreté des ustensiles influent considérablement sur la qualité du produit qu'on obtient. Ainsi le sel de cuivre doit être à peu près privé de fer, et l'eau de rivière, la moins chargée de sels, doit toujours être limpide et n'avoir aucune odeur. Tous les outils, et particulièrement les moulins, ne doivent rien contenir en fer, et sont lavés avec soin à la fin de la journée. Enfin l'atelier doit être très-bien aéré et éloigné autant que possible des émanations sulfureuses.

Toutes les cendres bleues en pâte qu'on prépare en France sont destinées à la peinture des papiers de tenture ; en poudre, il n'y a guère que les peintres de décors qui l'emploient. Elles sont à peu près inusitées dans la peinture à l'huile, car elles ne conservent pas leur teinte bleue et se délayent assez mal.

Un industriel a imaginé, pour préparer des bleus clairs propres à la fabrication des papiers de tenture, de mélanger une certaine quantité de kaolin au bleu d'azur. Cette substance, par sa nature pulvérulente et lourde, et par l'alumine qu'elle contient, se mélange très-bien aux autres couleurs et sèche très-vite.

Mais le bleu de montagne naturel possède une fixité beaucoup plus grande que celui préparé artificiellement.

Les peintres de l'antiquité en faisaient très-souvent usage, et on remarque que les fresques peintes avec cette substance ont parfaitement résisté à l'action du temps.

L'artiste et le détaillant peuvent avoir intérêt à distinguer les cendres bleues françaises, des cendres bleues anglaises. Pour cela il suffit, lorsqu'elles sont en pâte, de les dessécher d'une manière complète à une basse température, puis de les chauffer dans un tube avec une petite quantité de potasse ou de soude caustique réduite en poudre. L'odorat percevra facilement dans les premières la présence de l'alcali volatil, phénomène qui ne se présente pas avec les cendres d'origine anglaise.

INDIGO.

L'indigo, employé principalement en détrempe par les fabricants de papier peints, est le principe colorant des feuilles de diverses plantes du genre *indigofera* ou *nerium*, du *polygonum tinctorium* et du pastel (*isatis tintoria.*)

Les auteurs font remonter sa découverte aux Grecs et aux Romains, mais son usage n'est bien connu que depuis le seizième siècle. Il fut importé en Europe par les Hollandais, vers l'année 1645.

Cette matière colorante, d'un usage si répandu pour la teinture, éprouva dans l'origine un dénigrement tel, qu'en Saxe, dans le cours de l'année 1750, son emploi fut tout à fait défendu. Les teinturiers de Nuremberg s'entendirent pour ne teindre en bleu qu'avec le pastel. Le contre-coup de cette coalition se fit sentir jusqu'en

France; ainsi, Henri IV défendit son usage sous les peines les plus sévères, et, sous Colbert, l'emploi de l'indigo ne fut permis qu'à la condition de le mélanger avec son poids de pastel.

Cette espèce de proscription tenait à deux causes : d'abord, parce que les industriels regardaient l'indigo comme moins solide que le pastel ; ensuite, parce qu'il tendait à supprimer la culture de cette dernière plante, que certaines contrées de l'Allemagne, la Thuringe, notamment, exportaient en quantité considérable.

En 1737, le chimiste français Dufray montra par des expériences irrécusables, que l'indigo de bonne qualité possédait une solidité aussi grande et une teinte plus belle que les pastels. A partir de ce moment, son usage devint libre et général.

L'indigo se présente ordinairement avec les caractères suivants :

Il est bleu foncé, nuancé de violet et prend un éclat métallique et cuivré lorsqu'on le frotte avec un corps poli ; on estime que sa qualité est d'autant plus belle que cette teinte est plus prononcée. Il est sans odeur, sans saveur, et happe à la langue à la manière de l'argile. Sa densité est moins grande que celle de l'eau. Les agents de dissolution ont peu d'action sur lui ; ainsi, il est insoluble dans l'eau, l'alcool froid, l'éther, les huiles grasses et volatiles, les acides et les alcalis étendus d'eau. L'alcool concentré et bouillant en dissout une petite quantité. Exposé à l'action de la chaleur et à l'air, il entre en fusion vers $290°+0$, et se décompose en partie en répandant des vapeurs pourprées ou *indigotine*, sur laquelle nous aurons

l'occasion de revenir. Chauffé en vase clos, il se décompose entièrement en donnant des produits ammoniacaux et des cyanures volatils, et un résidu de charbon poreux et brillant.

Nous venons de dire que l'indigo était insoluble dans les acides dilués, mais traité par l'acide sulfurique anhydre (acide fumant de Nordhausen), il se dissout à peu près entièrement. Cette liqueur, considérée par les chimistes comme une véritable composition définie, porte, suivant les proportions d'acide, des noms différents; ainsi parties égales ou mieux équivalents égaux d'acide et d'indigo fournissent le *pourpre d'indigo* ; avec 8 à 10 parties d'indigo et 16 à 10 parties d'acide sulfurique, on obtient le *carmin d'indigo* ou *acide sulfindigotique*. Ces deux solutions, qui portent indistinctement dans les arts les noms de *bleu de Saxe, bleu en liqueur, bleu de composition*, sont exclusivement employées dans la teinture ; aussi nous contentons-nous de les signaler ici.

Il n'existe pas moins de 60 variétés d'indigo que l'on classe par le pays d'où on le retire et par leur qualité. Mais dans le commerce de détail, on n'en trouve que trois espèces, qui comprennent 12 à 15 variétés ; ce sont les *indigos* de *Guatimala, caraque* et *du Mexique* ; les plus estimés sont : l'*indigo Bengale bleu flottant* et l'*indigo Guatimarflor*.

Le procédé qu'on emploie pour les préparer varie avec la localité. Les modes opératoires ont subi depuis un certain nombre d'années des perfectionnements qui, tout en diminuant les frais de fabrication, ont contribué beaucoup à en améliorer les qualités ; ainsi, tel indigo qui, dans le

commencement de ce siècle, valait 50 à 60 fr., ne vaut plus actuellement que 20 à 24 fr. le kilogr.

C'est surtout dans les Indes orientales qu'on le fabrique en grande quantité. Voici, à part de légères modifications, le procédé qu'on suit généralement.

Lorsque la plante est en pleine floraison, et que quelques fruits commencent à se former, on détache de la tige, avant le lever du soleil, les feuilles qui contiennent principalement la matière colorante ; on les fait sécher au soleil, on les concasse finement, puis on les place dans des cuves en bois appelés *trempoirs*, et on les recouvre d'eau froide, de manière à ce que celle-ci occupe deux fois plus de volume que la poudre. Au bout de quelques heures, il s'établit une fermentation qui a pour but de faire passer toute la matière colorante à l'état soluble. La liqueur, de jaune qu'elle était dans le commencement, passe peu à peu au vert, puis au bleu plus ou moins foncé. Après cinq ou six heures de contact, pendant lesquelles on a remué la matière dix à douze fois avec des battes de sapin, on passe la dissolution à travers un tissu peu serré ; on la reçoit dans une cuve de bois nommée *batterie*, on l'agite sans cesse pour qu'elle absorbe le plus rapidement possible l'oxygène de l'air, puis on y ajoute environ 5 litres d'eau de chaux pour 100 kilogr. de feuilles sèches ; on laisse déposer, on décante, et lorsque le précipité s'est formé, on le jette sur une toile et on le lave parfaitement. La masse, suffisamment égouttée et réduite en consistance pâteuse, est convertie en pains qui pèsent, desséchés, 100 grammes environ. Ceux-ci sont séchés à l'ombre dans des caisses de bois.

Les premières eaux de lavage sont recueillies à part pour être remises dans les cuves à fermentation avec une nouvelle dose de feuilles.

D'après M. Perrotet, qui a fait de la culture de l'indigotier et de la fabrication de l'indigo l'objet d'une étude spéciale, il n'y aurait que dans l'Inde et en Egypte où on emploie des feuilles sèches : partout ailleurs on se servirait de feuilles fraîches, qui donnent de l'indigo aussi beau et à un prix moins élevé ; ensuite la pâte, avant de subir les différents lavages à l'eau froide, serait chauffée pendant deux heures environ dans une chaudière de métal.

Au dire de certains voyageurs, la macération se fait, dans l'Amérique du Nord, avec de l'eau chaude, qui dissout plus rapidement la matière colorante des feuilles.

Il est à remarquer que le principe contenu dans les différents végétaux qui servent à l'extraction de l'indigo est blanc ; ce n'est que par la fermentation et par l'absorption de l'oxygène de l'air qu'il prend la teinte bleue caractéristique.

A proprement parler, l'indigo est une véritable laque à base de chaux, de laquelle il est facile de séparer le principe colorant pur ou indigotine, dont le poids varie de 45 à 60 pour cent.

L'indigotine a pour formule chimique :

$$\underbrace{C^{16}}_{\text{Carbone.}} \quad \underbrace{H^5}_{\text{Hydrogène.}} \quad \underbrace{Az}_{\text{Azote.}} \quad \underbrace{O^2}_{\text{Oxygène.}}$$

On l'obtient de la manière suivante :

Dans un flacon pouvant contenir 6 litres d'eau envi-

ron, on met 125 grammes de bel indigo réduit en poudre fine avec 200 grammes d'une solution alcoolique et concentrée de soude caustique. On finit de remplir le flacon avec de l'alcool bouillant marquant 75° à l'alcoomètre de Gay-Lussac, et saturé de sucre de raisin. On agite à plusieurs reprises et on abandonne au repos. L'indigotine ne tarde pas à se dissoudre et à fournir une liqueur d'un rouge jaunâtre très-foncé. Lorsque la solution est tout à fait claire, on la décante dans une capsule de verre ou de porcelaine. La solution passe, par suite de l'absorption de l'oxygène de l'air, d'abord au rouge, ensuite au violet et enfin au bleu. Par le repos, on obtient 60 grammes environ d'indigotine cristallisée en aiguilles d'un bleu magnifique ; on la purifie par des lavages réitérés avec de l'alcool, puis avec de l'eau chaude.

L'indigotine n'a pas encore été employée en peinture ; il serait bien à désirer qu'on trouvât le moyen de la préparer à un prix moins élevé, car elle peut fournir, pour la fabrication des fleurs artificielles, une teinte qu'on chercherait en vain dans les autres matières colorantes connues. Elle se délaye parfaitement dans l'eau, et est, de plus, tout à fait inaltérable à l'air.

Tel qu'on le trouve dans le commerce, l'indigo ne possède jamais une composition identique. Il contient d'une manière générale, d'après Berzélius :

> Du gluten ;
> Un principe colorant brun ;
> Un principe colorant rouge ;
> Un principe colorant bleu ;
> De la fécule ;

De la silice ;
De l'alumine ;
De l'oxyde de fer ;
De la chaux.

On y rencontre encore d'autres substances, mais qui sont le fait de la falsification, comme de l'amidon, du bleu de Prusse, de l'argile, et, d'après quelques chimistes, de l'iodure d'amidon.

L'indigo dans lequel on a ajouté de l'amidon, forme une espèce de colle lorsqu'on le délaye dans l'eau chaude.

Préalablement décoloré par la potasse ou la soude caustique, il fournit, avec la teinture d'iode, une belle couleur bleue foncée d'iodure d'amidon.

Le bleu de Prusse est décelé au moyen du chlore, qui décolore l'indigo et n'attaque pas le bleu de Prusse. Traité par l'acide nitrique bouillant, il donne une dissolution dans laquelle les réactifs (ammoniaque, cyanure jaune de potassium et de fer) démontrent la présence du fer.

Pour reconnaître la présence de l'argile, il suffit de dissoudre une certaine quantité d'indigo dans de l'acide sulfurique fumant ; on obtient une liqueur de laquelle l'ammoniaque liquide précipite l'alumine, sous forme d'un précipité volumineux. Cet hydrate d'alumine recueilli et dissous dans l'acide sulfurique ordinaire, produit, avec une petite quantité de potasse, de l'alun parfaitement reconnaissable à sa forme cristalline.

Enfin l'iodure d'amidon se reconnaîtra au moyen de la potasse caustique, qui décolore l'indigo. La liqueur qu'on obtient, filtrée et saturée par l'acide nitrique, donne,

avec l'acétate de plomb, un précipité jaune d'iodure de plomb, et avec le bichlorure de mercure, du biiodure de mercure, d'une teinte rouge très-prononcée.

L'indigo ne peut pas être employé à l'huile : outre qu'il s'étend assez mal, il a le défaut, sous l'influence des véhicules gras, de noircir ou de verdir. Mais pour la peinture à la colle, il fournit des tons très-beaux et d'un éclat qu'on ne retrouve jamais dans le bleu de Prusse.

Les peintures exécutées avec cette substance ne doivent pas être exposées au soleil. Davy suppose que les figures et les ornements extérieurs des bains de Titus, et qui étaient profondément altérés, étaient peints avec des couleurs végétales, probablement l'indigo. C'est encore à l'emploi de cette couleur que l'on attribue le peu d'éclat que présentent les bleus dans plusieurs peintures de Paul Véronèse.

CARMIN BLEU.

Le carmin bleu qu'on emploie quelquefois en peinture à la place de l'indigo, est le précipité qui se forme lorsqu'on traite le bleu de Saxe (bleu en liqueur) par la potasse.

Voici comment on l'obtient :

Dans un mélange réfrigérant formé de sel marin et de glace pilée, on place un vase contenant 4 kilogr. d'acide sulfurique fumant de Nordhausen ; on y ajoute, par petites portions et en agitant sans cesse, 1 kilogr. d'indigo en poudre fine. Une fois la dissolution achevée, on soutire la liqueur au clair et on y verse une solution de sel de

tartre jusqu'à ce qu'il ne se forme plus de précipité. On abandonne le tout au repos, on recueille par décantation le dépôt qu'on lave à l'eau froide, jusqu'à ce que celle-ci n'ait plus de saveur acide ; on jette sur un filtre, et enfin on fait sécher à l'ombre dans un lieu aéré.

Le carmin bleu possède une teinte bleue très-vive ; il s'emploie comme l'indigo, pour les décors et à la colle, pour les fleurs artificielles ; mais il supporte difficilement les rayons solaires.

PLATT INDIGO.

Le *platt indigo*, nommé encore *bleu d'Angleterre*, *bleu de Hollande*, est un mélange de plusieurs couleurs, très-employé avant la découverte du bleu de Prusse.

On l'obtient habituellement en mélangeant dans des proportions indéterminées, du bleu de Prusse, de l'indigo, du smalt, de la craie et de l'amidon. On forme du tout une poudre très-homogène qu'on relie au moyen d'un mucilage de farine de riz. Lorsque la masse est en consistance de pâte molle, on la convertit en gâteaux ou en trochisques.

La teinte du platt indigo est assez belle, mais peu fixe.

La peinture des décors et des papiers consommait autrefois une grande quantité de bleu de tournesol, mais cette substance présente si peu de fixité et est d'une teinte si pâle, qu'elle n'est plus employée actuellement.

CHAPITRE VII

COULEURS VERTES

TERRE VERTE DE VÉRONE.

La terre verte de Vérone, nommée plus simplement dans le commerce de la droguerie, terre de Vérone, porte en minéralogie le nom de talc zographique (Haüy) et de chlorite baldogée (Saussure).

On la trouve à Bentonico, au nord du Monte-Baldo, près de Vérone; en Allemagne, en Saxe, au Hartz, dans le Tyrol, en Pologne, en Hongrie, en France et dans l'île de Chypre.

Elle est ordinairement en masses terreuses, assez volumineuses, ou en petits nodules de la grosseur d'un pois, disséminés d'une manière irrégulière dans les ro-

ches amygdaloïdes, plus rarement dans les basaltes, les porphyres et les grès récents.

Sa couleur est d'un vert céladon, lorsqu'elle est entière ; et d'un vert clair, en poudre.

Examinée à la loupe, elle présente une texture granuleuse de forme indéterminée ; sa cassure est assez résistante, et elle se coupe facilement au couteau ; onctueuse au toucher, elle prend un peu d'éclat par le frottement ; mais dans l'eau, elle répand l'odeur qui est particulière aux argiles.

Au feu elle devient noire, dans la partie qui n'a pas été exposée à l'air, et brun-rouge à la surface. Maintenue pendant quelque temps à la température du rouge obscur, elle fond en donnant un vert bulleux.

Un échantillon, provenant de Vérone, a donné à M. Delesse les résultats suivants :

 Silice.................... 51,25.
 Alumine................. 7,25.
 Protoxyde de fer........ 20,72.
 Magnésie................ 6,16.
 Soude................... 6,21.
 Eau..................... 4,49.
 Protoxyde de manganèse. Traces.

La qualité qui vient de Vérone est de beaucoup préférable aux autres ; celle de l'île de Chypre a une couleur qui tient le milieu entre le vert-pomme et le vert-de-gris, celle de Pologne est vert-poireau.

Le commerce la fournit aux artistes à l'état brut et à l'état lavé. C'est principalement pour la peinture de pay-

sage et de marine qu'on l'emploie ; elle possède une très-grande solidité et n'est pas vénéneuse.

On ignore encore à quelle matière on doit attribuer la coloration verte de cette substance, qui était connue comme couleur au temps des Romains et des Grecs. Chaptal et Davy l'ont retrouvée dans des pots enfouis sous les décombres de Pompéia, et dans les ruines du palais de Titus.

VERT DE RINNMANN.

Cette couleur, appelée *vert de cobalt*, et de *Rinnmann* du nom de son inventeur, est un mélange, peut-être même une combinaison, de l'oxyde de zinc avec l'oxyde de cobalt.

Voici comment Rinnmann la préparait :

On prend 500 grammes de minerai de cobalt, exempt autant que possible de cuivre et d'arsenic qu'on dissout à chaud dans 4 kilogr. d'acide nitrique concentré. On décante la liqueur et on y verse une solution de 500 grammes de sel marin.

D'une autre part, on fait dissoudre 1 kilogr. de zinc dans 5 kilogr. d'acide nitrique. Les deux solutions sont mélangées, puis étendues de dix à vingt fois leur poids d'eau. On y verse une solution de carbonate de potasse qui donne lieu à un précipité, d'abord blanc, ensuite rosé. On laisse reposer, on lave par décantation, et le dépôt, recueilli sur une toile et séché, est enfin chauffé dans un creuset à une haute température. De l'acide carbonique se dégage, et on obtient pour résidu une substance légère d'un très-beau vert.

Un procédé beaucoup plus simple consiste à chauffer ensemble, dans un creuset, un mélange en proportions variables d'oxyde de zinc et d'oxyde de cobalt. Mais aucun d'eux ne donne une couleur aussi belle que le suivant :

On dissout, dans une très-petite quantité d'eau, du nitrate de cobalt privé le plus possible de fer ; on délaye dans le liquide de l'oxyde de zinc en poudre ; on forme du tout une masse pâteuse qui est desséchée au bain de sable, puis calcinée dans un creuset jusqu'au rouge sombre.

Le produit de la calcination, réduit en poudre fine, fournit une couleur verte d'autant plus foncée que l'oxyde de zinc a été ajouté en moins grande quantité. Ainsi 2 parties d'oxyde de zinc et 1 partie de nitrate de cobalt donnent un vert d'une nuance foncée : 3 ou 4 parties d'oxyde de zinc pour 1 partie de sel de cobalt fournissent le vert clair.

MM. Barruel et Leclaire préparent le vert de Rinnmann de la manière suivante :

On prend 245 kilogr. d'oxyde de zinc, dont on forme, avec de l'eau, une pâte molle ; on y ajoute 49 kilogr. de sulfate de cobalt pur et sec. Lorsque le mélange est bien intime, on le fait sécher à l'étuve, puis on calcine au rouge sombre pendant trois heures dans un fourneau à réverbère ; on le projette dans l'eau ; après refroidissement, on lave par décantation et on fait sécher à l'étuve.

Cette couleur, que MM. Barruel et Leclaire désignent sous le nom de *vert de zinc*, est très-belle et très-solide.

Le vert de Rinnmann jouit de toutes les qualités d'une bonne couleur ; son éclat est en général assez beau, et il

couvre bien les objets sur lesquels on l'applique. Il est à regretter que son prix élevé ne permette pas de l'employer aussi souvent qu'on le désirerait.

VERT DE CHROME.

En découvrant le chrome, l'illustre Vauquelin comprit de suite tout le parti qu'on pourrait tirer, pour la peinture à l'huile et surtout pour les émaux, de l'oxyde vert de chrome, obtenu en décomposant, par la chaleur, le chromate de mercure.

Le vert de chrome possède des propriétés physiques qui varient avec le procédé employé pour le préparer.

Il se présente sous la forme d'une poudre d'un vert plus ou moins foncé, insoluble dans l'eau et les acides. On l'obtient par la voie sèche et par la voie humide. Mais quel que soit le procédé qu'on emploie, il a toujours la formule suivante :

$$\underbrace{Cr^2O^3}_{\text{Sesquioxyde de chrome.}}$$

On connaît différentes manières de le précipiter des dissolutions qui le contiennent. Voici la plus économique :

On fait une dissolution concentrée de bichromate de potasse, tel qu'on l'obtient lors de la calcination du minerai de fer chromé avec le sel de nitre; on la porte à l'ébullition et on y ajoute par petites portions de la fleur de soufre tamisée en poudre très-fine. Le mélange ne tarde pas à prendre une teinte jaune verdâtre prononcée, par suite de la réduction de l'acide chromique en sesquioxyde de

chrome, et le soufre passe à l'état d'acide sulfureux et d'acide sulfurique qui s'unissent à la potasse. Lorsque l'opération a été bien conduite, tout le chrome se convertit en hydrate d'oxyde gélatineux. On lave avec de l'eau bouillante, on sèche, et enfin on chauffe au rouge dans un creuset, afin de lui enlever son eau de constitution et une certaine quantité de soufre non combiné.

Le vert de chrome par la voie sèche s'obtient ainsi :

1° On fait un mélange à parties égales de bichromate de potasse et de fleur de soufre qu'on place dans un creuset de terre fermé, et on chauffe à la température rouge. Le produit de la calcination est traité, après le refroidissement, par de l'eau chaude qui dissout le sulfure de potassium et le sulfate de potasse formés; pour résidu on obtient l'oxyde de chrome sous forme d'une poudre verte fort belle. Ce procédé, indiqué pour la première fois par M. Lassaigne, est peu dispendieux et donne une couleur d'une teinte très-riche.

2° Dans une solution aussi neutre que possible de nitrate de protoxyde de mercure, on verse du bichromate de potasse qui donne lieu à un précipité jaune orangé. Celui-ci est lavé, séché à la température de l'étuve, pulvérisé et chauffé dans une cornue de grès munie d'un tube de porcelaine, qui plonge dans un vase contenant de l'eau froide.

Sous l'influence de la chaleur, le mercure se volatilise et vient se condenser dans l'eau. Dans la cornue, on trouve l'oxyde de chrome en poudre d'un vert foncé.

Obtenu avec le chromate de mercure, le vert de chrome est d'une très-belle qualité, mais il revient à un prix

beaucoup trop élevé pour être employé avec avantage dans la peinture à l'huile.

3° Un moyen plus économique consiste à chauffer dans un creuset un mélange de 3 parties de chromate neutre de potasse avec 2 parties de sel ammoniac. Il se forme du chlorure de potassium et de l'oxyde de chrome, qu'on sépare par des lavages réitérés à l'eau chaude. Dans cet état, l'oxyde n'a pas une teinte verte très-belle, mais si on le calcine de nouveau au rouge sombre, il acquiert un éclat très-beau. Le mélange des deux sels a besoin d'être très-bien fait, et la température portée graduellement au rouge. En négligeant ces précautions, on risque de volatiliser la plus grande partie du sel ammoniacal sans qu'il ait réagi. On obtient 30 à 35 pour % d'oxyde.

4° M. Barian, de Prague, a indiqué un procédé qui, au dire de M. le docteur Binder, est le plus simple et le meilleur de tous ceux proposés jusqu'à ce jour.

On mêle intimement :

> 4 kilogr. de bichromate de potasse ;
> 1 kilogr. de fécule de pomme de terre.

Le mélange, introduit dans un creuset de terre, est chauffé à une haute température. Le produit de la calcination est lavé à l'eau bouillante pour dissoudre le carbonate de potasse qui s'est formé et le chromate de potasse non décomposé. Le dépôt, recueilli sur un filtre, est séché, puis soumis à une seconde calcination, afin de volatiliser l'eau dont il est imprégné. L'oxyde, par ce moyen, s'élève toujours à 50 pour % du poids du sel de chrome. Il peut être livré au commerce, d'après M. Binder, au prix

de 1 fr. 20 à 1 fr. 30 c. le kilogr. Sa teinte est fort belle et sa poudre se laisse parfaitement travailler au pinceau.

Mais de tous les verts de chrome, le plus solide et le plus beau est le *vert émeraude* ou *vert Pannetier*, du nom de son inventeur.

Ce produit est de l'oxyde de chrome préparé à une température très-élevée et par un procédé tenu secret jusqu'à présent. Les acides froids et chauds sont sans action sur lui, et le nitrate de potasse le convertit par la calcination en chromate de potasse. Il est à regretter qu'il soit à un prix si élevé (140 fr. le kilogr.), car il donne une peinture d'une très-grande fixité.

L'oxyde de chrome, obtenu par la voie sèche ou par la voie humide, est regardé à juste titre comme le vert le plus solide qu'il y ait; malheureusement son prix ne permet pas de l'employer pour tous les genres de peinture. Il s'unit très-bien aux autres couleurs et résiste longtemps à l'air, aux rayons solaires et aux émanations sulfureuses; il est assez vénéneux.

OCRE VERTE.

M. Posselt a remarqué que lorsqu'on faisait bouillir pendant longtemps du cyanure ferrique acide, on obtenait un cyanure de fer particulier d'un beau vert foncé. Il est probable que c'est à la présence de ce composé que l'ocre verte de M. Bouland, d'Orléans, doit sa teinte.

Voici le procédé pour la préparer :

On pulvérise finement 50 kilogr. d'ocre jaune, séchée

à l'air et au soleil ; on la délaye dans une quantité suffisante d'eau pour en faire une bouillie épaisse, on verse peu à peu, et en remuant sans cesse, 1 kilogr. d'acide chlorhydrique du commerce. On abandonne le tout au repos pendant vingt-quatre heures environ, puis on ajoute une solution concentrée de 1 kilogr. de prussiate de potasse jaune, et enfin une solution de sulfate de sesquioxyde de fer. Le mélange est brassé à plusieurs reprises, lavé avec de l'eau froide par décantation, mis à égoutter sur une toile, et enfin séché à l'air et à l'ombre.

Cette couleur est un mélange de cyanure de fer vert et de terres alcalines que l'on rencontre ordinairement dans l'ocre jaune. Sa teinte est subordonnée à la quantité de fer qu'on a ajoutée.

On l'emploie exclusivement pour la fabrication des papiers peints. Elle possède une teinte verte assez belle, et peut être livrée à un prix peu élevé ; mais elle ne peut servir avec avantage à la peinture à l'huile, en raison du peu de solidité du cyanure de fer qui en forme la base.

C'est encore à un composé à base de cyanure de fer qu'il faut rattacher le cyanure ferroso-zincique découvert par MM. Barruel et Leclaire, et auquel on a donné, conjointement avec l'oxyde de cobalt et de zinc, le nom de *vert de zinc*.

Voici comment on prépare ce dernier :

Dans une solution concentrée de chlorure de zinc, on délaye du bleu de Prusse en poudre fine ; la bouillie liquide qui en résulte est abandonnée à elle-même pendant un certain temps, et, lorsqu'elle a acquis la teinte dési-

rée, on lave à grande eau, puis on recueille le précipité, qu'on fait sécher à l'ombre.

On obtient, selon les proportions réagissantes, des verts d'un éclat très-beau, mais qui partagent, comme toutes les couleurs dans lesquelles il entre des cyanures, le défaut d'être peu solides.

VERT DE PRUSSE.

Le cyanure jaune de potassium et de fer, versé jusqu'à cessation de précipité dans les sels solubles de cobalt (nitrate, sulfate ou chlorure), donne lieu à un sel double, le cyanure de fer et de cobalt, d'une teinte verte très-riche, mais qui passe au gris rouge à l'air.

C'est une mauvaise couleur, qui heureusement est peu connue dans le commerce.

CINABRE VERT.

Tout le monde sait que les couleurs bleues, unies aux couleurs jaunes, produisent la nuance verte.

On emploie quelquefois pour la peinture à l'huile, sous le nom de *cinabre vert*, une couleur que l'on obtient en mélangeant des proportions variables de chromate de plomb et de bleu de Prusse récemment précipités et encore humides. Le dépôt, suffisamment lavé, est recueilli et séché à l'étuve, modérément chauffée.

Le cinabre vert couvre assez bien, mais, comme l'ocre verte, le vert de zinc et le vert de Prusse, il est très-peu solide; les émanations sulfureuses le noircissent, et les rayons solaires le décolorent.

LAQUE VERTE.

La belle couleur verte des feuilles de certains végétaux ne peut fournir à la peinture des laques végétales assez solides pour être employées avec avantage.

On a cependant tenté de préparer une laque verte avec la laque de gaude et le bleu de Prusse; la couleur qui en résulte est en effet fort belle, mais ne jouit d'aucune fixité.

Les auteurs ont décrit à tort, et le commerce livre journellement, sous le nom de laque verte, deux matières colorantes très-différentes, que nous allons faire connaître.

La première est du vert de Schéele obtenu par un moyen différent.

On commence par préparer une solution d'arsénite de potasse, en faisant bouillir ensemble dans 8 litres d'eau 1 kilogr. de sel de tartre et 600 grammes d'acide arsénieux. Lorsque la dissolution est achevée, on la passe à travers une toile.

D'une autre part, on fait dissoudre à chaud 1 kilogr. de sulfate de cuivre dans 24 litres d'eau.

Les deux liqueurs, parfaitement claires, sont mélangées en agitant sans cesse; on laisse déposer, on décante la partie claire, on lave à plusieurs reprises avec de l'eau froide, puis on fait sécher à l'étuve. Il possède une teinte verte comparable à celle du beau vert de Schéele.

La seconde est un oxyde double de cuivre et de zinc, que l'on obtient de la manière suivante :

On fait dissoudre jusqu'à saturation du cuivre fortement

grillé dans de l'eau régale (acide nitrique, 1 partie; acide hydrochlorique, 3 parties); d'un autre côté, on fait une dissolution de zinc dans de l'acide nitrique concentré, on mélange les deux liqueurs, et on précipite au moyen du carbonate de potasse dissous dans une petite quantité d'eau; il se forme immédiatement un précipité vert clair qui est lavé, puis séché.

La matière, réduite en poudre fine, est placée dans un creuset de terre qu'on chauffe à une température élévée, jusqu'à ce qu'elle ait acquis une belle teinte verte.

Le produit de la calcination, réduit de nouveau en poudre, donne une couleur d'un ton riche, résistant assez bien à l'action de l'air. On l'emploie pour la peinture à l'huile et à la gouache.

Il se forme dans ce cas-là une véritable combinaison de l'oxyde de cuivre avec l'oxyde de zinc, combinaison dans laquelle l'un joue le rôle d'acide, et l'autre le rôle de base. Il diffère du vert de Rinnmann par la substitution de l'oxyde de cuivre à l'oxyde de cobalt.

Il est à regretter que l'inventeur de cette couleur n'ait pas indiqué les proportions de cuivre et de zinc; ce n'est donc que par tâtonnements qu'il est possible de l'obtenir très-belle.

On a remarqué que les sels solubles de cuivre, précipités dans de certaines conditions de température et de dilution, au moyen des alcalis, pouvaient fournir des couleurs vertes d'un éclat quelquefois très-beau et d'une solidité souvent assez grande, surtout pour la peinture qui n'est pas exposée aux émanations sulfureuses; mais toutes présentent l'inconvénient d'être très-dangereuses,

tant pour l'ouvrier qui les prépare, que pour le peintre qui les emploie. Il serait donc à désirer que l'on parvînt, comme pour la céruse, à proscrire le cuivre et ses composés dans ses nombreux usages en peinture.

VERT-DE-GRIS.

Le vert-de-gris est un acétate basique de cuivre hydraté, formé en proportions très-variables de deux sels différents :

1° L'acétate bibasique de cuivre,

$$\underbrace{C^4H^3O^3}_{\text{Acide acétique.}} + \underbrace{2\,CuO}_{\text{Oxyde de cuivre.}} + \underbrace{6\,HO}_{\text{Eau.}}$$

2° L'acétate tribasique,

$$C^4H^3O^3 + CuO + Aq.$$

Le vert-de-gris était connu des Grecs et des Romains, qui le préparaient en faisant dissoudre des lames de cuivre dans du vinaigre.

Vitruve le signale comme couleur.

Il est certain que les premiers verts employés par les peintres de l'antiquité étaient obtenus avec des composés de cuivre. Davy a indiqué la présence de ce métal dans les peintures des salles de bains de Titus, sur des ruines provenant des monuments de Caïus Sextius et sur des fragments de la Noce Aldobrandine.

La plus grande partie de vert-de-gris que les arts consomment se fabrique en France ; il s'en exporte à l'étranger pour des sommes considérables. On le prépare en

quantité notable à Narbonne (Aude) et dans le département de l'Hérault. Ce dernier surtout conserve depuis longtemps le monopole de cette fabrication. Pour cela, on suit un procédé que nous allons faire connaître maintenant.

La préparation de ce produit repose sur la propriété que possède le cuivre d'être oxydé par l'oxygène de l'air, sous l'influence des vapeurs d'acide acétique, puis de former un sel, l'acétate de cuivre. Voici, à quelques variantes près, le procédé suivi à Montpellier.

Autrefois, on employait la grappe du raisin pour produire l'acide acétique, mais depuis 1777, elle a été remplacée par le marc de raisin, qui fournit les mêmes résultats, et dont la valeur est à peu près nulle.

Le cuivre et le marc de raisin, avant d'être mis en contact, ont besoin de subir, de la part de l'opérateur, diverses préparations préliminaires qui ont pour but, soit de hâter la fabrication, soit d'obtenir un produit de belle qualité.

Ainsi, le cuivre doit être réduit en lames de 2 à 3 millimètres d'épaisseur environ, et fortement écroui, pour qu'il ne s'écaille pas après le premier ou le second grattage. Lorsqu'il est poli, les vapeurs acides ne l'attaquent pas, ou peu; mais si on le frotte dans toutes ses parties avec une petite quantité de vinaigre ou d'une dissolution concentrée de verdet, il acquiert un commencement d'oxydation qui le rend plus apte à être attaqué par l'acide acétique; il se produit dans cette circonstance un véritable phénomène de *propagation*, dont on retrouve plusieurs exemples dans les réactions chimiques. Les lames de

cuivre, avant d'être employées, sont placées dans des caisses et chauffées jusqu'à ce qu'on ne puisse plus y tenir la main.

Le marc fourni par les vignerons doit provenir de raisin de bonne qualité; on ne peut l'employer qu'après lui avoir fait subir la fermentation acétique. Pour cela, on le met, sans le fouler, dans des tonneaux placés dans un endroit sec et aéré; on bouche, puis on abandonne au repos; au bout de quelques jours, la matière s'échauffe et développe l'odeur propre au vinaigre.

Comme de la bonne préparation du marc dépend en partie le succès de l'opération, quelques fabricants l'essayent avant de l'employer : ils couchent dans la masse en fermentation une lame de cuivre préparée comme nous l'avons dit; après vingt-quatre heures de séjour, si sa surface est couverte uniformément de vert-de-gris, on commence la *mise en marc*; si au contraire on remarque des gouttes d'eau sur les lames, on dit que le *cuivre sue*; on remet alors l'opération au lendemain.

Dans des vases d'argile appelés *oulas*, dans des tonneaux de bois coupés par le milieu et percés de trous de distance en distance, ou bien dans des fosses construites en briques, on stratifie des lames de cuivre avec le marc; on en fait ainsi plusieurs couches, dont l'inférieure et la supérieure sont formées par le marc; on bouche, soit avec des couvercles, soit avec des planches, et on abandonne le tout au repos.

Au bout d'une semaine, on ouvre les appareils et on examine la couleur du marc; s'il a pris une teinte blanche, c'est une preuve que l'opération est achevée; dans le

cas contraire, on replace les couvercles, et on attend.

Le temps nécessaire à cette fabrication est très-variable ; la richesse du marc en principes spiritueux, la température de l'atmosphère, sont autant de circonstances qui accélèrent la formation du sel de cuivre.

Les lames de cuivre sont enlevées, puis exposées à l'air, pendant deux ou trois heures, dans des paniers ; on les porte dans une étuve chauffée à 25 ou 30°, et on les trempe dans de l'eau froide ; on les remet en place, et tous les quatre ou cinq jours on répète l'immersion. Cette opération s'exécute quatre, cinq, six ou sept fois, et comme autrefois on se servait de vin, on disait que le vert-de-gris avait reçu 4, 5, 6 ou 7 vins ; par ces diverses immersions, le vert-de-gris gonfle, se *nourrit* et acquiert une épaisseur de 2 à 3 millimètres environ ; on le détache facilement en le râclant avec un couteau.

Les plaques grattées sont de nouveau placées avec du marc neuf et on continue l'opération, jusqu'à ce qu'elles soient complétement usées. Quelques fabricants font resservir le marc en y ajoutant du vin et une petite quantité de vinaigre.

Le vert-de-gris gratté se présente sous la forme d'une pâte, qui porte le nom de vert-de-gris *frais* ou *humide* ; on le pétrit dans de grandes auges en bois, puis on l'introduit dans des sacs de cuir, qu'on expose à l'air et au soleil. Il perd, lorsqu'il est suffisamment desséché, 40 et 50 pour % de son poids. On reconnaît qu'il ne contient plus d'eau, lorsque la pointe d'un couteau plongée dans le pain à travers le cuir ne peut y pénétrer. On le dit alors à l'épreuve du couteau.

La fabrication du vert-de-gris s'exécute, à Montpellier, dans des caves ou dans des chambres très-obscures, humides et maintenues, autant que possible, à une température constante.

A Grenoble, on remplace le marc de raisin par du vinaigre, avec lequel on humecte les plaques de cuivre de temps en temps. Chaptal, qui a comparé les deux produits, a remarqué que le vert-de-gris de Montpellier est gras, pâteux, d'un beau vert et peu soluble dans l'eau; celui de Grenoble est plus sec, d'un bleu verdâtre et plus soluble dans l'eau.

En Suède, on prépare le vert-de-gris en empilant des lames de cuivre entre des morceaux de drap ou de flanelle épaisse, trempés préalablement dans du vinaigre. Le produit qu'on obtient possède une teinte verte très-prononcée et se rapproche beaucoup du vert-de-gris dit de Montpellier.

Dans le commerce, on trouve le vert-de-gris sous deux différents aspects; tantôt il est d'un vert pur, tantôt il est bleu verdâtre. Pendant longtemps on croyait que cette différence de couleur provenait d'un état d'hydratation particulier. Ainsi on disait que le vert-de-gris bleu verdâtre contenait 6 équivalents d'eau, et le vert-de-gris vert pur, 3 équivalents; mais maintenant qu'on connaît mieux les diverses combinaisons de l'acide acétique avec le bioxyde de cuivre, on s'accorde généralement à dire que le vert-de-gris possède une teinte bleue d'autant plus prononcée qu'il contient plus d'acétate sesquibasique.

Il est en masses compactes, très-tenaces et difficiles à réduire en poudre; il se délaye dans l'eau avec une grande

facilité et produit une bouillie savonneuse, formée de petites aiguilles cristallines ; il est très-peu soluble dans l'eau ; les lavages réitérés le décomposent en acide acétique et en oxyde noir de cuivre. Exposé à l'action d'une température de 140 à 160°, il perd une assez grande quantité d'eau ; de 240 à 250°, il se dégage de l'acide acétique.

Le vert-de-gris contient souvent des corps étrangers, tels qu'épidermes et grains de raisin ; on y rencontre quelquefois des morceaux de cuivre qui ont été détachés avec le couteau. Les substances qui proviennent du défaut de soin apporté à la préparation de ce produit ne sont pas considérées comme une falsification.

Mais il arrive quelquefois que l'on rencontre du vert-de-gris adultéré avec du sulfate de cuivre, de la craie et du plâtre.

Pour être pur, un vert-de-gris doit se dissoudre entièrement et sans effervescence dans les acides sulfurique et nitrique étendus. La dissolution avec l'acide nitrique ne doit pas fournir de précipité avec le chlorure de baryum, réactif qui sert, comme on sait, à découvrir l'acide sulfurique ; et de plus être soluble dans l'ammoniaque qui laisserait la chaux pour résidu.

Le vert-de-gris forme une couleur peu solide et excessivement vénéneuse.

VERDET CRISTALLISÉ.

Ce sel, nommé encore *vert distillé, vert cristallisé,*

cristaux de Vénus, fleurs de vert-de-gris, est l'acétate neutre de cuivre qui se représente par :

$$\underbrace{C^4H^3O^3}_{\text{Acide acétique.}} + \underbrace{CuO}_{\text{Oxyde de cuivre.}} + \underbrace{HO}_{\text{Eau.}}$$

Il se présente en gros cristaux rhomboédriques, d'un vert très-foncé, d'une saveur styptique et sucrée. Exposé à l'air, il s'effleurit légèrement et devient d'un vert bleuâtre pâle ; réduit en poudre, il possède la teinte du vert-de-gris. D'après les expériences de M. Roux, chauffé à 140°, il perd son équivalent d'eau ; de 240° à 260°, la chaleur élimine l'acide acétique, et si l'opération se fait dans un appareil distillatoire, on obtient des flocons blancs lanugineux, que Lassonne nommait fleurs de cuivre ; chauffé brusquement jusqu'à l'inflammation, il brûle en colorant la flamme en vert.

La plus grande partie du verdet cristallisé qu'on trouve dans le commerce nous vient des départements du Midi, de l'Hérault et de l'Aude. Pendant un certain nombre d'années, la France a été tributaire des Hollandais, qui venaient acheter à Montpellier du vert-de-gris, pour nous le revendre ensuite à l'état de verdet cristallisé.

On l'obtient de la manière suivante :

Dans une grande chaudière de cuivre on met 100 kilogr. de vert-de-gris à l'état frais ou humide, avec 200 kilogr. de vinaigre blanc distillé et fort ; on chauffe à une douce chaleur, en agitant de temps à autre avec une spatule de bois. Lorsque le vinaigre est saturé, on laisse déposer, et on transvase la liqueur dans une autre chaudière de cuivre où se fait l'évaporation ; le résidu de la première

chaudière est traité de la même manière par une autre quantité de vinaigre blanc, jusqu'à épuisement de toute matière soluble. On mélange les deux dissolutions et on les concentre jusqu'à consistance de sirop épais, ou jusqu'à formation de pellicule à la surface. Arrivé à ce point, on distribue la dissolution dans des vases de terre vernissée, contenant chacun deux ou trois bâtons de bois fendus en quatre, et maintenus écartés vers leur base au moyen de fiches de bois. Ces appareils sont abandonnés au repos dans une étuve modérément chauffée. Au bout de quinze jours ou trois semaines environ, on trouve toute la surface des bâtons garnie de gros cristaux qui forment ces belles grappes pyramidales, du poids de 2 à 3 kilogr., qu'on livre au commerce sous le nom de vert en grappes.

Les parois des cristallisoirs sont tapissées de cristaux plus petits qu'on vend à part ou bien qu'on fait redissoudre dans la chaudière à évaporation.

Les eaux mères, concentrées de nouveau, fournissent encore des cristaux.

Le verdet cristallisé peut s'obtenir par double décomposition de l'acétate de chaux, provenant de l'acide pyroligneux avec la chaux caustique et du sulfate de cuivre; il se produit de l'acétate de cuivre soluble et du sulfate de chaux ou plâtre insoluble qu'on sépare par décantation. La liqueur, convenablement évaporée, fournit des cristaux qui ont la même composition que le verdet de Montpellier.

Le verdet cristallisé est moins souvent employé en peinture que le vert-de-gris; dissous dans une eau alcaline, il donne une liqueur verte, connue sous le nom de *vert*

d'eau, employée pour le lavis des plans. Il forme une couleur peu solide et aussi vénéneuse que le vert-de-gris.

Il est quelquefois falsifié avec du sulfate de fer ou avec du sulfate de cuivre. On décèle ces deux substances au moyen du chlorure de baryum, qui ne doit pas fournir de précipité de sulfate de baryte, et au moyen de l'ammoniaque liquide, qui dissout entièrement le verdet pur, tandis qu'elle précipite l'oxyde de fer à l'état de poudre très-volumineuse, verte, puis rouge.

VERT DE MONTAGNE ET VERT DE BRÊME.

Dans les monts Ourals, en Sibérie, on rencontre un minerai de cuivre carbonaté, en petites masses mamelonneuses, fibreuses à l'intérieur, et composées de couches d'accroissement de différentes nuances de vert. Cette substance, à laquelle les minéralogistes ont donné le nom de malachite, et les chimistes la composition suivante :

$$\underbrace{CO^2}_{\text{Acide carbonique.}} + \underbrace{2\,CuO}_{\text{Oxyde de cuivre.}} + \underbrace{2\,HO}_{\text{Eau.}}$$

est réservée pour la fabrication des objets d'art, tels que vases, statuettes, tables, etc. Elle porte encore le nom de vert de Hongrie, parce qu'on la trouve dans les montagnes de Kernhausen, en Hongrie.

La malachite possède une teinte verte fort belle. Mais la petite quantité qui existe dans la nature, et la difficulté qu'on éprouve à la réduire en poudre très-fine, la font livrer aux artistes à un prix si élevé, que son usage est

très-restreint. Cependant elle donne une peinture fort belle et excessivement solide.

Pour remédier à cela, les chimistes ont cherché le moyen de l'obtenir par la voie artificielle.

En 1764, les frères Gravenhorst, de Brunswich, découvrirent le moyen de la préparer de toutes pièces. Ils en firent pendant un certain temps un commerce considérable, qui ne cessa que par l'indiscrétion de l'un de leurs employés. Ils le livraient alors sous le nom de vert de Brunswich, nom sous lequel on le désigne encore quelquefois (1).

Le vert de montagne, en raison des soins extrêmes qu'exige sa préparation, et de son peu de fixité, est assez peu employé maintenant. On lui préfère, à juste titre, le vert de Schweinfurt et le vert de Mittis, qui reviennent à meilleur marché et qui sont plus solides.

On le prépare de la manière suivante :

On fait dissoudre séparément dans de l'eau tiède, 20 kilogr. de sulfate de cuivre exempt de fer et 40 kilogr. de cristaux de soude (carbonate de soude). Les liqueurs chauffées à la température de 60° sont mélangées en agitant sans cesse. Lorsque le précipité possède la même couleur dans toutes ses parties, on le lave à plusieurs reprises par décantation avec de l'eau chauffée à 60 et 70°, puis on le fait sécher à l'air libre et à l'abri des émanations sulfureuses.

A l'état de pureté, le vert de montagne artificiel pos-

(1) En Allemagne, on désigne sous le nom de vert de Brunswich l'oxido-chlorure de cuivre.

sède la même composition que la malachite, mais dans le commerce on le trouve rarement ainsi ; il contient presque toujours du sulfate de baryte qui atténue d'autant sa nuance, et qui lui donne davantage la propriété de couvrir.

Lorsque, dans la préparation que nous venons d'indiquer, on remplace la moitié du sel de soude par 4 ou 500 grammes de potasse caustique, en ayant le soin d'opérer à une température moyenne, on obtient du carbonate de cuivre basique plus riche en oxyde que le précédent. Il possède une teinte bleue verdâtre, et se trouve dans le commerce en morceaux légers sous le nom de *vert de Brême*. Presque toujours on y ajoute une certaine quantité de sulfate de chaux.

Le vert de Brême ne paraît pas fournir à la peinture des résultats plus satisfaisants que le vert de montagne. Avec l'eau de chaux et la gélatine dissoute, il prend la teinte bleue.

L'un et l'autre sont des poisons violents.

VERT DE SCHÉELE.

Dans le cours de l'année 1778, l'illustre chimiste suédois Schéele fit connaître à l'Académie des sciences de Stockholm la couleur verte qui porte son nom.

Cette substance, dans son plus grand état de pureté, est un arsénite de cuivre neutre représenté par la formule :

$$\underbrace{AsO^3}_{\text{Acide arsénieux.}} + \underbrace{2\,CuO}_{\text{Bioxyde de cuivre.}}$$

et composé de :

> Acide arsénieux... 55,56.
> Bioxyde de cuivre. 44,44.
> ———
> 100,00.

Mais tout celui employé dans les arts contient une plus grande quantité d'oxyde de cuivre.

Le vert de Schéele se présente sous la forme d'une poudre vert pomme, qui s'altère assez facilement au contact de l'air, surtout dans les endroits humides; la chaleur le décompose en acide arsénieux qui se volatilise, et en bioxyde de cuivre noir.

Voici comment Schéele a conseillé de l'obtenir :

On fait dissoudre dans une chaudière de cuivre d'une grande capacité, 1 kilogr. de sulfate de cuivre, privé autant que possible de fer, dans 18 litres d'eau chaude; d'une autre part, on prépare de l'arsénite de potasse en faisant réagir ensemble 1 kilogr. de carbonate de potasse et 320 grammes d'acide arsénieux dans 6 litres d'eau chaude. Lorsque la dissolution de ces deux substances est opérée, on la passe à travers un linge fin et serré. On verse par petites portions à la fois, et en agitant sans cesse, la solution encore chaude d'arsénite de potasse dans celle également chaude de sulfate de cuivre. Une fois la décomposition opérée, on laisse refroidir, puis reposer. De l'arsénite de cuivre se précipite et du sulfate de potasse reste en dissolution. Le liquide clair est décanté et rejeté comme inutile; le précipité est lavé à plusieurs reprises avec de l'eau chaude, puis recueilli sur une toile, et lorsqu'il est bien égoutté on le fait sécher à une douce

chaleur. Ce procédé fournit 1 kilogr. 200 grammes environ de vert d'une belle teinte.

Les quantités de sulfate de cuivre, d'acide arsénieux et de carbonate de potasse, employées pour la fabrication de cette couleur, ne sont pas les mêmes partout. Quelques industriels ajoutent une plus grande quantité de sulfate de cuivre; ils obtiennent alors un produit plus basique qui possède une nuance verte plus belle, mais d'une solidité moins grande que l'arsénite neutre.

On peut, en variant le mode opératoire, et avec les quantités que nous avons prescrites, obtenir un vert d'une nuance plus belle.

Pour cela, on fait dissoudre à part, dans de l'eau chaude, l'acide arsénieux, le sulfate de cuivre et le carbonate de potasse. On mélange les deux premiers, qui ne fournissent pas de précipité par suite de la formation de l'arsénite acide de cuivre soluble. On verse dans celui-ci, par petites portions à la fois, et en agitant avec une spatule de bois, le sel de potasse; on s'arrête dès que le précipité a acquis son maximum d'intensité, puis on le lave comme nous l'avons dit.

Ce procédé fournit un résultat plus sûr, le carbonate de potasse ne contenant pas toujours la même quantité d'alcali.

Le vert de Schéele peut s'employer à l'eau et à l'huile. Mais la plus grande partie sert pour la fabrication des papiers peints. Son usage devient de jour en jour plus restreint par suite de l'application du vert de Schweinfurt, considéré généralement comme plus solide.

Il est excessivement vénéneux; et, malgré la teinte ri-

che qu'il possède, il serait à désirer qu'on pût la remplacer par une autre substance aussi belle et moins dangereuse. Déjà M. Gmelin a signalé, il y a une dizaine d'années, l'influence toxique des papiers de tenture peints avec cette couleur. D'après M. Louyet, cette couleur dégagerait incessamment, par suite de sa décomposition à l'air, du gaz hydrogène arséniqué dont l'action délétère est très-grande.

Disons aussi que l'action toxique de l'arsénite de cuivre et de quelques autres substances non moins dangereuses a été mise à profit pour peindre l'extérieur des navires et empêcher les animaux et les plantes de s'y attacher.

M. Glover a proposé pour cela le mélange suivant :

Arsénite ou arséniate de plomb. 2 parties.
Arsénite de cuivre............. 1 »
Orpiment..................... 1 »
Réalgar...................... 1 »

CENDRE VERTE.

La cendre verte est un mélange de sulfate et d'arsénite de cuivre.

Cette couleur a été découverte en voulant imiter la malachite, comme on était arrivé jusqu'à un certain point à obtenir l'azurite en composant les cendres bleues.

On la prépare de la manière suivante :

On commence par fabriquer de l'arsénite de chaux en faisant bouillir dans une chaudière de fonte 1 kilogr. de chaux caustique réduite en poudre avec 2 kilogr. d'acide arsénieux (arsenic blanc), et 25 ou 30 litres d'eau. Après

deux heures d'ébullition, on laisse reposer la dissolution qui est ensuite filtrée ou bien tirée au clair.

D'une autre part, on fait une solution de 4 kilogr. de sulfate de cuivre dans une suffisante quantité d'eau. On verse peu à peu et en agitant continuellement la liqueur arsénieuse dans celle de sulfate de cuivre. Par suite de la double décomposition qui s'opère, il s'est produit du sulfate de chaux et de l'arsénite de cuivre qui se précipitent ensemble sous la forme d'une poudre verte. On lave à plusieurs reprises par décantation, on jette sur une toile et on fait sécher dans un endroit obscur.

La cendre verte est une couleur très-vénéneuse et d'une médiocre solidité ; on lui reproche de manquer de corps : aussi ne peut-elle servir pour la peinture à l'huile.

Les coloristes ont l'habitude de la mélanger avec de la gomme arabique. Ils l'emploient alors pour produire des enluminures de feuillage et de gazon ; enfin, dans la peinture des verts qui demandent de la fraîcheur.

Davy assure que les verts des salles de bains de Titus étaient peints avec cette substance, ce qui en ferait remonter la découverte à une époque très-éloignée de nous.

VERT DE SCHWEINFURT.

Dans le but de préparer du vert de Schéele de qualité supérieure, deux fabricants de couleurs de Schweinfurt (Bavière), Rusz et Sattler, trouvèrent, dans le cours de l'année 1814, une couleur verte qui, assez différente, quant à sa composition, du vert de Schéele, lui est aussi préférable sous tous les rapports.

Cette substance fut répandue dans le commerce vers l'année 1816, et était alors fabriquée exclusivement par ses inventeurs. Mais, dans l'année 1822, M. Liebig en fit l'analyse et démontra qu'elle était formée d'acide arsénieux, d'oxyde de cuivre et d'acide acétique ; il indiqua de plus le moyen de l'obtenir. Quelques mois après la publication du travail de M. Liebig, M. Braconnot, de Nancy, ignorant le travail du chimiste de Giessen, arriva à un résultat tout à fait identique et donna un procédé différent pour l'obtenir.

Le vert de Schweinfurt possède une teinte aigue-marine ; l'air, la chaleur et les émanations sulfureuses ne l'altèrent pas.

Sa formule chimique se représente ainsi :

$$\underbrace{C^4H^3O^3CuO}_{\text{Acétate de cuivre.}} + \underbrace{AsO^3\,2\,CuO}_{\text{Arsénite de cuivre.}}$$

Nous donnons ici le procédé de M. Liebig, tel qu'il a été imprimé dans les *Annales de physique et de chimie*, 2º série, tome XXIII :

« On dissout à chaud, dans une chaudière de cuivre, une partie de vert-de-gris dans une suffisante quantité de vinaigre pur, et on ajoute une dissolution aqueuse d'une partie d'arsenic blanc. Il se forme ordinairement pendant le mélange de ces liquides un précipité d'un vert sale qu'il est nécessaire, pour la beauté de la couleur, de faire disparaître. A cet effet, on ajoute une nouvelle quantité de vinaigre, jusqu'à ce que le précipité soit parfaitement redissous. On fait bouillir le mélange ; il s'y forme après quelque temps un précipité cristallin grenu, d'un vert

de la plus grande beauté, lequel, étant séparé du liquide, bien lavé et séché, n'est autre chose que la couleur en question. Si après cela la liqueur contient encore un excès de cuivre, on y ajoute de nouveau de l'arsenic, et, si elle contient un excès du dernier, il faut ajouter du cuivre, et on opère du reste de la même manière. Il arrive souvent que cette liqueur contient un excès d'acide acétique; on peut alors l'employer de nouveau pour dissoudre le vert-de-gris. »

Cette couleur, ainsi préparée, possède une nuance bleuâtre; mais on demande souvent dans le commerce une nuance plus foncée et un peu jaunâtre, et d'ailleurs de la même beauté et du même éclat. Pour produire ce changement, on n'a qu'à dissoudre une livre de potasse du commerce dans une suffisante quantité d'eau, y ajouter 10 livres de la couleur obtenue par le procédé ci-dessus, et chauffer le tout à un feu modéré; bientôt on voit la masse se foncer et prendre la nuance demandée. Si on fait bouillir trop longtemps, la couleur s'approche du vert de Schéele; mais elle le surpasse toujours en beauté et en éclat. La liqueur alcaline qui reste après ce traitement peut servir encore pour préparer le vert de Schéele.

Voici maintenant le procédé indiqué par M. Braconnot :

On fait dissoudre dans une petite quantité d'eau chaude 6 parties de sulfate de cuivre; d'une autre part, on fait bouillir dans l'eau 6 parties d'acide arsénieux, avec 8 parties de carbonate de potasse du commerce; lorsqu'il ne se dégage plus de gaz acide carbonique, on mélange peu à peu les deux liqueurs en agitant sans cesse. Il se

produit un précipité d'un jaune verdâtre sale, fort abondant. On y ajoute de l'acide acétique en quantité telle qu'il y en ait un léger excès sensible à l'odorat après le mélange; peu à peu le précipité diminue de volume, et, au bout de quelques heures, il se dépose spontanément au fond de la liqueur, entièrement décolorée, une poudre d'une contexture cristalline et d'un très-beau vert; on le lave ensuite à l'eau bouillante pour enlever les dernières portions d'arsénite de potasse non combiné.

Il est nécessaire, pour le succès de cette opération, de se servir d'arsénite de potasse parfaitement neutre et de laisser dans la liqueur un léger excès d'acide acétique.

Sieberg obtient le vert de Schweinfurt en dissolvant une partie de vert-de-gris dans une certaine quantité de vinaigre pur; d'une autre part, on fait dissoudre une partie d'acide arsénieux dans une suffisante quantité d'eau; les liqueurs mélangées donnent lieu à un abondant précipité, sur lequel on verse du vinaigre fort; il s'opère une dissolution qu'on fait bouillir: il se forme bientôt un précipité qui, recueilli, lavé et séché, donne le vert de Schweinfurt d'une nuance très-riche.

M. Wingens, fabricant de couleurs, opère de la manière suivante :

Dans un vase de cuivre de grande dimension, on fait dissoudre à chaud 9 à 10 kilogr. d'acide arsénieux dans 14 seaux d'eau de rivière. Lorsque la solution est achevée, on y verse 10 kilogr. de vert-de-gris purifié par la cristallisation. On verse le liquide dans un tonneau de bois, et on y ajoute une dissolution de 500 gr. de potasse; on brasse bien le tout, puis on abandonne au repos, pen-

dant quelques heures ; le précipité lavé est recueilli sur une toile et séché.

On obtient encore du vert de Schweinfurt de qualité inférieure par le procédé de M. Drouard. Pour cela on délaye 1 ou 2 parties de chaux vive dans 60 parties d'eau, on chauffe jusqu'à 90°, puis on ajoute 10 parties d'acétate de cuivre et autant d'acide arsénieux : le précipité lavé ne possède jamais une teinte verte aussi belle que par le procédé de M. Wingens.

On donne quelquefois, dans le commerce de détail, pour du vert de Schweinfurt, le vert de Vienne, le vert de Brunswich, le vert de Mittis ou le vert anglais. L'examen que nous ferons de ces différentes couleurs montrera que l'on ne doit pas les confondre, tant sous le rapport de leur composition chimique que sous le rapport pratique.

Le vert de Schweinfurt rend aux artistes de très-grands services ; il fournit une peinture d'autant plus belle qu'il est de meilleure qualité.

Dans le commerce, on en forme divers numéros dont la teinte varie depuis le vert foncé jusqu'au vert pâle.

Il subit quelquefois de la part du fabricant diverses falsifications ; les substances étrangères qu'on y rencontre le plus souvent sont le spath pesant (sulfate de baryte) et le plâtre (sulfate de chaux). On fait cette addition en délayant ces deux sels en poudre dans le précipité encore humide.

Pour être pur, le vert de Schweinfurt doit être complétement soluble dans les acides nitrique et chlorhydrique bouillants, et la liqueur ne doit pas donner de précipité

avec le chlorure de baryum. Une insolubilité même partielle indiquerait la présence du sulfate de baryte, et le précipité blanc avec le sel de baryte décelerait l'acide sulfurique combiné à la chaux.

VERT DE MITTIS.

Cette couleur a été trouvée dans l'année 1814 par M. de Mittis, de Vienne. Elle consiste en arséniate de cuivre qui, dans son état le plus pur, a pour formule :

$$\underbrace{AsO^5}_{\text{Acide arsénique.}} + \underbrace{2CuO}_{\text{Oxyde de cuivre.}}$$

Elle porte encore dans les arts les noms de *vert de Vienne* et *vert de Kirchberger*. On la prépare de la manière suivante :

On convertit de l'acide arsénieux en acide arsénique, en le faisant bouillir avec de l'acide nitrique concentré. La liqueur filtrée est saturée par du carbonate de potasse qui donne lieu à de l'arséniate de potasse qu'on fait cristalliser.

On fait dissoudre à chaud 20 parties de ce sel dans 80 ou 100 parties d'eau pure.

D'une autre part, on dissout 20 parties de sulfate de cuivre dans suffisante quantité d'eau.

Les deux liqueurs, chauffées vers 90 ou 100°, sont mélangées en agitant sans cesse. Il se produit alors du sulfate de soude qui reste dissous et de l'arséniate de cuivre qui se précipite sous forme d'une poudre vert clair. On décante la partie liquide, et le précipité lavé est recueilli

et enfin séché à l'étuve. Dans cet état, il possède une teinte vert-pré assez belle.

Le vert de Mittis est très-rarement pur dans le commerce; presque toujours il contient des matières étrangères qui altèrent sa teinte. On en forme alors cinq ou six numéros différents.

La peinture en fait usage à l'eau et à l'huile, il fournit des résultats assez satisfaisants, mais il est très-vénéneux.

VERT PAUL VÉRONÈSE.

C'est encore l'arséniate de cuivre, préparé par un procédé tenu secret, qui forme la base du *vert Paul Véronèse.*

Le commerce tire cette couleur de l'Alsace et de l'Angleterre. On l'emploie pour la peinture à l'eau et à l'huile, et il est à regretter que son prix ne permette pas de l'utiliser pour tous les genres de peinture. On ne l'emploie guère que dans le tableau et pour les objets de prix. Elle est fort belle, très-solide et très-vénéneuse.

VERT MILORY.

Le vert Milory est l'une des plus belles couleurs vertes que le peintre emploie.

La fabrication de cette substance, désignée encore sous les noms de *vert en grains* et à tort de *vert anglais*, est tenue secrète par M. Milory, son inventeur.

Les auteurs disent qu'elle est composée de spath, de sulfate de plomb, de cyanure de potassium et de fer, et de chromate de potasse.

On peut imiter cette couleur en mélangeant ensemble des proportions déterminées de prussiate de potasse, de sulfate de fer, d'acétate de plomb et de bichromate de potasse. On obtient un précipité d'une teinte verte fort belle, mais qui, hâtons-nous de le dire, n'est jamais aussi solide que le vert Milory véritable.

Par la grande proportion de plomb qu'il contient, le vert Milory possède toutes les qualités qu'on recherche dans une bonne couleur. Sa teinte est en effet fort riche, il s'étend parfaitement bien sous le pinceau, et enfin résiste assez longtemps aux émanations sulfureuses et aux rayons solaires.

Il sert toujours pour la peinture à l'huile et s'allie assez bien avec la plupart des autres couleurs. Le commerce le livre en poudre et en trochisques. C'est sous cette dernière forme que sa teinte est la plus belle.

VERT ANGLAIS.

Le vert anglais est la couleur verte qui existe dans le commerce sous le plus grand nombre de variétés; c'est un produit complexe formé d'arsénite de cuivre (vert de Schéele) et de plusieurs matières blanches comme le sulfate de baryte et le sulfate de chaux.

On l'obtient par les mêmes moyens que nous avons indiqués pour le vert de Schéele, seulement on y ajoute, lorsqu'il est encore en pâte, les substances délayées avec soin dans une petite quantité d'eau.

Le plus beau possède une teinte vert-pomme, et la qualité inférieure est feuille-morte.

Le vert anglais est très-vénéneux, et couvre assez bien, mais il ne résiste pas longtemps à l'air: il a de plus le grave défaut de faire changer le ton d'un grand nombre de couleurs.

Le commerce de détail le livre à un prix peu élevé, aussi est-il d'un usage fréquent dans la grosse peinture à l'eau et à l'huile.

VERT MINÉRAL.

Le plus ordinairement, on désigne dans le commerce de la droguerie, sous le nom de *vert minéral*, le vert de Schéele; mais dans l'origine ces couleurs formaient deux espèces distinctes: en effet, le vert minéral, pour lequel il a été pris une patente anglaise en 1814, est un produit complexe qui se préparait ainsi:

　　　　　Vert de Schéele...... 2 parties.
　　　　　Céruse.............. 6 »
　　　　　Oxyde noir de cuivre. 2 »
　　　　　Bleu de montagne.... 3 »
　　　　　Sel de saturne....... 1/2 »

Sa teinte est le vert-pomme avec un reflet bleuâtre.

On le livre aux artistes sous la forme de morceaux peu volumineux, de deux teintes différentes: le vert foncé et le vert clair.

Lorsqu'il a été préparé avec les substances que nous indiquons, il couvre beaucoup mieux et sèche plus vite que tous les autres verts connus; mais il a le défaut de noircir assez promptement au contact des émanations sulfureuses.

VERT DE VESSIE.

Le vert de vessie, nommé vert végétal, est une laque qui résulte de la combinaison de la matière colorante du nerprun (*rhamnus catharticus*) avec la chaux ou l'alumine.

C'est en Allemagne, dans les environs de Nuremberg et dans le midi de la France, qu'on le prépare.

Voici le précédé qu'on suit :

Vers le mois d'octobre, les baies de nerprun, parvenues à leur parfaite maturité, et choisies autant que possible grosses, luisantes et abondantes en suc, sont écrasées au moyen d'un moulin. La masse est placée pendant huit à dix jours dans une cuve, où elle subit la fermentation ; on la soumet ensuite à la presse pour en extraire le suc. 100 parties de baies donnent environ 30 à 35 pour % d'un suc brun, presque noir, que les acides font passer au rouge clair et les alcalis au vert.

On prend 2 kilog. de suc, 500 gr. d'eau de chaux, ou bien la même quantité d'alun de potasse et 50 à 60 gr. de gomme arabique dissoute dans une petite quantité d'eau. On fait évaporer au bain-marie jusqu'à consistance de sirop épais. Arrivé à ce point, on le renferme dans des vessies de cochon, qu'on suspend dans une cheminée pour les dessécher.

Le vert de vessie est tout à fait inoffensif. Il est en masse d'un vert foncé, à cassure parfois brillante. Il ne convient nullement à la peinture à l'huile, mais pour la peinture à l'eau, pour peindre sur des éventails et pour faire les lavis des plans dressés par les ingénieurs,

il fournit des résultats très-satisfaisants. Il sert très-souvent pour la fabrication des pastels.

D'après M. Hagin, pour préparer du vert de vessie de belle qualité, il faut employer les baies de nerprun avant leur complète maturité, éviter une température élevée pour la cuisson, et remplacer la chaux par l'alun.

On prend des baies de nerprun, on les fait cuire avec un peu d'eau dans une bassine de cuivre, à un feu doux et en remuant continuellement, jusqu'à obtention d'une sorte de bouillie ; on soumet à la presse et on répète l'opération avec le résidu. On laisse reposer le suc, on le décante et on l'amène par évaporation en consistance d'extrait. On le pèse alors, et par chaque kilogr. on ajoute 65 grammes d'alun dissous dans quantité suffisante d'eau. Quand le mélange est opéré, on évapore de nouveau au bain-marie. On met la matière dans des vessies de veau qu'on fait sécher à l'air.

VERT D'IRIS.

Le vert d'iris s'obtient en faisant macérer à froid dans une solution d'alun ou même dans de l'eau gommée, l'épiderme satinée qui recouvre la fleur bleue de l'iris ; la liqueur qui en provient est passée à travers un linge fin, puis exposée à l'air et à l'abri du soleil dans des assiettes, où elle s'évapore spontanément.

Le vert d'iris n'est jamais employé dans la peinture à l'huile ; autrefois la miniature en faisait souvent usage, mais son peu de solidité fait que de nos jours il est à peu près tombé dans l'oubli.

BRONZE.

La couleur bronze résulte de la combinaison du vert, du noir et du blanc; pour l'obtenir, les peintres emploient de la céruse, du noir de fumée, du jaune de chrome et du bleu de Prusse en proportions variables; cette couleur porte alors le nom de faux bronze. Le bronze naturel ou vrai s'obtient principalement en réduisant en poudre certains alliages métalliques dont le cuivre forme la base.

C'est aussi de ce dernier que nous allons nous occuper.

POUDRE DE BRONZE.

Le cuivre métallique, réduit en poudre fine, possède d'abord une teinte jaunâtre qui ne tarde pas à passer au jaune-brun; il sert dans la peinture à préparer la nuance bronze.

Voici les procédés conseillés jusqu'à ce jour pour l'obtenir :

1° On fait une dissolution d'un sel soluble de cuivre (nitrate, sulfate), dans laquelle on plonge une lame de fer ; par suite de la décomposition qui s'opère, décomposition basée sur la plus grande affinité des acides pour le fer que pour le cuivre, tout ce dernier se précipite en poudre très-fine; on le recueille sur un filtre, on le lave à plusieurs eaux, puis on le fait sécher.

2° Le second procédé consiste à réduire du bronze pro-

prement dit (alliage de cuivre et d'étain) en feuilles très-minces ; on ajoute à celles-ci une certaine quantité de mélasse ou de miel, on broie sur un porphyre, on lave avec de l'eau chaude, puis on jette sur un filtre et on fait sécher. La poudre qu'on obtient dans ce cas est toujours très-ténue et donne une teinte bronzée plus belle que la précédente.

3° M. Bersemer, fabricant à Nuremberg, emploie les huiles grasses comme intermèdes pour réduire le cuivre en poudre.

Voici comment il opère.

On prend des feuilles de laiton ou de clinquant (alliage de cuivre et de zinc) ; on les étale sur un crible métallique à mailles très-serrées, puis on les arrose avec une petite quantité d'huile d'olive ; lorsque l'humectation est achevée, on les frotte fortement avec une brosse en fil de fer jusqu'à ce qu'il ne reste plus rien sur le tamis.

Le mélange d'huile et de cuivre est recueilli, puis placé dans un tambour en bronze, hérissé intérieurement d'un grand nombre de petites aiguilles d'acier poli, arrondies par le bout. L'appareil, mis en mouvement au moyen d'un arbre vertical communiquant avec un moteur analogue à une meule de moulin, subit une rotation très-grande qui a pour but de diviser le métal en une poudre fine. Pour lui donner une ténuité encore plus grande, on remplace ce tambour par un autre de même dimension, mais muni d'aiguilles plus fines. En sortant de cet appareil, la matière est sous la forme d'une pâte, on la soumet à une presse hydraulique pour en exprimer l'huile, on la lave à plusieurs reprises avec de l'eau bouillante, on la presse

de nouveau, et après deux ou trois traitements semblables, on obtient un gâteau qu'on fait sécher à l'étuve ; enfin on le pulvérise par les moyens ordinaires.

La poudre ainsi produite possède une teinte qui se rapproche beaucoup de celle du bronze ; il faut attribuer ce résultat à l'oxydation partielle du cuivre par le corps gras. On sait, en effet, que le cuivre, au contact des substances grasses, s'oxyde beaucoup plus facilement que lorsqu'on l'expose à l'air ou qu'on le mouille avec de l'eau.

Les différentes espèces de bronze se fabriquent à Nuremberg et se délivrent dans le commerce par paquets de 30 grammes.

On connaît : Le bronze florentin ou cramoisi ;

Le bronze doré rouge ;

Le bronze doré pâle ;

Le bronze blanc ;

Le bronze vert.

Quelques-uns de ceux-ci sont préparés par des procédés tenus secrets.

Lorsqu'on veut donner à la peinture une couleur grise presque semblable à celle du fer, on se sert de substances nommées *bronze blanc* et *argent mussif*.

Le bronze blanc n'est que de la poudre d'étain, préparée en fondant ce métal, et le versant dans une boîte sphérique enduite de craie intérieurement et rendue raboteuse par des pointes en fer ; on agite très-vivement et sans discontinuer jusqu'à ce qu'il soit entièrement refroidi.

La poudre qu'on obtient ainsi est passée au tamis de

soie ; délayée dans une dissolution de colle forte, elle fournit une couleur mate qu'on peut brunir pour l'avoir brillante.

L'argent mussif, dont l'emploi est très-restreint, s'obtient de la même manière, en réduisant en poudre un amalgame formé à parties égales de bismuth, d'étain et de mercure. Ces deux derniers servent pour imiter la teinte du fer.

TABLE DES MATIÈRES.

Acide carthamique.................................... 178
Alumine... 67
Antimoniate de plomb............................... 66
Antimonite de plomb................................ 65
Argent en coquille.................................. 21
Argent mussif...................................... 332
Argile ocreuse..................................... 141
Arsénite de plomb.................................. 104
Asphalte... 206
Auripigmentum...................................... 86
Azurite.. 275
Biiodure de Heller................................. 147
Bistre... 207
Bisulfure d'étain.................................. 83

Bitume...	206
Blanc de Bougival.................................	48
— de coquilles d'œufs........................	67
— d'Espagne...................................	48
— de fard.......................................	67
— de Meudon...................................	48
— de neige.....................................	35
— de plomb de Hambourg....................	51 et 61
— de plomb hollandais.......................	61
— — du Tyrol........................	51
— — de Venise......................	51 et 61
— de trémie....................................	36
— de Troyes ou de Champagne...............	48
— de Vitry......................................	37
— de zinc.......................................	27
Blende...	45
Bleu d'Angleterre.................................	292
— d'Anvers.....................................	243
— d'azur..	268
— de Berlin....................................	232
— de blanchissense...........................	273
— de chaux.....................................	277
— de cobalt....................................	263
— de cuivre....................................	277
— d'émail......................................	268
— d'empois.....................................	268
— d'Eschel.....................................	273
— de Hollande.................................	292
— minéral......................................	243
— de montagne................................	275
— de Paris.....................................	238
— de Prusse....................................	230

— de safre	268
— de Saxe	268
— de smalt	268
— Thénard	263
— de tournesol	292
— de Turnbull	238
Bol d'Arménie	141
— oriental	141
— rouge	141
Bronze	330
Bronze blanc	332
— des peintres	83
Brun de chicorée	209
— de manganèse	197
— de mars	82
— doré de plomb	199
— de Prusse	205
— rouge	77
— Vandick	198
Carbonate de baryte	67
— de chaux	47
— de manganèse	67
Carmin bleu	291
— de cochenille	180
— de garance	173
— liquide	187
Carthame	177
Carthamine	178
Cendre bleue	277
— d'outremer	246
— verte	318
Céruse	52

Céruse de Mulhouse.	62
Charbon animal.	217
— de bois.	216
Charbons végétaux.	215
Chaux brûlée.	25
— délitée.	25
— métallique.	159
— vive.	23
Chromate de baryte.	100
— de chaux.	99
— de zinc.	107
Chrysocolle bleu.	276
Cinabre.	148
— vert.	302
Colcothar.	138
Considérations générales.	7
Couleurs blanches.	21
— bleues.	228
— brunes.	197
— jaunes.	69
— noires.	213
— rouges.	132
— vertes.	293
Craie.	47
— de Bologne.	67
— rouge.	73
Cristaux de Vénus.	311
Curcuma.	129
Ecarlate.	146
Encre de Chine.	223
Enduit blanc.	26
Fard de la Chine.	179

Fleurs de vert-de-gris.	311
Fritte d'Alexandrie.	269
Gomme gutte.	125
Gris de zinc.	32
Indigo.	284
Indigotine.	285 et 288
Introduction.	1
Iodure de plomb.	89
Jaune d'antimoine.	98
— bouton d'or.	108
— de cadmium.	90
— de chrôme.	109
— — jonquille.	113
— — spooner.	110
— de Cologne.	114
— indien.	129
— de Kassler ou Cassel.	94
— de mars.	80
— minéral.	94 et 102
— — Mérimée.	98
— — surfin.	99
— de Naples.	105
— d'or.	112
— d'outremer.	100
— paille minérai.	102
— de Paris.	94
— de Turner.	94
— de Vérone.	94
Kaolin.	67
Laques brûlées.	121
Laque en boules de Venise.	176
— carminée.	187

— de Fernambouc.....	174
— de garance.....	164
— de garancine.....	172
— de Gaude.....	123
— en général.....	117
— de gomme gutte.....	128
— minérale.....	91
— de Paris.....	188
— plate d'Italie.....	177
— verte.....	303
— de Vienne.....	188
Litharge.....	136
Marne.....	67
Marron-rougeâtre.....	161
Massicot.....	134
Mine-orange.....	135
Minium.....	134
Noir d'Allemagne.....	216
— de Bougie.....	222
— de Cassel.....	217
— de charbon.....	214
— de châtaigne.....	216
— de Cologne.....	217
— de composition.....	223
— d'Espagne.....	215
— de Francfort.....	216
— de fumée.....	218
— de fumée de houille.....	221
— — de résine.....	219
— — de Russie.....	222
— de hêtre.....	215
— d'ivoire.....	217

— de lampe.	221
— de Liége.	215
— d'os.	217
— de pêche.	215
— de velours.	217
— de vigne.	215
Ocre jaune.	72
— rouge.	72
— de rue.	79
— verte.	300
Or.	69
— d'Allemagne.	71
— en chaux.	71
— en coquille.	71
— en feuille.	70
— de Judée.	83
— de Manheim.	72
— mosaïque.	83
— mussif.	83
— en poudre.	70
Orange de mars.	82
Orpiment.	86
Orpin.	86
Os calcinés.	67
Outremer.	244
Outremer de cobalt.	229 et 266
— de Gahn.	229
Oxyde d'antimoine.	43
— d'étain.	67
— de chrôme.	297
Oxydo-chlorure d'antimoine.	44
— de plomb.	46

Oxydo-chlorure de plomb surbasique.	94
Pâle orange.	112
Pierre d'Arménie.	275
Platt indigo.	292
Pourpre de Cassius.	190
Purree.	130
Réalgar.	144
Résine de gomme gutte.	127
Rose de cobalt.	143
Rouge d'Angleterre.	138
— d'Anvers.	79
— en assiette.	179
— brun.	143
— de carthame.	178
— d'Espagne.	178
— en feuille.	179
— de mars.	82
— de Nuremberg.	77
— portugais.	179
— pourpre.	162
— de Prusse.	77
— en tasse.	179
— végétal.	178
— de Venise.	79
Rubis d'arsenic.	144
Safran d'Allemagne.	177
Safranum.	178
Safre.	270
Scarlett.	146
Sépia.	210
Siccatifs pour le blanc de zinc.	39
Siccatifs en poudre.	42

Silice	67
Smalt	268
Stil de grain	117
Sulfate atomique	50
— de baryte	50
— de chaux	50
— de plomb	62
— de plomb basique	101
Sulfite de plomb	63
Sulfure jaune d'arsenic	86
— rouge d'arsenic	144
Talc	67
Terra merita	129
— rosa	79
Terre de Cassel	303
— de Cologne	203
— d'Italie	79
— de Lemnos	141
— d'Ombre	201
— d'Ombre de Cologne	203
— rouge	77
— de Sienne	202
— fine de Turquie	201
— de Vérone	293
Tungstate de plomb	64
Turbith minéral	102
Ulmine	208
Verdet cristallisé	310
— distillé	310
Verditer	281
Vermillon	148
Verre de cobalt	268

Vert anglais.................................... 326
— de Brême.................................. 313
— de chrôme................................. 297
— de cobalt.................................. 295
— cristallisé................................ 310
— d'eau..................................... 312
— émeraude.................................. 300
— en grains................................. 325
— de gris................................... 305
— d'iris.................................... 329
— de Kirchberger............................ 324
— minéral................................... 327
— Milory.................................... 325
— de Mittis................................. 324
— de montagne............................... 313
— Pannetier................................. 300
— de Prusse................................. 302
— de Rinmann................................ 295
— de Schéele................................ 315
— de Schweinfurt............................ 319
— végétal................................... 328
— Paul Véronèse............................. 325
— de vessie................................. 328
— de Vienne................................. 324
— de zinc............................... 296 et 301
Violet de mars.................................. 82
Violet végétal................................. 194

www.ingramcontent.com/pod-product-compliance
Lightning Source LLC
Chambersburg PA
CBHW071618220526
45469CB00002B/386